Public Diplomacy on the Front Line

Public Diplomacy on the Front Line

The Exhibition of Modern Brazilian Paintings

Hayle Gadelha

ANTHEM PRESS

Anthem Press
An imprint of Wimbledon Publishing Company
www.anthempress.com

This edition first published in UK and USA 2024
by ANTHEM PRESS
75–76 Blackfriars Road, London SE1 8HA, UK
or PO Box 9779, London SW19 7ZG, UK
and
244 Madison Ave #116, New York, NY 10016, USA

Copyright © Hayle Gadelha 2024

The author asserts the moral right to be identified as the author of this work.

All rights reserved. Without limiting the rights under copyright reserved above,
no part of this publication may be reproduced, stored or introduced into
a retrieval system, or transmitted, in any form or by any means
(electronic, mechanical, photocopying, recording or otherwise),
without the prior written permission of both the copyright
owner and the above publisher of this book.

British Library Cataloguing-in-Publication Data
A catalogue record for this book is available from the British Library.

Library of Congress Cataloging-in-Publication Data
A catalog record for this book has been requested.
2023941549

ISBN-13: 978-1-83998-939-1 (Hbk)
ISBN-10: 1-83998-939-4 (Hbk)

Cover Credit: Courtesy of João Candido Portinari

This title is also available as an e-book.

CONTENTS

Acknowledgements	vii
List of Figures and Tables	ix
List of Acronyms	xi
Introduction	1
1. Historical Context	**11**
Emergence of Modernism in Brazil	11
Internationalisation of Brazilian Visual Arts	17
Brazil's Wartime Foreign Policy	27
Brazil's Image before the Exhibition	36
2. The Exhibition	**51**
Background	51
Arrangements	59
The Show	75
The Catalogue	89
Navarra's Criticism	100
Press Coverage	106
Before the Show	106
At Burlington House	110
During the Tour	117
3. Hermeneutics of the Exhibition	**125**
Meanings	125
Legacies	139
Conclusions	155
References	163
Appendix	179
List of Artworks	179
Index	185

ACKNOWLEDGEMENTS

This book is an outcome of my PhD dissertation at King's College London, finished in 2021. I acknowledge the confident guidance of my supervisor Vinicius Mariano de Carvalho, whose teachings and friendship have been the most valuable legacy of this journey.

I am also grateful to my wife Ana Paula Pacheco and my daughter Lis Gadelha, whose first trip, at the age of two months, was to Belfast, during winter, thanks to my 1-year older research. They have shared my enthusiasm about my findings, understood my absences and listened to the same stories over and over again.

LIST OF FIGURES AND TABLES

Figures

1. Minister Oswaldo Aranha (Right) and Ambassador Noel Charles (Left) during the Exhibition opening at the Itamaraty Palace in Rio de Janeiro, 1943 (*The National Archives*) 67
2. Herbert James Gunn. Pauline in the yellow dress, 1944. *Harris Museum, Art Gallery & Library* 68
3. Lasar Segall. Lucy with flower, c.1939–1942. *Scottish National Gallery of Modern Art*. Courtesy of Museum Lasar Segall 69
4. Lord Sherwood during the Exhibition opening ceremony at the Royal Academy of Arts in London, 1944 (*The National Archives*) 74
5. The Duchess of Kent and the Brazilian *Chargé d'Affaires* Sousa-Leão observe architectural pictures at the Exhibition in the RAA (*The National Archives*) 78
6. Cover of the Exhibition catalogue (*The National Archives*) 92
7. Translation of the artists' open letter published in a Brazilian newspaper (*The National Archives*) 109
8. Candido Portinari. *A Boba* (Half-wit), 1940. *The Mercer Art Gallery*. Courtesy of João Candido Portinari 113

Table

1. Exhibition Venues and Dates 1

LIST OF ACRONYMS

ABI	Brazilian Press Association (*Associação Brasileira de Imprensa*)
ABL	Brazilian Academy of Letters (*Academia Brasileira de Letras*)
ABS	Anglo-Brazilian Society
BBC	British Broadcasting Corporation
BC	British Council
CEMA	Committee for Encouragement of Music and the Arts
DIP	Department of Press and Propaganda (*Departamento de Imprensa e Propaganda*)
ENBA	National School of Fine Arts (*Escola Nacional de Belas Artes*)
FCO	UK Foreign and Commonwealth Office
FO	UK Foreign Office
FEB	Brazilian Expeditionary Force (*Força Expedicionária Brasileira*)
ICA	Institute of Contemporary Arts
KCL	King's College London
LDN	National Defence League (*Liga de Defesa Nacional*)
MAM-RJ	Museum of Modern Art in Rio de Janeiro (*Museu de Arte Moderna do Rio de Janeiro*)
MAM-SP	Museum of Modern Art in São Paulo (*Museu de Arte Moderna de São Paulo*)
MASP	Assis Chateaubriand Museum of Art in São Paulo (*Museu de Arte de São Paulo Assis Chateaubriand*)
MNBA	National Museum of Fine Arts (*Museu Nacional de Belas Artes*)
MRE	Brazilian Ministry of Foreign Affairs (*Ministério das Relações Exteriores*, also known as *Itamaraty*)
OCIAA	Office of the Coordinator of Inter-American Affairs
RAA	Royal Academy of Arts
RAF	Royal Air Force
SPHAN	National Historic and Artistic Heritage Service (*Serviço do Patrimônio Histórico e Artístico Nacional*)
TAoD	'The Art of Diplomacy – Brazilian Modernism Painted for War' (2018 commemorative exhibition)

TNA	The National Archives
UNESCO	United Nations Educational, Scientific and Cultural Organization
USC	University of Southern California
USIA	United States Information Agency
USP	University of São Paulo (*Universidade de São Paulo*)
WW2	Second World War

INTRODUCTION

In the midst of the Second World War (WW2), the Exhibition of Modern Brazilian Paintings left Rio de Janeiro, crossed the Atlantic Ocean and arrived in London. This Exhibition, as it will be called throughout this book, consisted of 168 artworks donated by seventy of the most recognised Brazilian Modernist painters, including Candido Portinari, Emiliano Di Cavalcanti, Lasar Segall and Tarsila do Amaral. The largest collection sent abroad until that time, and still today the most remarkable show of Brazilian art ever displayed in the United Kingdom, it toured the country between October 1944 and September 1945. It was displayed firstly at the Royal Academy of Arts (RAA) in London and subsequently at the Castle Museum (Norwich), National Gallery (Edinburgh), Kelvingrove Gallery (Glasgow), Victoria Gallery (Bath), Bristol Museum and Art Gallery, Whitechapel Gallery (London) and Reading Museum and Art Gallery, as detailed in Table 1. As a contribution to the Allied War effort, the funds from its sales were given to the Royal Air Force (RAF) Benevolent Fund, at that time an organisation greatly admired by Brazilians.

Despite its relevance, the Exhibition has long been erased from Brazil's diplomatic and art history. This book reconstructs this little-known wartime

Table 1. Exhibition Venues and Dates

Royal Academy of Arts	London	November 22, 1944 – December 13, 1944
Castle Museum	Norwich	December 30, 1944 – January 21, 1945
National Gallery of Edinburgh	Edinburgh	February 9, 1945 – March 11, 1945
Kelvingrove Gallery	Glasgow	March 20, 1945 – April 15, 1945
Victoria Gallery	Bath	April 25, 1945 – May 14, 1945
Bristol Museum and Art Gallery	Bristol	May 29, 1945 – June 26, 1945
Whitechapel Gallery	London	July 7, 1945 – July 28, 1945
Reading Museum and Art Gallery	Reading	August 8, 1945 – September 3, 1945

2 PUBLIC DIPLOMACY ON THE FRONT LINE

initiative and raises two main questions. Initially, it seeks to understand why this unprecedented – and unique to this day – endeavour was enthusiastically championed by the Brazilian Ministry of Foreign Affairs (MRE), precisely during a most complicated period of War. Secondly, it evaluates whether the Exhibition attained its goals, by studying its outcomes and shortcomings. By questioning what led the MRE to support the unlikely action, this book demonstrates that the Exhibition was a Public Diplomacy component of a wider foreign policy designed during wartime. It was shown that the Exhibition pertained to a broad diplomatic drive launched by Brazil during WW2, aimed at enhancing its prestige and international status in the wake of the global conflict. It may thus contribute not only to showcasing an unheard-of example of a successful and sophisticated Public Diplomacy initiative, but also to recover hints of a national legacy in a field scarcely studied in Brazilian historiography.

At a critical time of war, massive efforts were required to organise a large-scale show of Brazilian Modern Art in the United Kingdom, and the virtual absence of historical records is stunning. The fact that it was hosted at the Royal Academy of Arts, the most traditionalist gallery in London and strongly averse to Modernism and non-European painting at the time, made it even more astonishing that the Brazilian Government succeeded in accomplishing this initiative. Its improbable timing, size, venue and comprehensiveness – as well as the logistical challenges of the Exhibition itself – justified a thorough investigation that offers an in-depth understanding of its motivations, circumstances and consequences. British-Brazilian relations, Brazil's WW2 foreign policy and its Modernism and arts internationalisation are all inter-related through this Exhibition, and an analysis of its roles and many aspects should reveal pertinent elements of the nation's history and diplomatic capabilities. This book focuses on the developments between the time in which Oswaldo Aranha (1894–1960) was appointed as Brazilian Minister of Foreign Affairs (1938–1944) and the end of WW2 (1945), in order to situate the Public Diplomacy aspects of this Exhibition within Brazil's foreign relations. It thus strives to demonstrate that decades before the coining of the concept – to this day discussed mostly between US and European scholars – Brazilian diplomacy was able to conceive and execute an initiative in line with twenty-first century state-of-the-art Public Diplomacy practices.

These hypotheses have been put forth throughout this book, which is divided into three chapters: a historical, a descriptive and an analytical one. The first one is comprised of four self-contained sections about the context of the Exhibition, enabling its posterior hermeneutics of it. The analysis of the artistic and diplomatic historical stages of Brazil in the early 1940s

INTRODUCTION

is instrumental in capturing meanings and motivations of the atypical and unprecedented initiative. In turn, the understanding of the internationalisation of Brazilian culture and of its reputation abroad prior to the Exhibition allows the further debate on its political and diplomatic significance and of its impacts on national image. The Chapter 2 is by nature descriptive and results mainly from the immersion and curatorial work on primary sources. It details the conception, execution and repercussions of the Exhibition, which has been for the first time focus of an academic study. This chapter provides the reader with the reconstruction of a relevant historical episode, which will be finally interpreted in the Chapter 3. This last part of the book brings together the two preceding ones into dialogue and, through a hermeneutic process of discernment, tests the hypotheses that the Exhibition constituted a diplomatic attempt to transform Brazil's reputation and reposition it in the post-War international order and that it achieved considerable successes.

Chapter 1 on the 'Historical Context' introduces, through historical reasoning, a general idea of the circumstances within which the Exhibition took place. By these means, it permits a better-informed interpretation of the initiative's multiple meanings. The analysis of the history of the ascension and consolidation of Modernism in Brazil and of its relationship with the movement's development elsewhere reveals the unfolding of a singular symbiotic connection between government and artists. The environment depicted in 'Culture Wars in Brazil' (Williams, 2001), in which Daryle Williams surveys, in detail, the complex and volatile alliance between Brazilian Modernism's emergence and the strengthening and self-legitimation of the Administration headed by President Getúlio Vargas (1882–1954), was fundamental for this book to understand the role that arts promotion played in this specific political context. To make sense of how this process evolved in Brazil, another relevant text was the article by Juliette Dumont and Anaïs Fléchet on Brazilian Cultural Diplomacy in the twentieth century (Dumont & Fléchet, 2014); by revealing patterns of the nation's actions in that field, it allowed this book to capture the backdrop and exceptional qualities of the Exhibition. The diplomatic moment in which Vargas' administration launched the internationalisation of Brazilian Modernism was reflected in a number of historical works, especially those of Gerson Moura (Moura, 1980, 1991, 2013), an expert on the foreign policy of Oswaldo Aranha. These readings provided the investigation with the notion of 'pragmatic equilibrium' that described Brazil's international affairs prior to WW2. They also furnish the ideas of the pursuit of an elevated role during the conflict and the failed attempt to develop a special relationship with the United States, following the Allied victory. Equally relevant was Neil Lochery's analysis, in the book entitled

'Brazil: The Fortunes of War' (Lochery, 2014), of a relevant list of foreign policy priorities prepared by Aranha for a meeting between Presidents Getúlio Vargas and Franklin Delano Roosevelt (1882–1945) in January 1943. Moreover, his argument that the late deployment and the early return of the Brazilian Expeditionary Force (FEB) reduced Brazil's gains from its part in the War was useful to grasp the significance of the Exhibition's outcomes in the mid and long run. The study of its wartime foreign policy explains why the Brazilian Government chose the United Kingdom – considered a counterbalance to the growing North American influence – to host the unprecedented art show and the way in which it was expected to contribute to increasing the country's international status. An innovative and comprehensive 1936 official report (Magno P. C., 1936) by Brazilian diplomat Paschoal Carlos Magno (1906–1980) granted a rare first-hand depiction of Brazil's cultural image among British society on the eve of the global conflict. The diplomat described the stereotypes and prejudices directed towards Brazil at that time and proposed a plan of cultural dissemination in order to mitigate these, which provided a reference with which to evaluate the Exhibition's impact and the way it could be perceived by the country that received the initiative.

After introducing its historical context, the book, in its Chapter 2 ('The Exhibition'), presents a descriptive *corpus* based on hundreds of fragments deciphered through the successive readings of documents that were hereby studied in conjunction for the first time. The examination of epistolary exchanges, official cables, press news and other texts and images made it possible to disclose an untold history of the Exhibition. Bringing significance to one another and reciprocally enabling mutual (re)interpretations, these parts formed a whole *phenomenon* and were (re)signified insofar as broader understanding of it was developed. From the circular reading of these documents, it was possible to trace back the idealisation of having an exhibition of Brazilian art in the United Kingdom and the manner in which it evolved across the years until it was concretised. The curatorial changes up to the point that it was decided that a Modernist show was the most appropriate choice can only be understood in light of the historic and diplomatic context. The reconstruction of the initial phases of the project unveils the first motivations of officials and artists who devised the Exhibition with Modernist features, which would reach London in support of Allied War efforts. It tells the story of how the Brazilian side undertook this enterprise in order to involve the British counterparts and make its way into the United Kingdom's highest-level political offices and most prestigious art circles. Detailed information obtained about logistical challenges, venue choice, curatorship, inauguration ceremony,

INTRODUCTION

display period, tour, publicity and repercussions portrays the Exhibition, the historical period in which it took place and Brazil's broader role in the War. The examination of the outputs of the initiative also offers parameters to the posterior attempts to judge its successes and limitations. The study of the Exhibition catalogue and the criticism of it, as well as of newspaper reviews, not only favours a reconstruction of the history in a more qualitative fashion but also illuminates perceptions of the show, taking into account each specific viewpoint.

Chapter 3 on the 'Hermeneutics of the Exhibition' refers to concepts of Public and Cultural Diplomacy as beacons for the interpretation of the *corpus vis-à-vis* its historical context. The notion of Public Diplomacy – bluntly understood as an approach slanted towards foreign societies instead of governments – and one of its subsets, Cultural Diplomacy, were deployed as theoretical *apparatus*. Thanks to them, this book could offer answers on why and with what degree of success did the Brazilian Government champion the Exhibition. Edmund Gullion's definition of Public Diplomacy[1] (Cowan & Cull, 2008, p. 6) is at the core of the hypothesis that the Brazilian MRE launched the initiative as a way of burnishing the nation's prestige amongst the British, creating a favourable atmosphere amongst the Allies that would enhance Brazil's status in the post-War international order. The book borrows ideas from authors such as British policy advisor Simon Anholt, who developed the Nation Branding and Competitive Identity approaches, for whom any diplomatic action is exclusive to the governmental realm, including those of Public Diplomacy (2015, p. 191). From Joseph Nye, creator of the notions of Soft and Smart Power, this book adopts the assumption that modern Public Diplomacy initiatives are necessarily two-way endeavours, in which the emitter country not only advocates but also listens to the receiver society (2008, p. 103). Another thinker whose work contributed immensely to this study is Mark Leonard, for whom Public Diplomacy activities operate in three different time frames, which correspond to the dimensions of media relations, personal relationships with key foreign actors, and long-term image building (2002, pp. 8–21). This was a central model for

1 According to its original definition by Edmund Gullion, Public Diplomacy as cited in (Cowan & Cull, 2008, p. 6) deals with the influence of public attitudes on the formation and execution of foreign policies. It encompasses dimensions of international relations beyond traditional diplomacy; the cultivation by governments of public opinion in other countries; the interaction of private groups and interests in one country with another; the reporting of foreign affairs and its impact on policy; communication between those whose jobs is communication, as diplomats and foreign correspondents; and the process of intercultural communication.

PUBLIC DIPLOMACY ON THE FRONT LINE

this work to hermeneutically interpret the accomplishments and outcomes of the Exhibition. A final decisive reading for completing this investigation was the book entitled 'The Art of Diplomacy – Brazilian Modernism Painted for War' (2018), which was simultaneously a consequence of and an input into this book.[2] Its publication reunited present-day specialised observers who, during the preparation of a show to commemorate the Exhibition in 2018,[3] reflected on the significance of the wartime initiative. The interpretations of these current views on the episode, fused with past opinions, were instrumental to conclude that the Exhibition was created as a public component of a specific foreign policy aimed at repositioning Brazil's credentials in the post-War order. It was also possible to demonstrate that this goal was to a large extent accomplished, in terms of both press coverage and the establishment of lasting ties with British society. However, its legacy could have endured longer had Brazil's foreign policy priorities not changed in the wake of WW2. Having gained some understanding about the Exhibition, its historical background and context, hermeneutics[4]

2 It presents introductory texts by the Brazilian Ambassador to the United Kingdom Eduardo dos Santos, the British Ambassador to Brazil Vijay Rangarajan, Royal Academy Artistic Director Tim Marlow, RAF Benevolent Fund Controller David Murray, British Council Chief Executive Ciarán Devane and The National Archives CEO and Keeper Jeff James. The catalogue then presents essays by Adrian Locke (Royal Academy), Dawn Ades (University of Essex), Vinicius Mariano de Carvalho (King's College London), Michael Asbury (Chelsea College of Arts) and this book's author, which analyse various aspects of the Exhibition and the 2018 show that remembered it, from diplomatic contexts to aesthetic issues and Brazil's role in the War.

3 The show 'The Art of Diplomacy – Brazilian Modernism Painted for War' (TAoD) was opened on April 5 and displayed until June 22, 2018, at the *Sala Brasil*, the exhibition hall at the Brazilian Embassy in Trafalgar Square, London. It displayed twenty-four paintings by twenty artists from collections of public galleries across seventeen cities in the United Kingdom, along with a video produced for the occasion (available at https://youtu.be/M2ASGjwaB3A) and several historical documents unearthed by this book. The meta-exhibition was originally intended to commemorate the 1944/5 event, and the investigation to make it possible preceded and motivated the present research. The TAoD, which was planned as a diplomatic initiative, as much as the event that it celebrated, took place within historical, political and cultural contexts entirely different from those of the wartime Exhibition.

4 According to Professor Thomas Schwandt, when working with the hermeneutic paradigm, researchers are interested in 'the various ways that people understand human *phenomena*, acknowledging that there are many ways of viewing these *phenomena*. Interpretivist thinking is associated with Max Weber, who suggested that in the human sciences we are concerned with *verstehen*' as cited in (Peterson & Higgs, 2005, p. 342). Indeed, the pursued *verstehen* – understanding of human material,

INTRODUCTION

was applied to interpret the significance of the object and offer a response to the question of what motivated the Brazilian MRE to mobilise significant resources in the midst of a world war to organise this remarkable cultural initiative. This book finally evaluates, from the analysis of all data collected, the benefits of the initiative, both in objective terms – the number of people impacted by it, the amount of money raised to help the War effort and the artworks that remained in foreign collections, whose data was discovered in archives and records – and in qualitative aspects, even though the latter are known to be refractory to precise measurements. In order to do so, this book has collected a plethora of articles, published in newspapers and in magazines specialised in arts and architecture, about Brazilian culture from before, during and after the Exhibition, as well as official reports relating to Brazil's cultural presence in the United Kingdom. The quantity and depth of the opinions are telling of a certain change in perceptions amongst the British as a result of the Exhibition, whose longer-term effectiveness and continuity are however, debatable.

Although the *corpus* of the book was mainly built from the study of abundant first-hand documents, the few dispersed references to the Exhibition found in the literature were relevant tools of contextualisation and indispensable for interpreting the object. Despite its innovativeness and indeed its relevance for the history of British-Brazilian relations, the Exhibition has been virtually absent from academic publications both in Brazil and in the United Kingdom. There are short mentions in works of three important Brazilian art historians – Frederico de Morais, Walter Zanini and Aracy Amaral. Frederico de Morais includes a comment on the Exhibition in his book entitled '*Cronologia das artes plásticas no Rio de Janeiro*' [*A chronology of visual arts in Rio de Janeiro*] (Morais, 1994). He also analyses its role within a broader

in opposition to the explanation of natural sciences – of the Exhibition presupposes capturing discourses, perceptions, opinions and prejudgements of third observers and placing them in social, cultural and historical context. Theologian Friedrich Schleiermarcher has been acknowledged as the founder of modern hermeneutics, moving beyond the interpretation of biblical texts to the human understanding. Described by Peterson and Higgs as the 'theory and practice of interpretation' (2005, p. 342), hermeneutics offers, in their words, a 'deeply interpretive research approach which can examine complex human *phenomena* from multiple standpoints to produce rich theoretical and experiential interpretations of these *phenomena*' (2005, p. 354). From this stance, this book cross-examined the largest possible number of views and opinions of direct and present-day observers of the Exhibition, which were scattered throughout various documents. This enabled the author to identify, among irreconcilable points of view, reliable arguments and arrive at satisfactory answers to the proposed questions.

8 PUBLIC DIPLOMACY ON THE FRONT LINE

political mobilisation of Brazilian artists in the catalogue of the show *Tempos de Guerra [Wartime]*, held in Rio de Janeiro in the 1980s (Morais, 1986). Walter Zanini, in his work '*A Arte no Brasil nas décadas de 1930–40' [Art in Brazil in the 1930s and 1940s]*, devotes a paragraph to briefly describing the Exhibition as 'voluminous and representative' (1991, p. 65), analysing its catalogue and listing the participating artists. He also alludes to the event in the article '*Exposições coletivas brasileiras no exterior (decênios de 1930 e 1940)' [Collective Brazilian Exhibitions abroad in 1930s and 1940s]*' (Zanini, 1991). Aracy Amaral refers to the Exhibition in the article 'Brazil: commemorative exhibitions or notes on the presence of Brazilian Modernists in international exhibitions' (Amaral, 2002). In this text, she cites a weekly chronicle from the 1940s by the writer and leading figure of Brazil's Modernism, Mário de Andrade, in which the Exhibition featured as part of an uneventful conversation between characters who discussed the clash of expectations between the Brazilians, who desired to display a 'white' art, and the British, who expected to see a 'black' one (1989, p. 132). These mainly descriptive passages in art history texts function as records of the initiative but do not venture a deeper examination of it. In any case, they have the merit of suggesting interesting debates around the political meaning of the Exhibition, by discussing it within the artists' stance in WW2, and the dissonant ways in which it was perceived by Brazilian and British audiences.

In the United Kingdom, the Exhibition earned no more than footnotes in histories of the Royal Academy of Arts by two former secretaries of the Academy, Walter (1931–1951) (Lamb, 1951) and Sidney Hutchison (1968–1982) (Hutchison, 1968). The absence of details and the little attention devoted to the event in these books, even in comparison to the longer references received by some other foreign shows, are symptomatic of a self-righteous attitude towards Brazilian art during that period. The main sources for the reconstruction of the *corpus* research, therefore, have been a) the catalogue of the Exhibition (RAA, 1944), prefaced by a British critic and a Brazilian one, Sacheverell Sitwell (1897–1988) and Ruben Navarra (1917–1955) respectively, as well as an article in Brazil's press in which the latter criticises the former's views on the show (Navarra R., 1945); (b) the wide media coverage by newspapers and magazines in the two countries; and (c) the abundant documents found in several archives in London, Rio de Janeiro, Paris, Bath, Bristol, Edinburgh, Glasgow, Manchester, Norwich and Reading. The astonishing scarcity of literature about the Exhibition makes telling its story a challenge in itself. By doing an extensive amount of primary research and systematising data, this book intends to fill this important historiographical gap. The sources from idioms other than English were translated by the own author, and the original formulations are reproduced in footnotes.

INTRODUCTION

Despite the vast literature about the *sui generis* period of Brazil's international relations and participation in WW2, there is virtually no bibliographic references to its Public Diplomacy efforts either. Except for the recent '*A diplomacia na construção do Brasil: 1750–2016*' by former Ambassador, Minister of Economy and Minister of Environment Rubens Ricupero, which represented an important connection between Brazil's foreign policies and Public Diplomacy, this concept has been largely neglected by the country's scholars. His claim that Brazil inherited from Portugal a certain tendency to exploit Public Diplomacy, based on culture, law and knowledge, converges with the overall interpretation of the Exhibition and its circumstances. This work sheds light on this aspect and contributes, through a relevant case study, to incorporate it into the studies of Brazilian diplomacy. It would be a great achievement to incentivise the necessary debate about a Brazilian strain of Public Diplomacy, whose discussion is still very incipient amongst Brazilianists and researchers in general. A desired indirect outcome of this book is thus to foster an academic interest about a Brazilian distinctiveness in the field, with regard not only to themes and objects of study, but also by developing new and useful analytical contributions to the theoretical debate and to the diplomatic *praxis*. Finally, although adopting a clear diplomatic standpoint, this book hopes to stimulate scholars from various areas to expand different and complementary views on the Exhibition and its effects.

Chapter 1

HISTORICAL CONTEXT

Emergence of Modernism in Brazil

Modernists needed to assure their multiple audiences that modernismo *and* brasilidade *were synonymous*

Daryle Williams[1]

Whilst a large part of Brazilian historiography, since its 'patron', Francisco Adolfo de Varnhagen (1816–1878), ignores precolonial times and considers the arrival of Europeans in 1500 as the beginning of national history, the chronology of its arts is even more limited. It commonly starts in 1816, when the French Artistic Mission led by Joachim Lebreton (1760–1819), a former director of the Louvre, arrived in Rio de Janeiro to establish the capital's artistic institutions and canons. According to historian Fernando Azevedo, it is with the installation of the Portuguese court in Brazil that, 'broadly speaking, the history of our culture begins, for, until this time, one cannot find anything, but sporadic manifestations of exceptional figures educated in Portugal and under foreign influence' (as cited in Williams, 2001, p. 622). Eight years before the arrival of the French Artistic Mission, the Portuguese royal family had moved to Brazil, escorted by the English fleet, fleeing from Napoleonic expansion. Subsequently the capital of the United Kingdom of Portugal, Brazil and the Algarves (1815–1822), Rio de Janeiro required a cultural *apparatus* compatible with its new status as the centre of a European monarchy. Portugal's King John VI (1767–1826) revoked the colonial prohibition of printing, and the royal library was brought from Lisbon. Lebreton and his cohort devised a Royal Academy dedicated to visual arts, crafts and architecture. The Academy, which was later transformed into the Imperial School of Fine Arts and finally the National School of Fine Arts (*Escola Nacional de Belas Artes – ENBA*), would drive the development of Brazilian visual arts, through its salons and prizes. Championed by officialdom for over a hundred years,

1 (Williams, 2001, p. 3657).

Brazil's visual arts were still attempting to emulate standards imported from Europe throughout the nineteenth century. Eventually, a nationalist quest to subvert the European influence emanated from the arts establishment, and this became an essential characteristic of Brazilian Modernism, as defining of the movement as the common attributes of universal Modernism listed by Peter Gay in his classic 'Modernism': subjectivism or self-scrutiny and the rupture with conventions (2010). The apparent anachronism between breaking with old aesthetics and continuously importing established patterns is explained by Daryle Williams, for whom 'the Brazilian elite worked to invent a civilised Brazil for Brazilian and international eyes. The standards of civilisation were always European, but civilisation itself was exhibited as a national project' (2001, p. 3384). The need to affirm an endogenous identity was indeed a founding element of Modernism in Brazil, present since its first appearance, but its relationship with Europe remained evident, even if often refuted by Brazilian artists and intellectuals.

The milestone of the emergence of Modernism differs according to different authors. Gay casts Gustave Flaubert (1821–1880), with his 'Madame Bovary' (1857), as 'Modernism's first hero' (2010, p. 5), and 'Olympia' and *'Déjeuner sur l'Herbe'*, both painted in 1863 by Édouard Manet (1832–1883), as the first Modernist paintings. In Brazil, Navarra, who wrote the Introduction for the Exhibition catalogue, surmises that the 1913 show of Lithuanian-Brazilian painter Lasar Segall was a watershed (RAA, 1944). Historian and literary critic Wilson Martins chooses 1917 because it was the year of the second exhibition of paintings by Anita Malfatti (1970, p. 19). Mendonça Telles argues that the true Modernist 'revolution' occurred in 1924, the year of Graça Aranha's breakaway from the Brazilian Academy of Letters (*Academia Brasileira de Letras* – ABL), of the *'Manifesto Pau-Brasil [Brazilwood Poetry Manifesto]'* by Oswald de Andrade and of two important texts by Mário de Andrade[2] (2012, p. 58). Despite date divergences and evidence that the Modernist movement had been active in Rio de Janeiro for years, its most consecrated turning point became the Modern Art Week held in São Paulo in 1922. One of its driving forces, writer and diplomat Graça Aranha (1868–1931), considered it 'not some mere *renaissance* of an art which does not exist [but] the birth of an art in Brazil' (as cited in Williams, 2001, p. 833), thereby demeaning the official historiography by Varnhagen and his followers. After returning from decades of living in Europe, a retired Aranha disseminated the aesthetic innovations that he had witnessed to a younger

2 There is no mention about which texts he refers to. Mário de Andrade's best known ones are *'Pauliceia desvairada'* (1922), *'A Escrava que não é Isaura'* (1925) and *'Macunaíma'* (1928).

HISTORICAL CONTEXT

generation of Brazilian intellectuals (Castro, 2019, p. 168). He was the bridge between the iconoclastic Modernists and the São Paulo coffee producers who sponsored the rebellious 1922 Modern Art Week,[3] whose opening conference was delivered by him. In defiance of the hegemonic academic art, diverse and often dissonant Modernist groups developed, in the wake of the Great War, an art that strove to represent a true Brazilianness, in open opposition to the European-moulded traditional art. In fact, Brazilian Modernism was largely influenced by European vanguards, which was constantly denied by its own founders (Mendonça Telles, 2012, p. 55).

But whereas European Modernists sought to dissolve and destroy the icons of tradition, in the art critic Ronaldo Brito's view, 'Brazilian vanguards endeavoured to embody the local conditions, by characterising and reifying them'[4] (as cited in Fabris, 2010, p. 14). Analysing the Exhibition and the Brazilian art trajectory abroad, Amaral concludes that 'contrarily to what is expected from Brazilian art in foreign countries, to date this [contradictory relationship with its European influences] stands as the forever unresolved issue or yet the desire for the self-assertion of Brazilian artists' (2002). This apparent dilemma may divert the proper analysis of Brazilian art, whose original path unfolded within singular geographic, historical and cultural circumstances. Regardless, the judgement of the Exhibition would be impacted by this tendency to evaluate its aesthetic qualities through Eurocentric lens.

After these inaugural years of consolidation, during which many Modernist groups in Brazil kept a certain distance from state patronage, the anti-establishment ascension of Getúlio Vargas changed the relationship between Modernism and officialdom. For Williams (2001, p. 871),

> anti-statism was an undercurrent in Modernist production, precisely because the cultural institutions protected by the state, such as the National School of Fine Arts, were hostile to Modernism. Prior to the Revolution of 1930, the renewal envisioned by the Modernists was of little use for the republican state.

From that moment on, Vargas' revolution, which challenged not only the elections but also the whole political system designed by the agrarian

3 When Di Cavalcanti, a participant of the Exhibition, told Aranha about the idea of promoting a scandalous festival, he introduced the painter to the writer and coffee magnate Paulo Prado, a friend of him (Castro, 2019, p. 168).

4 'A vanguarda brasileira se esforçava para assumir as condições locais, caracterizá-las, positivá-las, enfim' (as cited in Fabris, 2010, p. 14).

14 PUBLIC DIPLOMACY ON THE FRONT LINE

oligarchies that dominated Brazil's export-driven economy, sought a unifying and legitimising cultural narrative for its nationalist project of development. As noted by architect Lauro Cavalcanti, the country required simultaneously a double movement: to erect its nationality and its modernity (2005, p. 190). By then, the Modernists had perceived possibilities of convergence and eased up on their anti-state discourse. As the same Daryle Williams reasons, 'once at odds with officialdom, the Modernists were now seeking a place within the state' (2001, p. 1092). Indeed, disputes between Brazilian Modernists and Academicists, until then the unquestionable representatives of Brazilian culture, would be waged at the core of the Vargas Administration's quest for a national identity and, on the bottom line, for its own consolidation. In the Centennial Exhibition of 1922, which was seen by over 3.6 million visitors (Williams, 2001, p. 777), the academic currents were still hegemonic within Brazilian governmental discourse, including neo-colonial architecture, which was declared the paradigm of national aesthetic emancipation. The Government decreed that it was the Brazilian style *par excellence*, to be mandatorily adopted in official representations abroad, a norm that was observed until 1938 (Cavalcanti, 2005, p. 189). A central event in the struggle over the official cultural narrative was the appointment in 1931 of the Modernist architect Lucio Costa (1902–1998) to direct the National School of Fine Arts and to devise a structural and pedagogical reform of the nation's visual and architectural education. For Daryle Williams, it 'ignited a bitter conflict at the ENBA, turning the federal culture apparatus into a battleground, in an emerging pattern of cultural warfare that would define culture and politics during the Vargas regime' (2001, p. 1057). Tensions resurfaced when non-academic artworks entered the National Salon held at the ENBA in 1931, until then a space set aside exclusively for academic art. For the first time, the salon displayed pioneers of the Modernist movement, some of whom would participate in the 1944 Exhibition, such as Emiliano Di Cavalcanti, Tarsila do Amaral and Cícero Dias.

Eventually, traditionalists forced Costa out of office. ENBA students sympathetic to reform went on strike and managed to close the school for several months. Since the struggle surrounding the *Salão Revolucionário* in 1931, these two artistic movements had been fighting for governmental positions, patronage and prestige. In the anti-Modernist field, the painter, critic and founder of the National Museum of Fine Arts (*Museu Nacional de Belas Artes –* MNBA) Oswaldo Teixeira (1905–1974) was a mouthpiece of the academic movement, seeking to maintain its hegemony within the Vargas regime by flattering the President, whose protection of the arts he considered to be 'limitless' (1940, p. 48). Providing a clear idea of how dependent the artists

HISTORICAL CONTEXT

were of the *Estado Novo*,[5] he wrote that Vargas was the Brazilian equivalent of the pharaohs, or the likes of Pericles, Medici, Francis I, Phillip II and IV, as he looked after the artists' lives with sincere enthusiasm by offering them academic positions or commissioning works, especially in the domain of decorative painting, as well as instituting key posts for them in the federal administration (Teixeira, 1940, p. 51). Whilst the academic painters struggled to preserve governmental access, Vargas initially lost part of the Modernist *intelligentsia* that supported his liberal platform when he violently overruled the 'Revolution of 1932' that demanded elections and a new constitution in São Paulo. Subsequently, leftist intellectuals and artists were lured by commissions to develop large-scale educational and civic arts programmes (Lira Neto, 2013, p. 128). In this regard, the young Minister of Education and Health, Gustavo Capanema (1900–1985), played a central role, by bringing into the public administration some of the most important figures in the Modernist movement, who took on, in Daryle Williams' words (2001, p. 1436),

> paid and unpaid positions in the expanding network of federal cultural institutions ... Perhaps because of Capanema's opposition to totalitarianism, intellectuals associated with the moderate and left-wing political movements of the early 1930s somehow managed to make their peace with the Vargas regime.

The dynamic link between the two currents and the Vargas administration shows that governments are inescapable supporters of major cultural programmes, and, on the other hand, the state viscerally depends on all sorts of cultural subsidies in order to survive (Telles Ribeiro, 1989, p. 63).

Attracted by Vargas' nationalism, left-wing intellectuals ended up serving an authoritarian state, and it is impossible to deny the Modernists success in capturing the official cultural institutions. By the end of the 1940s, one could not ignore the hegemony achieved by Modernism, which appropriated the idea of Brazilianness. Painters who would take part in the 1944 Exhibition, such as Tarsila do Amaral, Cícero Dias, Emiliano Di Cavalcanti and Candido Portinari, were some of the pioneers in taking on Brazil as the theme, idiom and engine of their works (Cavalcanti, 2005, p. 190). The artistic system established by the French Artistic Mission had been, through long disputes, 'dominated from within' (Zilio, 2010, p. 103).

5 The authoritarian and nationalistic *Estado Novo* regime was established by Getúlio Vargas in November 1937, and lasted until the end of his first term in 1945.

It developed into a symbiotic relationship, as 'the intertwining of state power, cultural canons, the law and Modernism was vital to the process of inventing a particular politics of culture that characterises the Vargas era' (Williams, 2001, p. 2099). Modernism eventually achieved what literary critic Antônio Cândido called 'routinisation', evolving from a contesting, marginalised and exceptional movement into mainstream art that carried Brazil's identity (1984). The Brazilian case, as demonstrated, corroborates Gay's view that 'the absorptive capacity of a cultural establishment that Modernists had worked so hard to subvert was nothing less than impressive' (2010, p. 11). This replacement of the national cultural identity, also visible in terms of foreign representation, was accompanied by a new political attitude among Brazil's newly hegemonic artists.

As it gained status within officialdom, a large part of the Modernist movement started to request that the Vargas regime adopt in Brazil the same values for which it was fighting abroad and to demand a resolute standing in the Second World War, in line with the Allies. On the eve of the Exhibition's inauguration, Vargas was under pressure to hold free polls, as constitutionally prescribed, and his permanence in office was being questioned by different organisations and even by his own advisors. Heading up an increasingly popular groundswell, Foreign Minister Oswaldo Aranha had been openly defending prompt elections, whereas the most conservative sectors of the Vargas Administration preferred to wait for the end of the War. Despite the vainglorious and triumphalist narrative delivered by conservative intellectuals such as Oswaldo Teixeira, Brazil's official entrance in the War underscored the incongruence of a government that was ready to fight against totalitarianism externally while refusing to accept democratic contingencies internally (Lira Neto, 2013, p. 434).

If in 1940 many Modernists were somehow involved in the nationalistic crusade of the *Estado Novo* regime, by 1945 only the most conservative cultural institutions, such as the ABL, still backed the regime. In December 1943, President Vargas had been bestowed membership of the traditional and elitist literary society, without having written a single book. He had been elected to the Academy in 1941, but, symptomatically, the ceremony was only held at the moment when the *Estado Novo* underwent a conspicuous crisis of ideological and intellectual legitimacy (Lira Neto, 2013, p. 434). In his speech, Vargas reinforced that culture and art should be understood as propelling forces of national unity and the civic formation of a people, synthesising his strong commitment with arts promotion as a political tool. In his narrative, due to the symbiosis between men of thought and action, Brazil would have achieved its political emancipation, advanced its economic emancipation and begun its cultural emancipation (Vargas, 1943). Many dissatisfied artists and

HISTORICAL CONTEXT

intellectuals, in turn, joined groups such as the National Defence League (*Liga de Defesa Nacional* – LDN). It was originally a rightist organisation devoted to patriotic and civic cultivation established in 1916, which, during the early 1940s, exceptionally worked as an anti-Fascism stronghold, hosting the most diverse pro-Allied currents, from liberals to communists and even traditionalist oligarchs. The league urged elections, led grassroots support for the FEB, and organised several art shows in many Brazilian cities in order to raise funds for its campaign. In 1943, the artistic circles of Rio de Janeiro and São Paulo rallied together in protests against Nazism, and Anti-Axis exhibitions were held at the Itamaraty Palace and the Prestes Maia Gallery (Zanini, 1991, p. 35). In both shows, there were works by some of the artists who would later take part in the 1944 Exhibition. This would have represented, according to Morais, the apex of this mobilisation (1986, p. 186). It is noteworthy that, although there was a myriad of political positions amongst the writers and intellectuals who advanced the Modernist agenda, in the field of visual arts, there was an almost total predominance of a leftist stance (Zilio, 2010, p. 101).

In January 1945, when the Exhibition was being displayed in Norwich, the 1st Brazilian Congress of Writers was held in São Paulo. The conclusions that it reached would amount to the first large public manifestation of disavowal of the authoritarian *Estado Novo* regime, demanding freedom of expression and democratic suffrage (Lima, 2010). Less than two months later, the Exhibition reached Scotland, whilst the 1st Congress of Brazilian Visual Artists also published a letter supporting the writers' movement, advocating free elections and expressing solidarity with the FEB in its fight against Nazism (Correio da Manhã, 1945). The painters were fighting both in Brazil and abroad.

Internationalisation of Brazilian Visual Arts

The relation between diplomacy and culture is not only obvious but also richly documented since long ago

Antônio Cândido[6]

Although Brazilian proneness to the Cultural Diplomacy dates back to its Portuguese heritage, the promotional efforts were circumscribed to modest initiatives, mostly in the musical field, often led individually by diplomats connected with artists. Besides Graça Aranha, who during the Great War managed to release cargoes of coffee retained by the Germans that belonged

6 (as cited in Telles Ribeiro, 1989, p. 18).

to Paulo Prado, his friend and sponsor of the Modern Art Week of 1922 (Castro, 2019, p. 168) – another diplomat who promoted Brazilian visual arts was Luiz Martins Souza Dantas (1876–1954), Brazilian Ambassador to France between 1922 and 1944. Both cultivated friendships among intellectuals and businessmen in Brazil and Europe. From the 1930s onwards, Vargas turned cultural promotion, generally associated with trade interests, into a state policy. Two-way artistic exchanges were stimulated by the *Estado Novo*, which deployed a newly devised national identity to amalgamate Brazilians and project the image of a rapidly-developing country abroad. The artistic effervescence of the early 1940s reflected these fast-growing cultural flows, both in the United Kingdom and in Brazil. It revealed Brazilian artists and their output to audiences abroad, while simultaneously exposing them to international trends. At the same time, the United Kingdom began to open up to modern global aesthetics. Michael Asbury notes that 'in both contexts, admittedly for distinct reasons, the 1940s can be understood as a pivotal decade within the respective national Modern Art trajectories' (2018, p. 40). It is indeed interesting to compare the chronology of Modernism's emergence in Brazil and the United Kingdom. The Institute of Contemporary Arts (ICA), the first institution exclusively devoted to modern and contemporary art in London, was founded in 1946. In the following year, the Museum of Modern Art of São Paulo (MAM-SP) and the Assis Chateaubriand Museum of Art of São Paulo (MASP) were established, and, in 1948, the Museum of Modern Art of Rio de Janeiro (MAM-RJ) opened its doors. In 1951, both the Festival of Britain and the São Paulo Biennale took place for the first time, seeking to 'reconfigure the national sense of identity through modern aesthetics' (Asbury, 2018, p. 40). It is also remarkable that, for the first time, both Brazilian and British artists from modest backgrounds rose to the cultural elite, as until that time the *milieu* was almost exclusive to aristocrats and oligarchic families. Brazil was, for Asbury, 'on the verge of a cultural revolution' (2018, p. 40), which would impact the country's development and place in the world, as an observer but also as a creator of equal standing to the main artistic centres (Locke, 2018, p. 70).

Two exhibitions held in Rio de Janeiro in 1940 are telling of the relationship between Brazilian art circles and their European counterparts – in this case, French – influence. The Exhibition of French Art, hosted by the MNBA, displayed works by painters from Jacques-Louis David (1748–1825) to Pablo Picasso (1881–1973), attracted more than 40,000 visitors – a huge attendance by the standards of that time in Brazil – and has since been discussed in several art history books. Interestingly, the 1944 Exhibition in the United Kingdom would be visited by around 100,000 people. Among them, 37,000 would attend the show in Bristol, indicating that Brazil's appetite for the Fine

HISTORICAL CONTEXT

Arts was not comparable to that of the British, who were eager to visit an exhibition of an art as unfamiliar as Brazilian Modernism, even in wartime. The Exhibition of French Art, hosted midyear, had a special impact on Brazilian Modernists, who were highly interested in the French School. Commenting on the show, Quirino Campofiorito, an influential critic and artist who would later take part in the exhibition in the United Kingdom, criticised the Brazilian artists for not expressing the same level of innovation seen in French painting (Williams, 2001, p. 2861). Largely publicised by the MNBA, the show was welcomed and commented by the elite and upward middle classes from Rio de Janeiro. Diversely, the Exhibition of the French Artistic Mission, held in December of that same year, is virtually absent from the records of the cultural history of the period, despite its great relevance (Williams, p. n3055). According to Daryle Williams, 'part of the silence may be attributed to the fact that the exhibit went largely unseen by the public. In contrast to the unparalleled popularity of the *Exposição da Pintura Francesa*, the exhibit on the French Artistic Mission, recorded a meagre 1,201 visitors' (2001, p. 3055). Arguably, the latter evoked undesirable self-images among the Brazilian audience, including social and racial taboos, and the remembrance that the country had imported a civilisatory mission was incompatible with the *Estado Novo* spirit of valuing a strong and confident cultural identity for Brazil (Williams, p. 3080).

A few representative exhibitions of British art were likewise held in Brazil during the War.[7] In October 1941, a show of British children's art organised by the British Council (BC) opened at the MNBA in Rio de Janeiro (Morais, 1994, p. 173). In its catalogue foreword, BC Chairman Sir Malcom Robertson (1977–1951) underscores the institution's purpose of 'making better known abroad the British way of life and mindset, whilst promoting an intense exchange of knowledge and ideas with other peoples' (1941, p. 3), emphasising the diplomatic goal of this endeavour. In the following year, the same museum hosted the Exhibition of British Contemporary Prints, comprised of 240 works by 123 artists from the nineteenth and twentieth centuries. In 1943 and 1944, the Exhibition of British Contemporary Paintings would also be held at the MNBA, as well as at the Prestes Maia Gallery (São Paulo) and in Belo Horizonte. It included 163 paintings and prints by 110 artists, among whom were Henry Moore

7 Before the War, the 1938 and 1939 May Salons invited a group of young Surrealist artists from England to participate in the annual show, including Roland Penrose (1894–1982), Charles Howard (1899–1978), Ceri Richards (1903–1971), John Banting (1902–1972) and Julian Trevelyan (1910–88), alongside the Constructivist Ben Nicholson (1894–1982).

20 PUBLIC DIPLOMACY ON THE FRONT LINE

(1898–1986), Paul Nash (1889–1946) and John Piper (1903–1992) (Zanini, 1991, p. 55). The catalogue preface by art critic Herbert Read (1893–1968) interestingly contains caveats about its curatorial coherence – 'we ask Brazilian audience to accept it as rather a set of artworks than as a proper collection where to seek a definitive judgement about British painting' (1943, p. 3). It also acknowledges strong French influence over the show, which was 'unmistakable; signs of British ascendance are less evident but no less significant [as all artists] have resorted to Cézanne and his disciples. The content, however ... is essentially English' (Read, 1943, p. 3). It is quite revealing that these were exactly the same dilemmas experienced by Brazilian art at the time, also referred to in the Exhibition catalogue and in the following debate around it. In turn, Dawn Ades, when comparing both shows, asserts that the Brazilian Exhibition in London neither conformed to the expectations of the conservative Royal Academy nor 'fit the more Modernist bias of the exhibition Contemporary British Art that the British Council had sent [to Brazil] the previous year' (2018, p. 59). It is interesting to note, moreover, that the Exhibition of British Contemporary Paintings was very similar to the Exhibition of Modern Brazilian Paintings in London, in terms of size and contemporaneity. For past and hindsight observers, the latter functioned as a retribution to the British gesture.[8]

The increase in the number of foreign shows in Brazil was matched by the more active presence of Brazilian art abroad. As previously mentioned, the *Estado Novo* needed a cultural narrative not only to galvanise the domestic public but also to convey a new national image to the rest of the world. Vargas devoted substantial efforts to use culture as a vehicle to transform Brazilian reputation and to position the country as an industrialising regional power. To achieve that, it was necessary to replace Brazil's association with outdated land ownership structures. This was why 'the regime prized exhibitions, especially those staged abroad, for their potential to imagine a unified national community confident in the recovery of Brazil's cultural vocation' (Williams, 2001, p. 3366). From an outsider to a major force within official institutions, Modernism gradually disputed Brazilian cultural identity on the international scene, even though, as shown by Amaral, the attendance of Brazilian Modernists in international exhibitions began in an 'inconsistent manner, as they appeared next to other artists, some of whom were academics, other transitional' (2002, p. 1).

In 1924, the *Exhibition d'Art Américain-Latin* was held at the *Museé Gallièra* displaying thirteen Brazilian artists, including a few Modernists, such as Anita Malfatti, Victor Brecheret and a participant of the 1944 Exhibition,

8 See the 'Meanings' section.

HISTORICAL CONTEXT

Toledo Piza (Squeff, 2015). Six years later, a collective exhibition of exclusively Brazilian artists was hosted at the *Foyer Brésilien*, under the auspices of the Brazilian Ambassador to France, Luiz Martins Souza Dantas, a leading promoter of Brazilian Modernism and a key link with Parisian society. Among the eighteen paintings on display, there were works by Gastão Worms and Portinari, who would send paintings to the Exhibition in 1944 (Silva, 2009). The United States received a small Brazilian Modernist exhibit, The First Representative Collection of Paintings by Contemporary Brazilian Artists, at the Roerich Museum in New York, in 1930 (Amaral, 2002). Some artists who would have works on display at the Exhibition, such as Tarsila do Amaral, Cícero Dias, Emiliano Di Cavalcanti, Alberto da Veiga Guignard, Paulo Rossi Osir, Carlos Oswald and Quirino da Silva, participated in this show. In 1935, an eclectic delegation of Brazilian painters sent works to the annual exhibition at the Carnegie Institute in Pittsburgh. They included the Modernists who were the stars of the London Exhibition, Segall and Portinari, whose painting '*Café*' was awarded an honourable mention (Zanini, 1991). In 1937, another diverse group of Brazilian artists presented their paintings to the **XXVII** *Salón Nacional de Buenos Aires*, among whom were some of the participants in the Exhibition, such as Flávio de Carvalho, Guignard and Rossi Osir (Zanini, 1991). At that time, the Vargas Administration was setting in motion ambitious plans to improve the nation's profile in international circles, and opened trade bureaus in New York and several European capitals to promote Brazilian commerce (Williams, 2001, p. 3481). There was indeed a close connection between international trade – especially coffee, with Brazil exporting most of the world's output – and Modernism, which was supported by wealthy São Paulo's producers.

Portinari's '*Café*', rejected a couple of years earlier for the Brazilian Embassy collection in Washington and for the 1937 Paris World Fair, due to its Afro-Brazilian subject matter, would make another appearance in 1939 (Williams, 2001, p. 3717). That year, the 'Vargas regime gained its ticket into the world of tomorrow', in Daryle Williams' words (2001, p. 3702). During the New York World Fair, an estimated eight million visitors passed through the Brazilian Pavilion, designed by Modernist architects Lucio Costa and Oscar Niemeyer (1907–2012) and filled with Modernist artworks. From the New York Fair onwards, Portinari would become the pictorial representation of Brazil in the United States, where audiences were impressed by his art. Most of the works sent to New York were displayed at the Riverside exhibition, rather than in the Pavilion, and were conservative paintings by academic artists. It was sign of the ongoing (but decisive) battle between Academicists and Modernists in their fight

22 PUBLIC DIPLOMACY ON THE FRONT LINE

over exporting a Brazilian cultural narrative. Both styles were deployed in the New York Exhibition, but (Williams, 2001, p. 3599)

> the regime hit upon Modernism as the carrier of national identity. This seemed an entirely appropriate choice, because the Modernists employed cultural idioms of modernity accessible to international audiences, while maintaining a commitment to Brazilian sensibilities.

The hegemony of Modernism as the representation of Brazilian culture was once again challenged in 1940. In the Exhibition of the Lusitanian World, held in Lisbon, academic art was well suited to the common values shared by the Brazilian and Portuguese governments, twinned by the same *Estado Novo* label and by their sympathy for authoritarian regimes. The 2.8 million visitors to the exhibition saw a Brazilian Pavilion distant from the Modernist commercial emporium that captivated New York. '*Café*' was, on this occasion, the only Modernist artwork on display. In any case, the Vargas Administration would soon abandon its special alliance with António Salazar (1889–1970), as Brazil's entry into the War on the side of the Allies reordered its international priorities (Williams, 2001, p. 4103).

In 1943, the architectural photography show 'Brazil Builds', which would later accompany the Exhibition in the United Kingdom, was displayed at the Museum of Modern Art of New York (MoMA). The exhibition was memorialised in a book by Philip Goodwin (1881–1935), illustrated with photographs by architect Kidder Smith (1913–1997), and was intended to 'show Americans the charming old and inspiring new buildings in Brazil' (Goodwin, 1943, p. 25). This book had a great impact and was turned into a kind of guide to modern Brazilian architecture, becoming a recurrent work for its propagation (Carrilho, 1998, p. 8). After criticising the Washington-like taste for 'warmed-over Palladio', Goodwin affirmed that Rio de Janeiro 'was cured of its disease and began to reconsider its architectural possibilities in terms of modern life and modern building technique' (1943, p. 25). For him, Brazil had launched itself into an 'adventurous but inevitable course. The rest of the world can admire what has been done and looks forward to still finer as times goes on' (Goodwin, 1943, p. 103). Following a warm welcome in New York, the 'Brazil Builds' exhibition, which was comprised of 162 photographs, corresponding texts, three models (of the Ministry of Health and Education, the Brazilian Pavilion at the 1939 International Fair in New York and the Arnstein residence) as well as an audio-visual sequence of images, toured across several Brazilian, Mexican and US cities. It was later displayed in London, at Simpson's House, before

HISTORICAL CONTEXT

being sent to second the Exhibition at the Royal Academy of Arts and other galleries in the United Kingdom. The repercussions in the US press were widely favourable, and the *imprimatur* of an institution as renowned as the MoMA drew awareness, even among the Brazilian audience, to those achievements that were thriving in the international scene, despite being little acknowledged at home (Carrilho, 1998, p. 2). The resonance of the architectural show was amplified by its political underpinning. The support of the Brazilian government – Minister Capanema opened it in Rio de Janeiro – and of Nelson Rockefeller's (1908–1979) Office of the Coordinator of Inter-American Affairs (OCIAA), the powerful cultural arm of the US Good Neighbour Policy (1940), was well recognised by the organisers.[9] The selection of works to appear in the 'Brazil Builds' show reveals the direct participation of Brazilian authorities, as it coincides precisely with the buildings that were receiving attention and being reassessed by the newly-established National Historical and Artistic Heritage Service (*Serviço do Patrimônio Histórico e Artístico Nacional* – SPHAN), whose Heritage Division was headed by Lucio Costa.

Even considering that it was bolstered by official support, 'Brazil Builds' stood out for its aesthetic originality. Pioneering architectural initiatives launched in Europe had stalled with the advent of WW2, and in the dismal panorama of that period, there was the emergence of a Brazilian production that, despite the war's vicissitudes, seemed to convey great vitality (Carrilho, 1998). In an illustrative statement, referring to the new Ministry of Health and Education, Goodwin argues that (1943, p. 92)

> while federal classic in Washington, Royal Academy archaeology in London and Nazi classic in Munich are still triumphant, Brazil has had the courage to break away from the safe and easy path with the result that Rio can boast of the most beautiful government building in the Western hemisphere.

It is worth noting the antagonistic comparison between Brazilian modernity and the conservativeness of the British Royal Academy, which would ironically host the Exhibition a year later, albeit with some resistance. Goodwin remarkably concludes, having set France as the ultimate benchmark, by saying that 'at night the curving line of street lamps along the bay and the well-lighted parks and avenues recall the title Paris once

9 Amongst the acknowledgements in the catalogue, there are thanks to Minister Capanema and Rockfeller; as well as the landscaper Burle Marx and the architect Flávio de Carvalho, artists who would participate in the Exhibition.

held of the *Ville-Lumière*, a title to which Rio has some right in these days of general gloom' (1943, p. 95). This repercussion of the 'Brazil Builds' extrapolated to Brazilian modern architecture, which gained acclamation before the Modernist painting.

The official patronage of so many exhibitions and artistic activities overseas was a new *phenomenon*. Dumont and Fléchet claim that, circumscribed to literary initiatives and official visits of foreign scholars until the end of the nineteenth century, Brazilian Cultural Diplomacy[10] was consolidated after the Great War and that Brazil was a pioneer in this field, ahead of the other Latin American nations (2014, p. 204). Although since its imperial period a few sporadic initiatives of cultural dissemination directed at Europe and the United States were devised, Brazil had long been considered a mere repository of European and US cultural policies. During the 1930s, setting up the University of São Paulo (USP) in 1934 and adhering to the Good Neighbour Policy, announced by President Frank Delano Roosevelt as a way to foster harmonic and respectful coexistence in the Americas, were examples of the still pre-eminent influence of France and the United States in Brazil. Incidentally, France was the nation that first devoted an institution to cultural dissemination abroad, the Alliance Française, in 1883. It was followed by Italy, the United Kingdom, the United States, Canada and Brazil itself (Telles Ribeiro, 1989). Cultural promotion had been officially assigned to Itamaraty in 1920, although dispersed individual initiatives led by diplomats posted abroad took place in the decades that preceded the Brazilian Exhibition. Literary missions, tours of popular modern music groups and a few visual art shows were promoted during the First Republic period (1889–1930),

10 A report from the United States Department of State from 1959, prior to the conceptualisation of Public Diplomacy, defined Cultural Diplomacy as 'the direct and enduring contact between peoples of different regions [designed to help] create a better climate of international trust and understanding in which official relations can operate' (as cited in Gienow-Hecht J. D., 2010, p. 13). The roots of the institutionalised practice of Cultural Diplomacy can be traced back to the 1930s, when the BC (1934) and the Division of Cultural Relations in the Department of State (1938) were set up (Kim, 2017, p. 308). It is noteworthy that Brazil was amongst the first countries to establish a structure devoted to promoting its culture abroad, the Service of Intellectual Expansion, founded in 1934. The earliest scholars on the subject praised Brazil's cultural dissemination efforts. As early as 1946, McMurry & Lee presented an extremely positive view of Brazilian activities in the field of cultural dissemination (Telles Ribeiro, 1989, p. 88). The pioneering and proactivity of Aranha's Public Diplomacy policies, of which the Exhibition is an outstanding example, should have contributed to the early international recognition of Brazil – then a country of limited influence – in this field.

HISTORICAL CONTEXT 25

but there were no systematic policies of international dissemination. In 1934, the Service of Intellectual Expansion was established; and in 1937, the Service of Intellectual Cooperation replaced it, aligned with Minister Capanema's pursuit of an intensive propaganda[11] campaign, following the models of Italy, Russia, Germany and Portugal. It was turned into the Division of Intellectual Cooperation in 1938, after which time Brazilian Cultural Diplomacy, although institutionalised, remained mismanaged and spread out between different ministries, each of which was informed by a given ideological field (Dumont & Fléchet, 2014). During the 1930s and 1940s, the dissemination of Brazilian culture was handled simultaneously and in overlapping ways by the Department of Press and Propaganda (DIP), the Ministry of Health and Education and the Ministry of Foreign Affairs (Ferreira, 2013, p. 66). It is relevant to note that as early as 1946, McMurry and Lee, in 'The Cultural Approach', presented a remarkably positive evaluation of the Brazilian work of cultural dissemination, offering praise of Itamaraty's activities (Telles Ribeiro, 1989, p. 88).

The Inter-War period marked the consolidation of Brazilian cultural promotion and forged, according to Dumont and Fléchet, the lasting characteristics of Brazilian Cultural Diplomacy: pragmatism in the thematic and geographic choices; a gap between the cultural productions which were valued domestically and abroad; and institutional disorder (Dumont and Fléchet, 2014). In the midst of the intricate but disorganised governmental efforts at cultural promotion, the authors emphasise the leading role of

11 The expression Propaganda was widely used at that time. According to the political scientist Bruce Lannes Smith, Propaganda can be understood as the 'dissemination of information – facts, arguments, rumours, half-truths, or lies – to influence public opinion' (Lannes Smith, 2017) and has been largely deployed for 400 years. From the last century, though, it has become associated with authoritarian regimes and to psychological warfare. Nowadays, it conveys a highly negative and out-of-date connotation, especially for its linkage with the manipulation of information. It is also mainly a one-way form of interaction, in which a certain regime seeks to influence foreign populations by governmental and ideological messages, instead of listening and seeking to understand the others' minds. Since the 1970s, according to North American scholar Bruce Gregory, the United States practitioners adopted the term Public Diplomacy as an alternative to Propaganda and its pejorative connotations (2008, p. 275). In turn, the former British diplomat Alan Hunt defends that when the retired North American diplomat Edmund Gullion created the notion of Public Diplomacy in 1965, he was seeking 'a means of describing the activities undertaken by the United States to persuade and influence people that would distinguish them from those of the Soviet Union, which were regarded in the West as Propaganda' (2015, p. 18).

the Foreign Ministry, whose consistency gave a basic permanency and coherence to the first decades of Brazilian cultural internationalisation. Indeed, Brazil's diplomacy has been traditionally associated with what is currently called Public Diplomacy, although the historiography of international relations has seldom referred to co-related initiatives. Since its outset, the Brazilian Foreign Service has enjoyed widespread recognition, for bestowing itself with large and rich extensions of territory without exceptional military or economic power. For Ricupero – one of the first authors to include Public Diplomacy in the history of Brazil's foreign relations – this 'diplomacy of weakness' was inherited from the Portuguese. In order to compensate for their military inferiority in negotiations with the European powers – Britain, especially – they developed an intelligent power stemming from the diplomacy of knowledge and elements of moral and cultural leadership (Ricupero, 2017, p. 281). This painful experience with the United Kingdom would have thus strengthened an awareness among Brazilians that only diplomacy and law could mitigate the asymmetry of means. This *praxis* would have been cultivated since independence and was perfected by the Minister of Foreign Affairs Baron do Rio Branco (1845–1912), patron of Brazilian diplomacy, who realised the importance of perception and image, ingredients of diplomatic prestige that constituted an appreciable component of power (Ricupero, 2017, p. 290). In the words of polymath Gilberto Freyre, Itamaraty has historically been 'the supreme organ of irradiation and affirmation of Brazil's prestige' (as cited Dumont & Fléchet, 2014, p. 205), and it is notable that the Brazilian Embassy in London, during WW2, assembled a team of intellectuals who, in different ways, engaged in Public Diplomacy and strove to enhance the nation's image in the United Kingdom. They were excellent examples of the dual function described by Deborah Bull and Francesco Pisano, for whom 'diplomats are key agents in the service of Soft Power[12] and Cultural Diplomacy. They are both the delivery channel for their government's policies as well the embodiments of national culture and values' (2017, p. 8). Amongst the art enthusiasts and collectors who worked

12 As Nye Jr. first defined it in 1990, 'when one country gets other countries to want what it wants, [it] might be called co-optive or Soft Power in contrast with the hard or command power of ordering others to do what it wants' (Nye Jr., 1990). Soft Power, according to its creator, rests primarily on three resources: culture, political values and foreign policies. These Soft Power influences affect national reputation, attract international visitors and students, increase commerce and a country's political clout globally (Singh & Stuart, 2017, p. 7). Interestingly for the object of this book, several authors, consider culture the core – and most effective – element of Soft Power (Singh & Stuart, 2017, p. 12).

HISTORICAL CONTEXT

at the Embassy during the Exhibition were Ambassador José Joaquim Moniz de Aragão[13] (1887–1974), Counsellor Joaquim de Sousa-Leão Filho and the Secretaries Josias Leão, Hugo Gouthier and Paschoal Carlos Magno – the latter wrote the first official report about Brazilian cultural promotion in the United Kingdom in 1936[14] (Magno P. C., 1936). Regarding their image promotion efforts, it is relevant to note that, as mentioned by Roberta Ferreira, the prevailing model of cultural dissemination in Brazil at that time pursued a rosy picture of a modernising nation pursuing development and destined to become one of the great nations in the following decades (2013, p. 235). In order to achieve the international status envisioned by Minister Aranha, Brazil needed to create in the common imaginary the idea of a country in ascendance, so as to be granted a corresponding place in the concert of nations (Ferreira, 2013, p. 65). Before Vargas and Aranha decided to send abroad the Exhibition and its underlying political and aesthetic messages, a long history of Cultural Diplomacy had been built by several diplomatic actors. This Exhibition – and its broader objective of reinserting Brazil on the global stage – must be understood *vis-à-vis* the previous reputation of Brazilian culture and its emerging foreign policy during WW2.

Brazil's Wartime Foreign Policy

Brazil will inevitably (become) one of the great economic and political powers of the world

Oswaldo Aranha[15]

During the 1930s, shrinking British influence over the Brazilian economy and politics was replaced by renewed interest in the United States and Germany. The dispute between the emerging powers in the years that preceded WW2 and the special geopolitical circumstances of that period enabled President Vargas and Foreign Minister Aranha to develop a diplomacy of bargaining.

13 Decorated Commander of the British Empire, Moniz de Aragão was previously a Germanophile Ambassador to Berlin, who even devised a scheme of police cooperation with the Gestapo. He was declared *persona non grata* in September 1938 by the Nazi regime, following a bilateral crisis due to the prohibition of foreign parties and political activities issued by Vargas. When Brazil and Germany reassigned mutual Ambassadors, both appointed their Vice-Ministers, Kurt Prufer and Ciro Freitas-Vale, to head the diplomatic missions (Hilton, 1994, p. 319), signalling the high level of priority still attributed to the bilateral relations by both countries.

14 See section on 'Brazil's Image before the Exhibition'.

15 (as cited in Moura, 2013, p. 160).

The literature offers several examples that substantiate Vargas' intention of extracting benefits for Brazil through juggling Brazil's connections with both the Axis and Allies. This ambiguity led to distrust and several crises with its most traditional ally, the United Kingdom. Subsequently, the Atlantic Closure by the British Navy and the Pearl Harbour attacks in December 1941 compelled Brazil to abandon its neutrality and align with the Allies. Brazil's entry in the War, after open opposition from Britain was surmounted by US mediation, eventually led to a resumption of bilateral cooperation. Both Brazil and the United Kingdom feared excessive Brazilian dependence on the United States and wished to strengthen their commercial, economic and political ties. A study of official documents from that period corroborates the reciprocal interest in cultivating closer bilateral relations in the post-War era and proves that the Exhibition and its goal of changing perceptions about Brazil were part of that diplomatic effort.

The international crisis of 1929 accentuated the decline of British hegemony and the emergence of the United States over Brazilian politics (Fausto, 2012, p. 323). The economic, financial, commercial and cultural pre-eminence of the United Kingdom in Brazil, dating from Portuguese colonial times but whose pinnacle was the 'essentially British 19th century' (Almeida, 2005, p. 61), progressively gave way to increasing US influence. Simultaneously, Nazi Germany was ratcheting up its economic and ideological presence in Latin America. According to Moura (2013, p. 47),

> the interwar period therefore represented a growing challenge as the new powers both within and outside Europe sought to enlarge their own areas of influence, while the well-established old powers attempted to halt their own decline. In Latin America, the *interregnum* of 1919–1939 was characterised by a decline in British influence and a growth of German and North American influence.

Oswaldo Aranha, who had been Vargas' Minister of Economy (1931–1934) and Ambassador to the United States (1934–1937), was appointed Minister of Foreign Affairs in March 1938. According to Ricupero, he differed from his predecessors for really being a man of the new times, fated to become the central figure of Brazilian diplomacy in the decade (2017, p. 323). The most pro-West and the firmest liberal of the Brazilian statesmen, he enjoyed open channels and personal prestige among US leaders (Ricupero, 2017, p. 323). However, despite his privileged access to President Vargas and his extraordinary influence, Aranha had no absolute control over Brazilian foreign policy, as he lacked support amongst the members of the cabinet who had a say in ideological and security issues and admired Fascism.

HISTORICAL CONTEXT

The assignment of the Americanophile Aranha as Minister of Foreign Affairs occurred when, in contrast to the increased presence of the United States, British participation in the Brazilian economy had clearly retreated. The United Kingdom had no capacity for exerting a more assertive role in Brazil, having defined the protection of its financial interests as the main objective within their bilateral relations. In turn, the United States and Germany, respectively, prioritised the political and commercial aspects of their relations with the country (Moura, 2013). The dispute over areas of influence between the two emerging powers was in fact a conditioning circumstance of Aranha's term, from his appointment in 1938 until 1941. In order to obtain maximum benefit from their competition, Brazil adopted a shrewd diplomatic stance that Moura named 'pragmatic equilibrium', which produced a number of commercial benefits and increased Brazil's bargaining power in these years (Moura, 2013). Ricupero, an exception amongst diplomatic analysts, opines that the strategy was only a repetition of the 'diplomacy of weakness' that dated to colonial times and that Vargas dared little or nothing at all in terms of foreign policy (2017, p. 390). It seems clear that Vargas and Aranha managed to creatively operate and benefit from the opportunities of a unique geopolitical environment in which Brazil occupied an unprecedentedly strategic position. As explained by Moura, Natal[16] was 'not only the spring-board for offensive operations against the Dakar area of Africa, but the terrain feature, if securely held by the United States, could effectively control the East and North coasts of South America and secure, from Axis attack, the vital Caribbean area, including the Panama canal' (2013, p. 127). The Vargas regime identified within this new context an opportunity and put together cultural relations and commercial Propaganda in a clear attempt at 'improving Brazil's stature in the international community' (Williams, 2001, p. 3481), benefiting from its unrivalled capacity in exporting primary goods and its singular geopolitical position during this period. For a country whose economy in the thirties began to move away from the production of primary goods towards a rapid process of industrialisation and urbanisation, foreign trade was of paramount importance. Brazilian imports from the United Kingdom declined from 28.3% of the total in 1903 to 10.4% in 1938; imports flow from Germany increased from 13% to 25% in the same period. Exports followed the same tendency: in 1903, the United Kingdom bought 19.3% of Brazilian exports;

16 Capital of the Rio Grande do Norte state, located in the north-eastern Brazil, Natal is the country's closest city to Africa and Western Europe. Because of its strategic position, a North American air base (Parnamirim) was built there during the Second World War.

30 PUBLIC DIPLOMACY ON THE FRONT LINE

and in 1938, only 8.8%. Germany's share rose from 14.8% to 19.1% during that period (Almeida, 2005, p. 595). Trade agreements had been signed with both the United States (1935) and Germany (1936), the exports of the latter overtaking those of the former to become Brazil's main supplier in 1938 (Fausto, 2012, p. 324). Germany was more flexible in its commercial relations with Brazil, offering capital goods and technology transfer, and was open to negotiating two priority goals of Vargas' government, the arming of the Brazilian military and the construction of a steel mill, the centrepiece of the development plan of the *Estado Novo*. Both would eventually be financed by the United States, due to further developments in the War. This was the context that was well understood and manoeuvred by Brazil's authorities, who launched a foreign drive to transform its reputation and expand its role in global affairs.

Lira Neto examines Vargas' bargaining policy that sought to take advantage of this special geopolitical moment and affirms that 'nothing could be more illustrative of the Brazilian President's ambivalence than the fact that two of his sons [...] were studying abroad in totally opposing situations. One, in Germany; the other, in the United States'[17] (2013, P. 355). The ecumenism of the *Estado Novo* was most visible, according to him, in an episode when Edda Ciano Mussolini (1910–1995), daughter of the *Duce* and wife of the Italian Foreign Minister Count Galeazzo Ciano (1903–1944), danced some *samba* steps with the American chief-of-staff of the Department of War, General George Marshall (1880–1959), in the Brazilian presidential palace in 1939. The trip of Edda Mussolini, sent as a cultural ambassador for Fascism, would culminate, again according to Lira Neto, in a 'torrid night at Copacabana beach'[18] (203, p. 360) with Benjamin Vargas, the President's brother. Getúlio Vargas' flirtation with both sides of the conflict misled high authorities and close advisers. For the German Ambassador to Rio de Janeiro, Vargas had 'openly expressed his aversion towards England and the democratic system'[19] (as cited in Lira Neto, 2013, p. 385); whereas, in Aranha's view, Vargas was inwardly 'favourable to France and England and attempted to hide his anti-Germanism'[20] (as cited in Hilton, 1994, p. 344).

17 '*Nada poderia ser mais ilustrativo das ambivalências do presidente brasileiro do que o fato de dois de seus filhos ... estarem estudando fora do Brasil em situações frontalmente opostas. Um, na Alemanha; o outro, nos Estados Unidos*' (2013, p. 355).
18 '*Uma tórrida madrugada nas areias de Copacabana*' (Lira Neto, 2013, p. 360).
19 '*Ele exprimiu abertamente sua aversão pela Inglaterra e pelo sistema democrático*' (as cited in Lira Neto, 2013, p. 385).
20 '*O Getúlio, ainda quando no seu íntimo favorável à França e à Inglaterra, procura esconder seu antigermanismo*' (as cited in Hilton, 1994, p. 344).

HISTORICAL CONTEXT

In any case, British-Brazilian ties were increasingly marked by distrust and distancing and, from 1940 onward, all communication of the Brazilian Embassy in London was intercepted by the local government (Lochery, 2014, p. 64).

Before the outbreak of the Second World War, in 1938, Brazil had signed an £8 million contract with the German company Krupp to acquire weaponry, whose delivery, after the beginning of the conflict, was successively blocked by the British Navy (Lochery, 2014). The complex negotiations to receive the previously paid-for arms escalated and brought the traditionally close Anglo-Brazilian relations to the eve of a rupture. The Brazilian Minister of War and future successor of Vargas, General Eurico Dutra (1883–1974), suggested breaking diplomatic ties and even declaring war on the British, in the midst of WW2 (Lochery, 2014). The military was calling for a rupture in bilateral relations, with Aranha faced by increasing pressure to confront the United Kingdom. The issue had both international and domestic implications, and the largely Germanophile Brazilian army was looking for a battle with the British and with Aranha, who was the leader of the pro-Allies faction within Vargas' hitherto divided government (Lochery, 2014, p. 81). The Minister of Foreign Affairs wanted to preserve a harmonious relationship with the United Kingdom, but in trying to resolve the crisis, he would meet a strong reaction from the military (Hilton, 1994, p. 350). Aranha's point of view eventually prevailed, as the problem was addressed in 1941 and the Siqueira Campos was released due to the United States' pressure on the British government (Moura, 2013, p. 95). The severe crisis was indeed mediated by the United States, which was by that time openly acting as a sort of guarantor of Brazilian interests – and, as seen in the previous section, of its aesthetic messages. President Franklin Delano Roosevelt had replaced Theodore Roosevelt's (1859–1919) 'Big Stick Policy' with the 'Good Neighbour Policy' amongst the American countries and initiated an intense exchange of products, values and cultural goods. Brazilian efforts at cultural promotion, therefore, found its 'warmest reception in the United States, where the government of Frank Delano Roosevelt proved exceedingly receptive to strengthening cultural relations with the strategically important Brazil' (Williams, 2001, p. 3481). The two-way policy was subsumed into a wider strategy that aimed at securing Brazil's and Latin America's alignment with the United States, which was asserting itself as a great power and a central player in the new international system (Moura, 1991).

Since 1940, due to the naval blockade by the British Navy, commerce with Germany had ceased to be an option, and the German-Brazilian volume of trade fell to one-tenth of the previous year's level. The Atlantic closure, thus, removed one of the foundations of the Brazilian policy of

pragmatic equilibrium, which had to be discarded thereafter (Moura, 1980). In Moura's viewpoint, the Vargas administration gradually accepted that, in view of the rapid polarisation, it was necessary to choose one partner in the War (2013, p. 78). In a timely manner, the Brazilian Foreign Ministry was then 'organised along traditional liberal lines which allied it closely with American and British positions in international politics' (Moura, 2013, p. 67). By that moment, though, the United States had treated Brazil as their exclusive area of influence. From the British standpoint, officials commented at the end of 1942 that 'now that Rockefeller's organisation[21] is starting to work in Rio de Janeiro, we must be prepared to lose ground, as we are afraid that our best friend will succumb before the almighty dollar' (as cited in Moura, 1991, p. 35). The intense work of cultural exchange launched by Rockefeller, coordinator of the OCIAA, promoted grassroots expressions but also valued Brazil's Modernist production. His personal links with Brazilian arts patrons and US institutions fuelled several initiatives, including the 'Brazil Builds' show and the establishment of the MAM-SP and the MASP (Lima, 2010). British Ambassador to Rio de Janeiro, Noel Charles (1891–1975), wrote that (as cited in Moura, 2013, p. 162)

> American officials have in the course of conversation let drop the opinion that we British should consider United States' relations with Brazil to be on a par with our own relations with Egypt or South Africa (sic) thus indicating that Brazil is regarded by the US as a preserve in fact if not in theory.

He also sensed that 'in any competition with [the Americans] in South America, we must recognise that it is an area where they are prepared to pay a substantial premium for political prestige' (as cited in Moura, 2013, p. 162). The action of the OCIAA really afflicted British diplomacy, which foresaw a reduction of their own influence in Brazil. In commercial and financial terms, 'His Majesty's Embassy in Rio worried in 1942 about the degree to which British interests in Brazil would be affected by this general United States' economic offensive' (Moura, 2013, p. 140). The United Kingdom feared that the North Americans, while distributing Brazil's goods to the Allies, would gain control over its resources. Moreover, there was the risk that, in the post-War world, Latin America would become a captive market for United States' products and also a supplier of goods that had been previously acquired from the British.

21 See the section on the 'Internationalisation of Brazilian Visual Arts'.

HISTORICAL CONTEXT

In American circles, the analogue idea became current that they finally had a special position in Brazil and that the British should keep distance from Brazil (Moura, 1991, p. 68). The United States' entry into the conflict, in the wake of the Pearl Harbour attack, would compel Vargas to abandon any velleity of his ambiguous position and join the Pan-American stance defended by Roosevelt. In January 1942, during a meeting in Rio de Janeiro that confronted Brazilian and Argentinean diplomacies, Brazil led most of the region to break relations with the Axis countries, under auspices of the US Under-Secretary of State, Summer Welles (Doratioto & Vidigal, 2014, p. 63). The sought-after special alliance with the United States represented, for Brazilian diplomats, bureaucrats and the military, the possibility of consolidating a sub-regional hegemony, especially *vis-à-vis* Argentina, which remained neutral in the conflict, and of boosting Brazil's importance within the post-War international order (Moura, 2013). In the words of Aranha, Brazil would, in this way, 'inevitably [become] one of the great economic and political powers of the world' (as cited in Moura, 2013, p. 160). By August 1942, when Brazil finally declared war against Germany and Italy after the sinking of five Brazilian merchant vessels and following massive public outrage, pragmatic equilibrium was totally discarded, and there was substantial consensus across the establishment on the opportunity for launching a special alliance with the United States. Immediately, Brazilian planners began to talk about the part Brazil would play in the War, that is, the new political role the country would play in international politics (Moura, 2013, p. 151). It was expected that the collaboration with the United States would enlarge Brazil's role in the regional and global affairs. When Roosevelt secretly visited Vargas in Natal in January 1943, returning from the Casablanca Conference, Aranha had prepared a list of eleven priority goals for Brazilian foreign policy, the first of which was to achieve higher international status. On that occasion, the creation of a Brazilian force to fight the War was first discussed in a high-level meeting (Lochery, 2014). Brazilian leaders perceived the formation of the FEB as 'the nucleus of a political project designed to strengthen the Brazilian armed forces and give Brazil a new position of pre-eminence in Latin America and of great importance in the world as a special ally of the United States' (Moura, 2013, p. 162). This interest corresponded with 'definite pressures from pro-United States currents of opinion, among nationalist organisations such as the LDN' (Moura, 2013, p. 162). The British Ambassador reported an identical impression, by writing that the 'equipment [of FEB] is not so much intended for the purpose of fighting for a democratic victory against the Axis so as to strengthen [Brazil's] own position in the post-War discussions relating not only to South America and hemisphere problems but to questions of

34 PUBLIC DIPLOMACY ON THE FRONT LINE

even wider importance' (as cited in Moura, 2013, p. 162). This corroborates the argument that not only the Exhibition but even the military role played by Brazil in the War were driven by a wider diplomacy of prestige.

There is abundant evidence proving that Brazil's military participation in the War was more the result of its own government's desire to increase its international reputation than the consequence of any appeal from the Allies, since they did not want its direct participation in the conflict. Several communications show that the position of benevolent neutrality was considered adequate by the Allies, who in fact advised Brazil and its neighbours that cutting off diplomatic relations was a good enough expression of solidarity. Not only would Brazil's entry in the War divert the supplies necessary to satisfy their own needs, but its untrained Army was viewed as an unnecessary addition on the front.[22] In contrast to the public manifestation of satisfaction by the British, it was privately felt that 'the decision was somewhat unexpected in light of earlier advice offered by [Ambassador] Sir Noel Charles' (as cited in Moura, 2013, p. 152). When the Exhibition was handed by Aranha to Charles at the Itamaraty Palace in Rio de Janeiro in November 1943, the chances of Brazil sending a force to fight in Europe seemed remote, due to open opposition from the United Kingdom and some reluctance by the United States, which followed the presidential meeting in Natal. British Prime Minister Winston Churchill (1874–1965) himself opined that 'it would be a serious error to allow more than a brigade from Brazil' (as cited in Moura, 2013, p. 199), considering the multitude of more than twenty nationalities already coexisting in the theatre of operations (Barone, 2013). Nonetheless, in the midst of a severe economic crisis, Vargas made it an absolute priority to deploy the FEB to take part in the War, for both internal and external reasons. After all, the fight against a foreign enemy seemed appropriate 'during the final months of 1944 [, when Vargas] faced growing opposition to his regime from Brazilians who were tired of the economic situation in Brazil [and] the pressure for political changes only increased' (Lochery, 2014, p. 234). High officials from the US Department of State eventually changed their minds and pondered that 'to brush [Vargas] off ... may even weaken his government, whose record of cooperation in the War has been wholehearted' (as cited in Moura, 2013, p. 199). Lochery demonstrates that there had been (2014, p. 228)

> some disagreement between senior United States' and British officers
> [as] the British wanted nothing to do with the FEB, arguing that it would

22 General Marshall even talked of it as 'an additional headache' (as cited in Moura, 2013, p. 203).

HISTORICAL CONTEXT

get in the way of combat operations. The British viewed the force as little more than an American ruse, one intended to show that the United States enjoyed widespread support in South America. Nonetheless, the United States had signalled to Vargas, since the presidential meeting in Natal, that the FEB would be involved in combat operations and that its members would receive the best training and equipment that the United States had to offer – and this promise eventually trumped British objections to Brazil's participation.

In the end, Roosevelt's insistence persuaded Churchill of the political importance of fulfilling the promise that the Brazilians would fight (Barone, 2013, p. 109). The United States conceded to champion the FEB formation, in view of the collaboration consistently offered by Brazil during the War in commercial, political and military terms. In Carvalho's words, it was only thanks to a 'great effort of diplomacy on the part of Brazil and the eventual approval of the United States that the FEB was able to join the Fourth Corps of the United States Fifth Allied Army in Italy, where it fought bravely to break up the Gothic Line between Tuscany and Emilia-Romagna' (2019, p. 54). The United States, once more, sponsored Brazilian interests and lobbied the United Kingdom to acquiesce to the FEB deployment, which was formally agreed upon in May 1944, when the artworks for the Exhibition were already sailing to London.

Despite the resistance to the FEB's participation in the War, since Brazil broke relations with the Axis in January 1942, the British Ambassador had welcomed the change in its political attitude towards the United Kingdom, and Prime Minister Winston Churchill hailed the historic decision. The conditions were now propitious for the recovery of the traditional alliance, which had been eroded by mutual distrust in the previous years. The Foreign Office diplomats, including Ambassador Noel Charles, speculated that Brazilians 'do not want to throw themselves entirely into the arms of the United States but regard Britain as a desirable make-weight against the US influence' (as cited in Moura, 2013, p. 141). Aranha, a realistic statesman, sought to cultivate relations with London so as to counterbalance the American influence over the Brazilian economy. Despite how much he prioritised the special ties with the United States, Aranha acknowledged the risk of an excessive dependence generated by the War. He wrote to British Foreign Secretary Sir Anthony Eden (1897–1977), in February 1944, when the latter was already searching for a venue for the Exhibition, that Brazil desired to remain open to all friendly nations (Hilton, 1994, p. 405). In this way, through several reciprocal gestures and contacts, Brazil and the United Kingdom managed to create an atmosphere of growing solidarity in the months that preceded Brazil joining

PUBLIC DIPLOMACY ON THE FRONT LINE

the War (Hilton, 1994, p. 403). There seems little doubt that political factors were the main reason why the Exhibition was sent to London instead of the United States or some other European arts hub.

By the time the FEB troops disembarked in Naples and the Modernist artworks arrived in London, Brazilian politics and diplomacy had undergone radical changes. The geopolitical *calculi* were completely transformed by the successful Anglo-American invasion of North Africa, after which the risk of an Axis invasion of Brazilian territory waned (Moura, 2013, p. 165). In the domestic realm, Aranha's campaign for free elections undoubtedly contributed to the progressive distancing between him and Vargas in the first months of 1944, and they indeed spent weeks without meeting (Hilton, 1994, p. 421). Aranha's prestige made him the natural candidate to become the elected President in a potential poll to replace Vargas, who, as a precautionary measure, weakened his Ministry and authority within the government. Ricupero argues that the President was jealous of the popularity and brilliance of someone who could be perceived by international and domestic public opinion as a leader more suitable and desirable for a Brazil on the eve of redemocratisation (2017, p. 335). Along the same lines, Lochery feels that Vargas' most fatal decision of all was the 'choice to withdraw his support for an old friend: Oswaldo Aranha' (2014, p. 234). On August 21, the same day that Allied forces reached the outskirts of Nazi-occupied Paris, the Foreign Minister of Brazil resigned, after a lost political battle with the capital's chief of police, who ordered a search at the Society of Friends of America, of which Aranha himself was the Vice-President (Lochery, 2014, p. 235). The architect of the alignment with the Allies and the declaration of War was expelled from the government, by a baffling coincidence, at the very same moment when Brazil sent its first troops to fight in Europe and when the Exhibition of Modern Brazilian Paintings was reaching London, both initiatives mainly ensuing from his diplomacy of prestige, aimed at altering Brazilian national reputation.

Brazil's Image before the Exhibition

> *Brazil alone, therefore, will be not merely a great South American country, but a world power if she so chooses.*
>
> Adolf Berle[23]

Professor Dawn Ades, when commenting on the reaction to the Exhibition in the United Kingdom, calls attention to the fact that 'people were intrigued

23 (*The Times*, 1944).

HISTORICAL CONTEXT

to see paintings from Brazil, which they probably only associated with [...] the tropics and sugar' (Gadelha & Storm, 2018). Indeed, the image most commonly linked to Brazil in the early 1940s were primary goods, especially coffee, as the country used to yield three quarters of its global production at the beginning of the twentieth century (Almeida, 2005, p. 441). This reasoning was developed by Sousa-Leão, who in 1944 wrote that the country was 'first known for its dye wood, which gave the country its name ... and later for its sugar cultivation, gold cycle, cotton and tobacco, until coffee superseded them, in the second half of the nineteenth century' (1944, p. 80). In fact, by that time Brazilian economic development and governmental efforts to increase the nation's role in the international system were leading to a certain variegation of the national image abroad. Vargas' policies of transforming Brazil's reputation, studied at the previous sections, were proving to be effective. The impact of the Brazilian entrance in the War, even before the deployment of its 25,000-strong Expeditionary Force, rendered a nascent interest and admiration towards the country amongst the British. In a report on the year of 1943, *The South American Journal* highlighted the role that Brazil's military played in the conflict and its growing leadership amongst its neighbours (The South American Journal, 1944). The vague image that the country enjoyed in the United Kingdom was visibly being changed by new information on its role in the War. It was to some extent the result of a purposeful diplomatic endeavour since, as exemplified in Ferreira's research, Brazilian embassies, from 1941, received several films about its involvement in the War (2013, p. 80).

According to a memorandum written by Ambassador Charles to brief the Royal Air Force on the Exhibition, Brazil's strategic situation favoured the new ideas that the British public had been forming about Brazil, from that moment perceived as the 'leading nation of the Latin America, through the recent War events' (Charles, 1944). In the months that preceded the Brazilian military expedition, *The South American Journal* emphasised the geopolitical support of Brazil, which 'has been playing a role of prime importance, with air and naval bases in the bulge at the full disposal of the Allies. But more than that: the enemy submarines destroyed by Brazilian aircraft during 1943 are numbered in double figures' (The South American Journal, 1944). Later, when the FEB was already fighting in Europe, the Bath & Wilts Chronicle & Herald lamented that the British didn't appreciate enough the part played by Brazil in WW2 and its successive proofs of friendship (Bath & Wilts Chronicle & Herald, 1945). This daily mentions Brazil's homage to the RAF, 'by offering us a whole squadron of fighting planes. This offer, which was solemnly delivered by the Brazilian Ambassador in London, gratefully impressed the public in

general and was received with enthusiasm by the English press' (Bath & Wilts Chronicle & Herald, 1945). It was a reference to donations gathered by the Brazilian branch of the Fellowship of the Bellows. In 1940, the fellowship had been founded in Buenos Aires and rapidly expanded to the rest of South America, resonating across Brazil. It was aimed at raising funds from public subscriptions to buy airplanes for the Royal Air Force. Every member of the fraternity donated an amount for each Axis plane downed by the British. Seventeen Spitfires, at an approximate cost of £5,000 each (Barone, 2013, p. 77), nine Hawker Typhoons and one Lockheed Hudson were acquired by the Fellowship of the Bellows of Brazil (Portal FEB, n.d.). Some of the planes were formally handed over in October 1943 by Ambassador Moniz de Aragão to the 193 Squadron, which was henceforth called the Brazilian Squadron in honour of the country (RAF Harrowbeer, n.d.). Brazil's participation in the War, as noted by Under-Secretary of State for Air Lord Sherwood (1898–1970) at the Exhibition opening ceremony, was indeed multifaceted, encompassing military, economic, commercial and cultural contributions (Perowne V., 1944). All these aspects of collaboration, as much as the cultural promotion, were aimed at increasing Brazil's prestige, aligned with Vargas' foreign goals of expanding international influence.

The South American Journal also offered appraisals of 'the orderly progress of the *Estado Novo*' (1944, p. 25) and declared its hope that President Vargas would fulfil his promises of constitutional reforms after the War. He had managed to build up a reputation of an enlightened government amongst the British, as Sacheverell Sitwell referred to in the preface to the Exhibition catalogue (RAA, 1944, p. 5). The journal further extolled Brazilian economic and commercial achievements: 'exploitation of rubber, health and sanitation projects, cultivation of food goods in the Northern states, the construction of the iron and steel industry at Volta Redonda and the development of the Itabira iron mines have been the most notable activities in this regard in 1943' (The South American Journal, 1944, p. 25). The article forecast the 'continuation of the prosperity that has been so marked in the last three years' (The South American Journal, 1944, p. 25) and welcomed the industrial developments and the increase of the proportion of manufactured exports, including textiles, aero engines and merchant ships. In the beginning of 1944, Brazil was depicted as 'enjoying a phase of great prosperity, and high hopes were held by the bondholders in consequence' (The South American Journal, 1944, p. 25), in accordance with the image that the government desired to project as a way of repositioning Brazil in the international stage. It is noteworthy the mention to the inauguration of the Anglo-Brazilian Society (ABS) in London, 'which aims at doing in the cultural sphere what is being

HISTORICAL CONTEXT 39

done in the commercial field by the Brazilian Chamber of Commerce and Economic Affairs' (The South American Journal, 1944, p. 25). As a matter of fact, knowledge of Brazil and its arts in the United Kingdom in the 1930s and early 1940s was marginal. In that respect, Daryle Williams reminds one that (2001, p. 3470)

> no Brazilian wielded the international celebrity once commanded by diplomat-historian Oliveira Lima, the pioneer aviator Santos Dumont or Tarsila do Amaral ... who captivated the Parisian art scene in the 1920s. In the early 1930s, Brazilian art and architecture had very little impact on the international stage.

He explains that 'worldwide depression, the rise of political isolationism in Europe, and a sharp drop in international migration flows alienated Brazil from the West's imaginary, making it doubly hard for the *Estado Novo* to capture the world's attention' (2001, p. 3470). Despite the significant impact generated by Brazil's part in the War, the previously mentioned document prepared by the Foreign Office expressed that 'one subject which has not yet been properly brought to the knowledge of the British public is that of Brazilian contemporary culture, art for instance' (Charles, 1944). The report, in this respect, observes that 'the British public ... will have the opportunity of seeing for the first time the contemporary art of Brazil [which] up to now has gathered some notion of our South American Allies through comments made in the press about the important part Brazil is playing in the War and on account of her big economic resources' (Charles, 1944). These remarks contextualise the moment in which Itamaraty chose to launch the Exhibition and widen the perceptions associated to Brazil amongst the British.

Evidence that there was on course an active and planned work of intelligence to subsidise the increase and modernisation of cultural exchanges between Brazil and the United Kingdom was the already cited study from 1936 by Cultural *Attaché* Paschoal Carlos Magno about the bilateral intellectual cooperation, aimed at changing the local perception of Brazil as the 'great unknown' (Magno P. C., 1936). The report, ordered by Consul Alfredo Polzin, affirms that Brazil was constantly portrayed as a new motif, an exploration for those travellers who discovered, periodically, the Amazon, gold mines and other sensational things (Magno P. C., 1936). This limited notion was most of the time distorted, and Brazil was presented as a quasi-continent populated by savages and fierce animals, shaken by visceral wars and dominated by warlords (Magno P. C., 1936). In Magno's opinion, the nation was a victim of unscrupulous and thoughtless reporters who caused

40 PUBLIC DIPLOMACY ON THE FRONT LINE

widespread repercussions, although a few authors, artists and political leaders had proclaimed Brazilian virtues.[24] He regrets that the Portuguese language had not aroused any interest amongst the British to that date and exalts the fact that Heitor Villa-Lobos (1887–1959) was well known and spoken of in London and other European artistic centres and that his '*Moreninha*' composition was often performed by English entertainers on local radios. He laments, however, that no South American composer had ever been featured in the programmes of major London theatres and that purely Brazilian orchestras had not visited Britain. The report devotes little attention to the visual arts but notes amongst the British a tendency to applaud original and characterful painters and sculptors who embody the aesthetics of a determined region or people (Magno P. C., 1936). Magno alludes to the publication, by The Studio – 'perhaps the magazine of greatest circulation and the most exclusive in its appraisals in England'[25] (Magno P. C., 1936) –, of the painting '*Café*', by Portinari, which had been awarded the Carnegie Institute of Pittsburgh Prize in the previous year.[26] The magazine had fairly highlighted, according to Magno, that it was one of the most beautiful contributions from the South American painting to the Modernist pictorial movement (Magno P. C., 1936). Even though the same publication called him 'the famous Brazilian painter' (Boavista, 1943, p. 126) seven years later, not even Portinari attained undisputable distinction in the United Kingdom. An article entitled 'Brazil's Picasso', published in 1944 by the Daily Telegraph, would state that the most acclaimed Brazilian painter 'has great reputation in North as well as South America and has some murals in the Congressional building in Washington, [but] he is almost unknown in London' (1944, p. 4). Magno's pioneering text was openly intended to subsidise an effective and lasting effort of Brazilian intellectual Propaganda – a term in vogue during those times – to make Brazil known as an economic, geographic and intellectual hub. For this purpose, he recommends a modest plan of action, which included translation and publication of literary works, biographies and theatre plays and the dispatch of music records to local radios. There is no mention of an exhibition amongst the suggested initiatives in this study (Magno P. C., 1936). It was only in 1942 that the Brazilian Embassy would propose an art show in London, but a rather conservative one, in comparison

24 He mentions as examples Kipling, Compton Mackenzie, Cunningham Graham, Cyrill Maude, Lilah MacCarthy (Lady Keeble), John Simon and Lloyd George.

25 '*Talvez a revista de arte de maior circulação na Inglaterra e a mais exclusiva em seus elogios*' (Magno P. C., 1936).

26 See the section on the 'Internationalisation of Brazilian Visual Arts'.

HISTORICAL CONTEXT

to the Exhibition of 1944.[27] Finally, it is interesting to note that Magno's document considers that the work with cultural elites is certainly the most direct and efficient (Magno P. C., 1936). As an example, Magno mentions a recent meeting he had had with Stefan Zweig, who could not help extolling Brazil, from where he returned, with enthusiasm regarding everything he saw, its possibilities, both of material and cultural order, and of which he had so far been completely ignorant (Magno P. C., 1936).

The Austrian writer, 'an acute observer' of Brazil according to *The Times Literary Supplement* (1944, p. 92), was responsible for a germinal dissemination worldwide – but especially in England, where Zweig lived from 1934 to 1940 – of a novel and attractive narrative about Brazil during WW2. In his book about the country, whose subtitle – 'a land of the future' – became a cognomen and even permeates Brazilian national self-identity to this day, Zweig questions 'how can human beings achieve a peaceful coexistence on earth, despite all the disparate races, classes, colours, religions and convictions' (1941, p. 9). He answers himself by writing that Brazil was a felicitous and exemplary solution for this universal dilemma, due to its alleged peacefulness, social harmony and positive humane attitude, which altogether would make Brazil 'one of our best hopes for a future civilising and pacification of a world that has been desolated by hate' (Zweig, 1941, p. 15). Before the War, in times of political recrudescence and growing violence, Europe was not especially interested in and informed about the recent developments of the effervescent society governed under the contradictions of the modernising and authoritarian *Estado Novo* regime. Zweig confessed that, before delivering his idyllic and colourful view of Brazil, he had arrived in the country impregnated by prejudices and misconceptions typical of an average European of his time, expecting to find a turbulent political and economic environment and an unhealthy climate surrounded by beautiful sceneries. Despite his general surprise and amazement regarding culture, he corroborates that one could not anticipate intellectual stimulation from that '*terra incognita*' (Zweig, 1941, p. 5), aligned with overall ignorance and reluctance about Brazil's artistic production.

Brazilian culture and arts were, as demonstrated, virtually absent from British minds and major publications in the early 1940s. Noteworthy exceptions were special issues on Brazil by The Studio (October 1943), one of the 'most enduring and successful art periodicals in the English-speaking world' (Ashwin, 2017), founded in 1893 with the aim of, through visual communication, contributing to 'international understanding and peace'

27 See the 'Background' section.

42 PUBLIC DIPLOMACY ON THE FRONT LINE

(Revolvy, no date); and by the Architectural Review (June 1944), a magazine established in 1896, which had raised pioneering debates over Modernism since the 1930s. In view of their extraordinary outreach, this book devotes a few paragraphs to dissecting the narratives about Brazilian culture delivered by these publications. Due to the unawareness of Brazil's arts in the United Kingdom, most of the articles at The Studio were written by Brazilians, three of them diplomats posted at the Embassy in London. Its foreword is signed by the Ambassador to the United Kingdom. Besides, Joaquim de Sousa-Leão Filho writes about colonial architecture, and Secretary Paschoal Carlos Magno thoroughly examines Brazilian painting. Smaller pieces on dance, dolls, hand-made lace and cities are not signed. The United Kingdom-trained Brazilian engineer Paulo Boavista writes about Brazil's modern architecture, which became relatively known in the United Kingdom's architectural circles since it had been a sensation in the United States, following the 1939 Pavilion and the 'Brazil Builds' show in 1943.[28] Professor Angyone Costa, from the National Historical Museum of Rio de Janeiro, analyses indigenous ceramics. In an article about Brazilian sculpture, playwright Antonio Callado (1917–1997), by this time working at the British Broadcasting Corporation (BBC) World Service in London, offers an illustrative overview of the country's diffuse image, by saying that 'many Englishmen, even those who know Brazil well, if they think abstractly about it will say: "Brazil – butterflies"' (1943, p. 133).

Callado underscores the short history of Brazilian sculpture and states that it 'is very far from being anything accomplished as a whole' (1943, p. 133). He mentions a few artists from colonial times, such as Aleijadinho (1738–1814) and Mestre Valentim (1745–1813), but locates the beginning of Brazilian art, as was usually the case, with the arrival of the French Artistic Mission in 1816.[29] Just subsequently, he asserts that 'after Bernardelli, a truly Brazilian sculpture begins to disentangle itself from classicisms, schools and imitations' (Callado, 1943, p. 133) and places the starting point of Brazilian genuine art 'in our own time'. For him, 'a really national movement in sculpture only began in the full bloom of an aesthetic revolution which has made art more concerned with suggestion rather than form, with the fugitive invisible world hidden in matter rather than the matter itself, with the perfume rather than the bottle' (Callado, 1943, p. 134). Angyone Costa's text entitled 'Manifestations of Art in Brazilian Archaeology' considers Brazil's indigenous ceramics 'necessarily very poor, constructed by tribes of

28 See the section on the 'Internationalisation of Brazilian Visual Arts'.
29 See the section on the 'Emergence of Modernism in Brazil'.

HISTORICAL CONTEXT

very inferior culture, living in the Stone Age' (1943, p. 119). The exceptions, he explains, was pottery produced in Marajó, Santarém and Cunani, which had unfolded by 'a miracle which Brazilian archaeology has not yet clearly explained' (Costa, 1943, p. 119). In a slightly more receptive tone, he concludes that 'despite crudeness in quality, in form or in design, the ceramics produced by Brazilian *índios* reveals notable qualities of artistic sentiment, worthy of deep admiration' (Costa, 1943, p. 120).

Magno's article briefly refers to the pre-European indigenous art in Brazil and also suggests that no artistic school existed during colonial times, when painters were mainly former slaves or Europe-trained travellers who depicted, above all, religious themes. A new pictorial phase, he agrees, began with the arrival of the French Artistic Mission headed by Lebreton, which included sculptors, engravers, architects and the painters Jean Baptiste Debret (1768–1848) and Nicolas Antoine Taunay (1755–1830). They established an official Academy in 1826 and held Brazil's first art exhibition three years later. From that point on, the subjects were diversified, and the teaching of painting was disseminated. However, Brazilian art, he argues, 'was still a transposition of old-world patterns' (Magno P. C., 1943, p. 110). Interestingly, Magno singles out Mexican art as an influence on Brazilian Modernists as equal with the European – 'no longer was Europe the focus of these debates: eyes turned on Mexico, where the works of Rivera and Orozco proved themselves worthy of contemplation' (1943, p. 111). In his introduction for the Exhibition catalogue, Navarra similarly associated Brazilian and Mexican Modernist painters, whom had benefited from their knowledge of French 'liberty of spirit and plastic enquiry ... in search of a more sincere vision of native reality' (RAA, 1944, p. 8). Most of the 28 artworks illustrating the article belong to the academicist field, by painters such as Vitor Meirelles (1832–1903), Pedro Américo (1843–1905), Eliseu Visconti (1866–1944), Henrique Bernardelli (1858–1936) and Oswaldo Teixeira, which would fit Magno's first proposals of a Brazilian art show in London.[30] The publication presents only a few images by *avant-garde* painters. Two of these took part in the Exhibition, Carlos Oswald and Portinari, the latter being, according to Magno, 'outstanding today, commented by critics everywhere and admired by all' (1943, p. 112). There are brief mentions of other Modernist painters, including Tarsila do Amaral and Santa Rosa, both participants in the Exhibition. The article argues that only after the emergence of Modernism, could one speak of an essentially Brazilian art (Magno, P. C., 1943). And completes: 'neither do [those artists] let the judgement that London, Paris and New York pass on their people disturb

30 See the section on 'Background'.

44 PUBLIC DIPLOMACY ON THE FRONT LINE

them unduly, seeing that in doing their best to improve the requirements of their country, they are serving the interest of all humanity as well' (Magno, P. C., 1943, p. 112). For Magno, the message that Brazilian Modernist painters 'are attempting to convey, leaving aside their innate artistic qualities, is to show the way to better education and health, and – who knows – to better politics as well [and contribute to the] general betterment of mankind' (1943, p. 112). This statement by a diplomat, researcher of the English intellectual environment and a pre-eminent figure of the new generation of Brazilian *literati* (Polzin, 1936), endorses the idea that Brazil's Modernism was imbued with strong political motivation and that the Exhibition was conceived within a transformative context.

Sousa-Leão's piece on colonial architecture focuses on the work of the two aforementioned craftsmen, Mestre Valentim, 'educated in Lisbon', and Aleijadinho, 'son of a Portuguese architect' (1943, p. 116). He attributes a dramatic aesthetic change to the discovery of gold and diamonds in the mid-seventeenth century, shifting from classical correction to the influence of Italian baroque in Brazilian architecture and a French taste in its interior decoration. In any case, for the diplomat, 'apart from some decorative elements, borrowed from the local fauna and flora, [Brazilian colonial architecture] does not have not a vocabulary of its own' (Sousa-Leão J., 1943, p. 118). The following article by Boavista perceives in Brazilian modern architecture the overcoming of a purely imitative civilisation, which 'although inspired by foreign ideas, has developed and applied them in the solution of its own problems' (1943, p. 129). He considers the Modernists the 'forerunners of a true Brazilian architecture, well adapted to the country, taking full advantage of its materials and natural conditions' (Boavista, 1943, p. 129). In his argument, so as to deal with the excessive heat, Brazilian modern architecture resorted to new techniques and technological resources and 'liberated creative design from prevailing routine and traditionalism' (Boavista, 1943, p. 122).

The general view of The Studio columnists is that Brazilian pre-European and colonial arts were devoid of quality, except for rare individuals who had studied or lived abroad. The transfer of the court to Rio de Janeiro would have brought the beginning of a systematic artistic production, which was nonetheless strongly swayed by exogenous benchmarks. The Modernist movement represented, in this narrative, an inceptive attempt to break with those standards and to develop an art concerned with Brazilian issues. The field of architecture was the only one that achieved recognition as a mature school and earned remarkable appraisals, in part due to its previous success in the United States, as one can infer from the quotes taken from Philip Goodwin, Director of Architecture at the MoMA, who had curated the 'Brazil Builds' earlier that year. As for the exceptionality of Brazilian

HISTORICAL CONTEXT

architectural prestige, it is also worth commenting on the relevant edition dedicated to Brazil in 1944 by the Architectural Review'. The publication, according to the editors, was, along with the 'Brazil Builds', the result of a trip of Goodwin and Kidder Smith, 'one of the great architectural photographers of our time' (Architectural Review, 1944, p. 80), both sent by the MoMA to make a record of Brazilian Modernist movement. In its editorial, the publication cites Prime Minister Churchill, for whom the end of the War would lead to a rearrangement of the balance of power. The magazine opines, in this respect, that 'one of the new forces to be reckoned with may be the third largest political entity in the Western Hemisphere ... this, coupled with the fact that a Brazilian architectural exhibition is shortly to be opened in London,[31] has evoked this special issue' (Architectural Review, 1944, p. 80). Natural landscapes are exalted, and the cover portrays the bay of Rio de Janeiro, a setting described as 'glamorous' (Architectural Review, 1944, p. 78). The general eulogistic yet patronising tone of the edition can be summarised by the following passage: 'Brazil has emerged from the most primitive origins ... and now stands revealed, in these pages, as one of the most highly civilised of modern democracies' (Architectural Review, 1944, p. 81).

Here again, Sousa-Leão was invited to contribute an introductory text about Brazilian architecture. He atypically, considering his official position, calls the institution of the *Estado Novo* in 1937 a *'coup d'état* on the lines of Salazar's authoritarian democracy' (1944, p. 80), but remembers the governmental promise that after the War Brazil's people would shape its political structure. The diplomat affirms, in a race approach common in Brazil at that time, that a twentieth part of Brazilian population 'is still negro'; 60% white; and the remaining 35% 'is of mixed blood, in various combinations and proportions, gradually tending to white. Some authorities are even of the opinion that the coloured element will have been absorbed within a hundred years' (Sousa-Leão, J. d., 1944, p. 83), which demonstrates the naturalised racism that underpinned the effort to project the idea of a white European civilisation in the tropics. According to his negationist discourse attuned with Zweig's idealistic view, 'Brazil as a melting pot seems miraculously effective. She may yet show to the world the futility of the racial problem. All the people of Brazil form indeed one big happy family' (Sousa-Leão, J. d., 1944, p. 83). Sousa-Leão also reinforces notions of Brazilians as a tolerant and gentle

31 It refers to the 'Brazil Builds' exhibition, which was held in 1944 at the Simpson's and later at the Royal Academy together with the Exhibition, in both cases on the initiative of the Brazilian Embassy in London.

people, 'in a striking love of peace. The heroes of Brazil are not victorious generals alone, its continental aims are not imperialistic. Its political changes have been without bloodshed. Some day, who knows, she may endow mankind with an original civilisation based on racial equality and international goodwill' (1944, p. 83). Besides demonstrating the long-established narrative of Brazil as a country driven by diplomacy and persuasion, one can notice the pursuit of a romanticised national image and the notably ambitious goals of Brazil's cultural agents, who projected its uniqueness as a civilisatory contribution. With regard to the Brazilian artistic production, he refers to Minas Gerais' baroque style, embodied by sculptor Aleijadinho, painter Manuel Ataíde (1762–1830) and the poets from the Minas School. There is a mention to writer Machado de Assis (1839–1908), in his view, an outstanding figure of 'mixed race'.

Following the diplomatic narrative of Brazil provided by Sousa-Leão, the publication offers an insight from Sacheverell Sitwell, 'our greatest English expounder of the Baroque' (Architectural Review, 1944, p. 80), who would contribute a preface to the Exhibition catalogue a few months later. For him, the British people were looking beyond Europe, and especially to Latin America, so as to foresee the future (Sitwell, 1944, p. 85). He admits, nevertheless, that 'we know very little, most of us, about this continent and its pair of mysteries, Brazil and Mexico' and attributes to its neighbouring with the United States the relatively larger awareness of the latter (Sitwell, 1944, p. 85). Novel, according to him, was the fact that Brazil was three times more populous than Mexico and that the country 'has an old architecture worthy of its history and a modern architecture, not yet ten years old, the best architecture, there can be no question, in the modern world' (Sitwell, 1944, p. 85). He lists some famed artists and stereotyped images of Brazil, such as Aleijadinho, Mestre Valentim, Manuel Ataíde ('a master of painted ornament, but not quite a painter'), Carmen Miranda (1909–1955), the sea and mountains of Rio de Janeiro, 'the city of carnival' (Sitwell, 1944). He also cites the scenes of a bygone colonial life evoked by illustrations of Jean-Baptiste Debret (1768–1848) and Johann Moritz Rugendas[32] (1802–1858). In Sitwell's opinion, some may have thought in the early twentieth century that Brazil was destined to a prosperous future but that its arts would remain under the European lowest influences (1944, p. 89). He continues by questioning himself: 'how could it be otherwise, with a past consisting only of *rococo* and surrounded by all the worst excesses of

32 According to Sitwell, a German painter 'not so interesting as [the former]' (1944, p. 88).

HISTORICAL CONTEXT

the present?' (Sitwell, 1944, p. 89). For this critic, Brazil's cultural turning point was so recent that it was difficult to determine what had triggered the sudden transformation, but he had a few hunches. President Getúlio Vargas and his Minister Gustavo Capanema could have released the creative force of thinkers such as Lucio Costa, who were further encouraged by the visits of the Swiss-French architect Le Corbusier (1887–1965) that would have marked, in his view, the beginning of the Brazilian modern movement (Sitwell, 1944, p. 89). Although it is imprecise, as Modernism had already been developing for some years, Le Corbusier's visits to Brazil in 1929 and 1936, when he presented a series of lectures, had great impact among Brazilian architects. Leading figures of Brazil's modern architecture are examined by Sitwell, including Oscar Niemeyer, the Roberto brothers, Corrêa Lima, and Roberto Burle Marx – the latter would contribute artworks to the Exhibition. Sitwell concludes that 'in this crucible of races we may expect other things as well as architecture to emerge. More than all else, it may be music. Brazil has already one remarkable composer, Villa-Lobos, and a decorative painter, Portinari. Younger painters and sculptors will, in all probability, appear' (1944, p. 98). Apart from Brazilian and British viewpoints of Brazil, the magazine published also an article by US architect Kidder Smith, from MoMA, for whom Brazil 'is only now beginning to realise its possibilities and hint at modern maturity. Indications of its future greatness can be clearly seen in its present accomplishments' (1944, p. 99), even though, as he notes, most of its population was still illiterate. He also emphasises the importance of Le Corbusier's influence over prominent Brazilian architects such as Lucio Costa and Niemeyer, but ponders that 'the product has always been distinctly Brazilian' (Kidder Smith, 1944, p. 105). Kidder Smith considers the Ministry of Health and Education 'one of the finest buildings to be found in the world' (1944, p. 105) and, as much as the other contemporary contributors, perceives in Brazil's climate a key-factor to foster new ideas. The magazine, regarding this question, asserts that the problem of sun and light has been successfully solved in the country (Architectural Review, 1944), as Boavista had affirmed along similar lines a year earlier. Abundant references to race and climate issues and the allusion to European standards reveal the Eurocentric point of view adopted by those observers, including Brazilian diplomats and expatriates.

The goodwill of the arts establishment towards Brazil's architecture and aversion to its painting were visible even in the Exhibition catalogue itself. Intended to second the art show, the architectural photographs received effusive praise from Sitwell, who called Brazil's output 'first rate modern architecture' (RAA, 1944). Following what he and other columnists had written at the special edition of Architectural Review, Sitwell placed Brazil's

48 PUBLIC DIPLOMACY ON THE FRONT LINE

modern architecture on a much more elevated level than its painting, which should seek to emulate the architectural revolution.[33] According to Asbury, 'had his knowledge of the subject been a little more developed, he would have observed that the origins of both modern architecture and painting in Brazil had much in common' (2018, p. 38), since Le Corbusier's purism largely influenced Tarsila do Amaral and her peers as much as young Brazilian architects. Sitwell's comments about the Brazilian painters, however, were in fact condescending and uninformed. He recommended the audience to value the gesture for the sacrifice of the supposedly struggling Brazilian artists, which shows his unfamiliarity with the elitist artistic environment in Brazil[34] (RAA, 1944, p. 3). After criticising the influence over Brazilian painters of foreign blood from Central Europe, not of 'first rate quality' according to him, Sitwell extols the national character of the artworks – 'for it would be tragically disappointing if the art of South American tropics was in no way different from that of Czechoslovakia or Norway. As much as if the first returning cargoes of oranges and bananas were, in the end, but pears and apples' (RAA, 1944, p. 3). The impact of climatic conditions was also largely exploited by Sitwell, who attributes the 'over painting' of Latin Americans to the beauty of the surroundings, the landscape and nature, the prolific soil and the sunlight (RAA, 1944, p. 4).

Dawn Ades (2018, p. 62) adds to the debate by arguing that, in face of the unmatched stereotypes, given that it was presented as Brazilian and that there was virtually no previous familiarity with Brazilian art, architecture and culture in the United Kingdom, the question of origins and influence, as the only handle on anything familiar, dominated. Several critics admitted that the Exhibition confounded expectations: in place of the brilliant colours to be associated with the tropical, the paintings were quiet in colour and soft in treatment.

Indeed, a critic of *The Observer* registered that the impressions about the Exhibition were unexpected, for the ideas one forms of a country's aesthetics are stereotyped, and it was surprising that most of the Brazilian pictures were low in tone and restricted in colours (Lancaster, 1944, p. 2). For this very reason, he recommended that the visitor to read the catalogue before attending the Exhibition. *The Times*, along the same lines, stressed that the scarcity of bright colour which might have been expected in tropical

33 See 'The Catalogue' section.
34 See the section on the 'Emergence of Modernism in Brazil'.

HISTORICAL CONTEXT

painters was striking (The Times, 1944, p. 6). Interestingly, Brazilian Paulo Boavista, in his article for The Studio in 1943 endorses this Sitwell's view, by saying that 'contrary to the general belief, we seem to prefer sober tones, perhaps as a reaction against the luxury of nature' (Boavista, 1943, p. 126). Evidently, the British observers lacked knowledge and adequate analytical tools, which jeopardised an objective evaluation of the artworks. In light of that, they resorted to the available European lens to examine the Exhibition, which sometimes reinforced previously limited and biased perceptions.

The study of official correspondence about the preparation of the Exhibition reveals other anecdotal aspects that formed the image of Brazil among the British, or at least amongst part of their establishment. When Aranha announced via the press the donation of the artworks, the representative of the BC in Brazil, Francis Toye (1883–1964), grumbled to London that he 'at any rate cannot help feeling that we have been ingeniously, not to say typically, landed with the baby' (Toye, 1943). Afterwards, it became consensual that it was important to turn the gift into a great exhibition, since, according to Ambassador Charles, 'our Brazilian friends are very susceptible to flattery and are correspondingly liable to be disproportionately put-out if they think that a generous gesture on their part is not receiving proper appreciation' (Charles, 1944). Eventually, when planning a letter of thanks to the donating artists, the Director for Americas at the Foreign Office, Victor Perowne (1897–1951), observed that 'the Brazilians are, however, extremely vain, and what appears to us to be gross flattery is barely polite to them and this may therefore be insufficiently lush' (Perowne V., 1945). Over again, it is clear that the incipient British interest in Brazil in the early 1940s was filled with prejudice. The contents of the two magazines, the catalogue texts, official documents and Magno's study corroborate the existence of stereotypes about Brazil's exuberance and vanity; ignorance of its culture; and a goodwill towards its modern architecture, to a large extent due to the United States' approval of the show 'Brazil Builds'. In both magazines, official or semi-official voices portraying a self-indulgent image of a modernising nation forged with European values coexisted with uninformed British views that sought a US *imprimatur* in order to validate Brazilian Modernism. This does not mean that the efforts were in vain. Intense direct contact with Brazil's artistic output would interfere with bystanders' perceptions and generate thought and debate around it.

Observing the Exhibition from Brazil, Mário de Andrade (1893–1945) was the best critic to interpret the clash between British expectations of exotic folklore and black arts and Brazil's eagerness to present its culture as a white man's civilisation (Andrade M. d., 1989). Collector and curator Catherine Petitgas, alluding to the metaphor posed by Sitwell regarding the exoticism of

the show, comments that the British 'didn't want pears and apples; they wanted bananas, oranges, pineapples – they wanted Carmen Miranda. They didn't want the socialist realism that came out of someone like Portinari, for example. But that is what they got, and that was excellent art' (as cited in Gadelha & Storm, 2018). Locke, in turn, recurs to the same Sitwell's allegory to name an essay about the Exhibition, 'Oranges and bananas or pears and apples? Exhibition of Modern Brazilian Paintings at the Royal Academy of Arts' (Locke, 2018), in which he discusses the disagreement between the radical aesthetic message proposed by Brazil and the stereotyped expectations in the United Kingdom.

In Locke's words, 'what Sitwell meant when he called for the art of the tropics was the exotic whereas Brazilian artists were in pursuit of the radical and the modern' (2018, p. 69). Likewise, the image that the Brazilian bureaucrats desired to project abroad should overcome the perceptions of exuberance and wilderness and present an original contribution to the league of 'civilised' nations. In their view, African-Latin, indigenous and other folk elements were contrary to the image aspired to by Brazil's economic elites (Dumont & Fléchet, 2014). Its engagement in the War effort and, within this context, the Exhibition, created a favourable atmosphere amongst the British public and government. The previously mentioned document devised by the Foreign Office affirms that, due to the show, 'our knowledge of Brazil as a nation with a Western culture will be complete' (Charles, 1944), in perfect consonance with the message that Brazilian officials and artists wanted to communicate. And it concludes, as if it were written not by a British but by a Brazilian diplomat of the time, that 'the Exhibition will reveal to us the existence of a great country in America, which by its artistic tradition belongs to the same common trunk of that Western civilization, which England today so proudly claim also as hers' (Charles, 1944).

Chapter 2

THE EXHIBITION

Background

In the 1940s, North American culture broadcast here through multiple channels – radio, cinema, publications etc. – was increasingly taking the place of European culture, hegemonic in Brazil until WW2. In the field of painting, nevertheless, such influence apparently did not reach such a notable level[1]

Walter Zanini

Systematic efforts to increase and modernise cultural exchanges between Brazil and the United Kingdom has been under way since at least 1936, when Secretary Paschoal Carlos Magno wrote the previously discussed study about bilateral intellectual cooperation, aimed at changing the local perceptions of Brazil (Magno P. C., 1936). In 1942, the same Magno proposed to the BC the joint organisation of a comprehensive Brazilian art exhibition in London, focused on academic and traditional expressions, rather more conservative than the one that would eventually take shape two years later (Magno C. P., 1942). The initiative, supported by Brazilian academic painters such as Oswaldo Teixeira and Georgina de Albuquerque, did not prosper. In March 1943, Ambassador Moniz de Aragão returned to the idea, advocating to Minister Oswaldo Aranha the opportunity of holding an exhibition of Brazilian books and artworks in the United Kingdom, along the lines of a similar showing previously organised by the Mexican government (Moniz de Aragão J. J., 1943). In the same month, during its third meeting, the newly founded ABS decided to arrange an exhibition of Brazilian art at a convenient time (ABS, 1943). A couple of months later, Magno suggested that a series of photographs of modern industry and general development in Brazil should

1 '*Pela década de 1940, a cultura norte-americana, aqui difundida através de múltiplos canais – rádio, cinema, publicações etc. -, tomava boa parte do lugar da cultura europeia, predominante no Brasil até a Segunda Guerra Mundial. No terreno da pintura, entretanto, essa influência não parece ter alcançado plano notório*' (Zanini, 1991, p. 62).

52 PUBLIC DIPLOMACY ON THE FRONT LINE

be shown at the ABS exhibition, so that a wrong impression should not be given to the British public of life in Brazil (ABS, 1943). Evidently, the Brazilian diplomat, aligned with Vargas' foreign policy of projecting prestige, wanted to convey a message of a modernising Brazil, by benefiting from the plaudits earned by this showcase of the nation's culture in London.

In August 1943, those (up to that point parallel) initiatives by the Embassy and the ABS underwent important developments. The BC decided to sponsor a show regarding 'art and things of Brazil' (Moniz de Aragão, 1944), to be curated and arranged by Eric Church, from the Brazilian Society of English Culture. Church, also a member of the ABS, was appointed to be in charge of the thereinafter unified exhibitions. At the time acting as *Chargé d'Affaires* of the Brazilian Embassy, Sousa-Leão reported, in August 1943, the 'possibility of the [Anglo-Brazilian] Society obtaining a complete duplicate of the successful exhibition at present on tour in America, Brazil Builds' (ABS, 1943). Less than a month afterwards, the Brazilian press announced a Modernist painters' initiative, backed by Minister Aranha, presenting their artworks to be sold for the benefit of the United Kingdom's War effort (Estado de São Paulo, 1943, p. 3). Eventually, the 'Brazil Builds' pictures[2] were incorporated into the Modernist Exhibition, as per Magno's suggestion, but the curatorship and the selection of Brazilian art that would be shown in London would finally be established by the Brazilian Minister of Foreign Affairs and the Modernist artists themselves, instead of following the Embassy's preference for academic art. This constituted one late episode in the struggle for Brazil's cultural identity abroad,[3] which was also being waged within the Foreign Ministry. Aranha, attuned with the liberals and the Modernists, settled the dispute and determined that the first Brazilian art to be seen in London would have modern features. Itamaraty and the artists organised the offer and communicated the *fait accompli* to both the Brazilian Embassy in London and the British Embassy in Rio de Janeiro.

The beneficiary of the gift, the British government, had learnt of it by reading the Brazilian news, as set forth by Francis Toye: 'neither the Embassy nor this office was informed of the project beforehand and indeed His Excellency knew nothing about it till it was announced in the newspapers that it would be handed over to him at Itamaraty' (Toye, 1943). Only in October 1943, was Ambassador Charles formally notified by Minister Aranha of the initiative (Charles, 1943). In fact, a skilful operator of the media,

2 They had arrived in London by February 1944 (ABS, 1944) and were exhibited at Simpson's from October 10 (ABS, 1944).

3 See the section on the 'Internationalisation of Brazilian Visual Arts'.

THE EXHIBITION 53

Aranha shrewdly announced the initiative through the press, making it rather delicate for those British bureaucrats who saw the enterprise as a burden to drop the Brazilian offer. Even the Brazilian Embassy in London was told that it was a kind and spontaneous initiative by a group of painters (MRE, 1943), only after making inquiries to Itamaraty when more than two months had elapsed since the first news about the artistic offer. It is worth noting that the dailies which broke the story often functioned as mouthpieces for Aranha, who used to cultivate the sympathy of the press, both in Brazil and abroad (Hilton, 1994, p. 266). The *Diário Carioca* and the *Correio da Manhã*[4] belonged respectively to José Eduardo de Macedo Soares (1882–1967)[5] and Paulo Bittencourt (1895–1963),[6] two (at that time) unhesitating supporters of Aranha's crusading stance on the Allied cause.[7] In 1941, when the pro-Germany and pro-Allies factions disputed space within Vargas' government, both newspapers published pieces favouring the latter, which included Aranha's remarks on the British, triggering the fury of the military Ministers, who were inclined to side with the authoritarian powers (Lochery, 2014, p. 90) (Hilton, 1994, p. 353). According to the news on the Exhibition, an enlightened Oswaldo Aranha welcomed and most enthusiastically applauded the noble initiative and acquiesced to receive the paintings (Diário Carioca, 1943, p. 5). The artists, in turn, were confident of the potential for an increase in bilateral cultural interchange, for which 'we know we can count on Your Excellency's indispensable support'[8] (Diário Carioca, 1943, p. 5), denoting a common agenda between the Minister of Foreign Affairs, the anglophile newspapers

4 According to Hilton, the *Correio da Manhã* tended to favour Aranha, who intervened to free one of the newspapers managers, accused by Rio de Janeiro's police of conspiracy (1994, p. 277; 309).

5 Who lobbied 'both the British and US Embassies for support' (Lochery, 2014, p. 153), after having led the opposition to Aranha and organised anti-United States activities (Moura, 2013, pp. 145, 150).

6 Bittencourt, a well-known anglophile, 'enjoyed collecting modern art and furniture and showing them off at dinner parties [and] spoke perfect English, with an accent that came straight from one of Great Britain's finest public schools ... He respected the British Empire and attacked anybody who claimed that the empire was doomed [and] did not regard the Americans as the equals of the British in any sense, arguing that the Brazilians ... were the natural heirs of Great Britain' (Lochery, 2014, pp. 90–91).

7 The North American Embassy insinuated that 'any good relationship between the local press and the British was based on the generous subsidies that London offered to much of the local press' (Lochery, 2014, p. 153).

8 '*Estamos certos de que podemos contar com o indispensável apoio de v. excia*' (Diário Carioca, 1943, p. 5).

54 PUBLIC DIPLOMACY ON THE FRONT LINE

and the Modernist artists. This shows that Aranha was concerned both with the relevance of the press conveying the messages intended by the Exhibition and with involving non-governmental players in the initiative, aligned with the recommendations of today's Public Diplomacy scholars.

In November 1943, Ambassador Noel Charles and Francis Toye advised London about the Exhibition, which included works of 'all the Brazilian artists who are most highly thought of here, including Portinari and Segall' (Toye, 1943). Charles anticipated that the Brazilian government would pay for the frames, scarce in England due to wartime restrictions (Hutchison, 1968, p. 166), but the British would 'doubtlessly be expected to pay the cost of transport' (1943). He suggested that the Luso-Brazilian Council or the newly founded ABS should be considered as the grantees of the offer, instead of the RAF, the artists' first choice, as he had been told by the Itamaraty that channelling the sales proceeds for cultural purposes rather than for the War effort would not be a problem on the Brazilian side. One month later, after having symbolically received the artworks, Noel Charles mentioned the Brazilian donation to Foreign Secretary Anthony Eden: 'all arrangements were made by the artists and the Ministry of Foreign Affairs without my being informed … I was thus given no opportunity of referring the matter to you without running the risk of giving serious offence' (1943), he said, by way of excuse. Both Charles and Toye agreed that the funds for organising the Exhibition 'must be provided somehow, for a refusal or even an apparent unwillingness to send the pictures would have the most disastrous effect' (Toye, 1943). Toye could not help feeling, though, that they had 'been ingeniously, not to say typically, landed with the baby' (1943), which indicates that the Brazilian gesture was also perceived as a stratagem by them. The British government reaction to the Brazilian collection was one of mixed feelings, ranging from Ambassador Charles' enthusiasm – 'represents a very respectable artistic achievement' (1943) – to the derision of Victor Perowne, for whom the paintings were 'all likely to be horrible to judge by the reproductions I have seen recently of modern Brazilian painters [, and the Exhibition] may lead to all sorts of awkwardness unless we are prepared. Don't imagine also who will want to buy the things as we may have to inspire some (possibly anonymous) benefactors'[9] (1943). In any case, at the apex of an uncertain and lethal World War, to arrange an art exhibition of unheard-of painters was perceived, by most of the British bureaucrats involved, as an unwelcome enterprise. Nonetheless, those officers based in Brazil, more

9 This method of disposing of the works would eventually be proposed in an official document sent from London to the Embassy in Rio de Janeiro (FO, 1944).

THE EXHIBITION

familiar with its culture, were able to develop a considered and appreciative judgment of the artworks. Francis Toye, for instance, told his colleagues in London that the pictures were of 'undoubted interest' (Toye, 1943). Ambassador Charles, in a very rare self-effacing approach, hoped 'it will show that the average modern painter here can compare with the average in Europe' (1944). He seemed to be satisfied with the 'remarkable spontaneous gesture of the leading artists' (Charles, 1943) and was determined to make Propaganda of it. Charles alluded to the artists' desire to have the works sold in the most significant way, in artistic and political terms, as well as to turn a few paintings into the nucleus of a Brazilian collection.

At the end of 1943, despite all difficulties and resistance and regardless of which were the painters' primary motivations, the fact announced by the *Diário Carioca*, was that a group of artists spontaneously decided to donate works as a contribution to the War effort (Diário Carioca, 1943, p. 5). Three of them had the idea of sending pictures to London for the Exhibition of Modern Brazilian Paintings – they were Alcides da Rocha Miranda and Augusto Rodrigues, both based in Rio de Janeiro, who had been the first to contact the Minister of Foreign Affairs regarding the gesture via a joint letter, and Clóvis Graciano, from São Paulo, who subsequently joined them. The painters asserted that the initiative was of their own conception, and emphatically highlighted the spontaneity of their 'private entrepreneurship', thereby trying to distance themselves and the project from the authoritarian and increasingly contradictory[10] regime of President Getúlio Vargas. The Brazilian government equally held back from openly supporting the Exhibition, avoiding giving to it tones of officialdom. The press noticed that 'the absence of representatives from the General Division generated oddity'[11] (Diário Carioca, 1943, p. 3) during the handover of the pictures. Nevertheless, one of the artists' leaders, Alcides da Rocha Miranda, stated that an important portion of the government was greatly favourable to our Exhibition (Diário Carioca, 1943, p. 3), which reveals the direct involvement of the state. Here again, he finishes by saying that it was part of their effort to compel the Brazilian government to side with the Allies, making clear the underlying political attitude of the artists who took part in the Exhibition (Diário Carioca, 1943, p. 3).

10 As seen at the chapter on the 'Historical Context', the Brazilian government, aligned with the democratic cause of the Allies, was facing criticism at home for its dictatorial rule – Vargas had been in the office since 1930, without being directly elected.

11 '*A ausência de representantes da divisão geral provocou um movimento de estranheza*' (Diário Carioca, 1943, p. 3).

56 PUBLIC DIPLOMACY ON THE FRONT LINE

The reunion of diverse currents of Modernist painters around this political message raises an interesting debate over the artworks chosen to be sent to the United Kingdom. According to Zanini, the few small Brazilian painting shows held outside Brazil until then were marred by the absence of rigorous selection criteria (1991). Locke, on the other hand, underscores the random character of the Exhibition's paintings, devoid of a clear curatorial narrative (2018). For the participant artists, a couple of characteristics – experience abroad and distance from the academic tradition – had been considered. In their letter to Minister Aranha, the artists' leaders explained their choice of participants: only those 'whose artistic qualification is accredited and recognised by their attendance at international exhibitions and their permanent presence in the large museums of Modern Art in North America and in other parts of the world [would participate], befittingly representing our country' (Correio da Manhã, 1943, p. 9). The *Diário Carioca* would reinforce that half of the artists were already represented at the Museum of Modern Art of New York or in other European museums[12] (Diário Carioca, 1943, p. 5). Portinari, the most acclaimed Brazilian artist of the time, called the Exhibition a 'faithful representation of our art' (Diário Carioca, 1944); Aníbal Machado[13] (1894–1964), who would preside over the defiant 1st Congress of Brazilian Writers,[14] considered it 'the best ensemble of Brazilian paintings ever gathered together' (Diário Carioca, 1944). For the critic Ruben Navarra, who wrote the preface of the Exhibition catalogue, it encompassed 'virtually all the Brazilian painters whose visual arts tendencies – even among those who studied at the National School of Fine Arts – are towards complete independence regarding the academic routine norms [, whereas] painters from a rigid academic tradition were totally excluded' (Navarra R., 1945). According to Frederico Morais, all of the most important Brazilian artists have contributed artworks to the Exhibition, including all acting groups and their leaders and some European refugees based in Brazil (1986, p. 6).

Such well-informed opinions lead to the conclusion that, even though the choice of artworks was somehow arbitrary, the participant painters were indeed representative of the modern Brazilian art of the first half of

12 This book confirmed that at least nineteen of the seventy participant artists had works in foreign collections, mainly in the United States and France.

13 Modernist writer Aníbal Machado, an influential intellectual who would organise the 1st Congress of Brazilian Writers in 1945, was father of Maria Clara Machado (1921–2001), the leading author of theatre for children in Brazil.

14 See the section on the 'Emergence of Modernism in Brazil'.

THE EXHIBITION

the 1940s and that both foreign approval and the artists' non-compliance to traditional academic standards were two recurrent benchmarks. This book does not intend to analyse in depth the composition of that group of 70 painters, but, from basic research on specialised websites, in particular the *Enciclopédia Itaú Cultural*, it pursues an outline of these artists' profiles – which are listed in the Appendix – as a way of increasing the understanding of the political and artistic reasons behind this unique diplomatic enterprise. The average profile of the artists who participated at the Exhibition was that of a 39-year-old[15] white man, born and living in São Paulo or Rio de Janeiro. It reflected the still restricted artistic environment in Brazil of the 1940s, as in its extremely unequal society, access to education and art was almost exclusively the preserve of the white economic elite. While it is beyond the scope of this book to classify the painters into schools, it is possible to affirm, however, that around half of the seventy had a strong connection with the artistic scene of Rio de Janeiro, and at least twenty-seven with São Paulo's art movements. Amongst the artists who donated works for the show in the United Kingdom, thirteen were women[16] and only one, Heitor dos Prazeres, was referred to as a 'negro', both a racial and social category in Brazil's mixed but conspicuously racist society of the 1940s. Born in 1924, Poty Lazzarotto was the youngest artist, with the oldest born in 1861, Portugal's Cardoso Júnior. Overall, twenty-four were from São Paulo and eighteen from Rio de Janeiro states, Brazil's two main urban hubs; thirteen were born elsewhere in the world.[17] The arrival of refugees during the WW2 was of special significance to the artistic development of the Brazilian capital[18] (Zanini, 1991, p. 35). Many of these painters moved to Rio de Janeiro, Brazil's artistic hub, as may be inferred from the fact that at least twenty-seven of the Exhibition participants died there, with twenty dying in São Paulo. Eight ended their lives in other countries, five of them in Paris.[19]

No fewer than nineteen of the artists studied at the ENBA in Rio de Janeiro, and another seven in other institutions of the capital; nine attended schools

15 Amongst the seventy artists, this book found the birth dates of sixty-seven, whose average age was approximately 38.85 years.

16 It is interesting to note that 'of the 1,600 paintings owned by the MNBA in 1939, only twenty-two had been painted by women, [but paradoxically] women far outnumbered men in the graduating classes of the National History Museum' (Williams 2001, p. 3270).

17 Odette de Freitas was the only artist whose birthplace was not found by this study.

18 Rio de Janeiro was the capital of Brazil until 1960, when Brasília became the official capital.

19 This book has not found the place of death of nine of the artists.

58 PUBLIC DIPLOMACY ON THE FRONT LINE

in São Paulo; 22 studied abroad; and 11 were self-taught. At least 48 out of the 70 painters had travelled abroad, mainly to France and Italy; six of them had been to the United Kingdom. At least 38 had taught; 23 worked for the press; and 17 practised or studied architecture. More than half of the artists had shown works in National Salons, and more than a quarter had won scholarships to travel abroad. The reformulation of the traditional Salon, led by architect Lucio Costa, had finally granted Modern Artists access to its halls. Daryle Williams observes that 'a prize won at the Salon was an entryway to critical acclaim, public and private commissions and for a select few state-subsidised tours of study in Europe' (2001, p. 1118). The National Salon and its prizes functioned indeed as a market of reputation, and the artists struggled tenaciously for the coveted abroad-trip prizes, which favoured the traffic of ideas and the renovation of Brazilian *avant-garde* art. In terms of economic background, a superficial examination of the available biographies shows that twenty-seven of the participant painters presented signs of affluence; at least five others came from middle-class families of professors, journalists and intellectuals; and no less than eleven, including Portinari, came from lower-class families.[20] The presence of poorer artists was already a generational change, as the artists of the first Modernism, from the generation of 1922, belonged to high social classes and, according to Zanini, 'the coming generation [was] to some extent from a modest background and in general less sophisticated'[21] (1991, p. 20). In an exaggerated and generalising fashion, Mário de Andrade classified the new Modernists as being 'from the people; if not directly proletariat, they at least came from proletariat or less wealthy and illustrious backgrounds'[22] (as cited in Zanini, 1991, p. 22). Asbury remarks that Brazil and the United Kingdom underwent similar transformations in the early 1940s, since, whilst in the latter (2018, p. 40)

> the ICA would provide a platform for the first wave of artists to emerge from modest social backgrounds, such as those associated with the Independent Group, in Brazil artists such as Portinari and later Alfredo Volpi, demonstrated that it was possible even if still rare, for working class artists to rise to the cultural elite. The *Modernismo*

20 It was not possible to identify indications of the social class of twenty-eight of the artists from the available bibliographic information.
21 '*A geração entrante, em boa parte de modesta origem e de formação em geral menos sofisticada*' (Zanini, 1991, p. 20).
22 '*Todos do povo, senão diretamente proletários, pelo menos vindo de operários ou de gente de pequenos recursos econômicos e culturais*' (as cited in Zanini, 1991, p. 22).

THE EXHIBITION 59

of the 1920s had by then become known as somewhat aristocratic in nature, inextricably associated with the coffee oligarchies ... Likewise, the old aristocratic nature of British early Modernism, with its Bloomsbury Group, the Sitwells and all, was giving way to a new generation.

Many of the 70 painters were members of artistic groupings, a communitarian tendency to navigate the restricted cultural environment of the 1940s (Zanini, 1991) – at least nine belonged to the *Família Artística Paulista*; eight to the *Grupo Santa Helena*; eight to the *Sindicato de Artistas Paulistas*; four to the *Clube dos Artistas Modernos*; and three to the *Núcleo Bernardelli*. Many had strong personal links to leading Modernist artists and intellectuals, such as Di Cavalcanti, Lucio Costa, Mário de Andrade, Aníbal Machado and Portinari. The house of the latter two, along with the couple Vieira da Silva and Árpád Szenes' home, were 'must-be-there meeting places for the intellectuals and artists of Rio de Janeiro'" (Zanini, 1991, p. 36). These basic characteristics describe a small, elitist and inter-connected group of Brazilian Modernist artists, who joined a common political stance despite following diverse and often divergent aesthetic orientations. After the government decided to champion and organise the Exhibition proposed by this heterogeneous group, a number of challenging practical issues would arise.

Arrangements

> *The pictures have now reached this country, and it is urgent to do something about getting them accepted if we are not to disappoint our friends in Brazil*
>
> Victor Perowne[23]

In early 1944, Ambassador Charles had forwarded to London particulars written by the artists themselves, 'hence the rather shaky English' (Charles, 1944). Showing again his fondness for the works – 'Brazilian pictures should prove to be interesting' –, he asserted that he was willing to pay £25 for the picture 'Group of people with woman and child',[24] painted by Bellá Paes Leme, wife of the Polish sculptor and his friend, Count August Zamoyski (1893–1970). But, above all, he insisted that the Foreign Office should obtain publicity from the gift as Brazilians would be susceptible to flattery

23 (Perowne V., 1944).
24 He would effectively acquire the work.

60 PUBLIC DIPLOMACY ON THE FRONT LINE

and overreact if they felt that their gesture was not being appreciated[25] (Charles, 1944). The Foreign Office was eventually convinced and responded to Charles' cable indicating that 'if offence is to be avoided, there must be an Exhibition in London and possibly also in provinces under government auspices' (FO, 1944). Internally, it was understood that 'Sir Noel Charles has recommended that the maximum publicity should be given to this handsome gesture, and indeed urged that the gravest offence will be caused unless a considerable splash is made' (Perowne V., 1944). It is evident that the shrewd manner of offering this was successful in helping the Brazilian paintings to make their way into London's art world and thus to project political and aesthetic messages from Vargas' government amongst British society. Simultaneously, the same Perowne who was sure that the pictures were 'all likely to be horrible' (1943) asked the Ministry of War Transport to grant priority to their shipment from Rio de Janeiro and Customs to accord them free entry into England, as 'Mr Eden considers that it is politically important' (Perowne V., 1944). It corroborates the decisive role of ministerial intervention in both Brazil and the United Kingdom in order to make the Exhibition happen. The requests were promptly met. In the same way, the Treasury Secretary was asked whether they could advance public funds to pay the expenses involved, to be eventually refunded, to which he likewise agreed (Gurney, 1944).

The arrangements for the show were planned at very short notice. As late as April 1944, the Foreign Office asked the BC to handle the preparation of the Exhibition in both London and the provinces, as an official institution would be more appropriate than the ABS to deal with a present to His Majesty's Government (Gurney, 1944). It clarified that the endeavour would not involve any costs, since the Treasury would advance the expenses (Wilcox, 1944). Longden, in response, confirmed that the BC would undertake the work of exhibiting and selling the pictures (Longden A., 1944). In late May 1944, a diplomat from the Foreign Office noted that 'this is the first time that the Brazilian Embassy here has heard from us about the pictures' (McQuillen J., 1944), a statement that, although imprecise,[26] indicates a certain disengagement of the diplomatic representation in London at that stage.

25 Perowne's assessment was shared by the British Embassy in Rio de Janeiro, which on a different circumstance had warned the Foreign Secretary that 'the Brazilians, with all their love for bestowing and receiving flattery, are no fools and in the long run are more likely to be influenced by the circumstances of the day than by memories of expressions of praise, however highly placed theirs authors may be' (as cited in Lochery, 2014, p. 227).

26 In fact, the Embassy was officially informed of the Exhibition by the Itamaraty in November 1943 (MRE, 1943).

THE EXHIBITION 61

A week later, the BC sent photographs of the paintings and artists to the Foreign Office to forward to the Brazilian Ambassador, who had gone to Brazil on leave (Longden A., 1944). Sousa-Leão, the *Chargé d'Affaires*, proved to be personally distant from the preparation of the Exhibition, when answering that he was delighted to hear that His Majesty's Government was considering having an Exhibition made of these works (Sousa-Leão, 1944).

After the Exhibition had been held at the Itamaraty Palace library (Broadmed M., 1944), seven crates of pictures, weighing 623 kilograms (Allen, R. H., 1944) and insured for a value of £1,700 (Broadmed M., 1944) or 800,000 *cruzeiros* (Diário Carioca, 1944), were loaded in Rio de Janeiro, on March 17, 1944. The Ministry of War Transport asked the Lamport and Holt Lines to ship them at the first opportunity (Broadmed M., 1944).

Following several delays and problems with inappropriate packing cases, the pictures departed from Brazil in May.[27] At the beginning of August, officers raised the need for insurance against War risks for the period that the artworks were to stay in Britain, to 'be saved from a very awkward situation if anything were to happen to them through enemy action – a much more likely occurrence nowadays' (TNA/FO, 1944). The risks were real and indeed, on July 9, 1944, the Brazilian Ambassador in London reported the bombing of the Brazil's consulate in the English capital (MRE, 1944). Ten days later, the Brazilian ship Vital de Oliveira was sunk by a Nazi submarine on Rio de Janeiro's seacoast, killing ninety-nine people[28] (Barone, 2013, p. 35). British bureaucrats soon began to express their concerns about the delay in the arrival of the paintings, which would happen only on August 25 (Diário Carioca, 1944). One week earlier, Prime Minister Churchill had paid a visit and conveyed a message of confidence to the first 5,800 Brazilian troops – out of more than 25,000 that would be to be sent to Europe – who had just arrived in Naples,[29] from where they would move north to fight the Nazi forces.[30] Brazil was launching, simultaneously, ambitious and ground-breaking demonstrations of both military and persuasive power in the

27 It was not possible to pinpoint the exact departure date, but one can conclude from the exchange of official communications that it was between May 13 and 23.

28 Thirty-three Brazilian ships were torpedoed and another thirty-five attacked by the Axis forces in the South Atlantic during WW2. More than a thousand people are estimated to have died in these attacks (Barone, 2013, pp. 32–35).

29 The first echelon of the FEB set off from Rio de Janeiro port on July 2 and disembarked in Naples on July 16, 1944. The last of the five echelons would travel to Italy in February 1945 (Barone, 2013, p. 137).

30 Churchill's words – 'Brazilian and American soldiers, I bring to you confidence in victory' (Barone, 2013, p. 145) – illustrate the hope of a prompt end to the War, which was at that moment clearly indicating the Allies' triumph.

62 PUBLIC DIPLOMACY ON THE FRONT LINE

international arena, in what Vinicius Mariano de Carvalho called 'two fronts of the same War' (2019).

Meanwhile, the BC officers, once again, had asked 'who is responsible for the Exhibition and where is it to be held in London, as the Brazilian Embassy seems to know nothing about it' (TNA/FO, 1943), before eventually agreeing to defray expenses and make the final arrangements for the show. The mandate for the whole enterprise, rejected by other official institutions, would then be definitively taken on by the BC, which considered several galleries for hosting the show, although the final venue for the Exhibition would be settled at the very last moment, and thanks to the Foreign Office's intervention. The Tate, the Victoria & Albert Museum, the National Gallery, the National Portrait Gallery, the RAA, the Royal Exchange and the Wallace Collection were all approached by British representatives, besides a number of private galleries (McQuillen J., 1944). Perowne firstly expressed that 'the most suitable venue would be the National Gallery' (Perowne V., 1944) and drafted, in February 1944, a letter in order to secure its basement for the Exhibition. Foreign Secretary Eden himself was told that Sir Kenneth Clark[31] (1903–1983), the director of the National Gallery and Surveyor of the King's Pictures, had declined to host the show in its basements, on the grounds that he had previously refused, under the Foreign Office's instruction, to display American and Russian art shows. Confirming this statement, Eden's personal assistant reminded him that 'you had spoken to him personally about this' (TNA/FO, 1944). Clark suggested, as alternative venues, the Royal Academy, the Hertford House (the Wallace Collection) or private galleries, '[such] as the one in Suffolk Street' (TNA/FO, 1944). It is noteworthy that the young Clark, famous for continuing the National Gallery programme during the *Blitz*, was in a position to turn down the Secretary of State's request,[32] in an arrogant and paternalist stance. Two months before the opening of the Exhibition, McQuillen, Perowne's assistant at the South America Department of the Foreign Office, wrote a sorrowful report about the galleries prospected to host the paintings, at that moment temporarily housed at the BC premises. The Wallace Collection and the National Portrait Gallery had indicated that they were waiting for an early end to hostilities to return their own collections to walls; and the Royal Exchange that it had been too damaged by German attacks. The list of larger London galleries appeared to be exhausted, 'but Major Longden is trying

31 Baron of Saltwood in the county of Kent, from 1969, and author of 'Civilisation', a television series which tells the history of culture in an openly Eurocentric way.

32 It is also intriguing to ponder why the Foreign Office had advised him not to hold shows of Allies' artworks.

THE EXHIBITION 63

to interest Mr John Rothenstein[33] in the collection and hopes that he may be induced to allow part of the Tate Gallery' (McQuillen, 1944). Behind these several refusals, relies the fact that, as argued by Asbury, 'the very idea of exhibiting Modernist works from outside the main economic and cultural centres would have been considered by most institutions, even as late as the 1980s, an exercise in showcasing derivative Modern Art' (2018, p. 37). In the midst of WW2, it was necessary a political backing in order to open room for the Exhibition in the conservative British artistic establishment.

On March 1, 1944, Perowne approached the Royal Academy for the first time, addressing its secretary, Sir Walter Lamb, as President Edwin Lutyens had died on New Year's Day. On behalf of Foreign Secretary Eden, he wrote a letter assessing whether the Royal Academy would hold the Exhibition at its Burlington House rooms, enclosing photographs and a pamphlet regarding Segall as well as explanatory notes about the other participant artists (Perowne V., 1944). The Royal Academy, founded in 1768 by, among others, its first President Sir Joshua Reynolds (1723–1792), was from its earliest days identified with the authority of the King and with officialdom, the establishment, countryside Englishness, provincial intelligentsia, landed gentry, and the church; it aimed, congenitally, at generating a national visual culture (Taylor, 1999, pp. 1–28). Whereas the Tate Gallery embodied progressive enthusiasm, the Royal Academy was seen, in the 1940s, as an anti-modern moribund institution[34] (Taylor, 1999, p. 4), which was not surprising, as 'Modernists were by definition enemies of the cultural establishment' (Gay, 2010, p. 304). By 1945, Asbury explains, the Royal Academy 'was surviving on its reputation and its ability to supply what Andrew Brighton has called consensus art to conservative, middle class patrons' (2018, p. 40). For Locke, its 'outdated attitude, radiating an air of colonial superiority, captures the anachronistic position of the established art world of London in the 1940s within which the Royal Academy played a central role' (2018, p. 67). According to Taylor, the stage was set, at the time, 'for a radically revised relationship between the Tate and the Royal Academy over what was the legitimate European art of the day'[35] (Taylor, 1999, p. 136). Like the other major galleries of London, the oldest British society devoted to the fine arts had

33 Director of the Tate Gallery.

34 As late as 1925, another of the Royal Academy Presidents, Sir Frank Dicksee (1853–1928), declared that 'our ideals of beauty must be the white man's' (Taylor, 1999, p. 156).

35 An Evening News' cartoon of 1948 showed a headless modern figure with paintings by Chagall attempting to enter the Royal Academy and an aristocratic sir instructing a guard to 'kindly show this – er – person back to the Tate' (Taylor, 1999, p. 188).

64 PUBLIC DIPLOMACY ON THE FRONT LINE

to cancel exhibitions during wartime – such as one of art from Greater India planned for the winter of 1939/40 (which would eventually be held in 1947/8) – and suffered severe damage from four nearby bomb explosions between September 1939 and April 1940 (Lamb, 1951, pp. 89–90). In 1944, only three months before the Exhibition opening, 'great anxiety was caused … by the frequent passage of flying bombs over and close to the Academy in June, July and August' (Lamb, 1951, p. 93). No major loan exhibitions had been held there during the War, but there were small ones, of Greek art in 1942 and Yugoslav art in 1944[36] (Hutchison, 1968, p. 165). Besides, charitable United Artists exhibitions were promoted to support War relief efforts. All things considered, the Royal Academy can claim to have kept its doors wide open throughout the War, having held thirty-five showings during the period and continuing without a break the traditional Summer Exhibitions, dating from 1769 (Lamb, 1951, p. 94).

Lamb's initial response to Perowne was that it would hardly be possible to host the Exhibition, as other projects submitted before it would take precedence, but indicated that the matter would be put to the Academy Council for consideration. He suggested, if it proved impossible for the Royal Academy to host the Exhibition, that the Foreign Office should consider the National Portrait Gallery, where a show of Polish pictures had recently been held. In a diplomatic cable, one can read annotations made by a frustrated Perowne: 'disappointing but understandable' (Perowne V., 1944). During a meeting of the Royal Academy Council on March 14, the letter from Perowne was read, and, after an inspection of the photographs, Lamb would, on the following day, formally dismiss the Exhibition due to 'existing engagements' (Lamb, 1944). He conveyed to the Foreign Office the Council view that the National Gallery and the National Portrait Gallery would be appropriate choices for the Brazilian Exhibition. Nonetheless, between March and the end of September, the Royal Academy position changed entirely for unclear reasons, and the BC informed the Foreign Office that Lamb was prepared to consider lending the Lecture Room and Gallery 8 of the Royal Academy, 'extremely good ones' (Perowne V., 1944), for the Exhibition – it was the first positive reaction from a major gallery.[37] No evidence was found on what eventually persuaded the Academy to host the Exhibition, but it can be inferred

36 Hutchinson did not mention the Brazilian Exhibition even among the 'small exhibitions' hosted during the War.

37 In the same week, the British *Chargé d'Affaires* in Rio de Janeiro formally sent, via the Brazilian Ministry of Affairs, an invitation to the Minister of War, Eurico Gaspar Dutra, who was inspecting the Brazilian troops in Italy, to visit the United Kingdom 'as the guest of the Secretary of State for War' (Greenway, 1944).

THE EXHIBITION

that high-level contacts intervened in order to radically alter their original attitude. Locke, in this regard, assertively opines that the Academy 'was coerced into accepting the Exhibition under pressure from the government, through the offices of the Secretary of Foreign Affairs, Anthony Eden, and the British Council' (2018, p. 67). The Secretary of the Royal Academy explained, in quite a sincere fashion, that a letter signed by the Foreign Secretary would greatly facilitate matters, as its Council had turned down the request in March because 'they did not like the photographs' (Perowne V., 1944). It was also suggested that emphasis should be placed on the difficulties encountered when approaching the other venues. Perowne exclaimed, in a handwritten note, that it was 'amusing to hear that the Royal Academy turned us down on the ground that they didn't like the pictures! Neither do we! But that was not the point [Secretary Eden] must write to the President [of the Royal Academy]' (Perowne V., 1944). He wrote in another draft document that 'much time and ingenuity have been spent … in trying to find a suitable venue for the Exhibition of these pictures, but without success up to date. The pictures have now reached this country, and it is urgent to do something about getting them accepted if we are not to disappoint our friends in Brazil' (Perowne V., 1944). At that time, the Royal Academy had a new President, Alfred Munnings. Elected on the same March 14 that the Council declined the Exhibition, he was the personification of the Academy traditionalism and conservatism. A countryman from East Anglia 'addicted to pepper-and-salt suits' (Hutchison, 1968, p. 168), he had painted, from his youth, landscapes with gypsies, cattle and ponies; and, later, would become famous for painting horses, his greatest passion. During Munnings' term (1944–1949), considered by James Fenton as 'a truly disastrous presidency' (as cited in Locke, 2018, p. 67) of the RAA, he fought against *avant-garde* art and stood for traditional academic values. Since his election, the horse-painter publicly campaigned against Modernists[38] (Taylor, 1999, p. 195).

38 In 1948, former (and also future) Prime Minister Churchill, a long-time amateur Impressionist painter under the pseudonyms of David Winter and Charles Morin, would be appointed Honorary Academician Extraordinary by Munnings. This was an ambiguous and unique title, and the object of Churchill's own irony and jokes. In the following year, during the annual academy dinner, Munnings, 'not a little drunk' (Taylor, 1999), delivered a long-remembered speech, broadcast live to a radio audience of millions. He denounced 'a foolish interruption to all efforts in art' (Taylor, 1999, pp. 197–8) and hectored numerous people from the press and critics to the Government, academics and Modern Artists, namely Henry Moore, Picasso and Henri Matisse (1869–1954). In his painting 'Does the subject matter?', Munnings unleashed his aversion to the likes of Picasso and Barbara Hepworth (1903–1975), by sarcastically depicting bystanders appreciating a Modern Art exhibition.

66 PUBLIC DIPLOMACY ON THE FRONT LINE

Anthony Eden, as per suggested, sent a personal letter to Alfred Munnings, recalling the first official attempt to approach the Royal Academy in March and the unsuccessful conversations with the Tate and the Royal Exchange, both too damaged by bombs; and the Wallace Collection, the National Gallery and the National Portrait Gallery, all waiting to reopen their own collections depending on the progress of the War. He appealed to the Royal Academy as a matter of urgency, to avoid 'all the value of the artists' gesture [being lost as a consequence of an] apparent lack of interest or appreciation on our part' (Eden, 1944). He finally assured Munnings that it would be clearly stated on any posters and in the Exhibition catalogue that the pictures were presented by Brazilian artists. Only forty-two days before its opening, the Exhibition was finally formally accepted by the Royal Academy President, who pointed out that its 'Council were not favourably impressed by the specimens of these paintings ... but I am sure they will be glad to assist the Government in the difficulty that has arisen' (Munnings, 1944). As Asbury asserts, 'the Royal Academy ... only agreed to host it, after receiving considerable pressure from the Foreign Office in conjunction with the British Council' (2018, p. 37), which reveals the political and diplomatic backing of the Exhibition, by both British and Brazilian governments. With respect to the collection, Munnings insisted that the posters and the catalogue must clearly state its provenance, so that no responsibility for its quality would rest on the Royal Academy or the Foreign Office. The response, in the absence of Eden, was signed by his private secretary, Valentine Lawford, who wrote that the Foreign Secretary would 'value your cooperation ... which is most helpful from the standpoint of Anglo-Brazilian relations' (Lawford, 1944). This is another strong piece of proof that the Exhibition, for both countries involved, was not only about cultural exchange but rather a diplomatic endeavour aimed at strengthening relations and advancing mutual interests. In the meantime, a private gallery, Wildenstein & Co, had offered to host the Exhibition, as a way of aiding the British government. After expressing the Foreign Office's gratitude for the support, a representative explained that 'we have come to the conclusion that only display in a public gallery will give the requisite acknowledgement of the appreciation of His Majesty's Government'[39] (Jackson M., 1944). At a time when Modernist art was at the centre of an intense debate and was yet to be fully embraced by the British,[40] it was quite unforeseen that the Royal Academy, known for its conservatism and chauvinism, should host an Exhibition featuring *avant-garde* Brazilian painters virtually

39 In response, they (Wildenstein) lamented for not being of 'more material assistance' (Beddington, 1944).

40 See the section on the 'Internationalisation of Brazilian Visual Arts'.

unheard-of in the United Kingdom. The Royal Academy was still averse to modern and foreign art; and the 'first works by an artist of foreign birth to be purchased by the Academy were Lucien Pissarro's "All Saints Church, Hastings" (1918) and "April, Epping" (1894), for £131.5.0[41] and £157.10.0 respectively, in 1934 – and Pissarro had lived most of his life in England' (Taylor, 1999, p. 137). It is ironic, as noted by Locke, that the Exhibition ended up shown in 'exactly the type of institution that Brazilian artists had rejected in their pursuit of a national, Modern Art' (2018, p. 70). In view of the precarious situation of other potentially more sympathetic galleries, such as the Tate, the Academy's vocation for supporting the officialdom prevailed and provided the government with a necessary solution to the protracted issue of finding a proper venue for the Exhibition. The fact that its new President 'saw no place in art for abstractions and 'isms' and had a very low opinion of their adherents' (Hutchison, 1968, p. 168) made the Royal Academy an even more improbable venue to host the Exhibition, so distant from English academic tastes. Figures 1 and 2 conveys the stark contrast between

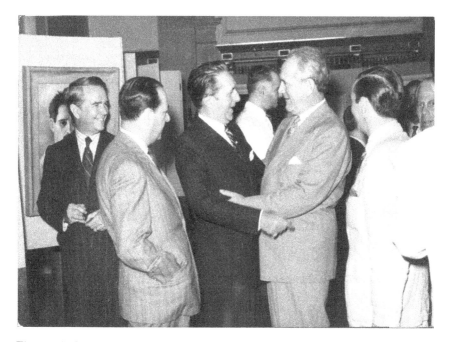

Figure 1. Minister Oswaldo Aranha (Right) and Ambassador Noel Charles (Left) during the Exhibition opening at the Itamaraty Palace in Rio de Janeiro, 1943 (*The National Archives*).

41 In the pre-decimal system (£.s.d.), in force until 1971, £1 was comprised 20 shillings or 240 pence.

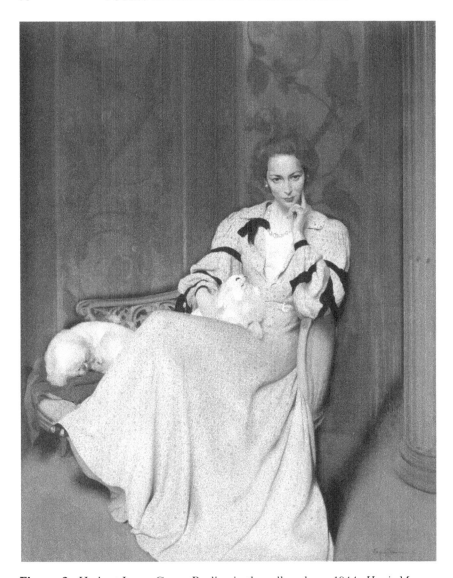

Figure 2. Herbert James Gunn. Pauline in the yellow dress, 1944. *Harris Museum, Art Gallery & Library.*

the conservatism of the Academy's hyper-realistic 'picture of the year' of 1944, 'Pauline in the yellow dress' by Herbert James Gunn (1893–1964) – described by the Daily Mail as 'the Mona Lisa of 1944' (Hutchison, 1968, p. 166) – and the modern 'Lucy with flower',[42] by Lasar Segall (Figure 3),

42 The model for the painting was Luci Citi Ferreira, a friend of Segall, who was also a painter and contributed artworks for the Exhibition.

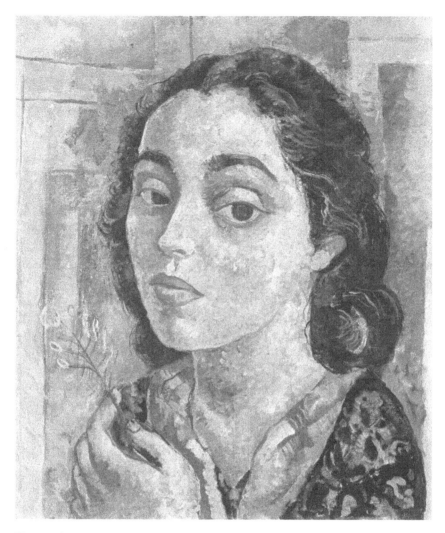

Figure 3. Lasar Segall. Lucy with flower, c.1939–1942. *Scottish National Gallery of Modern Art*. Courtesy of Museum Lasar Segall.

the Brazilian artwork that would stand out the most amongst those which were to be hung in its rooms in November of the same year.[13] It was arguably due to these stylistic and aesthetic divergences that so little of the Exhibition was preserved in the Royal Academy archives, memory and history.[14]

43 See Figures 1 and 2 at (artuk.org/discover/artworks).
44 In Hutchison's 'The History of the Royal Academy of Arts', there is only one line – 'Brazilian painters, 1944', in the 'Appendix E – Subject – Index of Exhibitions' dedicated to the Brazilian show (Hutchison, 1968, p. 277).

70 PUBLIC DIPLOMACY ON THE FRONT LINE

In October 1944, when the FEB was already fighting in Italy[45] and after finally having secured three rooms from the Royal Academy for the Exhibition, Perowne wrote to Longden about logistical and practical questions, ranging from the publicity arrangements, for which they would count on the help of the Ministry of Information and the BBC, to the catalogue and the subsequent provincial tour. Most importantly, Perowne was 'very anxious that the generosity of our Brazilian friends should be suitably acknowledged by us ... even if we cannot praise their output very highly' (Perowne V., 1944). He offered to visit the pictures, then in the Tate basements, along with Sousa-Leão, 'himself an art expert and a good friend of all of us in the department' (Perowne V., 1944). Longden agreed with his colleague from the Foreign Office and noted that they should also invite a suitable personality to perform at the opening ceremony (Longden A., 1944). The Exhibition curator went to the Tate Gallery, on October 21, to see the Brazilian pictures for the first time and opined that 'on the whole the standard is not bad though no picture is outstanding' (Longden, 1944), as he would tell Perowne on that same day. Longden suggested November 22 as the opening date of the Exhibition and indicated that he would approach other cities to host the show, after having conversations with Perowne and my 'old friend de Sousa-Leão' (Perowne V., 1944), a very well-connected Brazilian diplomat, as one can infer from the respectful and affectionate references by his British counterparts. Two days later, Longden visited the pictures at the Tate again, this time accompanied by Sousa-Leão; Ogilvie and Church (BC); Ward (Tate); and Perowne (Foreign Office), who finally conceded some artistic value to the Brazilian artworks – they would, in his words, 'make a surprisingly reassuring show, though one can understand that they might not, all of them, appeal to the council of the Royal Academy' (Perowne V., 1944). It shows that even extremely sceptical British observers like Perowne were more prone to appreciate Brazilian Modern Art than the Royal Academy board, regarded by him as a paradigm of traditionalism. Moreover, his change in mood was probably due to others' influence, since he went on to say that 'we all agreed that the Exhibition should be an interesting one and that provincial directors would be anxious to get hold of it' (Perowne V., 1944). On the occasion, it was accorded that he would approach the art critic Sir Osbert Sitwell (1892–1969) in order to entreat him to write the catalogue of the Exhibition.

Perowne also suggested that it would be desirable that 'one, or more, of the pictures should be acquired by or on behalf of His Majesty's Government

45 Brazilian troops first saw action on September 15, 1944. Three days later, they took control of the town of Camaiore (Barone, 2013, p. 174).

THE EXHIBITION 71

for inclusion in one of the national collections' (Perowne V., 1944), as well as to decorate the future new British Embassy in Rio de Janeiro.[46] One of the legacies of the Exhibition would be, indeed, the formation of a collection of Brazilian art throughout public galleries across the United Kingdom.[47] He also asserted that, at Sousa-Leão's suggestion, the photographs of the exhibition 'Brazil Builds' which was promoted by the ABS, at that time being held at Simpson's Gallery, would be included in the Royal Academy show.[48] With regard to the opening ceremony, Perowne stated that the Foreign Secretary would be the obvious person to perform, 'if he is willing' (Perowne V., 1944). He concluded by bluntly arguing that 'after all, our interest in this matter is a political, not an artistic, one'[49] (Perowne V., 1944). As much as for Brazil, for the United Kingdom the promotion of culture and the Exhibition, in particular, responded primarily to diplomatic concerns, as it is possible to infer from British officers' statements.

In a report sent to Perowne, Longden detailed the arrangements with the Royal Academy. The weekly cost of the galleries would be £14 for the Lecture Room (where the oil paintings would be displayed); £8 for the Gem Room (the long gallery alongside); and £8 for Gallery N. 8 (leading out of the long gallery), the latter to be paid for by the ABS, for the display of the architectural photographs. One wall would have to be used for black and white drawings, as, although all of the pictures could be exhibited in the first two galleries, 'Sousa-Leão very much wishes to show the photographs of Brazilian architecture entitled "Brazil Builds" ... provided that the Academy do not object' (Longden A., 1944). Walter Lamb agreed on waiving the Royal Academy's usual charge for the use of its galleries in the week preceding the opening, in consideration of the 'special circumstances' (Lamb, 1944) and sent an occupation agreement to be signed by someone representing the BC. When Longden informed Perowne that the Academy had granted the period of hanging for free, 'since the Brazilian artists were so generously

46 It would be constructed between 1946 and 1950, where the *Palácio da Cidade*, the Mayor's office, is located today.
47 See the 'Legacies' section.
48 Ambassador Moniz de Aragão had opened the 'Brazil Builds' on October 17, 1944. For him, it was a success, in spite of being a modest show that had no support from the Brazilian government (Moniz de Aragão J. J., 1944).
49 In a previous conversation, he interpreted that Eden had not declined attending it in advance by saying 'I cannot promise to do this' (Perowne V., 1944). Although Lawford, his Private Secretary, had informed that his presence would be materially possible, he advised his colleagues to wait for Eden's return to London in order to consult him, before considering other possibilities.

72 PUBLIC DIPLOMACY ON THE FRONT LINE

giving this exhibition for charity' (Longden A., 1944), he asked whether
the colleague from the Foreign Office would 'care to sign the forms ... since
it is a Foreign Office undertaking rather than one arranged by this Council'
(Longden A., 1944). After a telephone conversation about the 'paternity' of
the Exhibition, or at least about the responsibility for the Royal Academy
forms, the Foreign Office returned them back to the BC to be signed by
Longden, who had consented to do so. At the end of the letter, the Foreign
Office asserted that they were 'most grateful for all the trouble the British
Council are taking over this matter' (Jackson M., 1944).

On November 22, 1944, the FEB was stationed at the base of the Monte
Castello, in Italy, where three days afterwards it would fight the most
protracted and important amongst the battles in which it took part during
the War. Meanwhile, Brazil underwent a most severe supply crisis,[50]
and V2 rockets were falling over London rooftops.[51] In the courtyard of
Burlington House, on that day, two Brazilian flags were fluttering on either
side of the Union Jacks,[52] and posters inside the building that advertised
the Exhibition were framed in Brazilian colours. The traditional statue of
Royal Academy founder and first President, Sir Joshua Reynolds, was not
there, as valuable works had been displaced and stored between 1939 and
April 1945, so as to prevent them from being damaged by War attacks. With
all the major permanent collections closed, 'the public was starved of art
and, after an initial period of hibernation, was willing to face flying-bombs
to visit the Academy's exhibitions' (Hutchison, 1968, p. 166). The three
galleries devoted to the Exhibition were decorated with chrysanthemums
and the whole show presented a pleasing and impressive appearance,
as Perowne described in detail to the new Ambassador to Brazil (Perowne
V., 1944), Sir Donald Gainer (1891–1966), recently promoted and having
arrived from Venezuela (The Gazette, n.d.). From another viewpoint, Sousa-
Leão told Brazilian *ad interim* Minister of Foreign Affairs, Ambassador Pedro
Leão Velloso (1887–1947), that it was an 'event of great and unprecedented
relevance' (Sousa-Leão J. d., 1944). After a preview for the press, which

50 In December 1944, the stock market of grains would be closed, and President
 Vargas visited São Paulo in an attempt to restrain speculation (Barone, 2013, p. 98).
51 The V2, first ballistic missile and first man-made object to make a suborbital
 spaceflight, was deployed from September 1944 on by the German forces. Some 9,000
 Londoners lost their lives to the V2 attacks, 168 of which occurred on November 25,
 in New Cross, three days after and five miles away from the opening of the Exhibition
 at Burlington House (Londonist, n.d.).
52 Since the 1944 Summer Exhibition, 'Union Jacks were raised along the Piccadilly
 frontage of Burlington House' (Hutchison, 1968, p. 166).

THE EXHIBITION

rendered a number of positive articles on the Exhibition's opening day,[53] a selected list of people was invited for the launching ceremony. The guest list, which according to annotations by McQuillen 'may be useful to His Majesty's Government's entertainment' (1944), included celebrated names from London's art world, such as the writers T.S. Eliot, H. G. Wells, Julian S. Huxley and the Sitwell siblings; painters Julian Trevelyan, brothers John and Paul Nash, Dame Laura Knight and Feliks Topolski; art critic Nikolaus Pevsner; museum directors Samuel Cortauld, J.D. Duddington and Henry Tate; Sir Alec Martin, Director of the auction house Christie's; and the economist Lord Keynes, a *connoisseur* of the arts and the first Chairman of the Committee for Encouragement of Music and the Arts (CEMA), which would later turn into the Arts Council. Over 320 people, out of around 830 invitees,[54] attended the reception (Perowne V., 1944). Sousa-Leão reported the presence of authorities, members of Parliament, journalists and other 'socially prominent figures as well as many Brazilians living in London' (Sousa-Leão J. d., 1944). It is noteworthy that more than six decades later, Mark would write that 'Cultural Diplomacy's audiences may include members of a national Diaspora' (2009, p. 11). Among the cited attendees were Minister of Information Brendan Bracken,[55] writer Sacheverell Sitwell,[56] playwright Clifford Bax, actress Lilian Braithwaite, Nobel prize-winning diplomat Viscount Cecil, former Ambassador to Brazil Sir Hugh Gurney, Executive Director of the Bank of England Sir Otto Niemeyer and architects Sir Charles Reilly and Sir Augustus Daniel[57] (Perowne V., 1944).

The main speech was delivered by Lord Sherwood, as seen in Figure 4, as the Secretary for Air, Sir Archibald Sinclair (1890–1970), was unable to attend the opening due to a protracted Cabinet meeting that continued into the afternoon.[58] Sherwood's words were, according to Perowne, 'pleasant and

53 See the 'Press Coverage' section.

54 Including forty-three members of the RAF; thirty-three from the BC; twenty-five from the Foreign Office; twenty from the BBC; nineteen from the Brazilian Embassy; nineteen from the bilateral chamber of commerce; ten from the Ministry of Information; seven from the Brazilian Consulate; and five from the Ministry of Education.

55 From 1952 on, Viscount Bracken of Christchurch in the County of Southampton.

56 Later Sir Sacheverell Sitwell.

57 He also mentioned Professor Entwistle (Professor of Spanish Studies at the University of Oxford), Sir Charles and Lady Seligman, Sir S. Tallents, Cavalcanti and Norman Zimmern of the BBC, Lady Portal, Oliver Bonham Carter, Air-Vice-Marshall Cordingley, Air Vice-Mashall Sir Hamilton Nichols, Air Marshall Sir Bertine E. Sutton and Viscount Trenchard.

58 Or due to *force majeure*, according to Sousa-Leão (Sousa-Leão J. d., 1944).

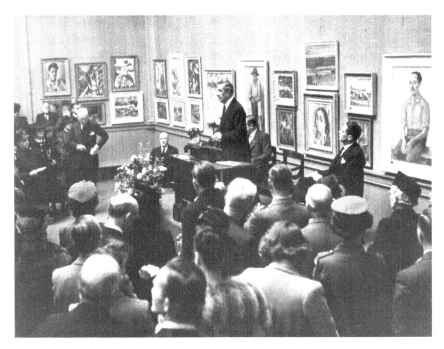

Figure 4. Lord Sherwood during the Exhibition opening ceremony at the Royal Academy of Arts in London, 1944 (*The National Archives*).

tactful' (Perowne V., 1944); and to Sousa-Leão, warm (Sousa-Leão J. d., 1944), with references to the Brazilian forces in action in Italy and the Brazilian air force patrolling of the home coast, as well as praise for the artists' elegance and kindness. Sherwood, who would acquire for himself the work 'Pen and ink drawing', by Burle Marx, finally emphasised that Brazil 'was not only a fair weather friend, but had stood by us in our darkest days in 1941' (Perowne V., 1944) and offered thanks for the gifts of money from the Fellowship of the Bellows,[59] whose Brazilian branch alone had 'raised £100,000 for the Royal Air Force' (A Manhã, 1944, p. 7). Sir Malcom Robertson, Chairman of the BC, who introduced the main speaker, 'had been entreated to keep his opening speech down to a few words, but he spoke at some length about his experiences in Brazil as *Chargé d'Affaires* during the last War and referred to its fine record before 1916 as a benevolent neutral, which made us all feel rather uncomfortable', in Perowne's words (Perowne V., 1944). In contrast, Sousa-Leão noted in Robertson's speech highly laudatory references to the Brazilian participation in the First World War (Sousa-Leão J. d., 1944). Representing

59 See the section on 'Brazil's Image before the Exhibition'.

THE EXHIBITION 75

the Brazilian Ambassador, who was still on leave in Brazil, he gave a speech of thanks for the compliments paid to Brazil and commented, as an art expert,[60] on the style and influences of the pictures (Sousa-Leão J. d., 1944).

In a picturesque official report, Perowne alluded to the Peruvian *Chargé d'Affaires*,[61] who 'blatantly gate-crashed the private view and was seen proceeding round the Exhibition with a scowl of envy on his face; however, he justified his presence by buying two pictures, one of them by a Peruvian artist, which he said was the best picture in the show'[62] (Perowne V., 1944). Julio Rosen, from the BBC, gave a broadcast talk to Latin America about the Exhibition on the opening day.[63] The day after the Exhibition opening ceremony, Sousa-Leão informed the capital about the successful reception, highlighting the speeches by Robertson and Sherwood and the wide press coverage. He alluded to the encouraging number of pictures already sold, 22 (Sousa-Leão J. d., 1944). The opening of the Exhibition was on its own an impressive exercise of Public Diplomacy and, as this book will further discuss in the 'Legacies' section, anticipated the remarkable outputs that would mark it along its nine-month tour across the RAA and seven other British galleries.

The Show

P.S. I have just heard that The Queen visited the Exhibition today

Victor Perowne[64]

By the Exhibition inauguration date, Brazilian soldiers were on the War front preparing their first unsuccessful attempt to take over Monte Castello, in the North of Italy.[65] The show was open to the public at the Royal Academy on November 23 and remained on display until December 13, open every day except Sundays, from 10am to 5pm; the admission price was one shilling. (The Times, 1944, p. 6). Perowne observed that there was 'quite a steady

60 Apart from collecting artworks, he wrote a few books and articles on Brazilian iconography and architecture.

61 Minister Fernando Breckemeyer.

62 'Landscape', by Quirino Campofiorito, and 'Figures', by Percy Lau.

63 Despite the reference by Perowne to the broadcast in an official document, no corresponding material was found in the BBC archives due to limited recordings being made and kept from that time.

64 In a cable to British Ambassador in Rio de Janeiro, Sir Donald Gainer (Perowne V., 1944).

65 Five attacks, on November 24, 25 and 29 and December 12, 1944, and February 20, 1945, were necessary to win the most protracted and mortal battle in which Brazilian troops took part during the campaign in Italy (Barone, 2013, p. 196).

76 PUBLIC DIPLOMACY ON THE FRONT LINE

flow of public (on a small scale) to the Exhibition' (Perowne V., 1944). After
one week of showing, Sousa-Leão reported a daily attendance of 100–200
people and the sale of fifty artworks, amounting to about £800. By the close
of the three-week Exhibition at Burlington House, it was visited by around
2,600 people, rendering £130 of entrance fees. A thousand catalogues were
sold and the sales of sixty-six pictures reached over £900 (RAA, 1945).
A pleased officer noted, in reference to the results, 'splendid' (Allen, 1944).
In January 1945, Perowne would reiterate that 'both sales and gate money,
up to date, have been very satisfactory' (Perowne V., 1945) and praised
the positive effects of the Exhibition on Anglo-Brazilian relations, attesting
to the success of the political goal defined by himself three months earlier.[66]

In mid-November, the same Perowne had asked, through an internal
document, for a position on whether Princess Marina (1906–1968) –
Duchess of Kent and Honorary President of the RAF Benevolent Fund –
would pay a visit to the Exhibition, and suggested writing to Captain Lord
Sidney Herbert to explain to him 'what it is all about' (Perowne V., 1944).
Representatives of the Foreign Office discussed who, from the governmental
departments involved, should accompany the potential royal visit. McQuillen
told Perowne that all she knew was that 'Lord Herbert had informed …
that though the Duchess would prefer not to open the Exhibition, she would
visit it sometime' (McQuillen J. M., 1944). On the same day, a British
diplomat wrote to Lord Herbert in relation to the Exhibition recalling
the popularity that the RAF enjoyed in Brazil, and asked him to mention
the Brazilian show to the Duchess of Kent, whose visit to the Royal Academy
would have a most happy effect on Anglo-Brazilian relations. Arrangements
would be made for the Brazilian *Chargé d'Affaires* – 'the Ambassador has had
to go on a visit to his country' (Allen R. H., 1944) – to be in attendance. The
representative from the Foreign Office consulted whether there would be
'objection to photographs of Her Royal Highness being taken and published
in the South American papers', before curiously adding that 'they would not,
of course, be published in this country if this was not desired' (Allen R. H.,
1944). Lord Herbert replied that Her Royal Highness would be very pleased
to visit the Exhibition and fixed the date for November 28. Clearly concerned
with protocol issues, he emphasised that at least the *Chargé d'Affaires* should be
present with members of the BC, asking for a list of those who would be there
to welcome her.[67] He went so far as to issue a reminder that 'lounge suit should

66 'After all, our interest in this matter is a political, not an artistic, one' (Perowne V., 1944).
67 Alfred Longden thanked Victor Perowne for being available to accompany her
 visit together with him and scheduled both to meet at Burlington House at 2.45 pm of
 November 28, in order to wait for her (Perowne V., 1944).

THE EXHIBITION

of course be worn' (Herbert, 1944). Herbert indicated having no objection to the press and photographers being present. The Duchess, he ended by saying, 'is much looking forward to the Exhibition' (Herbert, 1944) and was delighted to learn about the Brazilian artists' aid to the Benevolent Fund.[68] The Duchess of Kent's visit took more than half an hour and was marked by solemnity, as emphasised by Sousa-Leão, who reported, on the same day, that she was favourably impressed by the originality and vitality of Brazilian contemporary art (Sousa-Leão J. d., 1944). She was accompanied by Lady Herbert to the Royal Academy (Yorkshire Post and Leeds Mercury, 1944), where they were received by Chairman Robertson, Church and Somerville, from the BC; Captain Dore, from the Air Ministry; Perowne and Sousa-Leão (Perowne V., 1944). The Duchess 'took a great interest in the Exhibition, visiting every room and looking most carefully at the pictures' (Perowne V., 1944), according to the Foreign Office report to the Ministry of Information. She was also, in Sousa-Leão's opinion, amazed by the architectural exhibit (Sousa-Leão J. d., 1944). Conceived and facilitated by the Embassy, one can notice a special and recurrent enthusiasm displayed by the Brazilian diplomats when referring to the 'Brazil Builds'. The Duchess who, fifteen years later would visit Brasília – Brazil's Modernist capital where she met one of its conceptualisers, architect Oscar Niemeyer, and President Juscelino Kubitscheck (1902–1976)[69] – was indeed photographed at the Exhibition looking attentively at the architectural pictures, alongside Sousa-Leão, as seen in the Figure 5[70] (Evening News, 1944).

On November 29, Queen Elizabeth[71] (1900–2002), along with Princess Margaret (1930–2002), visited the Royal Academy, incognito and unannounced, according to Sousa-Leão (Sousa-Leão J. d., 1944), a fact that would have posed quite a challenge. Besides the Exhibition of Modern Brazilian Paintings, the royal family made an appearance at the Annual Exhibition of the Royal Society of Portrait Painters and one by Firemen Artists, held in another of

68 Sousa-Leão, on the same day, informed MRE of the upcoming Duchess's visit (Sousa-Leão J. d., 1944).

69 A very popular song, '*Tempos idos* [Times gone]' by the iconic composer Cartola, mentions the Duchess' visit. According to its lyrics, '*samba*' – which was traditionally restricted to ghettoes – had gathered prestige, 'managed to enter the Municipal Theatre/ after travelling the world/ with the same attire used in its origin/ displayed itself to Duchess of Kent at Itamaraty Palace *[Conseguiu penetrar no Municipal/ Depois de percorrer todo o universe/ Com a mesma roupagem que saiu daqui/ Exibiu-se pra Duquesa de Kent no Itamaraty]*'.

70 In another picture, she was captured admiring the painting 'Landscape', by Quirino da Silva.

71 The late mother of the current sovereign.

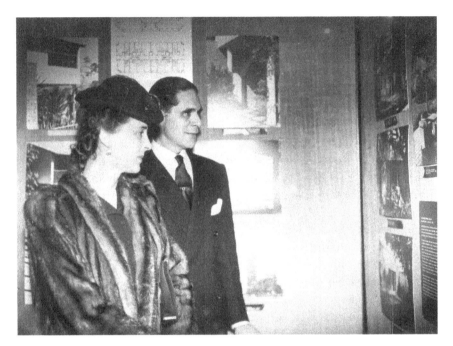

Figure 5. The Duchess of Kent and the Brazilian *Chargé d'Affaires* Sousa-Leão observe architectural pictures at the Exhibition in the RAA (*The National Archives*).

the Burlington House rooms (RAA, 1945). The Duchess of Kent's visit to the Exhibition was thoroughly planned, widely registered and publicised. It had a political purpose and drew attention to the initiative. The Queen's, in contrast, was spontaneous and marked by a low-profile attitude, seemingly an ordinary cultural outing to the Royal Academy.

After the warm receptivity to the three-week long show at Burlington House, the Exhibition was taken to several cities across the United Kingdom. Although the idea of a tour had been under consideration by the Foreign Office since January 1944 (TNA/FO, 1944), the cities and venues that would host it were decided at the last moment. In September, Longden guaranteed that he could arrange successful shows in regional centres, particularly in Glasgow and Edinburgh, as long as the 'pictures are good enough' (McQuillen, 1944). Besides the two Scottish cities, several English ones were considered by different people involved with the Exhibition, amongst them Bristol, Norwich, Manchester, Birmingham and Liverpool. In October 1944, after inspecting the Brazilian collection temporarily housed at the Tate Gallery and concluding that the pictures were 'not bad' (Longden, 1944), Longden told Perowne that he would approach galleries in Edinburgh, Birmingham, Manchester and Liverpool, but in fact, from amongst the cities he mentioned,

THE EXHIBITION

the Exhibition would only go to the Scottish capital. Discussing the tour during an ABS meeting, its Chairman Sir Thomas Cook[72] announced that he had written to Ms. Barnard, curator of the Castle Museum, requesting her to arrange with Longden for the Exhibition to go to Norwich (ABS, 1944). Ten days later, a representative of the BC wrote to the Foreign Office to confirm that the Exhibition would go there after its closing in London.

The Brazilian artworks were thus sent to Norwich, a city severely affected by War attacks. On December 30, Sir Thomas Cook, along with Lord Mayor Williamson and Mottram, the latter representing the BC, opened the Exhibition,[73] which occupied three of the grandiose Castle Museum rooms. In the following week, during a meeting of the ABS, he expressed his happiness as 'the Exhibition [opening] had been a great success' (ABS, 1945). Just after the end of the Exhibition in Norwich, Ms. Somerville, from the BC, forwarded a letter from the museum's curator to the Foreign Office, saying that it had created quite a lot of interest locally. According to her, however, 'much of the reaction was hostile, but that was to be expected' (Somerville L., 1945). The diplomats from the Foreign Office handwrote some slightly ironical comments on the letter: 'quite a sum of money was made out of the catalogues, even if the reaction to the pictures was "hostile" (I suppose Norwich is rather conservative in its artistic tastes)' and 'one would like to see the "hostile" cuttings sometime' (Perowne V., 1945). At Perowne's request for further explanation, Somerville moderated the tone, stating that 'the papers are certainly not hostile, and I think that Miss Barnard must have been referring to comments by visitors when she said "much of the reaction was hostile"' (Somerville L., 1945). She observed that any modern pictures in the provinces usually incur such criticism, 'most of the visitors having pre-conceived ideas of art being purely representational in the modern RA idiom' (Somerville L., 1945), indicating the narrow accepted limits for an emerging Modernism restrained by the establishment's institutions, as well as the Royal Academy's power in defining these limits. In fact, Norwich's press coverage was quite favourable,[74] and the public, albeit hostile, was large. The Exhibition at Castle Museum was seen by 14,118 people, and 344 catalogues, out of the 500 sent by the BC, were sold, amounting to £10.8.4 (Somerville L., 1945). There is a record of enquiries regarding ten of the pictures exhibited, but no proof has been found to determine whether the works were eventually acquired (Somerville L., 1945).

72 Member of Parliament (1931–1945) for the North Norfolk constituency (They work for you, n.d.).

73 It would be on display until January 21, 1945.

74 See the 'Press Coverage' section.

80 PUBLIC DIPLOMACY ON THE FRONT LINE

The Exhibition was then taken to Scotland, where it was inaugurated by Sousa-Leão at the prestigious Scottish National Gallery,[75] alongside the Lord Provost of Edinburgh, Sir John Ireland Falconer; Harvey Wood, from the BC; and Marshall Smart, from the RAF. The Lord Provost, on the occasion, said that the gesture on the part of the South American allies is one that touches deeply (Sousa-Leão J. d., 1945). Harvey Wood referred to Brazil's participation in the War, alluding to the Expeditionary Force at the moment fighting in the European theatre of War, the naval force 'patrolling the South Atlantic, releasing units of the American fleet for active duties elsewhere' (Sousa-Leão J. d., 1945), and its strategic exports. Thanking the Brazilian Ministry of Education for its cordial cooperation and anglophile societies for their enthusiasm, he extolled the work carried out by the BC in five of Brazil's main urban centres.[76] In turn, Sousa-Leão emphasised the Brazilian people's indebtedness to the RAF and affirmed that no other cause than that of the RAF Benevolent Fund would have been met with a readier response by the Brazilian artists (Sousa-Leão J. d., 1945). After delivering some remarks on Brazil's acknowledgement of Scottish literature, he stressed that it was high time for Brazilian culture to also become known in Scotland. A *connoisseur* of architecture and the main person responsible for bringing the 'Brazil Builds' exhibition, Sousa-Leão dedicated substantial time to appraising the photography show and the Brazilian innovations in that field, concluding that the architectural section of the Exhibition would be of more than ordinary interest to Edinburgh's citizens (Sousa-Leão J. d., 1945). After opening the Exhibition, Sousa-Leão wrote enthusiastically to the Brazilian *interim* Minister of Foreign Affairs, Pedro Leão Velloso, to say that it would certainly be very successful in Edinburgh, which he regarded as a first-rate artistic centre (Sousa-Leão J. d., 1945), alluding to the very favourable press reviews.[77] After one month, he returned to Leão Velloso to confirm that the interest aroused by the Exhibition was appreciable. He attached to his telegram a laudatory missive from Joseph Lea Gleave, Head of the School of Architecture and Town Planning at the Edinburgh College of Art[78] (Sousa-Leão J. d., 1945). Seven paintings were sold in Edinburgh, and

75 It was shown there between February 9 and March 11, 1945.
76 According to him, in Rio de Janeiro, São Paulo, Belo Horizonte, Curitiba and Santos, there were 4,000 Brazilians studying English, with the equivalent of an English University in Brazil (Sousa-Leão J. d., 1945).
77 See the 'Press Coverage' section.
78 He won an international contest to design the Columbus Lighthouse in Santo Domingo, Dominican Republic. The building would be inaugurated only in 1992, inspired by his original drawings (Scottish architects, n.d.).

THE EXHIBITION 81

the sales of 1,560 catalogues totalled £32.10.0 (Foreign Office, 1945). Ten days after the end of the showing, the National Gallery of Scotland's trustees announced to Harvey Wood, from the BC, their acceptance of the picture 'Lucy with flower' by Lasar Segall,[79] 'as adding to the group which we are slowly forming for a Gallery of Modern Art' (Edinburgh National Gallery, 1945). It was accentuated how pleased they had been to collaborate with the BC on the many exhibitions held in the gallery during the War period. On a personal note, the gallery director emphasised his own satisfaction, as 'Lucy with flower' was 'one of the finest works in the Brazilian show and will be a very valuable and interesting addition to our collection' (Edinburgh National Gallery, 1945).

After being displayed in Edinburgh, upon Brazilian troops finally winning the prolonged battle of Monte Castello and occupied Castelnuovo and Soprassasso in Italy,[80] the collection was presented to the public of the Kelvingrove Gallery[81] in the neighbouring city of Glasgow. Its 1945 cultural calendar described the show as a 'small but important exhibition [that] presents a cross-section of South American art, with which most of us are unfamiliar' (Glasgow Museum and Art Galleries, 1945). Not exactly in an inviting fashion, it added: 'when shown in London it gave rise to much controversy, and it is more likely that the same thing will happen here. However, there is no harm in seeing it!' (Glasgow Museum and Art Galleries, 1945). Nevertheless, no evidence was found of much controversy in London, at least publicly expressed.[82] Moreover, the show was presumably very popular in Glasgow, as in no other city were so many – 2,316 – copies of the Exhibition catalogue sold; £47.15.0. were raised through their sale[83] (Foreign Office, 1945).

From Scotland, the Exhibition moved to Bath, a city in Southwest England that had been heavily bombed during the *Blitz*. Its Mayor, Edgar Clements, offered a lunch to First Secretary Hugo Gouthier, the representative of the Brazilian Embassy who, accompanied by his wife, opened the Exhibition at the Victoria Gallery on April 25.[84] Toasts were offered to Brazil, President

79 Its image can be found on the 'Arrangements' section.
80 In that period, FEB took Monte Castello (February 21), Castelnuovo and Soprassasso (March 5, 1945) (Barone, 2013, p. 201).
81 It was on show from March 20 to April 15, 1945.
82 See the Exhibition repercussion in the 'Press Coverage' section.
83 There is no official information on attendance in Scotland, nor for most of the galleries where the Exhibition was displayed.
84 The Exhibition was in Bath from April 25 to May 14, 1945.

Vargas and King George VI (1895–1952). Amongst the Mayor's guests[85] were Eleanor Hennessy (wife of the painter Lord Methuen) and the Deputy Mayor of Bath, Councillor Joseph Plowman,[86] who had lived in Brazil for some years and would have given the Mayor 'valuable instruction in Brazilian etiquette' (Bath Weekly Chronicle and Herald, 1945). During the solemn opening ceremony of the Exhibition, Air Commodore Arthur Vere Harvey[87] declared that 'we don't appreciate sufficiently the part played by Brazil in this War, and that is because they are playing their part in other parts of the world, and, from what I know, absolutely to the full on the Italian front' (Bath & Wilts Chronicle & Herald, 1945). At that time, Roosevelt had died, and Harry Truman (1884–1972) was the new President of the United States. While Adolf Hitler (1889–1945) believed that it could be a sign of a turning point in the War in his favour, the FEB occupied Montese, Zocca and Vignola,[88] helping consolidate Allied advances.

In his speech, Secretary Gouthier, also an important art collector, honoured Brazilian contemporary culture and the 'vitality which animates Modern Art in my country' (Bath & Wilts Chronicle & Herald, 1945). He maintained that as 'a new nation, Brazil offers an appropriate atmosphere for the expression and development of a Modern Art, in which the psychological feeling predominates over the purely photographic characteristics and the faithful representation of images' (Bath & Wilts Chronicle & Herald, 1945). But he laid special emphasis, as his colleague Sousa-Leão had done in Edinburgh, on the photographs of Brazilian architecture, 'which portray well her advanced, practical and realistic spirit' (Bath & Wilts Chronicle & Herald, 1945), serving as a reminder that 'Brazilian architects like Oscar Niemeyer and Lucio Costa are today in the forefront of the world's modern architecture' (Moniz de Aragão J. J., 1945). The reverence towards the 'Brazil Builds' exhibition, often shown by the Brazilian diplomats, evidences their pride for national Modernist architecture. It also indicates their intention to extol the merits of the photography exhibition, in which the Embassy had a leading role, over those of the Exhibition of Modern Brazilian Paintings, conceived of in Rio de Janeiro and in respect of which it had played a much more passive one.[89] Alluding to the British-Brazilian brotherhood in arms, Gouthier spoke of the potential strengthening of bilateral cultural relations

85 The president of the Rotary Club and the vice-chairman of the Bathavon Rural District Council were also mentioned in the news.

86 He was also former Mayor of Bath.

87 From 1957, Baron Harvey of Prestbury.

88 Respectively on April 16, 21 and 22, 1945.

89 See the 'Arrangements' section.

THE EXHIBITION 83

after the return of peace. Amongst the steps to be taken, he listed student exchanges, reciprocal visits by professors and experts, the screening of British films in Brazil, the translation of the best literature of the two countries, the enlargement of tourist traffic, art exhibitions and more extended broadcast shows, a true and still current programme of Public Diplomacy. The ever-increasing activities of the BC, he recalled, 'are rendering immense assistance in fostering closer cultural relations between Brazil and the United Kingdom' (Bath & Wilts Chronicle & Herald, 1945). The press noticed the acquisition, by Secretary Gouthier himself, of 'one of the pictures for over £200' (Bath Weekly Chronicle and Herald, 1945). In fact, he had paid £180 for 'Group' ('*Mulher e crianças*'), according to a letter to his friend Portinari not only for finding it admirable but also to avoid that any person bought it and dumped the painting in an apartment room (Gouthier, 1944). Several local newspapers published varied views on the show,[90] which was visited by 2,612 people and whose 286 catalogues sale earned £7.3.0. during its fifteen-day stay at the riverfront Victoria Art Gallery (Victoria Art Gallery, 1945). Ambassador Moniz de Aragão called the Exhibition in Bath an event of great cultural significance and magnificent Propaganda for Brazil (Moniz de Aragão J. J., 1945) in a report sent via telegram to Rio de Janeiro. The impact on perceptions about Brazil and its culture, one can infer from his emphatic statement, could be attested to when the show was still touring the United Kingdom.

The world had dramatically changed when the Exhibition arrived in the neighbouring city of Bristol, also heavily damaged during the War, which had finally come to an end. Hitler had committed suicide; the Labour party leader Clement Attlee (1883–1967) had replaced Winston Churchill as the United Kingdom's Prime Minister; the Nazis had surrendered first in Italy and then unconditionally capitulated. King George VI, on V-Day, wrote a letter to President Getúlio Vargas saying that, 'on this historic occasion [...] Brazil may claim a worthy share in the victory of the united nations' (George VI, 1945). Brazil's role in the conflict was finally being recognised by its reluctant ally, and it was converting into prestige for the country.[91] Bristol Museum and Art Gallery[92] had been the first museum outside London to confirm its interest in hosting the Brazilian artworks, on November 27, 1944, by saying that 'we should be delighted to have them in Bristol and will leave the dates to your convenience'

90 See the 'Press Coverage' section.
91 See the chapter on the 'Historical Context'.
92 The Bristol Museum and Art Gallery hosted the Exhibition from May 29 to June 26, 1945.

84 PUBLIC DIPLOMACY ON THE FRONT LINE

(Wallis F. S., 1944), but only 45–50 of them, due to its alleged lack of space. In addition, the gallery would 'also wish to have included the excellent photographic exhibition "Brazil Builds", which is sponsored by the Anglo-Brazilian Society' (Wallis F. S., 1944). More than a month later,[93] Longden consented to sending the architectural photographs, but demonstrated some disappointment with the limit on the number of paintings that could be accommodated by the Bristol Museum. As the Exhibition would be coming from Bath and was meant to be going afterwards to Manchester,[94] the pictures, he thought, should be kept together. He suggested sending the entire collection to Bristol and leaving it to them to hang as many of them as possible, with the caveat that '50 seems a small proportion but possibly you can put some works in the corridor' (Longden A., 1945). Later, Longden's assistant would insist on having more paintings hung, in which case the BC 'should be glad to let you have a reprint of this catalogue at approximately fivepence each, but if you only have room for 45 to 50 paintings, I am afraid it will mean you printing your own catalogue' (Somerville, 1945). After confirming the inadequacy of space for the whole Exhibition, he proposed a reprint of fifty complete catalogues, with indication of the works on display, to be sold for sixpence each, 'a more convenient sum to deal with' (Wallis J. S., 1945), as the non-displayed pictures would be available to potential buyers. In a letter to the BC's local representative, the Bristol Museum director once again rejoiced with the 'excellent series of photographs entitled "Brazil Builds" [and the fact that] the whole Exhibition is the one shown at Burlington House' (Wallis J. S., 1945). The Exhibition finally took place in galleries V and VI of the City Art Gallery. Lord Mayor of Bristol William Frederick Cottrell presided at the opening ceremony, and Vice-Marshall Cassidy represented the RAF Benevolent Fund (Western Daily, 1945, p. 1). Ambassador Moniz de Aragão, having returned from Brazil, visited the Exhibition for the first time, when he opened the show in Bristol, on May 29. In a short telegram to the Chancery, he stressed that the ceremony was very crowded and that many compliments were paid to Brazil (Moniz de Aragão J. J., 1945). Nevertheless, Bristol was the venue where the fewest catalogues (156) were sold, as indicated by the meagre sales figure of £3.18.0. In 1949, 'Composition', by Thea Haberfeld, which was part of the Exhibition, would be donated to the Bristol Art Gallery by the BC, 'on behalf of the Brazilian government' (Bristol Art Museum and Art Gallery, 1949).

93 The late answer was due to another trip made by Longden, this time to hang the Yugoslav exhibition in Belfast.
94 Eventually, it was not displayed in Manchester.

THE EXHIBITION 85

The show at the Manchester Art Gallery was scheduled for the period between July 10 and 31, 1945, immediately after leaving Bristol.[95] One can find references to the planned Exhibition in Manchester in the *Enciclopédia Itaú Cultural*,[96] in Brazilian art history books (Zanini, 1991, p. 65) and articles (Amaral, 2002) as well as in a RAF Benevolent Fund magazine from 1948 (RAF, 1948), as if it had really happened. However, as one can read in the Manchester Art Gallery curator's annual report of 1945, 'owing to the date of the town planning exhibition having been put back, it had been found necessary to cancel the arrangements for the Exhibition of Brazilian Art' (Mancheseter Gallery Archive, 1945). This is an example of how little known and poorly documented the Exhibition has been to date and illustrates the importance of cyclically reassess and interpret the dispersed fragments of information about it. The Manchester Art Gallery would be, four years later, gifted with one of the Exhibition artworks, '*Natureza morta com lâmpada* [Still life with lamp]', by Lucy Citti Ferreira.

After the show in Bristol, the Exhibition was actually sent back to London in July. This time, it was seen by a wholly new audience, at the *avant-garde* Whitechapel Gallery.[97] The gallery, in the East End of London, had been founded in 1901 and premiered many modern international artists, with the idea of an 'essentially local but well-connected venue, a focus for philanthropic culture as well as a metropolitan gallery in its own right' (Taylor, 1999, p. 92). The Exhibition was opened by architect Sir Charles Reilly (1874–1948), who drew the audience's attention to the collection of architectural photographs (East London, 1945). £6.14.0 resulted from the sale of 268 catalogues during the three-week Exhibition in East London (Foreign Office, 1945).

In August, between the two nuclear attacks against Japan, the Exhibition would make its last appearance in the United Kingdom, at the Reading Museum and Art Gallery,[98] 40 miles west from central London. By then, the Brazilian troops had returned to Brazil from Europe, with the loss of around 500 men in combat, and the Allied leaders had sketched out the post-War international order at the Potsdam Conference. The opening ceremony in Reading was presided over by Mayor W. M. Newham (Reading Mercury, 1945, p. 4)

95 Longden made it clear to Wallis, Director of the Bristol Museum and Art Gallery, that 'the Exhibition will be coming to you from Bath and will go on to Manchester' (Longden, 1945).

96 Exhibition of Modern Brazilian Paintings. 1945: Manchester, United Kingdom. (Enciclopédia Itau Cultural, n.d.).

97 It was on display there from July 7 to 28, 1945.

98 It was displayed in Reading from August 8 to September 3, 1945.

86 PUBLIC DIPLOMACY ON THE FRONT LINE

and attended by Secretary Magno, from the Brazilian Embassy in London (Parkinson, 1945); Longden and Vining, from the BC; Air Vice-Marshall Sir Philip Babington; as well as the curator W. A. Smallcombe and the Brazilian artist Francisco Rebolo Gonçalves, who contributed artworks to the Exhibition. In the 'first big contemporary collection of contemporary foreign art to reach these shores since the War began' (The Reading Standard, 1945, p. 8), £9.8.9. were brought in through the sale of a further 453 catalogues (Foreign Office, 1945).

On August 31, 1945, the BC's Fine Arts Department informed the Foreign Office's Cultural Relations Department that a selection of nineteen of the Brazilian paintings from the Exhibition which had not been sold was going to be sent for a short show in Amsterdam and would be returning to London around the end of October[99] (Nash, 1945). On a still-cynical Perowne's handwritten annotation, one reads 'I fear that Holland will not gain a very good impression of the standard of art in Brazil' (Perowne V., 1945). More than a year later, in September 1946, Paulo Carneiro, Brazilian delegate to UNESCO, wrote to Longden, from Paris, with respect to the organisation's inaugural exhibition, to be held in November, saying that Secretary Gouthier would telephone him to convey further details on Brazilian participation and the need for the BC support (Carneiro, 1946). In parallel, Carneiro called Ambassador Moniz de Aragão, who agreed to facilitate the transport, from London to Paris, of the artworks which had taken part in the Exhibition, at that time in the care of the BC at forty-three Portland Place; the ABS photographs of 'Brazil Builds'; and a few paintings in the possession of private individuals. The showing would be completed with 'paintings already in France by Portinari, Dias, Segall, Dacosta etc' (Carline, 1946). Meanwhile, Longden wrote to the Foreign Office confirming that they 'have been approached by the Brazilian Embassy to assist them in forming a Brazilian contribution to the *Exhibition Internationale d'Art Moderne* which is being organised by UNESCO in Paris from November 19 to December 28, 1946' (Longden A., 1946). After fifteen years in office, Vargas was no longer the President of Brazil when the pictures, some of which had been sold during the Exhibition, were sent to Paris.[100] Thirty of the thirty-three

99 Nevertheless, in mid-February 1946 the Brazilian artworks had not yet returned from Amsterdam (Longden A., 1946).

100 The pictures sent were the following: 'Group' (Iberê Camargo); 'Jacuicanga River' (Cardoso Júnior, sold); 'Fish wives' and 'Composition' (Vieira da Silva, the former sold); 'The bather' and 'Lovers' (Percy Deane); Batrachians, huns and bersaglieri' (Urbano de Macedo); two works both entitled 'Painting' (Cícero Dias); 'Women from Bahia' (Di Cavalcanti); 'Children in the garden' (Djanira, sold); 'Landscape' (Tarsila do

THE EXHIBITION 87

pictures that comprised the *Exhibition Internationale d'Art Moderne* came from London, as its catalogue states: '*plusieurs des oeuvres exposées ont été obligeamment prêtées par le* British Council' (UNESCO, 1946). Revealing that the disposal of the Exhibition's remaining paintings had at that time become an issue for the British Government, he added that 'it is not likely however that all the pictures now in our possession would be sent to Paris and it would therefore be possible to dispose of the remainder almost at once' (Longden A., 1946). McQuillen annotated that 'while technically UNESCO did not allow sales from their exhibition, enquiries about buying would always be addressed to the British Council [and] we may get rid of a few more pictures in this way' (McQuillen J. M., 1946).

Whilst the works were still in the United Kingdom, a British diplomat had registered, in a handwritten note, that 'when all this is ended up we must not forget to thank the artists properly – possibly through Mr Augusto Rodrigues' (Perowne V., 1945), in the form of an individual letter enclosing a printed and illuminated message of thanks from the RAF. In February 1945, the British Embassy in Rio de Janeiro agreed with the proposal, which 'would be much appreciated by the artists concerned' (British Embassy in Rio de Janeiro, 1945), suggesting that the illumination should be done by a well-known and good Modern Artist and that each copy should be autographed by someone high up in the RAF whose name should be recognisable. At the Foreign Office, a diplomat annotated that the BC had 'suggested that John Piper (1903–1992)[101] might be suitable [and] might do the work at a reduced fee, as a gesture in token of gratitude' (British Embassy in Rio de Janeiro, 1945). By April, Longden had contacted John Farleigh (1900–1965),[102] whom he considered 'a very suitable artist', regarding the illuminated letter (Somerville L., 1945). Broadmead, a diplomat who had recently returned following a number of years posted as a Counsellor to the Embassy in Rio de Janeiro, was consulted with regard to the letter and

Amaral, sold); 'Brazilian dance' (João Maria dos Santos, sold); 'Composition' (Mariusa Fernandez); 'Refugee' (Lucy Citti Ferreira); 'Boy in the library' (Martim Gonçalves); '*Bailarina*' (Clóvis Graciano); 'Figures' (Percy Lau, sold); 'Composition' and 'Girls' (Carlos Leão); 'Suburb' and 'Town' (Manoel Martins); 'Composition' (Alcides da Rocha Miranda); 'Drunkards' (Poty Lazzarotto); 'Pastoral', 'Circus' (sold) and 'Brazilian dance' (Luís Soares); 'Women' (Aldari Toledo); '*Negrinho do pastoreio*' (Paulo Werneck); and 'Still life' (Gastão Worms).

101 John Piper, painter, writer and designer for the theatre, was an official war artist and would paint decorations for the British Embassy in Rio de Janeiro, in 1948 (Tate, n.d.).

102 John Farleigh, painter and writer, was famous for depicting the post-*Blitz* London (National Portrait Gallery, n.d.).

said that he reckoned 'Brazilian taste as very colourful without vulgarity. The symbols would have to be flags, I think, not arms' (Broadmed, 1945). He added that a typed letter of thanks 'signed by the Duchess of Kent with her own hand would have done the trick' (Broadmed, 1945). There were arguments over the cost of producing such a letter, which artist would make it and who would sign it. Longden wanted to insert a 'British Council coat-of-arms in the middle of the presentation' (Longden A., 1945), an idea that was dismissed by Perowne, who wrote that he was not 'quite sure about the inclusion of the Council escutcheon, or whether flags could suitably be included, since their colours would probably accord ill with the coloured design; I would myself prefer nothing – or some suitable Royal Air Force emblem' (Perowne V., 1945). It was eventually agreed that the letter would be printed in black and white or red and white. Concerning the content, Perowne suggested a very direct text of thanks: 'presented to … in token of gratitude for generosity towards the RAF Benevolent Fund', wondering to himself 'is this nsufficiently lush?' (Perowne V., 1945). The Brazilians, in his words, were 'extremely vain, and what appears to us to be gross flattery is barely polite to them and this may therefore be insufficiently lush' (Perowne V., 1945). The Embassy in Rio de Janeiro indeed added some glow to the paragraph and suggested the following text: 'presented to […] as an expression of warmest gratitude for his generosity in sending his valuable picture(s) amid the hazards of War to be sold for the benefit of the RAF Benevolent Fund' (British Embassy in Rio de Janeiro, 1945). Longden informed that, approached by him, Lord Herbert regretfully declined, on behalf of the Duchess of Kent, the invitation to sign the letters of thanks, as 'this would be creating precedent which might give rise to complications' (Longden A., 1945). For Lord Herbert and the BC, the best person to sign the letters would be its acting Chairman – and also Chairman of the RAF Benevolent Fund – Lord Riverdale. The suggestion had initially been dismissed by the Foreign Office: 'I cannot help thinking that Lord Riverdale's name may not be very well known in Brazil and that the effect of such a letter would be largely thrown away unless some really outstanding signature appears on it, i.e., some high-ranking officer in the Royal Air Force' (McQuillen J., 1945). After further demonstrations of deeply rooted scepticism at the Foreign Office – 'I still do not think Lord Riverdale to be the best person […] nor do I see why the BC's name need appear on the letter' (Perowne V., 1945) – in this matter the BC's opinion eventually prevailed. Perowne at the end agreed that Lord Riverdale would sign it, 'but we should prefer that he should sign explicitly as Chairman of the RAF Benevolent Fund, and that there should be no mention of the Council' (Perowne V., 1945). Although the Foreign Office had requested and previously acknowledged

THE EXHIBITION 89

the major responsibility taken by the BC in organising the Exhibition, there
was an unmistakable institutional quarrel over the signature of the letter of
thanks. In any case, the illuminated letter by John Farleigh, which would
cost 'only about five pounds' (Jackson R. F., 1946), had not been produced
as late as October 1946 and there is no evidence that it was ever done.

The Catalogue[103]

> *Brazilian artists, in company with Mexican painters, know the seduction of
> the formulas in fashion in the clamorous Parisian circles, with all their 'isms' and
> gladiatorial combats. We Brazilians must accept the fact as natural, given our
> particular intimacy with French artistic tradition*
>
> Ruben Navarra[104]

> *What Brazil needs is not more exiles from Central Europe but the presence of a true*
> chef d'école *from Paris, or even London*
>
> Sacheverell Sitwell[105]

Only in October 1944, a month prior to its opening, was the printing of
a catalogue for the Exhibition considered for the first time. By then, Foreign
Secretary Anthony Eden approached the newly elected President of the RAA,
Alfred Munnings, insisting that, for political reasons, the Academy should
reconsider its negative position and host the Brazilian Modernist artworks.
In order to strengthen his appeal, Eden argued that 'it would be clearly stated
on any posters and in the catalogue … that the pictures were presented by
Brazilian artists … thus taking any responsibility of selection from your
Council or ourselves' (Eden, 1944). The catalogue would thus help to exempt
the RAA Council and the Foreign Office itself from any curatorial liability.
Ten days later, Perowne would comment to Longden that 'some Brazilian
critic is anxious to write the [catalogue] preface. I should like to know how
matters stand in this respect, before approaching either of the Sitwells with
the suggestion' (Perowne V., 1944). He was probably referring to Ruben
Navarra, who would eventually write the Brazilian part of the preface,
although one year earlier, in the very first official communication sent to
London about the initiative, the BC representative in Brazil mentioned

103 In this section, the quotations refer to the Exhibition catalogue (RAA, 1944), unless
 stated differently.
104 (RAA, 1944)
105 (RAA, 1944)

90 PUBLIC DIPLOMACY ON THE FRONT LINE

that 'a message to accompany the Exhibition has been written by Dr. Aníbal Machado, father of our Clara' (Toye, 1943).

On October 24, Perowne, an art lover himself (Who Was Who, n.d.), sent a letter to his acquaintance Sir Osbert Sitwell, one of the three eccentric – or attention-seeking, as others might put it – Sitwell siblings. In Michael Asbury's words, the Sitwells 'had constructed a rather snobbish reputation for themselves amongst the British cultural elite' (2018, p. 37).[106] Perowne and Osbert had studied at the traditional and exclusive Eton College, although the latter liked to say that he was educated 'during the holidays from Eton' (Who Was Who, n.d.). The diplomat mentioned the presence of Portinari and Segall among the artists involved and highlighted the popularity of the RAF among Brazilians. He would had been told that Osbert was 'especially interested in the arts of Brazil' (Perowne V., 1944), which is why he asked whether the writer would be willing to contribute a preface to the Exhibition catalogue. According to him, the 'interest and attraction of the catalogue would be greatly enhanced, the Brazilian artists themselves would be immensely pleased that so distinguished a writer ... should be associated with their gesture, and the general effect on Anglo-Brazilian relations should be a very happy one' (Perowne V., 1944). One day after the letter was written, Perowne met, by chance, Osbert, who suggested that his brother Sacheverell would be a more suitable person to write the preface and that he would himself approach his sibling (Perowne V., 1944). Sacheverell immediately accepted the invitation, as Perowne would find out in a letter left at the St. James's,[107] a gentlemen's club at 106 Pall Mall attended by both. 'Sachie', as Perowne referred to his contemporary from Eton College, replied that he was 'delighted to write, as you suggest, about the Brazilian painters' (Sitwell, 1944), noting that he needed more information so that he could know exactly what was wanted. In fact, Osbert's work indicated no special interest in Brazil and 'Sachie was not particularly familiar with Brazilian arts either – nor perhaps was any other British critic in the early 1940s' (Gadelha, 2018, p. 28). Twenty years before, Sacheverell Sitwell had mentioned Brazil in the poem 'Rio Grande'[108] – later turned into a popular song by his friend Constant Lambert (1905–1951) –, in which he depicted an idyllic land whose

106 For Taylor (as cited in Asbury, 2018, p. 37), 'it would be impossible ever to take the late Sacheverell Sitwell quite as seriously as he took himself'.

107 St. James's Club was famous for having a room solely devoted to backgammon and for being home, during WW2, to Ian Fleming (1908–1964), creator of James Bond (St James Club, n.d.).

108 'By the Rio Grande
They dance in sarabande
On level banks like lawns above the glassy, lolling tide.

THE EXHIBITION

joyful dance contrasts with sad European music (Sitwell, 1924). One can venture the supposition that such Arcadian exoticism, which he associated with Brazil, might have informed his expectations about Brazilian contemporary art. However, as an expert in baroque architecture, he had enthusiasm for new Brazilian architectural developments. As a matter of fact, he had written in that same year, for the prestigious Architectural Review, that Brazil's was 'the best architecture, there can be no question, in the modern world'[109] (Sitwell, 1944). In Asbury's opinion, 'the assumption was that his interest in baroque architecture and the Exhibition of Modern French Art that he had organised with his brother Osbert at the Mansard Gallery in Heals Department Store in 1919 would have constituted sufficient expertise' (2018, p. 37). Very limited knowledge, indeed, subsidised Sitwell's foreword, which became, however, highly influential among the public.

Following the acceptance to contribute a preface to the Exhibition catalogue, Perowne asked Longden to get in touch with Sacheverell Sitwell at Weston Hall, his Tudor seventeenth century house in Northamptonshire, 73 miles north from London. A few days later, Longden telephoned Perowne to inform him that Sacheverell was going to London to inspect the pictures. 'I hope the effect won't be too depressive'

(Perowne V., 1944), Perowne handwrote, in his usual depreciative tone about the Brazilian artworks. On November 1, the BC sent to the Foreign Office the wording of the preface, title page and cover along with a *précis* of Ruben Navarra's introduction, asking for their opinion on them (Ward, 1944). This reduction in text would annoy the Brazilian critic,[110] for whom the catalogue was disappointing (Navarra R., 1945). The cut was allegedly due to wartime economy but might also have been done to keep Navarra's text to the same size as Sitwell's. The BC produced a small catalogue on good-quality paper, honouring the English printing tradition and compatible

Nor sing they forlorn madrigals
Whose sad note stirs the sleeping gales
Till they wake among the trees and shake the boughs,
And fright the nightingales.
But they dance in the city, down the public squares,
On the marble pavers with each colour laid in shares,
At the open church doors loud with light within.
At the bell's huge tolling,
By the river music, gurgling, thin
Through the soft Brazilian air'

109 See the section 'Brazil's Image before the Exhibition'.

110 The full version of the introduction would be published by the *Revista Acadêmica* in April 1945 (Navarra R., 1945).

with the rationing constraints (Navarra R., 1945), as seen in Figure 6 below. On the cover, one could read 'Exhibition of Modern Brazilian Paintings – Royal Academy of Arts 1944 – Catalogue'.

The title page added 'Arranged by His Majesty's Government in the United Kingdom of Great Britain and Northern Ireland'; 'Being a collection of 168 paintings and drawings presented by 70 artists of Brazil to be sold for the benefit of the Royal Air Force Benevolent Fund'.[111] The first twelve pages were filled with the preface, 'written at great speed' (Ades, 2018, p. 60) by Sacheverell Sitwell, 'one of our most accomplished writers' (Perowne V., 1944); and the introduction,[112] by Ruben Navarra, one of Brazil's most renowned art critics during the 1940s (Lins, 2013), whose remarks convey significantly different, not to say incompatible, views on the Brazilian artworks.

To the reader's bewilderment, immediately after eloquently praising the artists' gift, contemplating how they had 'so delicately phrased a tribute to the body of young men who saved civilisation and kept the mechanised brutes from our shores', Sitwell condescendingly affirms that 'the least we can

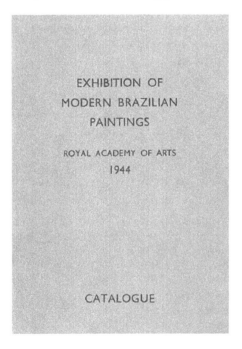

Figure 6. Cover of the Exhibition catalogue (*The National Archives*).

111 The following information was also included: 'Royal Academy of Arts – Piccadilly, W1'; and 'November 23rd – December 13th, 10 am – 5pm'.
112 Which the British Council admitted being a '*précis* of an article'.

THE EXHIBITION

do is to take their painting seriously and try, in return, to help them with our criticisms'. Assuming that 'many of the artists represented are certainly poor and struggling', he ponders that a 'gift of a canvas represents a big sacrifice on the part of a young painter. This being so, the size and dimensions of many of the paintings is the measure of their gift to us. For they have attempted, evidently, to send us of their best'. Such a patronising tone in fact reveals Sitwell's unawareness of the Brazilian painters involved in the Exhibition, many of whom were part of the Brazilian economic elite.[113] Sitwell bases his appreciation of the paintings on two main observations, the 'absolute predominance of the modern idiom' and the 'national character' of Brazilian painting. Several times in the text, he explicitly expresses reservations on the aesthetic quality of the works, which 'may or may not appeal to every taste but, at least ... are contemporary'. In regard to the national idiom, he alludes to the fact that one could even forget Brazil's Lusitanian ascendency when seeing the Exhibition and stresses 'the increasing strength of the newer nation, for so far, the Exhibition has been Brazilian and not Portuguese'. He also refers to the exiles, who, jointly with the natives, 'compose into the Brazilian total and achieve a style', whose unity was 'one of landscape and of nature'.

Sitwell reserves a substantial portion of his criticism to pointing out – and expressing his disapproval of – what he perceived to be a Central European influence over Brazilian modern painting, asserting that 'painters from those ravaged lands have settled in Brazil'. External influences, according to the openly racist English critic, 'have come from foreign exiles and from Brazilians returned from Paris', but 'foreign blood has not been, so far, of first-rate quality ... Should a great painter, of whom there are still a few alive, transfer himself to this land of energy and opportunity, then the results on the Brazilians would be most interesting'. He highlights Brazilian artists' need for direction and predicts that 'until this happens, there may never be a Brazilian painter of true eminence'. The peak of his racism is directed towards Lasar Segall, 'an expression of the Central European School', a 'painter of Russian-Jewish origin' who had 'the undoubted talent manifested in this race of minor painters, whether it be Kandinsky, Chagall or Mark Gertler'. Asbury laments the comment, which 'our contemporary sensibilities could only describe as anti-Semitic'[114] (2018, p. 38). Despite the presence of

113 As seen in the 'Background' section, these artists were neither young nor poor on average. The typical artist was a 39-year-old upper-class white man who was born and lived in Rio de Janeiro or São Paulo and who had studied art at one of these cities' main universities or abroad (Gadelha H, 2018, p. 29).

114 Nonetheless, Navarra, at that time, reacted in the very same way, asking if 'does it not sound almost anti-Semitic' (Navarra R., 1945).

94 PUBLIC DIPLOMACY ON THE FRONT LINE

these influences, Sitwell underscores that 'the tropical note is struck from the beginning'. He exalts the idiosyncrasies of Brazilian painting, in a very peculiar way, signalling how disappointing it would be if 'the first returning cargoes of oranges and bananas were, in the end, but pears and apples'.

Notwithstanding his manifest prejudice, Sitwell considers Segall's head in oils, 'Lucy with flower', to be the best painting in the Exhibition. One of the very few painters singled out by the English writer, Segall was, for him, of 'more than passing interest'. Sitwell found equally remarkable the 'beautiful large drawing of the tiled roofs of a town' by Roberto Burle Marx.[115] There was further praise for a 'charming landscape by Guignard,[116] a painter who has lived much in Europe', an amateur, like other Brazilian painters 'who have been compelled to paint by the beauty of their surroundings'. More moderate compliments were directed to Cícero Dias and Heitor dos Prazeres, whose style Sitwell associates with 'the naïf children's manner, a technique that aggravates in our sober northern clime', making clear that 'here it applies itself charmingly and without offence'. Portinari, 'the most considerable name in Brazilian painting' was, for Sitwell, victim of the 'exuberance of the motif' that may make an artist's output 'too prolific', which would also be the case of Brazilian composer Villa-Lobos ('he has written too much music') and Mexican painter Diego Rivera (1886–1957) ('has over painted'). The English writer criticises the profligacy of Brazil's cultural output, by saying that the 'progress of painting has been fast on this prolific soil, so fast that we may hope it will become slower and more serious'. The danger, for him, was that 'subjects are too plentiful and easy'. He ponders, in a rather naturalistic manner, that it had to be 'so much more tempting to become a painter if you live in Rio or Bahia than if your home happens to be in Middlesbrough or Liverpool'. A rare and incisive criticism to Sitwell came from The *Reading Standard*, whose critic asserted, regarding this passage, that 'the eye of the artists worthy of the name is served as well in the drab streets of Middlesbrough as in the obvious brilliancies of the tropics. There could hardly be a better exponent of this than Mr Sitwell himself, when he writes as an artist' (Reading Standard, 1945, p. 8). In line with a then current determinist argument, Sitwell asserts that the multiplying effect of climate on fertility 'can be reproached in the same breath with the under painting or under writing that comes of too great a fluency'. For him, Portinari's huge frescoes in Rio de Janeiro and Washington were 'too diffuse to hold attention. The natural charm and talent of Portinari are

115 '*Lapa* [Pen and ink drawing]'.
116 'Landscape, Ouro Preto' or just '*Ouro Preto*'.

THE EXHIBITION 95

more easily appreciated in smaller works, such as the pair of groups shown in this Exhibition'.[117] He controversially affirms that the most acclaimed Brazilian painter had 'all the wit and delicacy of Marie Laurencin'.[118] Part of the British press challenged the analogy,[119] which was, according to Dawn Ades, 'clearly intended as an insult by Sitwell, choosing the feyest of the Parisian Modernists to compare to the Brazilian Modernist' (Ades, 2018, p. 62).

Sacheverell Sitwell saves his limited enthusiasm for the photographs of 'the most recent and best of modern architecture ... owing to the encouragement of an enlightened government', in an open recognition for Vargas' leading role in Brazil's cultural output. He dates the onset of Brazilian modern architecture to the visits of Le Corbusier and to 'his suggestions and advice'. In an ambiguous exercise of cultural relativism, he underscores that the new architectural forms were 'more suited to sunlight than to rain, and that what looks fine and splendid in Rio or São Paulo will not do in London or Sussex', stressing that 'this is no argument that the new buildings are not beautiful. They must speak for themselves in the photographs'. The achievements of Brazil in the architectural field gave Sitwell, who considered it 'the one country with a first-rate modern architecture [that] has perhaps too many diverse echoes in its painting', hopes that the artists could also learn from the old world, 'while this generation of European masters is alive, and before it is too late'. He goes so far as to propose Picasso, 'the living genius of our day, and a Latin of the Latins' as the ideal leader for a Brazilian artistic revolution.[120] Fortunately, in his opinion, Brazilians 'are quick to learn from foreign influence. They assimilate and before long it will become their own'. Returning to the subject of the paintings' Brazilianness, Sitwell regarded them as national 'in subject but not in handling', whereas 'the modern architects are already masters of their setting. They have found the formula'. In the artworks, he perceives 'a dozen or more contemporary influences, French, indigenous Brazilian, or Central European', but concedes that 'signs of awareness and vitality are to be seen on every hand. There is abundant evidence of talent'. Attempting to convey

117 '*Mulher e crianças* [Group]' and '*A boba* [The half-wit]'.

118 Marie Laurencin (1883–1956) was a French Cubist painter. The comparison provoked criticism among critics from both Brazil – 'ridiculous' (Navarra R., 1945)– and the United Kingdom – 'but there is a monumental quality about the work of the former I have never seen in Laurencin's charming but superficial work' (Eastern Daily Press, 1945).

119 See the 'Press Coverage' section.

120 'This and lesser opportunities lie open to post-War patrons of the arts'.

96 PUBLIC DIPLOMACY ON THE FRONT LINE

some empathy, Sitwell closes his preface by saying that 'that their painters will prosper, and that Brazil may have musicians, poets, architects to match her beauties of nature will be the wish of all who visit this Exhibition'. According to most contemporary observers, such as Tim Marlow, a former Artistic Director of the Royal Academy (2014–2019), Sitwell's preface is characterised by his 'patronising tone and cultural arrogance' (2018, p. 17). Similarly, Adrian Locke calls it 'patronising and misguided' (2018, p. 69). Asbury, who considered Sitwell's choice an odd figure to have been commissioned to writing the preface suggested that a critic such as Herbert Read could do a better service for the Exhibition purposes (2018, p. 40). Examining Sitwell's attitude, he concludes that (Asbury, 2018, p. 38)

the old British colonial arrogance that seeps through Sitwell's preface overshadows the fact that, at least as Modern Art was concerned, there were many similarities between Britain and Brazil. Both countries still held France, or more specifically Paris, as the source for modern aesthetic advances, neither country had by then developed significant institutional structures for the promotion and exhibition of contemporary art, nor any visible national school in comparison with what became known as the School of Paris.

His preface, which offered some better informed and rather positive views on Brazil's architecture, was indeed characterised by ignorance and arrogance towards its visual arts. Some condescending appraisals could not hide the lack of interest and appreciation of the critic about Brazilian painting. Sitwell's posture, even though he was an admirer of the country's modern architecture, arguably jeopardised the conveyance of a positive message regarding Brazilian visual arts.

In stark contrast, Navarra proudly (and mistakenly)[121] announces, in his opening words, that it was 'the first collective Exhibition ever made by Brazilian painters in Europe' and recalls the fact that 'not long ago, the British Council sent to Brazil an exhibition of contemporary British paintings, then an exhibition of children's drawings and a fine collection by British engravers'.[122] He then comments on the artists' differences in age and tendencies, going on to assert that the reason for them being chosen was 'the idea that the painting called "modern" is that which represents the living and contemporary

121 Few smaller shows had been held in Paris, as discussed at the section on the 'Internationalisation of Brazilian Visual Arts'.
122 See section on the 'Internationalisation of Brazilian Visual Arts'.

THE EXHIBITION 97

spirit in art'. The critic summarises the history of Brazilian modern painting, indicating landmarks in its emergence[123] and delivers a comparative analysis of the artistic environment in São Paulo and Rio de Janeiro, 'the principal axis of the Brazilian aesthetic revolution', with a brief mention to the North-Eastern painters, 'most of whom emigrated to Rio or to Europe'. Navarra contrasts Rio de Janeiro's 'grassroots tradition in art' and São Paulo's 'characteristics of a Western industrialised metropolis' to synthesise that 'the future of Brazilian art will be dominated by an intercourse and an enrichment resulting from the meeting of these two elements – the universal and human (São Paulo) and the regional and picturesque (Rio de Janeiro, Bahia, Recife and Pará[124])'. In pictorial terms, he argues that Rio de Janeiro, 'with its tropical atmosphere, has a tendency to solid structure and a warmer *palette*', while São Paulo, 'more European, tends towards *flou* and a cold *palette*'. The two schools would have in Portinari and Segall, respectively, their chief exponents. For Navarra, São Paulo represented the 'European element *par excellence*', which was central to his examination of the Brazilian artistic scene. Brazil's first Modern Artists, he said, 'recognised themselves fraternally in all the *mis-en-scène* of Cocteau and the surrealist *claque*'. Demonstrating the referential role played by the ideas of 'Europe' and 'France' in his own *rationale*, also perceivable in his frequent resource to expressions in French, he adds that 'the new painters were sometimes caught by the seduction of European formulas, so that one finds cases in which the clay is Brazilian, but the mould still betrays a European mark. The European element tends, however, to dissolve more and more before the prestige of the regional element'. The French influence could not, thus, be looked on as a 'weakness, but as a simple historical necessity'. Simultaneously, he highlights, 'the chief characteristic of contemporary Brazilian painting is the dominant note of regional or native preoccupation [as] the history of modern painting in Brazil illustrates the conversion of a European influence into an indigenous artistic experience'. From this standpoint, he argues in a positivist fashion that the 'Brazilian artistic revolution followed the European, which shows that it obeyed an organic necessity'. For Navarra, the novelty was that the modern movements fostered a genuinely Brazilian art. In his opinion, in the previous national art 'there was not much worthy ... at least in the official and academic field, [it] was a pile of artifices, conventions and learned *impromptus* directly transplanted from the most suspect French

123 He lists the first exhibition in Brazil of Lasar Sagall, 'one of the founders of the Expressionist movement in Europe', in 1913; Anita Malfatti's show in 1916; and the Modern Art Week in 1922. He opines that the Modern Art Week 'gave São Paulo, by a purely formal claim, the honour of having heralded the movement'.

124 The three latter are in the North and North-East regions of Brazil.

98 PUBLIC DIPLOMACY ON THE FRONT LINE

models'. But by returning to 'the good aspects of the Brazilian past, the real native traditions, such as that of folklore or the old colonial churches', the 'most intransigent Modernists' quickly developed a Brazilian painting, which should necessarily depict 'the land with its scenery, its lights, its colours, its customs and traditions'.

To illustrate how positive the outcome of these dialectic influences had been, he picks the example of Guignard, 'who, of all Brazilian painters, received the longest European training [and] is one of the most representative of the regional spirit ... though a master of a technique refined through years of study in Europe, he is, nevertheless, the negation of the *virtuoso* spirit'. Tarsila do Amaral is also mentioned, for having made, alongside Anita Malfatti, 'the most daring experiment in introducing a Brazilian *palette*, influenced by tropical light, folklore colouring'. Amongst the other artists cited in Navarra's introduction, there are Heitor dos Prazeres, 'the genius of the negro race in my country';[125] Pancetti, 'the greatest landscape painter that the modern revolution has so far produced';[126] Cícero Dias, 'the Chagall of the regional tradition of his land';[127] and Portinari, 'without doubt the greatest exponent of South American mural painting'. He dedicates some space to introducing Portinari, Brazil's most popular painter, to the British public, underscoring that he had 'succeeded in acquiring an exceptional reputation in Brazil and in America'.[128] Embodying Navarra's ideal Modernist, Portinari 'was the first Brazilian painter to exploit [the regional] element systematically with a plastic value and a social bias at the same time ... the regional sense of painting is powerfully represented through him'. In an effort to synthesise the dichotomies that he had postulated – between Rio de Janeiro and

125 'He, although known only to a few intellectuals and artists, needs no vindication. His painting is nothing else than Brazil – the Brazil of the negroes, of the workers and of the people, in their typical scenes, in their typical life ... pure instinctive, with no didactic training, living an isolated and humble life, without contact with great painters, without intellectual inspirations and surely without knowledge of foreign painting'.

126 'Pancetti is today well-known to every Brazilian intellectual and artist ... he won in the Official Salon 1941 the "*Grande prêmio de viagem*". It was the last definite victory of the new art against the secular academic tradition [and there is] unanimity of opinion in Brazil in considering Pancetti one of our truly great painters'.

127 'A great Brazilian painter ... his talented poetic nature has always refused any cultivation of technique which leads to virtuosity. Dias is an organic anti-*virtuoso*'.

128 'No other painter, except, perhaps, Cícero Dias, has aroused so much interest in Brazilian intellectual circles ... His tendency has always been towards monumentalism'. Navarra highlights his decorative works for the modern building of the Ministry of Education and Health (Rio de Janeiro), Tupi Radio (Rio de Janeiro and São Paulo), and the Library of Congress (Washington).

THE EXHIBITION 99

São Paulo; nativism and European influence; grassroots and academic, – Navarra affirms Brazil as part of the West, whose peoples 'tended for the internationalisation of values, intellectual and artistic, in which the cultural unity of its common civilisation is demonstrated'. It is interesting to note that although Navarra believed that Modernism represented the long-overdue possibility of a truly Brazilian art, he often resorts to a European endorsement in order to legitimise national developments and emphasises several times the Brazilian artists' training in Europe ('Dias has lived now for seven years in Europe and has exhibited in Paris', for instance).

The catalogue features images of ten of the paintings, which were randomly selected, according to Navarra.[129] They are 'Group', by Portinari; 'Landscape, Ouro Preto', by Guignard; 'Fish', by Rossi Osir; 'War', by Árpád Szenes; 'Fish', by Burle Marx; 'Painting', by Cícero Dias; 'Cyclists', by Dacosta; 'Portrait of the artist', by Pancetti; 'Figure', by Carlos Prado; 'Landscape', by Quirino da Silva; 'Landscape', by Tarsila do Amaral; and 'Lucy with flower', by Segall. Following this, there is a list of the 80 oil paintings displayed at Gallery I, some of them accompanied by a short biography of the author; and the 88 pictures composed using diverse techniques exhibited at Gallery II.[130] Finally, the catalogue indicates that there was, at Gallery III, an 'exhibition of 162 photographs of modern and colonial Brazilian architecture produced by the British Council from material assembled by the Museum of Modern Art, New York, on loan from the Anglo-Brazilian Society, London'.

The catalogue's critical *apparatus* heavily influenced critics and media with regard to the Exhibition, both in Brazil and in the United Kingdom, and, having sold 6,383 copies, is by itself an important legacy of the Exhibition.[131] Amongst the British, Sitwell's authoritative words had an especially significant impact; after all, as a newspaper advised, in 'dealing with an art so far removed from our own conventions, it is perhaps wise to give the eye every assistance' (The Reading Standard, 1945, p. 5). In general, this influence has been inferred from others' clearly imitative opinions, but sometimes it was openly expressed – the Scotsman, for example, stated that the visitor 'should read the preface to the catalogue by Sacheverell Sitwell and the introduction by Ruben Navarra [before proceeding further, so that s/he] will take a different view' (Scotsman, 1945). Even in Brazil, Sitwell's preface had significant resonance. On the day the Exhibition opened to the public, both the *Jornal do Brasil* and the *Estado de São Paulo*, influential newspapers in the two most

129 'A true raffle, in which some important painters were prized; and others, injured' (Navarra R., 1945).
130 See the 'Appendix' with the list of artworks.
131 See the 'Legacies' section.

100 PUBLIC DIPLOMACY ON THE FRONT LINE

important Brazilian cities, published translations of the same long article by Reuters. It was fundamentally concerned with Sitwell, to whom the article refers as an outstanding art critic and great friend of Brazil (Bettany, 1944, p. 7) Curiously, the most prejudicial passages, including the explicitly racist segments, are among the many excerpts reproduced in a rather uncritical manner, as if they were neutral and inoffensive.

After the Exhibition left the Royal Academy, its catalogue was adapted for its subsequent tour of the United Kingdom, including acknowledgements to buyers allowing their newly- acquired works to remain on display; a paragraph 'stating that the pictures are for sale and that all enquiries should be made to the British Council in London' (Somerville L., 1944); and, from the Edinburgh show on, a mention to the addition of eight drawings by Portinari and five by Burle Marx; eight pen and ink works by Carlos Leão; and seven etchings by Segall (National Gallery of Scotland, 1945). When the Exhibition was still on display in Edinburgh, the Brazilian critic would publicise his reservations about the catalogue.

Navarra's Criticism[132]

> *The illustrious critic seems to have lost a little of his balance*[133]
>
> Ruben Navarra

In February 1945, just after the first copies of the Exhibition catalogue had arrived in Rio de Janeiro, a furious Ruben Navarra published an article in the *Correio da Manhã* unleashing severe criticisms of it. He begins his text celebrating the 'appreciable triumph'[134] of Brazilian arts and architecture, which had passed the hard test of being presented to one of the most cultivated audiences in the world. For him, such a feat should be highly valued by Brazilians and could 'enlighten national public opinion'.[135] He criticises the domestic resistance to non-academic art, towards which many supposedly well-informed people were still suspicious. Apart from intellectuals and snobs, he continues, 'a large part of official and grassroots public opinion still sees our Modern Artists as jesters'.[136] However, he asserts, in a quite self-deprecating

132 In this subsection, the quotations will refer to Navarra's article for the *Correio da Manhã* (Navarra R., 1945), unless stated differently.

133 '*O ilustre crítico me pareceu perder um pouco do seu equilíbrio*' (Navarra R., 1945).

134 '*Triunfo apreciável*'.

135 '*Elemento esclarecedor para a opinião pública nacional*'.

136 '*Uma grande parte da opinião oficial e popular continua olhando nossos artista "modernos" como uns gozadores*'

THE EXHIBITION

tone, that the continual success of Brazilian Modernists in 'circles more cultivated than ours'[137] should inspire reflection. Regarding the catalogue, he laments how frustrating it was for the Brazilian artists, except for those who only wish for publicity at any price, challenging painter Luiz Aquila (b.1943) – son of Alcides da Rocha Miranda – understanding that the painters who took part in the Exhibition were moved by exclusively altruistic and ideological reasons.[138] Navarra finds problem neither in the small format nor in its quality. His first motive for frustration was the absence of images of most painters' works; only ten lucky artists had their pictures in the catalogue, selected through a 'true raffle'[139] which prized some important names and excluded others. His own introductory text, he adds, was also edited, 'naturally due to wartime economies'.[140] However, the real object of his displeasure was Sitwell's preface, which earns numerous attacks, from elegant comments and rational deconstructions to ironic disdain and aggressive accusations. Justifiably, Navarra is remembered for his penetrating observation and his intelligent and shrewd reasoning moulded in an acid language (Zanini, 1991, p. 83).

At the beginning of his article, Navarra says that Brazilians should not form a grudge against Sitwell, but actually be grateful, forgiving the frankness of his British temperament. Sentimentalists like the Brazilians, he affirms, would never return with severe appreciation the kind offer of a friendly nation. Navarra somewhat ironically blames himself for Sitwell's text, as the latter would have visibly based his information on his own study. The constant comparison between Brazilian Modern Art and its European counterpart that had inspired it was indeed a central topic in both Sitwell's preface and Navarra's introduction. Nevertheless, the English writer, who knew poorly Brazilian painting, would have exaggerated and generalised Navarra's comments and concluded imprecisely that Brazilian art was still too dependent on European influence and had not reached its maturity. Sitwell's superficial familiarity with Brazil's painting had not inspired precaution, as he had only been able to perceive the most apparent affiliation to European art. The Brazilian critic dismisses Sitwell's argument that Central-European art was influencing and jeopardising the future of Brazilian painting as a 'big misunderstanding'.[141] It was due to a 'misinterpretation of the information we provided',[142] since 'as a real English man Sitwell did not conceal

137 '*Em meios mais cultivados que os nossos*'.
138 See the 'Background' section.
139 '*Um verdadeiro sorteio*'.
140 '*Naturalmente por economia de tempo de guerra…*'.
141 '*Um grande mal-entendido de ordem geral*'.
142 '*Interpretou mal as nossas informações*'.

102 PUBLIC DIPLOMACY ON THE FRONT LINE

his aversion towards anything that reminds him of the map of Germany and its political satellites'.[143] For him, Sitwell would not have liked learning that Segall and Guignard had studied in Berlin and Dresden nor appreciated the 'generosity of our exiles – all of them fierce opponents of Nazism'.[144] Navarra's assessment is echoed in Taylor's evaluation that 'the dynamic of progressive taste [in British art was] already dovetailing neatly with events on the international stage [and] bringing pro-French and anti-German sentiments to the fore' (1999, p. 140).

Navarra accuses Sitwell of being ungrateful when, contaminated by an obsession with Central Europe, he categorically said that the foreign blood received in Brazil had been not of first rate. He regrets Sitwell's 'silly and gloomy reservations'[145] about 'two or three painters from Austria and the Balkans [who are] peaceful creatures in the margins of the history of Brazilian painting'.[146] Alluding to the labelling of minor paintings (sic) attributed by Sitwell to those of Russian-Jewish origin, such as Segall, Wassily Kandinsky (1866–1944), Marc Chagall (1887–1985) or Mark Gertler (1831–1939), Navarra wonders whether ' 'does it not sound almost anti-Semitic'.[147] He also vituperates his counterpart for the inconsistency of accusing Brazilian art of being affected by too many influences, including indigenous – 'to say that something is influenced by itself is nonsense and does not denote any subtleness of the critic'.[148] Navarra finds Sitwell's statement that Brazil's architecture had accomplished much more original achievements than its painting to be unfair. Moreover, he does not excuse the derogatory view of Portinari, who had been compared to Marie Laurencin, which he regarded as ridiculous. In a final and disdainful attack, Navarra writes, 'with all due respect to the English critic',[149] that, after denouncing so many foreign influences, to claim that the salvation for Brazilian painting should be by hiring a celebrity from Paris or London, 'the illustrious critic seems to have lost a little of his balance'.[150] He concludes the text affirming that 'in regard to the new Picassos, Mr Sitwell, rest assured that they abound here'.[151]

143 *'Como bom inglês não esconde sua antipatia pelo que lhe recorda o mapa da Alemanha e seus satélites políticos'.*

144 *'A generosidade de nossos exilados – todos eles adversários tenazes do Nazismo'.*

145 *'Infantil e sombria prevenção'*

146 *'Dois ou três pintores refugiados naturais da Áustria ou dos Balcãs, criaturas pacíficas e à margem da história da pintura brasileira'.*

147 *'Não parece o tom de um quase anti-semita?'.*

148 *'Dizer que uma coisa é 'influenciada' por ela mesma não tem sentido nem recomenda a sutileza do crítico'.*

149 *'O crítico inglês que me perdoe'.*

150 *'O ilustre crítico me pareceu perder um pouco do seu equilíbrio'*

151 *'E quanto a novos Picassos, sr. Sitwell, fique descansado que eles estão é sobrando por aqui'.*

THE EXHIBITION 103

In April 1945, Ruben Navarra eventually published, at the *Revista Acadêmica*, the full fifteen-page introduction that he had written for the Exhibition catalogue and that allegedly inspired Sitwell's impressions.[152] A note explains that the study had been written to be published in English in the catalogue of the Exhibition of Modern Brazilian Paintings which has just been 'successfully held in London' (1945, p. 16). In a brief foreword, he says that 'by choosing the glorious city of London to host the first collective Exhibition to a foreign audience ... our artists, in number of more than 50,[153] [perceived] the British as their comrades-in-arms'[154] (1945, p. 16). Navarra highlights that a few of the artists were foreign exiles[155] who generously offered their works as a tribute to the English and as a gesture of solidarity to the Brazilians. Some of them, he sets forth, attended before the War the best art schools and galleries in Europe, descending from the best visual arts traditions (1945, p. 16), singling out Szenes and Vieira da Silva, 'who have paintings in museums and collections in Paris, London and New York and symbolise in Brazil the presence of the School of Paris'[156] (1945, p. 16), as well as Marcier and Leskoschek.

Following on from this, his article offers a wide panorama of modern Brazilian painting, which actually goes far beyond the scope of the Exhibition, citing multiple artists who had not taken part in it.[157] He approaches, even more fully than in the *précis*, the relationship between Brazilian and European art and the international character of art, tracing it back to the Renaissance. With further emphasis, Navarra places Brazil among the Western, Christian, civilised countries, stressing the universal and transnational quality of its art. Here he develops in more detail the theory that the School of Paris' major legacy in Brazil was its free

152 The catalogue had presented a *précis* of it, edited by the British Council.

153 The imprecision of numbers – fifty artists and 150 works, instead of the actual seventy and 168 – may indicate that Navarra was not directly involved in the Exhibition conception, as could be inferred from the fact that he wrote the introduction for the catalogue.

154 '*Escolhendo a gloriosa cidade de Londres como local da sua primeira exposição conjunta para um público estrangeiro ... nossos artistas, em número de mais de cinquenta [enxergam] nos britânicos uns camaradas de armas*'

155 Thirteen of the seventy artists who took part in the Exhibition were born outside of Brazil, not all exiles or refugees. See the 'Background' section.

156 '*Têm trabalhos nos museus de Paris, Londres e Nova York e simbolizam no Brasil a presença da "Escola de Paris"*' (1945, p. 16).

157 Such as Anita Malfatti (who was mentioned in the catalogue as well), Ismael Nery, Adami, Luiz Santos, Luiz Jardim and the Rego Monteiro siblings.

104 PUBLIC DIPLOMACY ON THE FRONT LINE

spiritedness and strength in visual arts research; for him, the effect of the school was awakening a feeling of research inspired by the lyric discovery of themes (1945, p. 18). Furthermore, accusing Brazilian academic painting of being entirely European, he exalts the regionalism of the anti-academic Modern Art. In synthesis, he ascertains, 'nationalism and internationalism will indeed have to communicate, since they exist to complement and enrich each other, in both politics and arts'[158] (1945, p. 18). It is evident, again, that Navarra himself had a very Eurocentric standpoint and that the old world was, for him, not only the cradle of art but a benchmark to be emulated. At the same point in the text where he defends Brazilian artistic maturity, he contradictorily says that Brazil was still in its cultural adolescence. By trying to argue that Brazil had a national painting, he actually reveals that he considers it to be an ongoing construction, as 'it is not only about subject: the problem involves the subject and its treatment [and] one cannot think of Brazil's painting if this painting is not rooted in its land'[159] (1945, p. 22). In another passage, he argues that 'the unquestionable existence of a modern atmosphere in our modern painting ... enables us to consider the existence of a Brazilian painting' (1945, p. 26), confirming that this was not taken for granted, even by him. By comparing national painting with music, he thanks God for Brazil already having the latter. Similarly, he considers the European experience of several artists to be what qualified them, such as Malfatti ('knew intimately the School of Paris'); Cícero Dias ('went to Europe, where has been living for many years'); Guignard ('one of the Brazilian painters who received the longest European training'); and the writer Gilberto Freyre ('coming not from Paris, but Oxford'). Nevertheless, in a visible effort to affirm Brazil's independent stance in the visual arts, Navarra reasons that Brazilian contemporary artists were conscious of their freedom and really wanted to produce a national art (1945, p. 28).

In this full version of the introduction, Navarra's arguments are better developed and more solidly underpinned, examining the emergence of Brazilian Modern Art, its complex and multifaceted relationship with European influence, and the idiosyncrasies of Rio de Janeiro and São Paulo, which were cultural hubs. Navarra directly refers to forty-two out of the seventy

158 'Internacionalismo e nacionalismo terão que acabar mesmo é se entendendo, pois existem para se completarem e mutuamente se enriquecerem, seja tratando-se de política seja de arte' (1945, p. 18).

159 'Não se trata de admitir que o "assunto" seja bastante para definir uma arte como tal: o problema está no assunto mas na maneira de trata-lo também ... ninguém pode falar em "pintura brasileira" se essa pintura não tem raízes na terra'.

painters who sent artworks to the Exhibition, devoting more lines to Heitor dos Prazeres ('the afro-Brazilian Rousseau'), Cardoso Júnior ('fantastic qualities of a Parisian surrealist'), Djanira ('who came from the mob'), Pancetti ('our great romantic painter'), Cícero Dias ('Brazil's Chagall') and Portinari ('greatest mural painter in South-America'). The article includes images of twenty-one of the Exhibition's paintings; the only paintings that were printed in both the catalogue and Navarra's article were 'Lucy with flower', by Segall, and 'Portrait of the artist', by Pancetti. In a note, it is explained that it was not possible to reproduce, as had originally been intended, one work by each of the artists who participated in the Exhibition. Tarsila do Amaral and Heitor dos Prazeres are specifically named amongst those whose important pictures were not obtained for reproduction in the article.

The way in which many Brazilians perceived their own Modern Art and their place in modernity, evident in Navarra's narrative, contrasted entirely with the view of Brazil from the British establishment standpoint, well represented by Sitwell's analysis. With scarce knowledge of Brazilian society, he naturally resorted to the 'question of origins and influence' (Ades, 2018, p. 62), prejudice and *clichés* and apparently borrowed some impressions from Navarra's text[160] and from his acquaintance Victor Perowne, who held Brazilian Modern Art in very low regard.[161] The English writer's review, in any case, would notably influence the media and public opinion about the Exhibition in the United Kingdom.[162] In a way, therefore, Navarra's observations, which supposedly informed Sitwell's ideas, had an indirect impact on the – overall positive yet spotted with prejudice – reviews by the British. The authoritative opinions of the renowned English critic were often uncritically assimilated, with few exceptions of direct criticism, such as that found in *The Reading Mercury*, which considered his observations 'at least, debatable' (Reading Mercury, 1945). In any case, the long and dense content of the catalogue, as well as its already-mentioned success in selling, made it, in its own right, an important outcome of the Exhibition, which fostered awareness of Brazil and its culture and visual arts among British society.[163] It impacted the press coverage and helped to form a general opinion regarding the Exhibition.

160 Who points it out clearly, even taking responsibility for Sitwell's misinterpretation of Brazilian art (Navarra R., 1945).

161 Amongst tens of negative references to Brazilian art, Perowne wrote, when he learnt that Sitwell had inspected the Exhibition artworks, 'I hope the effect won't be too depressive' (Perowne V., 1944).

162 See the 'Press Coverage' section.

163 See the 'Legacies' section.

106 PUBLIC DIPLOMACY ON THE FRONT LINE

Press Coverage

Before the Show

Its significance will be well understood by British people[164]

Noel Charles

The earliest mention of the Exhibition found in the press was published on September 16, 1943, by the *Estado de São Paulo*. Highlighting the Allies' shared fight for freedom and democracy and the noble aspect of political and cultural cooperation (Estado de São Paulo, 1943, p. 3), the daily observed that it would be the first time that the British public would be introduced to Brazilian modern painting. It anticipated that the artworks would be handed to the British Ambassador in that same month at the Brazilian Press Association (ABI), which eventually did not happen – the pictures would be officially presented at the Itamaraty Palace, in November 1943. A couple of weeks after the *Estado de São Paulo* broke the news, two other dailies, the *Diário Carioca* and the *Correio da Manhã*, issued identical articles about the Exhibition, indicating that the text may have been conceived in coordination with the Brazilian government, probably with the MRE, which represented the pro-Allies stronghold within Vargas' regime.[165] The pieces made the Exhibition known, by announcing that Minister Oswaldo Aranha had received a letter about the initiative by two of the artists' leaders, Alcides da Rocha Miranda and Augusto Rodrigues. According to the news, a group of painters had spontaneously decided to donate artworks as a contribution to the War effort (Estado de São Paulo, 1943, p. 3). The articles reproduced the artists' words stressing the expected repercussions of their gesture and the hopes of fostering the cultural exchange promoted by Brazilian and British governments.

On November 12, 1943, the same *Diário Carioca* reported a press visit to the conference room of the Itamaraty Palace, where the donated artworks were on display. The newspaper emphasised, once again, the enthusiastic and decisive support of Minister Aranha, in whose opinion it was fair that the artists joined, with their works of beauty, the effort of all good men against evil, in that War in which the freedom of artistic creation was at stake (Diário Carioca, 1943, p. 3). This statement reveals a conscious decision to convey, with the Exhibition, a message of shared values and political engagement. The piece also quotes the British Ambassador Noel Charles, who considered

164 '*Sua significação e seus resultados serão bem compreendidos pelo povo britânico*' (as cited in Diário Carioca, 1943, p. 3).
165 See the 'Background' section.

THE EXHIBITION

that the Exhibition in London was a good start for the intellectual cooperation between the two nations (Diário Carioca, 1943, p. 3), demonstrating that the show was a two-way diplomatic endeavour. Both the spontaneity of the artists' gesture and the presence of their works in foreign collections were underlined, and the intention of selecting ten paintings to initiate a Brazilian art collection in England was mentioned (Diário Carioca, 1943, p. 3). The set of pictures was estimated to be worth 800,000 *cruzeiros*;[166] 'Lucy with flower', 'one of the best recent paintings by Segall',[167] alone was priced at 40,000 *cruzeiros* (Diário Carioca, 1943, p. 3). Besides, the daily made remarks about works by Carlos Leão ('several drawings, surprisingly one of the most confident and spontaneous artists'[168]), Percy Lau ('allying documentary and great artistic interest, Brazilian types and landscapes'[169]), Portinari ('two paintings from one of his most important phases, previously displayed in several prestigious museums in North America'[170]), Tarsila do Amaral ('an excellent landscape of Brazil's countryside'[171]), Pancetti ('two excellent landscapes simply and vigorously depicted and a self-portrait of exceptional quality'[172]), Goeldi ('wood engravings of fishers that reveal his vigorous temperament'[173]), Guignard ('two portraits of girls and two landscapes of Ouro Preto'[174]), Clóvis Graciano ('three pictures that represent his painting, as strong aesthetically as in terms of research'[175]) and Flávio de Carvalho ('an audacious and very personal portrait'[176]) (Diário Carioca, 1943, p. 3). Several newspapers from the United Kingdom, at the end of November 1943, published a short note on the Exhibition, produced by *Reuters*. It advertised

166 Or £10,000, according to British Embassy approximate exchange rate of £1:80 *cruzeiros* (British Embassy in Rio de Janeiro, 1944).

167 '*Um dos melhores quadros recentes de Segall*' (Diário Carioca, 1943, p. 3).

168 '*Que se revela inesperadamente como um dos mais seguros e espontâneos, exibe vários desenhos*' (Diário Carioca, 1943, p. 3).

169 '*Aliando ao documentário um grande interesse artístico, nos dá tipos e paisagens brasileiras*' (Diário Carioca, 1943, p. 3).

170 '*Comparece com dois quadros de uma das fases mais importantes de sua pintura e que já foram expostos em vários museus dos mais prestigiosos da América do Norte*' (Diário Carioca, 1943, p. 3).

171 '*Se representa com uma excelente paisagem do interior do Brasil*' (Diário Carioca, 1943, p. 3).

172 '*Expõe duas excelentes paisagens de realização vigorosa e simples e um autorretrato de excepcionais qualidades*' (Diário Carioca, 1943, p. 3).

173 '*Com as suas xilogravuras de pescadores, onde se sente a marca de seu vigoroso temperamento*' (Diário Carioca, 1943, p. 3).

174 '*Com dois retratos de menina e duas paisagens de Ouro Preto*' (Diário Carioca, 1943, p. 3).

175 '*Nos dá três quadros que representam a sua pintura tão forte de sentido quanto de pesquisa e caráter plástico*' (Diário Carioca, 1943, p. 3).

176 '*Apresenta um retrato arrojado e personalíssimo*' (Diário Carioca, 1943, p. 3).

108 PUBLIC DIPLOMACY ON THE FRONT LINE

the Brazilian gift and referred to the planned sale of the artworks as well as to the basis of a collection of Brazilian art to be established in that country.[177]

In August 1944, the *Diário Carioca* published another long piece on the Exhibition and its deeply political meaning, announcing its recent arrival in London.[178] The daily listed the artists who took part in the initiative and reproduced their message of goodwill that accompanied the artworks, whose translation appears in Figure 7.

Their total value was again calculated to be 800,000 *cruzeiros*, according to a newspaper's source (Diário Carioca, 1944). The two paintings by Portinari were priced at 80,000 *cruzeiros*. The painter was quoted with regard to the Exhibition, which he considered a 'truthful expression of our art, revealing to our English friends – who too remotely have had contact with our artistic movement – our visual arts' level of sophistication'[179] (Diário Carioca, 1944). Some other artists were mentioned: Pancetti ('the painter sailor, with three of his best works'[180]), Mariusa Fernandez ('victim of the War'[181]), Raimundo Cela ('who studied in the United Kingdom'[182]), Flávio de Carvalho ('with excellent works'[183]), Heitor dos Prazeres, Poty Lazzarotto, Cardoso Júnior, Vieira da Silva and Árpád Szenes. The *paulista* current was represented, continued the article, by Segall ('with one of his best works'[184]) and Toledo Piza ('who died during the Exhibition's preparation'[185]), among others[186] (Diário Carioca, 1944). The anglophile newspaper treated the then former Ambassador

177 Amongst the dailies which publicised the gesture, were *The Hull Daily Mail* (Hull Daily Mail, 1943), *The Dundee Evening Telegraph* (Dundee Evening Telegraph, 1943), *The Manchester Evening News* (Manchester Evening News, 1943), *The Daily Mail* (Daily Mail, 1943), *The Lincolnshire Echo* (Lincolnshire Echo, 1943), *The Nottingham Evening Post* (Nottingham Evening Post, 1943) and *The Sunderland Daily Echo & Shipping Gazette* (Sunderland Daily Echo & Shipping Gazette, 1943).

178 They arrived on August 25 in London, according to the news by *Reuters* cited in the Brazilian daily.

179 '*Expressão fiel da nossa arte, servindo para dar a conhecer aos amigos ingleses – que muito remotamente têm contacto com o nosso movimento artístico – o grau de cultura das nossas artes plásticas*' (Diário Carioca, 1944).

180 '*Pintor marinheiro, com três de seus melhores trabalhos*' (Diário Carioca, 1944).

181 '*Vítima da Guerra*' (Diário Carioca, 1944).

182 '*Estudou no Reino Unido*' (Diário Carioca, 1944).

183 '*Com excelentes trabalhos*' (Diário Carioca, 1944).

184 '*Com um de seus melhores trabalhos*' (Diário Carioca, 1944).

185 '*Morto aparentemente no proceso*' (Diário Carioca, 1944).

186 Clóvis Graciano, Livio Abramo, Aldo Bonadei, Andrade Filho, Quirino da Silva, Francisco Rebolo, Mario Zanini, Pancetti, Osir Rossi, Flávio de Carvalho, Tarsila do Amaral, Carlos Prado, Carlos Scliar, Noemia Mourão, Di Cavalcanti, Lucy Citti Ferreira, Duja Gross, Volpi and Jacob Ruchti were named.

THE EXHIBITION 109

Translation. "O Jornal" of the
 14th December, 1943.

"The presence of our pictures in London represents
the contribution which we are making to the English war
effort.

As artists this was the best way we could find to
express to the English our admiration and solidarity, and
we hope that our gesture will be appreciated by its moral
and symbolical significance rather than by its material
value.

It is for us a source of pride to know that we are
at England's side in the struggle against the Nazi-Fascist
barbarism.

We are convinced that the English people are
defending above all the dignity of man, the heritage of
the spirit and the conquests of democracy.

We shall never forget the touching message of
your children who, in the most tragic days of their exis-
tence, sent us their works of painting which made us under-
stand that the artistic gifts of the British people repre-
sent a reserve of sensibility and of poetry, which the Nazi
squadrons have tried but have not been able to destroy in
England's own skies.

Conscious of the necessity of victory, Brazil's
plastic artists salute in thought and deed the English
people and reaffirm their ardent confidence in victory."

- - - - - - - - -

Figure 7. Translation of the artists' open letter published in a Brazilian newspaper
(*The National Archives*).

Noel Charles as a 'gentleman' who left many friends in Brazil[187] and who did not
hide his enthusiasm for the Exhibition (Diário Carioca, 1944). Equally signalling
the high-level political backing enjoyed by the Exhibition, it entitled Oswaldo
Aranha 'one of the chief encouragers of the initiative'[188] (Diário Carioca, 1944).

187 In March 1944, Noel Charles was appointed member of the Advisory Committee for
Italian Affairs (the Allies had not yet reassigned Ambassadors to Rome).
188 *'Um dos grandes estimuladores da iniciativa'* (Diário Carioca, 1944).

110 PUBLIC DIPLOMACY ON THE FRONT LINE

At that time, he had also just left his ministerial position, in the midst of political turmoil and pressure for the return of democracy in Brazil. Much indeed had changed by then, as at that moment Brazilian troops were fighting in Italy, on behalf of the 'sacred principles [...] defended by our people, now with arms in hand'[189] (Diário Carioca, 1944). The news reflected the ambiguities of the Brazilian government, authoritarian at home and aligned with the Western democracies on the European War front, which were becoming too evident and contested, and made the artists increasingly oppose the Vargas regime.[190] The *Diário Carioca* cited a few opinions on the meaning of the Exhibition. Manoel Martins, one of the participating artists, stressed the necessity of joining the War effort, above all, when the Allied nations' soldiers were defending the freedom of artistic creation (Diário Carioca, 1944). Augusto Rodrigues, one of the Exhibition's masterminds, called it the largest set of Brazilian paintings ever sent abroad. He added that Ambassador Charles had told him that only once in his diplomatic career had he experienced so deep an emotion. Rodrigues recognised the decisive support received by Minister Oswaldo Aranha and the efficient *stimulus* granted by Ambassador Leão Velloso[191] (Diário Carioca, 1944), making it clear that governmental championing, although sometimes discreet, was crucial for the success of the Exhibition. The press coverage would change its focus and perform other roles when the Exhibition was finally opened in London on November 22, 1944.

At Burlington House

> *A cursory preview of the Exhibition of Brazilian paintings at Burlington House is sufficient to impress one with the modernity of Brazilian artists*
> The Daily Telegraph[192]

In October 1944, the Press Department of the BC sent to the Foreign Office a draft of a press release that would accompany the invitation for media representatives to attend the Exhibition press preview on November 21, and the opening the next day. On November 13, the BC's press officer issued the definitive press release for what it called the first collective exhibition of Brazilian painters to be sent to Europe, an expression of friendship and

189 '*Princípios sagrados [...] que nosso povo defende, já agora de armas nas mãos*' (Diário Carioca, 1944).
190 See the chapter on the 'Historical Context'.
191 Ambassador Leão Veloso was Oswaldo Aranha's deputy (Secretary-General) and took on his position, *ad interim*, when Aranha left the government in August 1944.
192 (The Daily Telegraph, 1944).

THE EXHIBITION

111

admiration by 'some of the most distinguished' Brazilian artists (Rodd, 1944). It was said that the Secretary for Air, Sir Archibald Sinclair, would open the show, which included the 'Brazil Builds' photographs, previously displayed at the Museum of Modern Art in New York. A few days later, a representative from Dorland Advertising informed the RAF Benevolent Fund, in charge of the Exhibition's public relations, that he had issued an advertisement for the show to *The Times, The Observer, The Sunday Times, The Telegraph, The Daily Express, Daily Mail, The Evening News, The Standard, The Star, The Spectator, The New Statesman* and *Time & Tide*, observing the late inclusion of the latter three, as 'they seem to appeal to art lovers' (Anderson, 1944). He also indicated that he did not know 'whether we will get all the insertions asked for, but we will certainly get some' (Anderson, 1944).

During the week preceding its opening, the Exhibition was publicised in various newspapers in both Brazil and the United Kingdom. *The Yorkshire Post* (Yorkshire Post and Leeds Intelligencer, 1944, p. 2) and *The Manchester Evening News* (Manchester Evening News, 1944, p. 5) practically reproduced the contents of the press release. On November 16, *The Nottingham Post* published a quite favourable piece on the Exhibition, noting that 'it is rather strange to learn that this is the first collective Exhibition by Brazilian painters ever to be sent to Europe. This is remarkable, since the Brazilians have already exhibited that natural taste for art that is so common among the Latin nations of the old world' (*Nottingham Evening Post*, 1943, p. 4). In relation to its aesthetic qualities, the daily observed that 'Brazilian art, to this day, remains to some extent under the influence of the French School' (*Nottingham Evening Post*,1943, p. 4), anticipating what would prove to be the major aesthetic debate over the Exhibition. The *Correio da Manhã* (*Correio da Manhã*, 1944) and the *Estado de São Paulo* (*Estado de São Paulo, 1944*, p. 1) also issued brief notes on the show, the latter stressing that the artworks had left Brazil a long time before.

On the opening day, the *Jornal do Brasil* and the *Estado de São Paulo* published the same article by Reuters, focusing on the preface written by the so-called great friend of Brazil, Sacheverell Sitwell (Bettany, 1944, p. 7). Even the poor quality of the translation into Portuguese could not hide the fact that some of the most prejudicial evaluations made by Sitwell were quoted in the Brazilian dailies, in a strangely neutral (not to say excited) way. It reproduces, for instance, the English's opinion that Brazil's art progress should become slower and more serious and the racist argument that its painters were too influenced by Central-Europeans (Bettany, 1944, p. 7). The piece considered the Brazilian pictures to be admirably displayed and highlighted the presence, in the press preview, of a large number of critics and journalists, in addition to all the Brazilian diplomatic corps, headed by Sousa-Leão (Estado de São Paulo, 1944). The overall impression amongst those observers, most of whom

112 PUBLIC DIPLOMACY ON THE FRONT LINE

had never had contact with Brazilian art, according to *Reuters*, was extremely favourable (Bettany, 1944, p. 7). As a proof of such approval, the article mentioned the fact that, even though the Exhibition was not yet open to the public, many bids to acquire the paintings had already been submitted.[193] The *Diário da Noite* affirmed that the Brazilian *Chargé d'Affaires* had declared the intention of acquiring 12 pictures for the Embassy in London (Diário da Noite, 1944, pp. 1–2). It underscored the 'strong impression' caused by Portinari's works, quoting *The Daily Telegraph*, which in its London Day by Day column had called him 'the Picasso of Brazil'. According to the British daily (The Daily Telegraph, 1944, p. 4),

> Portinari's are the highest-priced pictures in the show, being marked at £250, which I learnt was below what they would fetch in Rio de Janeiro. In Brazil, Portinari will get as much as £1,000 for a portrait.

His works, it continues, 'are certain to excite interests here' (The Daily Telegraph, 1944, p. 4). *The Daily Telegraph* critic finally narrates his meeting with Sousa-Leão,[194] 'the tall and distinguished-looking Brazilian Minister [who was] surveying the well-arranged pictures with a critical but not dissatisfied eye and told me that he hoped to secure one or two for the Embassy' (The Daily Telegraph, 1944, p. 4). In a positive appraisal, the article stated that 'a cursory preview … is sufficient to impress one with the modernity of Brazilian artists' (The Daily Telegraph, 1944, p. 4).

The Foreign Office regarded the press coverage of the opening as quite good, especially considering 'the extreme shortage of space in our one-page newspapers and other excitements such as V2, which is being very fully reported just now' (Perowne V., 1944).[195] Nonetheless, it requested support from the Ministry of Information in 'interesting the popular press in the gesture which has led to the Exhibition, [as the British Council had] done their stuff well with the art critics but, as you know, they have no pull with the ordinary run of journalists' (McQuillen J. M., 1944). The Brazilian Embassy in London likewise considered the Exhibition to have had 'great repercussions' (Sousa-Leão J. d., 1944), citing, in a report sent to Rio de Janeiro, the reviews by *The Times*, *The Observer* and *The Sunday Times*. *The Times* highlighted that 'what strikes the visitor most forcibly about the collection as a whole is the comparative

193 The article mentioned Sitwell's references to Segall, Cícero Dias, Heitor dos Prazeres, Burle Marx and Guignard.
194 'Its Ambassador is on leave', explained the newspaper.
195 In another document, a Foreign Office representative said that 'we have had quite a good press considering wartime difficulties of space etc.' (McQuillen J. M., 1944).

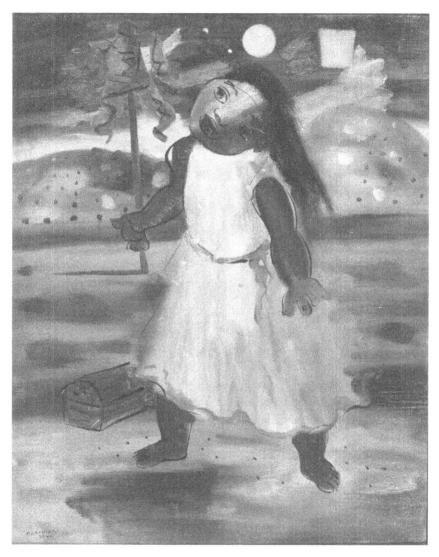

Figure 8. Candido Portinari. *A Boba* (Half-wit), 1940. *The Mercer Art Gallery.* Courtesy of João Candido Portinari.

scarcity of the bright colour which might have been expected in painters bred in a tropical country' (The Times, 1944, p. 6).[196] The two pictures by Portinari (the oil painting *A Boba* appears in Figure 8), 'the living Brazilian painter with the most considerable reputation ... show him to be addicted to darkly

196 *The Times* also advertised the Exhibition, providing general details, such as its opening hours, dates, and entrance fee.

114 PUBLIC DIPLOMACY ON THE FRONT LINE

glowing colours, in which blue is prominent, smudgy and sooty shadow, and a loose naïve style of figure drawing, which yet manages to convey a sense of rather gruesome animation' (The Times, 1944, p. 6).

A more obviously Brazilian aesthetic could be seen 'in such a picture as Milton Dacosta's 'Cyclists', who are represented with an elongated formalism that is decorative and entertaining' (The Times, 1944, p. 6). However, it states (The Times, 1944, p. 6),

> there is little brilliant colour, and some of the most pleasing of the artists use soft and quiet shades almost entirely. This is true of Francisco Rebolo Gonçalves, whose four paintings show to be a delicately charming landscape artist, and of Quirino da Silva, whose large view over pale red roofs towards grey distant hills is another attractive thing.

Clearly animated by Sitwell's evaluation in the catalogue's preface, *The Times* (1944, p. 6) concludes that

> indeed, the principal criticism to be offered is that the Brazilian school does not really tell us enough about its own country and its national way of life. The room of photographs of Brazilian architecture, both old and modern, which also forms part of the Exhibition, seems to say much more than do the painters about Brazil and not merely about its appearance but about the spirit of the land and the people.

The daily summarises it by saying that 'the inspiration of many of the pictures very clearly comes from the studios of Paris rather than from Brazil' (The Times, 1944, p. 6), resorting to this 'easy handle', as, devoid of appropriate analytical tools, British critics preferred to comment on the origins of Brazilian Modern Art (Ades, 2018). Along the same lines, *The Observer* agreed that 'the general effect is not what one would have expected, so arbitrary are the ideas one forms of national temperaments [and because] most of the pictures were low in tone and their range of colour restricted' (Lancaster, 1944, p. 2). Equally informed by Sitwell's text, it 'opined' that the 'predominant influence appears to be Central European rather than French' (Lancaster, 1944, p. 2). An especially positive review concerned the drawings, which 'on the whole, make a more immediate appeal than the paintings' (Lancaster, 1944, p. 2). In particular, *The Observer* critic praised 'a line drawing of a square by Burle Marx, where the architecture is observed with wit and a sound topographical sense'[197] (Lancaster, 1944, p. 2).

197 It refers to the '*Lapa*' [Pen and ink drawing]'.

THE EXHIBITION 115

In a mixture of sincerity, prejudice and ingenuity, *The Sunday Times'* critic begins his review stating that he knew 'nothing of the history of Brazilian art. Apparently there is very little to know' (Newton, 1944, p. 2). Here again, the aesthetic evaluation is circumscribed to the influence of the old world: 'no wonder the Exhibition contains hardly anything that is stylistically unfamiliar to European eyes' (Newton, 1944, p. 2). The article explains that 'these familiar idioms are inevitable. Until the outbreak of War, the Americas were artistic dependencies of Paris. Art had become almost international: new national traditions – with the exception perhaps of the Mexican school – had not begun to emerge' (Newton, 1944, p. 2). In a condescending tone, which involuntarily conveys the idea of 'anthropophagy', a founding concept of Brazilian Modernism,[198] the critic asserts that, by digesting the Parisian idiom, a 'surprisingly large proportion of the painters use it with all the ease of a native language' (Newton, 1944, p. 2). For the critic, Brazilian art was in a necessary initial phase, its 'May flower stage'. He judges that 'soon doubtless, it will develop South American kinks and idiosyncrasies. In Candido Portinari's work the process has already begun' (Newton, 1944, p. 2). A few remarks are made about Segall's artwork, 'anything but Expressionist' (Newton, 1944, p. 2). The Brazilian artists, says *The Sunday Times* critic emphasising the moral value of their gesture before their pictorial skills, 'paid more than pen-service to heroism' (Newton, 1944, p. 2).

The Yorkshire Post and Leeds Intelligencer, similarly, 'was struck by the apparent influence of the French impressionists on Brazilian art [and by] some exquisite landscapes, full of colour' (Yorkshire Post and Leeds Intelligencer, 1944, p. 2). It singles out 'Lucy with flower' by Segall, 'father of Brazilian art' (Yorkshire Post and Leeds Intelligencer, 1944, p. 2), which is described as a girl with dusky features and big round brown eyes. Another article by *The Daily Telegraph*[199] also highlights the patterns and colours of the Exhibition, which bring 'an exotic richness to the walls of Burlington House' (Daily Telegraph, 1944). It remarks the 'impression of intense artistic vitality, ranging from the clearly defined "Landscape" of Quirino da Silva to the traced fantasy "Painting" by Cicero Dias' (Daily Telegraph, 1944). A very positive review is also given of Segall's 'graceful "Lucy with flower", whose simple but characterful style is shared by Carlos Prado's "Figure" and Pancetti's "Self-portrait"' (Daily Telegraph, 1944). 'Grandly dramatic', it goes on, 'are Guignard's "Ouro Preto" and Portinari's "Group". They have the same

198 Oswald de Andrade proclaims the 'absorption of the sacral enemy' (Andrade O. d., 1928) in the Anthropophagic Manifesto, published in 1928 or in the year 374 after the swallow of Bishop Sardinha.

199 *The Daily Telegraph* also issued a short note on the day after the opening.

116 PUBLIC DIPLOMACY ON THE FRONT LINE

elemental quality as Árpád Szenes' 'War', 'bold in tint and driving straight to the emotional core of the subject' (Daily Telegraph, 1944). The arts magazine Horizon, at that time a major source of information for 'quoters and mis-quoters' (Taylor, 1999, p. 193), printed the images of four of the Exhibition paintings: 'Lucy with flower' by Lasar Segall, 'Washerwoman' by Heitor dos Prazeres, 'Group' by Portinari and 'Landscape' by Tarsila do Amaral (Horizon, 1944). The latter artwork was acquired for £25 by Peter Watson, owner of the magazine. The only openly negative review in the London press was published by the *Time and Tide* (Time & Tide, 1944), which considered the pictures 'interesting as showing what is going on in the art world of Brazil, but as an exhibition of paintings is not of a high order' (Time & Tide, 1944). Some value was perceived in 'two strange but personal and well-painted pictures [by Portinari, and in] a crucifixion by Emeric Marcier, who is really a Transylvanian who lived in Paris till 1940' (Time & Tide, 1944). The rest, it laments, were 'in general local renderings of the various French manners, some, like Lasar Segall's "Lucy with flower", being highly accomplished' (Time & Tide, 1944).

In Brazil, the *Manhã* published an article by Reuters about the opening ceremony, essentially focused on Lord Sherwood's words. His appraisal of the Fellowship of the Bellows of Brazil warranted special attention. The association between Brazil and the RAF 'will be remembered for long, with pride; and we gratefully recall Brazil's splendid contribution to the Allied cause, under the vigorous government of President Vargas'[200] (A Manhã, 1944, p. 7), Sherwood had said. He also affirmed that the artworks on display conveyed the 'expression of artistic talent and vitality of Brazil, [concluding that] when we have the pleasure of appreciating them, they will remind us of that nation' (Time & Tide, 1944). The *Revista da Semana* wrote about the central role played by the artist Augusto Rodrigues in conceiving, organising and publicising the Exhibition, which would have been the greatest of his achievements (Aulicus, 1944). The *Correio da Manhã*, in turn, dedicated a long article,[201] signed by Ruben Navarra, to examining and criticising the Exhibition catalogue, more specifically its preface by Sacheverell Sitwell (Navarra R., 1945);[202] and the full catalogue introduction by Navarra was published by the *Revista Acadêmica*.[203] Other news registered the Duchess' visit to the Exhibition (Yorkshire Post and Leeds Mercury, 1944) and the presentation to the Tate collection of its first

200 '*Será relembrada por muito tempo com orgulho, e recordaremos com gratidão a esplêndida contribuição do Brasil, sob o vigoroso governo do Presidente Vargas*'.
201 The article is analysed in detail in 'The Catalogue' section.
202 See 'The Catalogue' section.
203 See 'The Catalogue' section.

THE EXHIBITION

Brazilian painting, '*Elas se divertem* [They amuse themselves]', by Cardoso Júnior, which had been acquired for £42, another notable outcome of the initiative. In that respect, a representative of the Foreign Office advised the BC that they 'may not release it to the press until it has appeared in *The Times*, as the Tate have given them priority. The director of the Tate has empowered me to say how pleased he is with the picture and is especially glad that the Tate now has a painting by a Brazilian artist in its collection' (Somerville L., 1945). For *The Times*, his work had 'a pronounced Brazilian quality and, though he is in no sense an amateur, his art bears a poetic relation to that of the French Sunday painters' (Times, 1945). It underlines also that he had lately 'returned to painting upon the advice and under the influence of Candido Portinari' (Times, 1945). This comprehensive and mainly laudatory coverage would become more heterogeneous during the tour of the Exhibition through seven other British galleries.

During the Tour

> *Brazil has sent us some tough nuts to crack*
> The Glasgow Evening News[204]

In January 1945, Perowne celebrated the success of the Exhibition, 'which, having received a good deal of publicity, both here and in Brazil, has now gone on tour to the provinces' (Perowne V., 1945). *The Manchester Evening News* (Manchester Evening News, 1944, p. 5) and *The Birmingham Post*, whose cities were supposed to host the Exhibition, published pieces on it. The latter announced that, by arrangements with the BC, it would be shown in Birmingham and other cities, and highlighted 'the influence of the modern French School [and the works by] Lasar Segall, Portinari (three of whose panels were shown at the New York world fair), Pancetti, Cícero Dias, and the negro artist Heitor dos Prazeres' (The Birmingham Post, 1944). The Exhibition, however, would never go to Manchester or Birmingham, as seen in the 'Arrangements' section.

On its first stop, at the Castle Museum of Norwich, the Exhibition received wide and rather favourable coverage, despite the already cited museum curator's evaluation that the reaction was 'hostile'[205] (Somerville L., 1945). *The Eastern Daily Press*, in an article later republished by *The Norfolk Mercury & People's Weekly Journal*, declaredly chose to draw attention to the artistic aspects

204 (*Glasgow Evening News*, 1945)
205 See 'The Show' section.

118 PUBLIC DIPLOMACY ON THE FRONT LINE

of the show, instead of its symbolic value, as 'the high quality of this Exhibition leads one to believe that the artists are men and women of sufficiently serious purpose to prefer that their work shall be judged on its intrinsic merits rather than on sentimental grounds' (Eastern Daily Press, 1945, p. 2). The Norwich critic affirms, in quite an encouraging tone, that 'with no little curiosity ... we in England welcome an opportunity of seeing what Brazil, a republic 65 times the size of England and with a high standard of culture, has to contribute to the world of art' (Eastern Daily Press, 1945, p. 2). In relation to exogenous influences, the newspaper joined those voices that accused too much European inspiration when it ascertains that the first impression of the show is one of

> talent, vitality, and a high degree of sophistication. On second glance one is somewhat disappointed. With its obvious eclecticism no one would quarrel if there were present qualities which undeniably proclaimed the paintings apart from subject matter, as indigenously Brazilian [...] with the single exception, perhaps, of Candido Portinari, whose two canvases blossom in that collection with an exotic and disturbing beauty, there is very little in the Exhibition which might not have been painted by any European-trained Latin artist or European for that matter. Portinari who is of Italian origin, has been compared with the French painter Laurencin but there is a monumental quality about the work of the former I have never seen in Laurencin's charming but superficial work.

Here, there is a clear and rare criticism of Sitwell's preface to the catalogue, which presented the aforementioned comparison. Nevertheless, even the highly praised 'Lucy with flower', by Segall, would not, according to *The Eastern Daily Press*, generate surprise if shown alongside English moderns. Some remarks were directed to Cícero Dias ('interesting painter with a poet's vision, has two provocative pictures, one of a boy in the act of levitation, his bewildered family looking on'); Burle Marx ('the large study of fish ... is very Braque-like'); Carlos Prado and Bellá Paes Leme ('accomplished enough, proclaim their debt to Rivera'); Martim Gonçalves (whose 'two landscapes ... will probably appeal to the English taste as being nearer to our tradition, while some admirable pen and ink drawings show the nervous vitality and sensibility of the Chinese'); Luís Soares (whose 'Brazilian dance' 'is among a few canvases full of the atmosphere and colour of a semi-tropical climate') (Eastern Daily Press, 1945, p. 2). For this newspaper (Eastern Daily Press, 1945, p. 2),

> considering that the infiltration of French influence into Brazilian art began only as recently as the early 19th century and that the majority of

THE EXHIBITION
119

modern Brazilian artists have been trained in Paris, the predominance of European influence is not surprising. But there are indications in this Exhibition that when the varying influences have become thoroughly assimilated, the world may well look forward to an interesting contribution in the plastic arts from these gifted people.

The indications refer to the 'Brazil Builds' photographs, the regular recipient of superlative praise. The critic finally reckons the Exhibition as capable of promoting 'understanding and appreciation of the cultural and spiritual values of the people of another land' (Eastern Daily Press, 1945, p. 2). *The Eastern Evening News*, in turn, states that the Exhibition demanded special attention for 'it is a striking tribute from the painters of Brazil, many of them poor [and secondly for] it is the first of the inter-allied exhibitions held in the Castle Museum since the War' (Eastern Evening News, 1945, pp. 3–4). Resorting to ambiguous rhetoric, the daily affirms that (Eastern Evening News, 1945, p. 4)

> these paintings are really all in a modern idiom and some people will fail to understand them. Nevertheless [the British Council] is to be congratulated upon organising a tour [and] giving the public a chance to distinguish between the genuine and the spurious. At first it is disappointing to see that the European influence is so strong, but it should be remembered that at one time, without travel abroad it was almost impossible for a writer or a painter to make a name for himself or a living.

Again, the question of a European influence stood out, but here there is an attempt at giving it a positive connotation, by stating that (Eastern Evening News, 1945, p. 4)

> the whole tendency of today, however, is towards internationalisation of values intellectual and artistic, due to easy and rapid travel ... Americans are only a few generations removed from European soil and retaining many European customs and traditions. In importing the art from Europe, they are in a sense importing their own past upon which they must build their future. Unfortunately, a snobbish and indiscriminate preference for everything European has often deprived its own artists of the patronage of the wealthy.

Amongst the Brazilian artists, Portinari is singled out as being, 'without doubt, the greatest exponent of South American mural painting. He has done for the Brazilian negro what Diego Rivera has done for the Mexican Indian'

(Eastern Evening News, 1945, p. 3). There is also mention to 'some charming portraits, including "Portrait of the artist" by Carlos Prado, "Lucy with flower" by Lasar Segall [and] an excellent painting by Martim Gonçalves called "Boy in the library", where the delicate play of the firelight on the boy's figure is so unemphatically suggested' (Eastern Evening News, 1945, p. 3). The drawings, etchings and lithographs received particular attention, as their composition 'of necessity largely in monochrome, shows perhaps that some painters have not yet discovered a *palette* suitable to the Brazilian climate and atmosphere' (Eastern Evening News, 1945, p. 3). In the end, as proved to be common in press comments about the Exhibition, the newspaper drew attention to the Brazilian architecture, which had 'developed a style magnificently suited to a land of strong sunlight and hard shadows' (Eastern Evening News, 1945, p. 4), practically in the same words that Sitwell had used. The general impression that one derives from the Exhibition, says the critic reproducing the catalogue ideas, 'is that the modern architects are masters of their setting, but the painters are still uncertain of their direction' (Eastern Evening News, 1945, p. 4). In this respect, it is interesting to consider Adrian Locke's argument that the 'Brazil Builds' narrative was 'easier to follow and, most likely, more coherent since it was chronological, covering nearly 300 years of history. The paintings and works on paper were not selected by a curator but rather donations from artists, which implies a wide variety of styles and subject matter making it much less cohesive as a group' (2018, p. 69).

In comparison with Norwich, Edinburgh's visitors and critics appeared to be more sceptical and superficial towards the Exhibition. The press seemed repeatedly impressed by the photographs of Brazilian architecture, 'probably the most "modern" architecture of today' (Scotsman, 1945). The Scotsman magazine recommended the audience to start the visit through the 'Brazil Builds' room, noting that (Scotsman, 1945)

> expansion in Brazil came at a time when events in Europe dispersed to the end of the earth architects who had been thinking deeply of construction in relation to modern needs. Under wholly new conditions, an opportunity arose of applying theories which had hardly got beyond the drawing-board, but, in conjunction with American building methods, a new architecture has been evolved. The problem was Brazilian and equatorial, but the lesson is there for us to read.

With regard to the paintings, the Scottish journal recommended reading the preface to the catalogue by Sacheverell Sitwell and the introduction by Ruben Navarra, so that the visitor to the Exhibition 'will take a different approach, [after all] in dealing with an art so far removed from our own

THE EXHIBITION

conventions, it is perhaps wise to give the eye every assistance' (Scotsman, 1945). Contradicting the general opinion of the press, it notices that Brazilian art's links with European art were of the most tenuous kind, adding that 'a few stray Europeans had found their way to Brazil, a few Brazilians had come to Paris, but the traffic was never sufficient to establish the Parisian influence, and what little there was dissolved rapidly under the urge to find expression for native artistic experience' (Scotsman, 1945). More aligned with Sitwell's catalogue preface, *The Glasgow Herald*, referring to the show in Edinburgh, stresses that the 'modern idiom predominates, yet the pictures are marked by their national character' (as cited in Sousa-Leão J. d., 1945). In a conservative tone, it is said that some of the paintings (as cited in Sousa-Leão J. d., 1945),

> will cause much discussion. For example, a picture by Cícero Dias, one of Brazil's outstanding painters, which is entitled simply 'Painting'. It shows an interior with half a dozen figures – conventional if you like –, but raised towards the raftered ceiling is the figure of a woman in short skirt in a recumbent position.

Glasgow's press, which was highly doubtful about the quality of the Exhibition, noted that, in Brazil, 'advanced Modernist tendencies, probably originally introduced from Europe, have been taken up enthusiastically by native artists and developed by them in their own way' (Glasgow Herald, 1945). A common characteristic of the artworks observed by *The Glasgow Herald* critic is the restraint from representation, which 'has led to distortion, not always for artistic ends [, and] the avoidance of quality of paint, as if afraid of descending to the "pretty"' (Glasgow Herald, 1945). It summarises the overall impressions by disappointedly saying that 'this is, however, the genuine contemporary art of the Brazilians' (Glasgow Herald, 1945). The periodical reserves some praise for Pancetti ('warm unity in a landscape'), Quirino Campofiorito ('good arrangement in a landscape'), Segall ('"Lucy with flower" stands out as a serious study carried out consistently in cool tones of his own') and slightly positive evaluations of Milton Dacosta ('"Cyclists", a clever burlesque') and Heitor dos Prazeres ('spirit of comedy which is very much alive in "The washerwoman"'). The most emphatic remark was occasioned by the surprise of finding 'so many attractive drawings and prints', especially Portinari's 'My mother' and 'Peasants working in the fields' ('masterly'). In Leão's works, one could, according to the article, note an 'artist in direct pen drawing on figures' (Glasgow Herald, 1945). The critic of *The Glasgow Evening News* seemed to be quite puzzled when he wrote that 'I must submit that in this instance Brazil has sent us some tough nuts to crack ... most of the paintings are in Modernist idiom, and one's reaction

122 PUBLIC DIPLOMACY ON THE FRONT LINE

tends to correspond with the emotional indecisions currently being expressed by crooners over the air: "is you is or is you ain't ma baby?"[206] (Glasgow Evening News, 1945).

In Bath, press coverage was equally hesitant. The *Bath Chronicle* published a piece, 'Bicycle at crucifixion', so entitled after one of the artworks[207] that portrayed 'the Crucifixion with a man on a bicycle among the spectators. The explanation of this by Major Longden ... was that the picture depicts the old worshippers and the new!' (Bath Weekly Chronicle and Herald, 1945, p. 12). The periodical affirmed that the Exhibition should attract a large number of visitors, due to its unique scenes. Another picture singled out by it is 'The artist's family', in which the lesser-known painter Urbano de Macedo depicts a family wearing gasmasks. Once more, the architectural photographs, some of them displayed at the Pump Room as not all of them could be accommodated at the Art Gallery, earned praise: 'recent architectural developments in the big cities of Brazil have been noteworthy, and I was told that the Bathonians might learn much from Brazilians, which might be of use in the Bath Plan' (Bath Weekly Chronicle and Herald, 1945, p. 12).

In Bristol, *The Western Daily* and *The Bristol Evening Post* published short and plain notes on the Exhibition, emphasising the presence of the Brazilian Ambassador, Moniz de Aragão, and the symbolic dimension of that 'most generous and graceful gesture' (Bristol Evening Post, 1945, p. 2). It made an unusual mention of the hope, voiced by Bristol's Lord Mayor Cottrell, that 'our business relations with Brazil (interrupted through no fault of our own) might be resumed and expanded at an early date' (Bristol Evening Post, 1945, p. 2).

Back in London, this time after the end of the War, the Exhibition received much less attention from the press. According to a local newspaper from East London, history was made at Whitechapel, which hosted a show of the first all-Brazilian exhibition to be seen in Europe. In their approbatory opinion, 'Brazilian artists had evolved a style of their own, which, when developed, would cause Brazilian art to rise to great heights' (East London, 1945).

During its final stop, in Reading, the Exhibition was extensively advertised by several newspapers. *The Reading Standard* courteously stated that 'Brazil has enriched this country by giving us a part of itself' (Reading Standard, 1945, p. 8). It highlighted works by Guignard ('Landscape' was considered 'pleasing in composition and style'), Pancetti ('Self-portrait' was called 'arresting and

206 The 1944 song by Louis Jordan reached number 1 on the United States folk/country chart (Whitburn, 2004, p. 184). It was recorded by Glenn Miller on a radio broadcast from Europe during the WW2.

207 By Emeric Marcier.

THE EXHIBITION 123

original'), as well as the artists Segall ('one of the most characteristic painters of the Expressionist movement in Central Europe'), Cícero Dias ('an "organic anti-*virtuoso*"') and Portinari ('today the most famous South American painter') (Reading Standard, 1945, p. 8). The daily strongly dismissed some of Sitwell's prejudiced passages in the catalogue preface. It affirmed that some of the English critic's observations about Brazilian painters were 'at least debatable' and, disputing his determinist arguments, stated that 'it is hard to believe that so great a painter as Gauguin was compelled to paint by the beauty of his surroundings' (Reading Standard, 1945, p. 8). *The Reading Mercury* called the Brazilian collection an 'extremely interesting Exhibition' (Reading Mercury, 1945, p. 4). Many of the pictures, it states, had already been disposed of at good prices, but remained on view. In a moderate tone, the newspaper opines that 'some of their products will claim ready admiration, but in other cases the axiom (applicable not alone to painting) that it is necessary to understand before criticising, must be applied' (Reading Mercury, 1945, p. 4). After mentioning Segall, Portinari and Pancetti as some of Brazil's greatest artists, the daily cites Vice-Marshall Babington, who 'suspected that, like those in this country, Brazilian artists were not blessed with large income so that the Exhibition represented a great sacrifice on their part' (Reading Mercury, 1945), an argument derived from lack of knowledge and/or from the reading of Sitwell's review. In another and more elaborate piece, *The Reading Standard* comments that the show was the first big contemporary collection of contemporary foreign art (Reading Standard, 1945, p. 8)

> to reach these shores since the War began, [which] emphasises the artistic isolation which this nation has experienced during the War years. This is probably one of the reasons why the first reaction of the visitor to this Exhibition is likely to be one of almost physical shock [...] these pictures possess for us a double exoticism. Practically every one of them presents an arresting combination of the exotic background of its creation, upon which is superimposed a super-modernity, in mode of expression. To our English eyes, attuned as they are to the quietest appeal of our national art tradition, these pictures are likely at first to baffle and perplex. Viewed sympathetically, however, it becomes obvious ... that Brazil has passed through a fundamental revolution in thought, and the work of her artists is, no doubt, but one expression of it.

After rhetorically posing the question of whether or not such experiments would succeed, the daily surmises that 'everyone will probably have a different answer to this' (Reading Standard, 1945, p. 8). For the newspaper, it was possible to 'discover much beauty expressed in this strange new

idiom [such as in Segall's] lovely study ... probably the finest work, [Portinari's] two arresting oils and a number of drawings' (Reading Standard, 1945, p. 8). Other laudatory references were made to Burle Marx's 'Landscape' ('a fine jungle study'); Quirino Campofiorito's 'very pleasing composition, modestly described as a "Landscape"'; Quirino da Silva's 'Landscape' ('another excellent study in oils ... the best landscape in the Exhibition'); Rossi Osir's seascape 'Fish' ('the many coloured freshly caught fish lie piled on the rocky foreshore and in the background is the choppy sea and stormy-looking horizon. One can almost smell the ozone!'); Guignard's 'two delightful landscapes'; Pancetti's 'Self-portrait' ('striking'); and Carlos Prado's 'Figure' and 'Portrait of the artist' ('a fine character study').

As one can infer from its coverage, the Brazilian press, except when reproducing *Reuters* news, played a major role in publicising and supporting the Exhibition, positively propagating the initiative amongst the domestic public. For the most part liberal and aligned with both the Modernist artists' and Minister Oswaldo Aranha's pro-Allies stance, some of the most important Brazilian newspapers acted as true campaigners for the Exhibition. By turn, the British media response to the Exhibition varied largely from city to city. In cosmopolitan London, as well as in Reading and Norwich, the evaluations were predominantly enthusiastic and the reviews focused on the aesthetic value of the Brazilian artworks, singling out painters' styles and qualities. In Edinburgh and Bristol, the evaluations were neutral; in the latter, the emphasis was placed on the sentimental and commercial aspects of the bilateral relations rather than on the paintings themselves. Glasgow's and Bath's dailies were more reluctant regarding the Exhibition's artistic quality. Professor Dawn Ades summarises her view of the coverage by saying that 'critical reception of the Exhibition in the United Kingdom press was on the whole positive if not extensive' (2018, p. 62). On a more encouraging note, and considering the interest in Brazilian culture among the British press prior to the Exhibition, the coverage was not only largely favourable but also surprisingly vast.

Chapter 3

HERMENEUTICS OF THE EXHIBITION

Meanings

Prestige is a constitutive element [...] of the power that arises not from arms or economic embargoes, but from the good example, from moral and cultural leadership[1]

Rubens Ricupero[2]

By a circular reading[3] of its components and circumstances, it was possible to form a coherent idea of the initiative as a whole and to offer answers to the intriguing questions that inspired this book. The interpretation of the *corpus* in its context allows this book to explain why the MRE, headed by Oswaldo Aranha, devoted uncommon efforts to promote the Exhibition. Thanks to a time horizons fusion that involved the cross-examination of

1 'O prestígio é um elemento constitutivo [...] do poder que nasce não das armas ou dos bloqueios econômicos, mas do exemplo, da liderança moral e cultural' (Ricupero, 2017, p. 631).

2 (Ricupero, 2017, p. 631).

3 The notion of circular interpretation was first developed by Friedrich Ast. For him, the foundational law of all understanding and knowledge is 'to find the spirit of the whole through the individual, and through the whole to grasp the individual' (as cited in Mantzavinos, 2016, p. 4). As a matter of fact, to depict the significance of the Exhibition, it was necessary to inter-relate hundreds of text fragments that mutually illuminate connotations of one another. In psychologist Martin Packer's words, a 'unique characteristic of hermeneutics is its openly dialogical nature: the returning to the object of inquiry again and again, each time with an increased understanding and a more complete interpretive account' (as cited in Peterson & Higgs, 2005, p. 343). Crotty summarises the subject by asserting that through the hermeneutic circle, the researcher attempts to understand 'the whole through grasping its parts and comprehending the meaning of the parts dividing the whole' (as cited in Peterson & Higgs, 2005, p. 345). The researcher becomes thus part of this circle, moving repeatedly between interpretations of parts and interpretations of the whole, generating an emerging understanding of the *phenomenon*. Using this method, the author of this book recognises the Exhibition as a whole, and, at the same time, identifies how this whole contextualises each of its elements, seeking to illuminate the *phenomenon* within its context.

126 PUBLIC DIPLOMACY ON THE FRONT LINE

past and present viewpoints,[4] it was possible to build the understanding that the Exhibition was conceived as a Public Diplomacy initiative *avant la lettre*, aimed at transforming Brazil's international reputation and advancing broader diplomatic objectives. More specifically, it constituted an action of Cultural Diplomacy intended to create a better environment for operating inter-state relations. Thought by its governmental planners as an action of Propaganda – the current term at that time, but today not appropriate for analysing the initiative – the superlative efforts devoted to produce the Exhibition were motivated by the foreign policy goal of renewing Brazil's cultural image among the British and the Allies. The pursued enhancement of Brazilian prestige was perceived by President Vargas and Minister Aranha as a means of positioning the nation as a major player in the global order that would emerge from the War. Analogously, the British government, which had organised shows in Brazil in the preceding years, saw the Exhibition as a foreign policy endeavour, opportune in a period when the South American country was growingly under the United States' sphere of influence. Magno's detailed 1936 diplomatic report about the intellectual environment in the United Kingdom and the hosting of British art shows in Brazil prior to the Exhibition show that it was, differently from what characterises the unidirectional Propaganda, a reciprocal action, which involved listening and understanding the host nation, so as to efficiently

4 Philosopher Hans-Georg Gadamer introduced the concept of understanding research findings through a fusion of horizons, by which the historical horizon of the past and the present horizon of the interpreter bridge the gap between the familiar and the unfamiliar (Peterson & Higgs, 2005, p. 346). The goal in hermeneutic research is to fuse the horizons of past, present and future understanding, using the hermeneutic circle and, as proposed by Professor Gary Aylesworth, relating 'the thing itself to the dialogue between the text and the reader' (as cited in Peterson & Higgs, 2005, p. 346). Through this method, it was possible to – despite divergent opinions about who idealised the Exhibition (bureaucrats or artists) and its underlying motivations (beneficence, marketing and politics) – develop an interpretive hypothesis of a governmental Public Diplomacy initiative. Similarly, thanks to the hermeneutic approach and to Mark Leonard's three-dimension framework (2002, pp. 8–21), this book was able to interpret the outcomes of the initiative, notwithstanding the temporal distance and the scarcity and dispersity of information, which hinders a rigorous monitoring of its effects. The catalogue for 'The Art of Diplomacy: Brazilian Modernism Painted for War' (2018), a development of and a source for this investigation, conveys this effort of fusing past and contemporary time frames, as indicated in its introductory text called '*A Modernist Palimpsest*' (Gadelha, 2018). After seventy-four years since the Exhibition, informed experts pored over primary texts in order to interpret various aspects of that past episode, benefiting from the advantageous retrospective viewpoint.

frame the Public Diplomacy enterprise. The message of solidarity in wartime was appealing for the British audience and succeeded in attracting its attention to a nation that was not especially memorable at that time. The entry into the War of a Latin-American country not obviously involved in the conflict, through the deployment of the FEB and sending the Exhibition, shaped the idea of a fast-modernising nation that could contribute in different realms to the post-War international order. The credible narrative found the right communication channels and matched the norms and values then dominant among the Western powers that would forge the new system, as desired by Brazilian leaders. The two-way nature of the initiative, the high-level political engagement, the involvement of British individuals and institutions, the non-governmental participation, the intentional apparent distance from officialdom and its domestic effects, together, demonstrate the sophistication of this Public Diplomacy drive. Aligned with Brazil's declared foreign policy priorities, the diplomatic message was successfully conveyed, benefitting from the singular geopolitical circumstances and the previously gathered knowledge about the host society and its wartime cultural context. The perceptions of Brazil were thus impacted by a well-planned and developed Public Diplomacy endeavour, consistent with both the nation's policies and the United Kingdom's conjuncture.

As studied in the sections 'Background' and 'Arrangements', the Exhibition was announced in the press as a purely private and spontaneous initiative devised by Brazilian Modernist painters. In open letters and interviews, they emphasised the supposedly unofficial aspect of the enterprise, which could lead a superficial research to accept this version, also encouraged by authorities of those times. However, the hermeneutic examination of the fragmented information on the Exhibition, especially of bureaucratic documents from Brazil and the United Kingdom, proved that even though a few artists had idealised the endeavour, its concretisation was only possible due to the resolute work of the Itamaraty, led by Oswaldo Aranha. It was not an isolated case, as an alliance of cultural agents, journalists and diplomats had launched a campaign to make Modernism the international representation of Brazil's culture, in order to better project a national image in line with Vargas' external objectives[5] (Williams, 2001, p. 3657). Aranha cultivated personal relationships and shared liberal and pro-Allies attitudes with Modernist intellectuals and was, for these reasons, the natural recipient of a letter in which the painters Alcides da Rocha Miranda and Augusto Rodrigues expressed their wish that 'Your Excellency support us so that our

5 See the section on the 'Internationalisation of Brazilian Visual Arts'.

128 PUBLIC DIPLOMACY ON THE FRONT LINE

contribution obtain the relevance we expect'[6] (Diário Carioca, 1943, p. 5). Shortly after, Rocha Miranda would publicly acknowledge the engagement of part of the government and enthusiastically recognise Aranha's decisive role in advancing the initiative (Estado de São Paulo, 1943, p. 3). On several occasions, the artists praised the Minister's and his successor's support, without which, as this book demonstrates, the Exhibition would have been no more than a romantic idea. Aranha was the one who enticed the press and, by means of it, persuaded a reluctant British government to back the project. In fact, official communications reveal that the major reason for the United Kingdom's bureaucracy to take part in the endeavour was not to displease the Brazilian government. Furthermore, all complex logistics, from shipping to finding a venue for the artworks, resulted from official actions and negotiations.

In truth, the original motivations of the artists only partially coincided with the motives that drove the Ministry of Foreign Affairs' direct commitment with the Exhibition. The Modernist painters who conceived of the sending their works to London highlighted the values that they shared with the British and the Allies in those times of WW2. They also spoke of cultural exchange and democratic causes, such as the freedom of expression. Rocha Miranda, a first advocate of the project, openly said that they wanted to compel the government to side with the Allies (Estado de São Paulo, 1943, p. 3). Manoel Martins, in turn, underscored their purpose of joining the War effort (Diário Carioca, 1944). Portinari, the most renowned painter who contributed works to the Exhibition, referred to the intention of revealing to the British the high level of quality of Brazilian art (Diário Carioca, 1944). Finally, there was a certain concern with their own recognition abroad, in varied degrees. Rubem Navarra alluded to some participating painters who wanted self-promotion at any cost and would thus have been satisfied with the content of the catalogue, in his opinion depreciative of Brazilian Modern Art[7] (Navarra R., 1945). The declared goal of forming a collection of Brazilian paintings in the United Kingdom also highlights the self-interest of some artists, even if outweighed by altruistic and romantic feelings. Luiz Aquila believes that political idealism 'was indeed the driving force behind the artists' gesture, rather than any self-promotional consideration' (as cited in Gadelha, 2018, p. 29). In his opinion, the artists were unfamiliar with the idea of an art market, very incipient in Brazil at that time, and would

6 *'Desejaríamos que v. excia nos apoiasse para que a nossa contribuição obtivesse o relevo que esperamos'* (Diário Carioca, 1943, p. 5).

7 See the 'Navarra's Criticism' subsection.

have been moved by a somehow naive desire of contributing to the Allied effort and pleading with the Brazilian government to side with Western powers and values. In a different and intermediary view, Zanini argues that the Exhibition merged interests of solidarity in the War against Nazism and of artistic promotion (1991, p. 63). Each of the seventy artists involved with the initiative had their own specific incentives, but it should be natural that self-interested considerations affected at least some of them. In any case, the endeavour would promptly become an official enterprise, and this book's central question relates to the Brazilian government's *rationale*. Minister Aranha was, as demonstrated, the main responsible for the Exhibition come to fruition, despite public attempts to make it look like a spontaneous gesture of Modernist artists. This shows that he was concerned both with distancing the show from overtly official messages and with involving non-governmental players in the initiative, aligned with the recommendations of today Public Diplomacy scholars. In this way, he achieved to lend credibility to the message projected by the Brazilian diplomacy. On the other hand, this desirable participation of unofficial actors makes some of the Public Diplomacy initiatives' developments uncontrollable. An example of that were the controversial and prejudiced words of Sitwell published in the catalogue, which resonated throughout the press.[8] Effectively, his uninformed and uncomplimentary view of Brazilian art was not favourable to the Exhibition and constituted a side-effect of the inherently unruly engagement of non-governmental players in initiatives of Public Diplomacy (Gienow-Hecht, 2010, p. 4).

It is worth noting that, as much as Aranha's, the main interest of the British in holding the Exhibition was declared 'a political, not an artistic one' (Perowne V., 1944), as Victor Perowne affirmed at the time. Aranha's counterpart, the Foreign Secretary Eden, was an early practitioner of Propaganda or, as argued along this book, of Public Diplomacy *avant la lettre*. For him 'good cultural Propaganda cannot remedy the damage done by a bad foreign policy, but it is no exaggeration to say that even the best of diplomatic policies may fail if it neglects the task of interpretation and persuasion which modern conditions impose' (as cited in Nye Jr., 2008, p. 97). In turn, the British Ambassador to Rio de Janeiro referred to the Exhibition as a form of intellectual cooperation and urged his government to extract 'the maximum Propaganda value' from the gesture of Brazilian artists (Charles, 1943). Similarly, the Exhibition curator Alfred Longden, in a BC report, affirmed that 'one of the [BC's] most important missions should be to indulge in Propaganda abroad

8 See the 'Press Coverage' and 'The Catalogue' sections.

in the sphere of the arts, [since it] has repercussions not only in the political but also in the commercial fields' (Longden A. A., 1935). Bristol's Lord Mayor Cottrell, who hosted the Exhibition in his city, also expressed that 'our business relations with Brazil (interrupted through no fault of our own) might be resumed and expanded at an early date' (Bristol Evening Post, 1945, p. 2). These views meet the previously proposed interpretation that the British, in 1944, were looking towards the post-War bilateral relations and anticipating lucrative trade deals that they could negotiate with Brazil (Lochery, 2014, p. 227). On the Brazilian side, the *Chargé d'Affaires* in London also used the term Propaganda and opined that the Exhibition was of unprecedented relevance (Sousa-Leão J. d., 1944). Ambassador Moniz de Aragão called it an event of great cultural significance and magnificent Propaganda for Brazil (Moniz de Aragão J. J., 1945) and Cultural *Attaché* Magno had, a decade before, planned an active work of intellectual Propaganda in London.[9] The prolific allusions to the Exhibition's positive effects on the bilateral relations, from representative of both countries, corroborates Bull & Pisano's belief that 'art is rarely "for art sake", as politics and ideology are never far away' (2017, p. 10). It is relevant to note that, at the same time when the Exhibition was being prepared, the Brazilian government was launching parallel actions of commercial promotion, including the opening of trade bureaus abroad, and demanding a greater role in the definition of the post-War international concert.

The interpretation of perceptions from past observers favours the fusion of time horizons and allows one to understand how the available interpretive tools influence the hermeneutics of the Exhibition *phenomenon*. Notwithstanding that it was then classified by its own conceivers as a (successful) Propaganda action, its innovative and sophisticated characteristics would distance the Exhibition from what is currently understood as Propaganda. The initiative was deployed – and received – as a Propaganda initiative to advance political, economic and trade interests, but its two-way approach extrapolated the currently contaminated notion of Propaganda and embraced elements that characterise what one calls, nowadays, a Public Diplomacy drive. Nye Jr. teaches that effective Public Diplomacy involves listening and talking and presupposes understanding the minds of foreigners and the values shared with them (2008, p. 103). For Leonard, if the Public Diplomacy activity 'seems to be coming from a standpoint of mutual interest rather than promotional work by one country

9 Secretary Gouthier, when opened the show in Bath, listed further actions which could comprise a contemporary Public Diplomacy plan that included listening, advocacy, Cultural Diplomacy, exchange diplomacy and international news broadcasting (Cowan & Cull, 2008).

HERMENEUTICS OF THE EXHIBITION

in another, then it will have greater a impact and be treated with less suspicion on both sides' (2002, p. 50). Initial evidence that the Exhibition encompassed not only advocating but also listening is the fact that, years before holding the show, the Brazilian Embassy in London had prepared the previously analysed report about the cultural presence of Brazil in the United Kingdom, which underpinned a plan for future intellectual cooperation. The diplomatic report by Magno studied in the section on 'Brazil's Image before the Exhibition' disclosed a serious pursuit in apprehending the role of culture in British society and the opportunities for updating perceptions about Brazil. The decision to convey a message of solidarity in the dark times of War revealed an acute discernment of the United Kingdom's context and proved to be effective in engaging its society. Moreover, the Itamaraty had recently helped the BCorganise at least three art shows in Brazil – one of children's art (1941), the Exhibition of British Contemporary Prints (1942) and the Exhibition of British Contemporary Paintings (1943–1944).[10] The latter was organised along very similar lines of the Exhibition, demonstrating the mutual enthusiasm for fostering reciprocal knowledge and admiration between the two societies. It is noteworthy that this perception of the Exhibition as being a retribution was expressed by British authorities on several occasions. During its opening at the Royal Academy, for instance, BC Chairman Robertson, made a reference – that corroborates this idea of reciprocity – to 'how generous the Brazilian government had been in lending galleries in Brazil to the British Council' (Perowne V., 1944). In Zanini's view, the Exhibition in London indeed functioned as a kind of repayment by Brazilian artists to the British (1991, p. 56). Likewise, Navarra called it a retribution sign that Brazilians warmly welcome the interexchange of feelings and ideas (1945, p. 16). High-level bilateral contacts around cultural initiatives by authorities concerned with public aspects of diplomacy reveal the two-way nature of the Exhibition and other contemporary diplomatic actions.

From a Public Diplomacy standpoint, image enhancement efforts are also thought of as part of broader strategies that involve increasing economic and political clout abroad. The extraordinary level of diplomatic involvement in the initiative endorses the argument that the Exhibition dealt, in line with the original definition of Public Diplomacy by Gullion, with the influence of public attitudes on foreign policies, the cultivation by governments of public opinion in other countries, interaction of private groups and interests in one country with another and intercultural communications (Cowan & Cull, 2008, p. 6). At the same time, it is evident that the Exhibition comprised the

10 See the section on the 'Internationalisation of Brazilian visual arts'.

Cultural Diplomacy subset of Public Diplomacy, which aims at establishing direct and enduring contact between peoples to develop an environment of trust and understanding in which official relations operate better (Gienow-Hecht J. D., 2010, p. 13). It constituted, therefore, a mutually interesting enterprise of Cultural Diplomacy – a category of Public Diplomacy – intended to facilitate further political and economic diplomatic goals by means of strengthening ties between Brazilian and British societies. The Exhibition was thus an effective part of a broader foreign programme of prestige, as inferred from the cyclic reading of past data and present views. It is illustrative to quote a few authorities who have recently – animated by the research that led to this book– examined the 1944 initiative. Eduardo dos Santos, former Brazilian Ambassador to the United Kingdom (2015–2018), opines that 'the initiative was indeed a creative and effective action of Public Diplomacy, aimed at bringing the Brazilians and British closer together during those dark days of global conflict' (2018, p. 11). From the United Kingdom's standpoint, Ciáran Devane, Chief Executive of the BC (2015–2021), endorses this view when he states that the Exhibition 'is an extraordinary testament to the power of Cultural Diplomacy, and the deep connections between our two countries' (2018, p. 21). Air-Vice Marshall and Controller of the RAF Benevolent Fund (2016–2020), David Murray (2016–2020), considers the 1944 Exhibition 'an important milestone in bilateral relations and in Cultural Diplomacy' (2018, p. 19). Adrian Locke, finally, judges that Brazil 'was preparing itself for a bright and prosperous future as a true global player in which art and culture would play a significant role' (2018, p. 70).

This book argues that, although these concepts had not yet been coined at the time, the FEB and the Exhibition, both of which crossed the Atlantic Ocean in 1944, are examples of Brazil's active presence on what Carvalho called 'two fronts of the same War' (2018, p. 54) and aimed at repositioning the nation as a major global player. The direct participation of several individuals and institutions both in Brazil and in the United Kingdom denotes its intricacy and the ambition of the Exhibition planners, as this involvement increased its credibility and the chances of impacting national reputation. The Exhibition benefited from great support and engagement of important organisations from the host society, such as the BC, the Foreign Office and the RAA, in line with today's argument that cultural promotion is a means of building international relationships (Zaharna, 2009, p. 88). In this sense, British diplomat Shaun Riordan asserts that Public Diplomacy is more effective 'with the help of non-governmental agents of the sending country's own civil society and by employing local networks in target countries' (as cited in Melissen, 2005, p. 16). For similar reasons that were only elaborated by current days' Public Diplomacy scholars, the initiative planners had evidently intuited former British diplomat Alan

HERMENEUTICS OF THE EXHIBITION 133

Hunt's proposition that in cultural exchanges, 'there is an argument, in terms of enhancing their credibility, for putting some distance between them and the government themselves' (2015, p. 62). This aspect was cultivated by the bureaucrats behind the Exhibition, who emphatically underscored the spontaneity of the gesture, which should be seen as one conceived and led by the Brazilian artists (Diário Carioca, 1943), despite the manifest backing of the government and the Ministry of Foreign Affairs, especially. This book further ascertains, therefore, that the reason why the Itamaraty devoted notable efforts to promote the Exhibition was its potential to, together with Brazilian military participation in WW2, alter British perceptions about Brazil, a country of clearly limited relevance for British people at that time. After all, as proved in the section on 'Brazil's Wartime Foreign Policy', the declining political and economic relevance of the nation for the United Kingdom reached a minimum in the isolationist environment that preceded the War, when severe crises impacted the bilateral relations. The once solid alliance between Brazil and the United Kingdom was replaced by ignorance in the British society about the South American country, whose culture was virtually unknown in Europe at that time. The unawareness about Brazil in the United Kingdom, as stressed in the 1936 Embassy report, was a handicap, but also, as understood by the Vargas government, an opportunity. The internationalisation of Brazilian culture during the 1940s would benefit from what Simon Anholt calls 'the critical issue of relevance', meaning that people who do not feel that a foreign country is important to their lives are less inclined to pay attention to it, although their minds may be more likely to be changed by new and appealing events (2010, p. 148). Today, in contrast, there is a complex fabric of perceptions about Brazil amongst the British. An emblematic example of that is the fact that, contrarily to what happened in the early 1940s, the 2018 catalogue of 'The Art of Diplomacy – Brazilian Modernism Painted for War' (TAoD) contains in-depth essays by several experts on Brazil's Modernism. It is notably easier to draw attention to the country nowadays, but far more challenging to considerably alter its consolidated manifold image. To achieve a greater impact, the Exhibition took advantage from the United States' support, as their influence over the hemisphere and Brazil in special had increased enormously after the Great War. As an emerging power, the United States was acting as a mediator between the then distant former allies. It resolved serious diplomatic crises involving the release of arms bought by Brazil from Germany, backed the deployment of the FEB against British reluctance and validated Brazilian cultural expressions that would transform the international perceptions about the country.[11]

11 See the chapter on the 'Historical Context'.

134 PUBLIC DIPLOMACY ON THE FRONT LINE

Whereas the deployment of troops by Brazil was an unexpected contribution amid WW2, the uncommon resolution behind sending an unprecedented art collection to Europe was even more outstanding considering the capital challenges imposed by the conflict. The consummation of both the Exhibition and the FEB relied on Aranha's personal commitment. Since the show's outset, he has directly participated, devising a specific narrative with Modernist choices, coordinating logistics, broadcasting through media channels and establishing high-level political contacts to ensure British engagement. By means of publicising a powerful narrative, he managed to convince Ambassador Charles and Foreign Secretary Eden of the Exhibition's political importance for strengthening bilateral ties. This way, it was guaranteed the financing, shipping, insurance, storage and display of the 168 artworks that entered British soil during wartime. From the examination of the Exhibition's preparation and its historical context, it is evident that, as much as the Expeditionary Force, this unparalleled cultural initiative can only be understood within a specific diplomatic framework intended to transform Brazil's image abroad and its global role. As discussed previously, the enhancement of British-Brazilian relations was a mutual goal, and first-hand observers perceived reciprocal diplomatic moves intended to resume the political and economic alliance between Brazil and the United Kingdom. It is important to highlight that the capacity to gather political support in order to hold the Exhibition was a distinctive feature granted by Oswaldo Aranha to the endeavour, which mitigates Anholt's criticism about the frequent disconnection between governmental decisions and foreign communication objectives (2010, p. 99). In this aspect, notwithstanding the validity of these theoretical caveats, one realises that the Exhibition was exceptional, for its architect enjoyed enormous domestic power and political influence, having direct access, almost in equal terms, to President Vargas (Ricupero, 2017, p. 323). This unique position arguably enabled him to precociously accomplish advancing his Public Diplomacy to sophisticated levels, even before Edward Murrow's[12] (1908–1965) famed aeronautic analogy about the importance of considering it during the first stages ('take-off') of the domestic decision-making process.

Moreover, the Exhibition was first idealised by a group of artists representative of Brazilian Modernism, which, having gained domestic legitimacy, was at that time expanding beyond national borders.[13] It is interesting to mention that not only was this heterogeneous movement

12 Head of the United States Information Agency (USIA) under President John Kennedy (1917–1963) administration (1961–1963).

13 See the section on the 'Internationalisation of Brazilian Visual Arts'.

a constituency for the initiative, but it also found in the project (and in the pro-Allies stance in general) a unifying theme that appealed to painters from very different backgrounds and aesthetic currents. Until then, the Modernists used to form multiple dissimilar groupings, most of which were represented in the Exhibition. It constituted an early example of a certain coadunation of interests that would become more visible in the following decade. Ten years after the Exhibition, a few of its contributors – Camargo, Dacosta and Djanira – would lead the *Salão Preto e Branco* (Black and White Salon). On this occasion, Brazilian artists presented only achromatic artworks as a protest against the governmental decision of taxing paint and other artistic materials as non-essential products, ironically conceived by the then Minister of Economy (1953–1954), Oswaldo Aranha. The participation in this salon of other painters who had sent works to the Exhibition, including the prize-winners Bonadei and Rebolo, suggests that the mobilisation of wartime strengthened relationships between artists, which would develop into a professional union around common causes (Morais, 1994 pp. 229–230). Other domestic aspect of the Exhibition, thought by the artists as a form of pressure against the successive postponements of the presidential elections in Brazil, was its contribution to changing the way Brazilians perceived their own culture. A view by Ruben Navarra, the Brazilian art critic who had written an introduction to the Exhibition catalogue, is illustrative of this. He opined that Brazil had passed the test of being presented to a most cultivated audience in London, a triumph that should inform those in Brazil who were still suspicious of its modern painting (Navarra R., 1945). This statement indicates an underlying intention of, by means of the Exhibition, influencing the domestic audience through the *imprimatur* of external acceptance, in line with Mark's idea of 'feel good effect' (2009, p. 29). The degree of the internal impacts, as the theory goes, depends on the extent of media coverage. Once more, the unprecedented attention devoted by British and Brazilian newspapers to the Exhibition, as discussed in the 'Press Coverage' section, ratifies the argument that, as a Public Diplomacy action, it had significant domestic consequences. All this considered, the Exhibition represented a paradigm of deploying Public Diplomacy as an essential part of a broader and articulated diplomacy, anchored in domestic policies and interests, which current theory considers a condition for its effectiveness. Another trait of Cultural Diplomacy present in the Exhibition was the engagement of diaspora members (Mark, 2009, p. 11). It was attended by many Brazilians living in London (Sousa-Leão J. d., 1944), some of whom, such as the playwright Antonio Callado, even acquired artworks for their private collections.[14]

14 Callado bought the 'Head of a Girl', by Guignard, for £12.12.

136 PUBLIC DIPLOMACY ON THE FRONT LINE

The interpretive study of the *corpus*, furthermore, reveals the occurrence of the lasting characteristics that, according to Dumont and Fléchet, had just been forged and characterised a Brazilian mark of Cultural Diplomacy.[15] Institutional disorder was notorious for the divergences in opinion between the Itamaraty and other organs of the Brazilian government, and even between the former and the Embassy in London. Aranha's concept of the Exhibition, to detriment of the Ambassador's recommendation of a traditional art show, was emblematic. It is also meaningful that the Embassy was informed of the Exhibition by the press.[16] At the same time, the pragmatism in the thematic and geographic choices was evident in the case of the Exhibition, which reflected a coherent attempt to convey a specific message – progress – to a determined society – the British. Finally, the election of Modernism, which was still controversial at home, to be the protagonist of Brazil's image enhancement initiative, was a fundamental aspect of the Exhibition, clearly indicating its diplomatic motivation, as the message was tailor-made for Vargas's administration's foreign goals. In this regard, Daryle Williams highlights that 'Brazilian Modernism provided a language that bespoke of tomorrowness and otherness' (2001, p. 3599). According to the document prepared by Aranha for the meeting between Vargas and Roosevelt in Natal, Brazil's top priority in the early 1940s was to improve its reputation and thus achieve higher status on the post-War world stage.[17] Both the FEB deployment and the Exhibition were, indeed, part of a comprehensive political strategy devised by the Minister, an early advocate of siding with the Allies in the long-time fickle Vargas' cabinet. It is interesting to note that even when deploying its expeditionary armed force, Brazil was ultimately pursuing prestige (Hilton, 1994, p. 1417). As a matter of fact, recurrent positive public references from the British regarding the Brazilian involvement in the War demonstrated its potential for Public Diplomacy, by creating affective ties between the two societies. In the openings of the Exhibition across the United Kingdom, speaking authorities usually exalted the Brazilian military's part in the War, including the reverential words of Lord Sherwood at the RAA.[18] It is finally noteworthy the clever use of the military comradeship narrative – dovetailed for the British audience in wartime – considering that Brazil had long cultivated its image of a pacific nation. Sousa-Leão had written in 1944 that Brazil loved peace and its heroes were not military (1944, p. 83), in a clear reference to the Baron of Rio Branco, the patron of

15 See the section on the 'Internationalisation of Brazilian Visual Arts'.
16 'See the 'Background' section.
17 See the section on 'Brazil's Wartime Foreign Policy'.
18 See the 'Arrangements' section and the 'At Burlington House' subsection.

HERMENEUTICS OF THE EXHIBITION

Brazilian diplomacy, who is still today considered a master of the persuasive foreign policy, in opposition to the coercive one. This discursive adaptation endorses the argument that Brazilian diplomacy studied and interpreted the special circumstances of WW2 and developed a befitting message to convey to the Allies. Whilst Aranha's list revealed Brazilian priorities and Magno's report laid out challenges in the cultural relations with the United Kingdom, the aforementioned document prepared by the Foreign Office to brief the RAF about the Exhibition expressed that the British audience was becoming aware of Brazil for its economic development and for its part in the War, but was still ignorant of its contemporary culture (Charles, 1944). Boosting perceptions of Brazil – prompted by its thriving economy, regional leadership and especially its battles fought in WW2 – created an inviting environment for the nation to renew its international credentials. The positive impressions caused by these recent events, including the already commented donation of airplanes by Brazilian individuals organised at the Fellowship of the Bellows,[19] made it possible for Brazil to successfully brand the Exhibition as a gesture of friendship and solidarity, as the RAF itself used to call the initiative (RAF, 1948, p. 244). The vague image of Brazil prevalent in the United Kingdom that the time was being visibly updated by this new information on its role in the War. It was to a large extent the result of a purposeful diplomatic project, since Brazilian embassies were receiving Propaganda-tinged materials on the nation's involvement in WW2 (Ferreira, 2013, p. 80). As analysed in detail throughout Chapter 1, Brazil intended to profit from the *momentum* and present itself beyond old stereotypes, by offering its contribution to more sophisticated human fields, such as *avant-garde* culture. The Vargas administration's goal was to project the image of a 'civilised' modern country, capable of producing art equal to that of Western countries, with which Brazil believed to share values and a common destiny.

In order to bridge this gap, Aranha's diplomacy sensed that the Exhibition could contribute to building highly positive perceptions and goodwill towards Brazil. The goal of transforming Brazil's image required the development of a powerful and suitable message, which would be carried by its military and cultural involvement in the War. The Brazilian government managed to convey through both ways an image of morally like-minded, artistically compelling and militarily powerful nation. As revealed by the study of official cables, Aranha ignored the Embassy in London's recommendations of organising a traditional show of conservative art in the British capital. After all, his foreign policy goal of repositioning the image of Brazil

19 See the section on 'Brazil's Image before the Exhibition'.

as a producer of new culture required a different sort of aesthetic. He wanted to demonstrate that Brazil could contribute to the world order by offering vanguard artistic expressions instead of only exporting primary goods. The same logic was behind the inclusion of the already canonised Brazilian modern architecture pictures, since countries convey 'a modern image of themselves to help advance their economic interests and to make themselves more attractive to foreign publics' (Mark, 2009, p. 23). In this sense, the artists' projected values – Navarra summarised them as belonging to the Western, Christian, civilised and universal group of nations (1945, p. 18) – converged with Aranha's view of the Brazilian place in the global system. When he handed the Exhibition to the British Ambassador in Rio de Janeiro, he spoke to the press about the fight against the Nazism evil and the defence of the freedom of artistic creation (Diário Carioca, 1943, p. 3), which discloses the thoroughly devised core message of the narrative. It also shows the potent combination of morality, strength, aesthetics and relevance contained in the message conveyed by the Exhibition, aligned with the attributes of national reputation posed by Simon Anholt (2015, p. 199). After all, as Naren Chitty argues, 'benignity and rectitude may be viewed as core civic virtues, attractive behaviours associated with promoting the public good rather than one's personal interests' (2017, p. 27). In addition, according to Nancy Snow's theory, the change of a nation's perceptions occurs when its culture and ideas access major communication channels and match the internationally prevailing norms, based on domestic and external behaviour that inspire credibility (2009, p. 3). As a matter of fact, Brazilian Modernist aesthetics corresponded to the emerging universal artistic standards, even though the British were not at the forefront of the movement.[20] By means of the show, Brazilian foreign policy wanted to project, having reached mainstream communication channels, its universal and Modern Art, which agreed with Western hegemonic values at the time. The analysis of discourses by British authorities confirms that the double part played by Brazil in the War, of which the FEB and the Exhibition would represent its hard and soft expressions (Carvalho, 2019), led to the increase of the nation's prestige. For Carvalho, 'in few moments of Brazilian history did an initiative of Cultural Diplomacy act in parallel with robust actions designed to project international power abroad' (2018, p. 54). The impact of the Exhibition on the then prevailing perceptions about Brazil was patent. The governmental message, as viewed in the historical chapter, converged with Modernist painters' self-perception and their desire of aligning Brazil

20 See the section on the 'Internationalisation of Brazilian Visual Arts'.

with the envisaged West intellectual and artistic unity. Thus, the label of a noble gesture of cultural cooperation against the authoritarian forces, which was part of the Exhibition's conception, proved to be attuned with British and Allied sensibilities during the War period. Brazilian diplomacy demonstrated its capacity of developing a world-class, consistent and coherent message, which is arguably the central element of a Public Diplomacy initiative (Anholt, 2015, p. 190). As this book demonstrates, the Exhibition accomplished to reap benefits from all these elements that comprise a state-of-the-art model of Public Diplomacy. The uncovering and cyclic interpretation of the *corpus* revealed that the Exhibition formed a diplomatic attempt to impact Brazilian international image and improve relations with the British.

Legacies

The effectiveness of Public Diplomacy is measured by minds changed
Joseph Nye Jr.[21]

The hermeneutic analysis of the *corpus* of this book reveals a genuine satisfaction among the actors involved in the Exhibition, both in Brazil and the United Kingdom, who chose superlative adjectives to describe the initiative in private, official and public texts. 'Splendid', 'magnificent', 'unprecedented', 'very satisfactory' and "appreciable triumph" are a few of the expressions mentioned in this book that were used by those who observed the Exhibition in the 1940s, including some of the initially sceptical ones. They emphasised, as commented in the previous section, the 'most happy effects' on bilateral relations, whose improvement was, for the Brazilian and British governments, the initiative's first objective. As demonstrated, the Exhibition, together with Brazilian military participation in WW2, formed a consistent attempt to alter national perceptions in the United Kingdom, by means of a well-planned and executed Public Diplomacy action. The importance attributed by its government to changing Brazil's reputation amongst the British and other Western societies explains the unique efforts allotted by the Itamaraty to bring the Exhibition to fruition. The circular readings of the book's *corpus* and the utilisation of contemporary diplomatic concepts have made it viable to delve into the evaluation of the results of the Exhibition, now understood as a public – and cultural – diplomacy initiative. Through the examination of multiple documents, it was possible to decipher fragments of data in order to

21 (Nye Jr., 2008, p. 101).

have some indication of whether and to what extent the enterprise achieved its main goals. One of the few consensuses amongst scholars of international communication is the complexity of achieving an efficient measurement of its impacts. Strategic communication scholar James Pamment goes farther still in asserting that 'evaluation of Public Diplomacy is more or less impossible' (2015, p. 364). Communication researchers Gerry Power and Tom Curran argue that multi-country *indices* are part of the arsenal of the Public Diplomacy community, albeit many actors express reservations about their methodology (2018). Amongst what he calls the 'dirty dozen' obstacles to the assessment of Public Diplomacy, Robert Banks lists its intangibility, the challenge of tracking elites, the labour and costs involved in the process, the vague causality links, the scarcity of baseline data, the lack of continuity and the necessity of a long-term analysis (Hunt, 2015, p. 118), all of which are verifiable in this case study. The time horizon of analysis is indeed a major factor for gauging Public Diplomacy actions, which led various authors to differentiate outputs – immediate quantitative impacts of interventions, such as attendance – from outcomes – indirect and slow-burning qualitative impacts over a longer period (Anholt, 2015, p. 194) (Bull & Pisano, 2017, p. 9). In the case of the Exhibition, the latter are especially hard to scrutinise, considering the lapse of time since the event and the scarcity of existing data. Nonetheless, Hunt reminds one that, despite being difficult and expensive, evaluation of Public Diplomacy is necessary, and 'confident measurement of long-term outcomes remains the Holy Grail for which all Public Diplomacy practitioners still strive' (2015, p. 123). As per the benefits of the challenging endeavour, banks emphasises the possibility of better allocating resources and justifying budget requests, the build-up of a domestic constituency for Public Diplomacy and the setting of best practices (Hunt, 2015, p. 118).

In view of this, hermeneutics was an appropriate methodological choice for examining the Exhibition's impacts since the interpretive analysis of a myriad of texts interrelated in multiple ways enabled the research behind this book to identify not only outputs but also outcomes and shortcomings of the studied *phenomenon*. In order to evaluate the successes and flaws of the Exhibition, from the collected information, it is necessary in the first place to list and distinguish its different international goals,[22] and afterwards

22 As already examined in the 'Emergence of Modernism in Brazil' section, there was also a domestic component, since the Exhibition was used by Modernist painters as leverage, calling for immediate free elections in Brazil, aligned and for coherence with its stance in the international conflict. Elections were held in December 1945.

HERMENEUTICS OF THE EXHIBITION

gather evidence to analyse its impacts. The most immediate and openly expressed intention of the artists who donated their artworks, according to them, was to contribute to the British War effort, through raising funds to aid the RAF. Another cultural goal, debated since the planning stage of the show, was to form the basis of a collection of Brazilian art in the United Kingdom, as widely advertised by British newspapers at the end of 1943.[23] In addition, and more importantly for the painters, was their desire to make a symbolic gesture to show support to the Allies and the democratic cause.[24] From the Brazilian diplomatic standpoint, which is the one privileged by this book, Vargas' government aimed, by means of sending the Exhibition to the United Kingdom, at gaining prestige and accomplishing foreign goals with both bilateral and more diffuse effects. After a period of strained relations with the United Kingdom,[25] the Itamaraty pursued stronger ties to the British, who were seen as a potential political and economic counterweight to Brazilian growing dependence on the United States. From a global viewpoint, Brazil's policymakers had the ambition for a role of first importance in the order that would emerge from WW2. As understood by Vargas' diplomacy, symbolic credentials were required to strengthen relations with the United Kingdom and to bring the nation into the group of powers that would forge and command the new international concert. The governmental and artistic objectives, hence, converged around the development of a renewed perception of Brazil abroad. The Exhibition, as shown in the Meanings section, was conceived as a vehicle for a tailor-made message, intended to transform the image of Brazil into one of a modernising and culturally effervescent nation and a leading country in the post-War international system.

Following Hunt's lesson that, 'the easy part is measuring inputs and outputs [as] outcomes are more difficult to judge' (Hunt, 2015, p. 113), this book has first gathered sufficient data to demonstrate the Exhibition's quantifiable and immediate results. Along the *corpus* chapter, this book presented and examined the press repercussion of the Exhibition, the sales of artworks and catalogues, the formation of a collection of Brazilian art and other measurable figures of the initiative. In order to gauge the public reach of the Exhibition, official records and newspaper articles from that period were thoroughly analysed. A most tangible output of the initiative is the financial contribution to the British War effort. Around 80 of the 168 canvases displayed

23 See the 'Press Coverage' section.
24 See the 'Background' and 'Meanings' sections.
25 See the section on 'Brazil's Wartime Foreign Policy'.

142 PUBLIC DIPLOMACY ON THE FRONT LINE

at the show were sold for £1,184.16.5. This amount, summed with another £307.9.1 from tickets and an estimated 6,383 catalogues sold,[26] was gifted to the RAF Benevolent Fund,[27] as per the initial wish of the donating artists (Foreign Office, 1945). In an internal publication called *Flight*, the RAF gratefully notes that 'nearly £1,500 has been collected for the RAF Benevolent Fund by the sale and Exhibition of pictures by noted Brazilian artists' (RAF, 1948, p. 244). The most highly valued artworks, as expected, were Portinari's 'Group', acquired for £180 by Brazilian diplomat Hugo Gouthier; and Segall's 'Lucy with flower', bought for £75 by the BC to be later donated to the Edinburgh Art Gallery (Longden A., 1945). The originally assessed value of the collection, in Brazil, was £10,000;[28] the British, in turn, had insured the paintings for £1,700.[29] One could argue that the total given money was unimpressive, in comparison, for instance, to the donation of £100,000 by the Fellowship of the Bellows of Brazil earlier that year.[30] An opposing and indulgent opinion is delivered by Air Vice-Marshall David Murray, Controller of the RAF, for whom the Exhibition 'raised considerable monies for the RAF Benevolent Fund' (2018, p. 19). This author judges the money raised a satisfactory output, in view of the virtual unawareness of Brazilian art in the United Kingdom and taking into account the previously estimated value of the whole collection.

The goal of building the embryo of a Brazilian collection was accomplished and contributed, to some extent, to the subsequent cultural interexchange between the two countries. This book located the whereabouts of some of the displayed artworks, which spread not only throughout the United Kingdom but worldwide after the Exhibition was dismantled. For instance, in Ceará State, North-East Brazil, '*Mulher e crianças* [Group]' by Portinari, '*Menino na paisagem* [Music]' by Aldo Bonadei, and 'Circus' by Raimundo Cela were found – the former two in private collections and the latter at the Federal University Art Museum. In São Paulo, there are 'Landscape', by Tarsila do Amaral, originally acquired by Peter Watson from Horizon magazine and now in a private collection; and 'Red fish', by Oswaldo

26 The catalogue print run cost £215.5.7, and their sale rendered £70 at the Royal Academy, £47.15.0 in Glasgow, £32.10.0 in Edinburgh, £10.8.4 in Norwich, £9.8.9 in Reading, £7.3.0 in Bath, £6.14.0 at Whitechapel and £3.18.0 in Bristol (Foreign Office, 1945).

27 Costs of galleries lending, transporting and printing the catalogues amounted to £681.5.5.

28 See the 'Press Coverage' section.

29 See the 'Arrangements' section.

30 See the section on 'Brazil's Image before the Exhibition'.

HERMENEUTICS OF THE EXHIBITION

Goeldi, at the MAM-SP. Works by Poty Lazzarotto and Paulo Werneck belong mostly to their families in Curitiba and Rio de Janeiro, respectively. Vieira da Silva's *Lisboa* [Composition]' was found in a private gallery in Paris. The Auckland Art Gallery Toi o Tamaki houses eight of the Exhibition works (*Vila operária* [Town]' by Livio Abramo; *Nausicaa*' by Axl Leskoschek; 'Fishermen' by Goeldi; *Desenho* [Women at the window]' by Augusto Rodrigues; 'Girls' by Carlos Leão; 'Figure' by Oscar Meira; 'Prophet 1' and 'Prophet 11' by Emeric Marcier). Burle Marx's *Lapa* [Pen and ink drawing]', first bought by Lord Sherwood, is currently, after being sold in successive auctions, in a private collection in Buenos Aires, Argentina. Another 25 paintings by various artists are nowadays part of the public collections of 21 different museums and galleries across 17 cities in the United Kingdom, including the Tate in London.[31] Amongst the canvases currently on British soil,[32] there are works by some renowned artists, such as Portinari (The Mercer Art Gallery), Di Cavalcanti (Brighton and Hove Museums and Art Galleries), Segall (Scottish National Gallery of Modern Art), Burle Marx (Kirklees Museums and Galleries and Brighton and Hove Museums and Art Galleries), Pancetti (Kirklees Museums and Galleries) and Dacosta (Plymouth Museums and Galleries), even though there are striking absences, among which Tarsila do Amaral, Cícero Dias and Alfredo Volpi. In this regard, Asbury opines that the Exhibition represented a lost opportunity for British museums and galleries, since 'such works would be considered very desirable indeed [and] would today be very welcome additions to the collections of any international museum with global pretentions' (2018, p. 35). As mentioned before, after the Exhibition, 'They amuse themselves', by the lesser-known Cardoso Júnior, became the first Brazilian artwork to enter the Tate collection. Rebaza-Soraluz, in relation to the acquisition, points out that the painting, which shows women bathing at the beach, was chosen precisely for its stereotyped representation of Brazil, which fit the British expectations rather than the Brazilian desire for artistic radicalism (Rebaza-Soraluz, 2007). Locke, along the same lines, affirms that the Tate and other British art institutions failed to acquire works from artists of the likes of Tarsila do Amaral, because 'the Exhibition, it seems, came too early for the United Kingdom to fully appreciate its significance' (2018, p. 70). For him, despite these donations, there is, to this day, a virtual absence of major holdings of Brazilian art in British

31 Twenty-four of them were displayed together at the exhibition entitled 'The Art of Diplomacy – Brazilian Modernism Painted for War', held between April and June 2018, in the Brazilian Embassy in London.

32 All the works can be viewed in the online image library of Art UK (artuk.org/discover/artworks).

144 PUBLIC DIPLOMACY ON THE FRONT LINE

museums, which would have always been more interested in collecting objects from its former colonies (Locke, 2018, p. 71). In any case, for the first time Brazilian artworks had made their way into relevant British art institutions. In addition to initiating a collection in the United Kingdom, the Exhibition has contributed to further internationalise Brazil's Modern Art, as its works spread throughout relevant institutions of other countries.

Whereas the success of the Exhibition in terms of fundraising and forming a Brazilian collection of art in the United Kingdom may be debatable, the numbers of attendance, and therefore of 'minds changed' by the message conveyed by the show, are undisputedly positive. More than 2,600 people visited the show at the Royal Academy (Somerville L., 1944) and around 100,000 attended it in the nine-month tour throughout Norwich, Edinburgh, Glasgow, Bath, Bristol, London (at the Whitechapel) and Reading, where they had direct contact with Brazilian art for the first time. As noted, this is an audience 1.5 times higher than the attendance at the landmark Exhibition of French Art, held at the MNBA of Rio de Janeiro in 1940. In the words of Vijay Rangarajan, former British Ambassador to Brazil (2017–2020), 'the perseverance and vision of those who put on the Exhibition, the generosity and talent of the artists, and the powerful social signal it sent, were rewarded with a record crowd of over 100,000 visitors, including famously the Queen Mother' (Foreword, 2018, p. 15). Furthermore, the sales of more than 6,000 copies of a content-rich catalogue, notwithstanding its reduced size and some notorious prejudgements, offered an enlightening material to the British public about the art and its history in Brazil.[33] After uncovering and analysing facts and figures that spotlight the tangible accomplishments of the Exhibition, it is clear that, as celebrated by Ambassador Charles, Brazil's painters 'have taken a big step towards making their art known in England' (Charles, 1944). Benefitting from the advantageous hindsight, one can affirm that the Exhibition represented a milestone in Brazilian cultural promotion, for its remarkable ripple effects.

Although there is no indisputably efficient framework to evaluate non-quantifiable outcomes of a long-past non-monitored *phenomenon*, this book author has interpreted the research's *corpus* in light of Mark Leonard's three-dimension theory in order to analyse lesser tangible outcomes of the Exhibition. According to it, the desirable results of a Public Diplomacy initiative are the day-to-day relations with media; the establishment of long-lasting relationships with key figures of foreign societies; and the strategic communication, aimed at consolidating long-term perceptions

33 As examined in 'The Catalogue' section.

(Leonard, 2002, pp. 8–21). This framework, which distinguishes three categories of results with different time frames, proved to be extremely useful for examining and interpreting the diplomatic impacts of the Exhibition and to evaluate its effects over time.

Press relations efforts by the Exhibition planners underscore that publicly targeting and enhancing Brazil's image among the British were priority goals of the initiative. Aranha's personal engagement with Brazilian press and the coordinated work of the BC and the British Ministry of Information in devising a customised plan of communication – which differentiated messages directed at art niches and to the general public – denoted a precocious strategic thinking in Public Diplomacy. The flexibility and linkage to the governmental broader message, as recommended by Leonard (2002, pp. 12–14), were proved along this book, which highlighted Aranha's role in influencing and providing newspapers with relevant information on the Exhibition. Taking into account that in the early 1940s, Brazil's access to British media channels was extremely limited and that, due to the scarcity of paper, the reduced newspapers were focusing on combat-related news, the press coverage, as deeply studied in the Conclusions section, was outstanding. The show alone rendered Brazilian arts more and finer pieces than what had been published altogether in the previous years.[34] The Foreign Office and the Itamaraty, both of which devoted great efforts to press relations, regarded the coverage as excellent. In the view of a British official, 'we have had quite a good press considering wartime difficulties of space' (McQuillen J. M., 1944). The wide repercussion notably met Joseph Nye Jr.'s recommendation that the foreign press must be an important goal of Public Diplomacy (2008, p. 101). It has been exhaustively demonstrated that, regarding this short-term measurement of press relations, the achievements of the Exhibitions are sound, especially in a comparative analysis with the previous exposure of Brazil's culture to the British media.[35]

Similarly, in relation to the enduring development of trustful ties with key figures, one can affirm that the Exhibition planners shrewdly deployed the notion of culture as a vehicle to forge relationships (Zaharna, 2009, p. 88). The apparently neutral atmosphere surrounding the initiative helped the involvement of several personalities, who underwent a positive interaction with Brazil, in some cases exposed to future experiences that reinforced the original impressions (Leonard, 2002, pp. 18–20). It is interesting that in his 1936 report, Magno had highlighted the importance of

34 See the 'Press Coverage' section.
35 See the section on the 'Internationalisation of Brazilian Visual Arts'.

establishing contacts with prominent personalities of the United Kingdom, alluding to his recent meeting with Stefan Zweig.[36] The extensive study of the engagements of British individuals with the Exhibition presented in the *corpus* chapter reveals that this dimension of Public Diplomacy would be equally attained through the initiative. Amongst its bystanders, there were manifestly influential public figures at that time, including the Queen Mother, Princess Margaret and the Duchess of Kent. As clearly put forth by Marlow, on those days, the attendance by the Queen was the measure of success (Gadelha & Storm, 2018). Despite their differences of arrangements and publicising, the royal visits realised a major goal of Public Diplomacy in general, and of the Exhibition, that is, to create affective and long-standing connections between a country's culture and key-figures abroad. During her trip to Brazil in 1959, the Duchess of Kent – who had praised the architectural pictures of the Exhibition fifteen years earlier – was claimed to have said that the Brazilian presidential palace was one of the most important works of international modern architecture (brasiliapoetica.blog. br, n.d.). As commented, a popular *samba* song was then composed as a tribute to her.[37] This shows an emblematic case of building a long-term relationship with an influential member of a foreign society. The guest list for the opening ceremony also contained celebrated names of the British political and artistic circles, as analysed in the section 'Arrangements'. In this sense too, the show proved to be an effective diplomatic initiative that managed to reach key members of the British society who otherwise would hardly be engaged with Brazil. Furthermore, the entrance of artworks into major collections has developed, by means of cultural exchange, connections between Brazil and British institutions and society that last to this day.

The even more intangible strategic communication component is especially relevant for this diplomacy-driven research, since Brazil's foreign policy was striving to transform the country's reputation in order to enhance its international status, a goal that was necessarily of long term. As expressed by Leonard, this dimension demands high communicational skills and the capacity of organising events that capture the imagination, both of which were fundamental traces of the Exhibition. Furthermore, a clear, simple, and logical message was developed, but it was not sustained as it should so as to maximise the initiative's impacts (Leonard, 2002, pp. 14–18). Whilst the quantitative and qualitative results commented on above demonstrate that the Exhibition was fruitful, in order to gather a broader and more

36 See section on 'Brazil's Image before the Exhibition'.
37 See 'The Show' section.

accurate understanding of its strategic benefits, it will hereby be evaluated in the context of Brazilian international relations and goals in the early 1940s, presented and examined in the section on 'Brazil's Wartime Foreign Policy'. After all, this book considers that Public Diplomacy is a technique to achieve governmental objectives (Hocking, 2005, p. 36) and that it should be judged in terms of their contributions to foreign policies (Telles Ribeiro, 1989, p. 35). As discussed before, the Brazilian government had an ostensive goal of revamping perceptions of its homeland amongst the United Kingdom and other Allied societies, in general. In order to turn the long-lasting idea of a slavery agrarian exporter into one of a prosperous Western industrialising nation, the *Estado Novo* launched a Public Diplomacy drive that included the Exhibition, amidst a set of other initiatives.[38] In the early 1940s, Brazil's role in WW2, the solidarity towards the Allies' War efforts, burgeoning regional leadership, and its economic achievements were all building up powerful *momentum*. Brazil was showing itself as more attractive and succeeding in presenting a modern image to advance its international interests. An exact reflection of this desired change in perceptions was published and propagated by the Architectural Review, which declared that Brazil had by then evolved from primitive origins to become a most civilised modern democracy (1944, p. 81). Nonetheless, the overall unawareness of Brazilian culture was viewed as a grave setback for a nation eager to be seen as an equal by the world powers. Even Villa-Lobos and Portinari, the only Brazilian artists who had amassed some fame in the United Kingdom's cultural niches, were vaguely spoken of by the general public. Outdated stereotypes – like Carnival, the savages and warlords or Carmen Miranda – should thus be urgently replaced by modern and cosmopolitan references, in the view adopted by the Vargas Administration. However, cultural distance made it particularly challenging for Vargas' diplomacy to capture international attention. Modern architecture was the only cultural field in which Brazil had gained international acclamation, following the success of its pavilion at the World Expo and the 'Brazil Builds' show, both held in New York earlier that decade. This considered, the Embassy's initiative of displaying photographs of the latter as part of the Exhibition[39] was a smart way of lending Brazil's architecture prestige to its hitherto unknown paintings, in accordance with the modernising official narrative that Oswaldo Aranha's foreign policy intended to convey in those years.

38 See the section on the 'Internationalisation of Brazilian Visual Arts'.

39 Diplomat Paschoal Carlos Magno suggested the addition, 'in order that a wrong impression should not be given to the British public of life in Brazil' (ABS, 1943).

148 PUBLIC DIPLOMACY ON THE FRONT LINE

Brazil's number one international priority, listed on the already mentioned key document produced by Aranha in January 1943,[40] was to boost Brazil to a higher rank in world politics. In this respect, Rubens Ricupero states that, immediately after the War, when the Exhibition was still on tour, Brazil's prestige reached its climax in many decades (2017, p. 339). Indeed, on V-Day, when the show was being displayed at the Victoria Gallery in Bath, King George VI sent a personal letter to Vargas celebrating the part played by Brazil, which should claim a worthy share in the Allied victory (George VI, 1945). The only Latin-American country to fight on the battlefields of Europe, Brazil was militarily and diplomatically empowered by the end of the War and well-positioned to play a leading role in the reconstruction of the new international system. It is noteworthy that, overcoming the phase of low growth between 1939 and 1942, the Brazilian economy had expanded 8% on average in 1943 and 1944. Through the 'Lend Lease' programme (Ricupero, 2017, p. 338),

the value of equipment and weaponry supplied to Brazil topped US$ 330 million, the fifth main beneficiary, after the United Kingdom, the URSS, China and France. During the post-War period, the Brazilian Army increased from 80,000 to 200,000 troops; the Navy acquired modern vessels and expanded its crews by 20%; and the Brazilian Air Force flew 500 aircrafts, becoming the largest in South America. Emerging from the conflict with the most powerful Armed Forces in Latin America, Brazil was also the only nation in this region with experience of modern warfare.[41]

As seen, Brazil left the Peace Conference with high prestige in Europe, especially considering its limited contributions during the War and its actual capacity to influence events on the international stage (Ricupero, 2017, p. 309). The British Ambassador who had prepared the briefing document to be sent to the RAF classified Brazil as a Western nation whose artistic tradition belonged to the same civilisatory trunk of England[42] (Charles, 1944),

40 See the section on 'Brazil's Wartime Foreign Policy'.
41 'O valor dos equipamentos e armas fornecidos ao Brasil ultrapassou US$ 330 milhões, o quinto maior beneficiário, depois do Reino Unido, da URSS, da China e da França. Ao final da Guerra, o exército saltara de oitenta para mais de duzentos mil homens, a Marinha adquirira navios mais modernos, com aumento de 20% do contingente, e a Força Aérea contava com quinhentas aeronaves, tornando-se a maior da América do Sul. O país emergia do conflito com a principal força armada da América Latina e a única que ganhara experiência moderna de combate' (Ricupero, 2017, p. 338).
42 See section on 'Brazil's Image before the Exhibition'.

HERMENEUTICS OF THE EXHIBITION 149

attesting to the adequacy of the message chose by Brazilian diplomacy. Equally, the pursued association between Brazil and the RAF was consistent with the initiative's diplomatic objectives and proved effective, as made clear by Under-Secretary of State for Air Lord Sherwood, for whom the Exhibition would be remembered for long and with pride as a Brazil's splendid contribution to the Allied cause (A Manhã, 1944, p. 7). In light of the deeply discussed outputs and its unprecedented repercussions, the Exhibition arguably contributed to that increase of Brazilian prestige, thus stepping up its international status. In sum, even though it is demonstrably difficult to quantify it, there are good indications that, also in boosting national image, the Exhibition was successful. It is important to point that, despite the visible impact that the Exhibition had over minds, through media and influential figures, the change of mindsets demands a long-term approach (Ji, 2016, p. 82).

Notwithstanding the new level of prestige reached by Brazil and the unprecedented exposure of its culture to British society during the War, as it came to an end, according to Carvalho (2018, p. 54),

> little by little, the memory of the Brazilian participation waned, almost to the point of oblivion. Now, the few times when it is remembered, its importance is always understated. Political factors did not favour an appreciation of these military exploits and even in the field of foreign policy this fact was not adequately appreciated within the concert of nations after the Armistice.

Indeed, the historical evanescence that followed the FEB and the Exhibition mitigated the potential benefits which Brazil could have extracted from them. The prevailing optimism within the Brazilian bureaucracy shortly after the War was followed by a sense of disappointment. Ricupero writes that 'there was a widespread frustration in the high circles; it begun with the military, spread through those who expected a prestigious political role in the peace arrangements and culminated with those in charge of economic and development policies'[43] (2017, p. 349). The nation did not accomplish the major role that it strived to play in the new global order. The unique strategic condition enjoyed during the War weakened as Brazil's Northeast lost geopolitical importance.[44] By then, as the whole

43 'A frustração é geral nos círculos dirigentes; começa pelos militares; alastra-se pelos que contavam com um papel político prestigioso nos arranjos de paz e culmina com os responsáveis pela economia e o desenvolvimento' (Ricupero, 2017, p. 349).

44 See the section on 'Brazil's Wartime Foreign Policy'.

of South America aligned with the Allies, after latecomer Argentina had finally declared war against the Axis as late as March 1945 and new challenges had arisen with the Soviet advances, US goodwill vanished (Ricupero, 2017, p. 349). In 1950, apart from the modest plan of technical cooperation Point IV (1949), the Latin-American continent was the only one that did not count on any aid programme of the United States. Brazil's military entrance in the War was arguably late and the troops return was precocious, which belittled the gains obtained from its part in the conflict (Lochery, 2014). The country thus lost a unique opportunity to establish a mature relation with its main partner, which would have leveraged its relevance in the post-War international order (Almeida, 207, p. 228). Minister Aranha, who had quit the cabinet in 1944 after being defeated by his antagonists within Vargas' cabinet, was no longer conducting Brazilian foreign policy when the FEB fought in Italy and the Exhibition was opened in London, two initiatives that ensued from his personal commitment. After the period of a few months, Vargas was also ousted from office. Under new circumstances, his former Minister of War and successor in the presidency, Marshall Dutra, led an inflexion in Brazil's international relations. In a moment when global powers channelled their strategic priorities and efforts to other regions, Vargas' pragmatic equilibrium and quest for prestige were substituted with a complete alignment to the United States, based on an alleged common defence of freedom in face of the Cold War (Moura, 1991, p. 105).

The discontinuity of the wartime foreign policy devised by Vargas and Aranha naturally affected Brazil's Cultural Diplomacy and the image of the country's arts abroad, including in the United Kingdom. Locke emphasises that a few exhibitions of Brazilian art have been held in the United Kingdom since and that it took forty years from the Exhibition until the next large show was hosted in London (2018, p. 71). The consequences of this interruption are patent in the catalogue of the show 'Portraits of a Country', held at the Barbican Centre in 1984. One reads in it that the British were almost certainly seeing Brazilian art for the first time (Pontual, 1984, p. 7), in very similar terms to those of the one produced for the Exhibition four decades earlier. It demonstrates a *hiatus* in the efforts to promote Brazilian visual culture in the United Kingdom in the years that followed the War. In 1989, Telles Ribeiro mentioned, amidst the major contributions of the Itamaraty to Brazil's cultural dissemination in the second half of the twentieth century, the promotion of the concert which launched Bossa Nova in 1962 at the Carnegie Hall and the determining support to the commercialisation of Brazilian cinema

HERMENEUTICS OF THE EXHIBITION 151

in Latin America from the second half of the 1970s. In the field of visual arts, he follows (Telles Ribeiro, 1989, p. 91),

> after some notable efforts of large retrospective shows in Europe, involving renowned artists such as Fayga Ostrower (Palace of Culture in Madrid), watercolours and drawings by Lasar Segall (museums in Portugal, United Kingdom, France and Germany), watercolours and drawings by Debret (Paris) or samples of indigenous art in the Museum of Mankind (London), the Itamaraty began to prioritise, due to underfunding, itinerant shows of engravers, photographers and drawers, especially in Latin America. However, even these projects were affected by the economic crises that hit the sector from 1980. Despite that, in 1985 the Itamaraty promoted at least three important collective exhibitions in Europe, the United States and Japan. Furthermore, the Itamaraty has coordinated jointly with Funarte Brazilian participation in the biennales of Paris and Venice.[45]

Besides those referred to above, Brazilian art had a relevant representation in the United Kingdom at the landmark exhibition 'Art in Latin America', organised by Dawn Ades at the South Bank Centre in London in 1989. Asbury recalls other shows that included Brazilian art held in the United Kingdom subsequent to the Exhibition, such as those organised by David Medalla at the Signals Gallery in 1965, the 'Brazilian Art Today', an official show held at the Royal College of Arts in the same year, the Midland Group's in Nottingham, in various venues in 1968, as well as the landmark Hélio Oiticica Whitechapel exhibition in 1969 (2018, p. 40). Adrian Locke adds the 'Experiment/*Experiência*: Art in Brazil 1985–2000' (Museum of Modern Art, Oxford, 2000); 'Heroes and Artists: Popular Art and

45 '*Após alguns esforços de vulto com retrospectivas de maior porte na Europa, envolvendo artistas de renome como Fayga Ostrower (Palácio da Cultura de Madri), aquarelas e desenhos de Lasar Segall (museus em Portugal, Reino Unido, França e República Federal da Alemanha), aquarelas e desenhos de Debret (Paris) ou a mostra de arte indígena no* Museum of Mankind *(Londres), o Itamaraty passou, em consequência da falta de recursos, a privilegiar mostras itinerantes de gravadores, fotógrafos e desenhistas, principalmente na América Latina. Contudo, até mesmo esses projetos foram afetados pela crise econômica que atingiu o setor a partir de 1980. Apesar disso, em 1985 o Itamaraty promoveu pelo menos três importantes mostras coletivas na Europa, Estados Unidos e Japão. Além dessas atividades, o Itamaraty tem coordenado com a Funarte a participação brasileira nas bienais de Veneza e Paris*' (Telles Ribeiro, 1989, p. 91).

the Brazilian Imagination' (Fitzwilliam Museum, Cambridge, 2000); and '*Gambiarra* – New Art from Brazil' (Gasworks, London, 2003 and Firstsite, Colchester, 2004) (2018, p. 71). Amaral opines that 'it was the reading and projection extended to Brazilian artists by the sensibility of [the British art historian] Guy Brett that imparted visibility, in the European art scene, to the art production of an entire Brazilian experimental generation, beginning in the late sixties and early seventies' (2002, p. 4). Even though there were important artists and movements represented in these shows, one can notice that the displays of Brazilian art to the British public after the War were far less representative and ambitious than the Exhibition of Modern Brazilian Paintings. Nonetheless, as Anholt asserts, 'only a consistent, coordinated and unbroken stream of useful, noticeable, world-class and above all relevant ideas, products and policies can, gradually, enhance the reputation of the country that produces them' (2015, p. 190). The examination of the Exhibition's lasting consequences underscores its limited impacts on the image of Brazilian art amongst the British public in the long term. Despite a striking exposure during the presence of the Exhibition on British soil, only steady assaults, sustained for long periods, can start to change public opinion (Anholt, 2015, p. 199). This author evaluates that whereas the Exhibition was an outstanding success in terms of outreach, media repercussions, development of trustful relations with prominent personalities and immediate enhancement of Brazil's image, it lacked a proper follow-up in consolidating strategic long-term perceptions, which should be nursed over time. Tim Marlow correctly affirms that 'the most significant legacy of the exhibition was the beginning of an interest in Brazilian art and architecture in Britain' (2018, p. 17), but regretfully the nascent visibility was not developed by further (and necessary) efforts of Public Diplomacy. The discontinuity of the policies behind the Exhibition that followed political and diplomatic developments in Brazil reduced the time horizon of the initiative's outcomes. In sum, its potential impact in terms of foreign policy have not been totally fulfilled, due to the incongruities in the diplomatic standpoints between Aranha and his successors at the conduction of Brazilian international relations.

Telles Ribeiro equally attributes this sort of inconsistency to the frequent change in leadership in the capital and at the Brazilian embassies, but also points out the lack of coordination between the Itamaraty and other ministries and the low governmental priority given to Cultural Diplomacy (1989, p. 89). In addition to the profound changes in Brazilian diplomacy and the diffuse domestic articulation of Public Diplomacy policies, the absence of Government yardsticks for measuring the outreach and efficiency of Public

HERMENEUTICS OF THE EXHIBITION

Diplomacy initiatives has arguably contributed to its weakening in the subsequent years. Mark judges that (2009, p. 3)

> the low priority accorded to Cultural Diplomacy is exacerbated by the difficulty in determining Cultural Diplomacy's long-term impact on the behaviour of audiences. There have always been methods of measuring the success or otherwise of Cultural Diplomacy events and activities, such as the number of people who turned up [...] but support for Cultural Diplomacy of those involved in securing funding for it – diplomats, politicians and treasury officials – has been dampened because of the lack of proof of the practice's impact on audiences over time.

This imperfect undertaking to gauge the outputs and outcomes of the Exhibition has the intention, therefore, to foster this sort of exercise amongst Brazilian scholars and practitioners and thus to better inform their diplomatic initiatives towards foreign societies. Conceived as a vehicle to transform perceptions about Brazil in accordance with a foreign policy of prestige, the Exhibition was an unassailable success. By communicating to public and press values and aesthetics attuned with the Allies' current norms, the initiative contributed to reposition Brazil in British minds. Moreover, considering the United Kingdom's privileged position within global cultural networks, one can infer that these positive associations spread by media spilled over into other Western societies. Despite this author's view that the strategic long-term objectives of the diplomatic policies behind the Exhibition were not entirely accomplished, it should still be considered one of the earliest, cleverest and most successful Brazilian initiatives of Public Diplomacy (Gadelha, 2018, p. 44). As much as the first-hand witnesses of the Exhibition, today the analysts previously cited appreciate, in unison, the diplomatic accomplishments of the Exhibition as 'ground-breaking', 'extraordinary', 'milestone' and 'effective'. The joint survey of past and present views has enabled the interpretive effort of gaining a broad understanding of the significance of the Exhibition and of its results in relation to its objectives of Public Diplomacy.

CONCLUSIONS

The soft power of archaeological or historical objects may be re-politicised and activated by influentials. Long-forgotten narratives may be 'discovered' and politicised by cultural entrepreneurs and political brokers respectively

Chitty, Ji, Rawnsley & Hayden[1]

It has been an interesting challenge and a unique opportunity to research and to write about a virtually unheard-of yet relevant historical *phenomenon*. During the process of uncovering, reconstructing and interpreting the Exhibition of Modern Brazilian Paintings, a number of intriguing questions have arisen. Perhaps the most important was to explore into the motivations behind such an atypical and meaningful art display in the midst of a World War. It is noteworthy that the Olympic Games planned for summer 1944 in London were cancelled due to WW2, while a show of unknown paintings from the other side of the Atlantic Ocean reached the British capital and was hosted by its most traditional art institution.

This improbable event was started by non-governmental players – Brazilian Modernist painters – as widely publicised at the time. An uncritical reading of 1940s newspapers might indicate that this was indeed a mainly private endeavour, as labelled by artists and civil servants. The in-depth cross-examination of pieces of news, letters and official documents discarded this hypothesis and proved that the initiative was only made possible by the championing of Brazilian diplomacy and its commander, Oswaldo Aranha. At a second stage, once offloaded on British soil, its organisation relied on the decisive support of UK government interests. A thorough analysis of primary sources clearly showed that MRE acted as the main driving force that planned and undertook this ambitious endeavour, which, even though inspired by Modernist painters, came to fruition as an official and diplomacy-driven enterprise. This book argues that the initiative was part of a broader diplomatic programme developed by Minister Oswaldo Aranha. Aiming

1 (Chitty, Ji, Rawnsley & Hayden, 2017, p. 23).

at advancing bilateral ties with the United Kingdom, Aranha sought to foster closer relations between Brazilian and British societies. Furthermore, the Exhibition worked as a cultural component of the part in the War played by Brazil, the only Latin American nation to deploy an important contingent – of 25,000 troops – to fight on the European front. Both the military and artistic contributions must be understood as diplomatic attempts to amass international prestige and reposition Brazil in the post-War emerging order. Having consolidated its regional leadership, the nation aspired to be perceived as a global player that shared the prevailing Western values and aesthetics.

As demonstrated throughout this book, the Exhibition was inserted in a wider and coherent strategy of diplomacy put in place by the MRE during the WW2. Bilaterally, it was Brazil's intention to resume and strengthen relations with the United Kingdom, as both countries underwent extreme diplomatic crises in the early 1940s, and dependence on the United States was perceived by policymakers as disproportionate. The United Kingdom seemed to offer a possible counterweight, mitigating this imbalance. From a global standpoint, Brazil understood its unprecedentedly advantageous wartime geopolitical position as an opportunity to enhance its international status and play a major role in the definition of the post-War system. Since it abandoned the pragmatic equilibrium policy of bargaining with the Axis and Allied countries, Brazil, sponsored by the United States, accomplished to expand, equip, train and field test its armed forces, securing a military hegemony in South America. Its economy was urbanised, modernised and industrialised in the same period, thanks largely to North American support. Analogously, collaboration with the United States endowed Brazil with an aesthetic *imprimatur*, which favoured the promotion of some cultural expressions, in special Modern Art and architecture. This comprehensive allegiance with the emerging superpower granted Brazil a special political position and helped it to overcome several diplomatic challenges, particularly in dealing with the United Kingdom throughout successive bilateral impasses. The deployment of the FEB, also an initiative that ensued from the direct commitment of Oswaldo Aranha, was the most emblematic example of that. Largely part of Brazil's policy of pursuit for prestige, the participation on the European War front was not a demand of the Allies and was opposed, in particular, by the British. The United States eventually backed the Brazilian decision to send troops to Italy, not only in political terms but also by financing, arming and training Brazilian military. As the only Latin-American country to effectively cross the Atlantic and fight the War, Brazil earned the status of a reliable partner in the Allied societies, during those turbulent times when a new world order was being forged. To be recognised as a global power capable of co-shaping the emerging concert and setting the post-War agenda, Brazilian Diplomacy pursued being perceived as on par by the victor nations;

CONCLUSIONS 157

and to achieve that, it was urgent to transform its international image, which was very limited, stereotyped and somewhat derogatory. The Exhibition was, therefore, an innovative and purposeful cultural component of Brazil's Public Diplomacy campaign aimed at projecting an image of a modern country, in tune with the prevailing Western values.

It is significant that no other show of Brazilian art in the United Kingdom would ever emulate the Exhibition magnitude, devised in the challenging context of War. The coherence between narrative and diplomatic objectives, the powerful and tailor-made message and its appeal to receptors, the involvement of non-official players as well as the high-level political support made the Exhibition a role model for the cultural category of Public Diplomacy *avant la lettre*. Even though the concepts of Public and Cultural Diplomacy had not been created by that time, the initiative had all main characteristics that comprise them. Diplomatic observers from the 1940s called the Exhibition an effort of Propaganda, for it sought to influence foreign audiences and affect Brazil's image abroad. Nowadays, however, the idea of Propaganda has become inadequate to describe the Exhibition, which contained some of the most advanced and sophisticated features of a contemporary Public Diplomacy initiative. First of all, the Brazilian Government had clearly defined its foreign policy goals, with stepping up its political stature on the world stage being the first priority. Furthermore, the Ministry of Foreign Affairs was able to develop a solid judgement of Brazil's own international stance, of its reputation among British society and of the United Kingdom's cultural environment. Hence, it was accordingly defined a compelling narrative compatible with the emerging hegemonic values in the West. In this sense, the choice of the modern idiom and its cosmopolitanism to represent Brazilian art abroad suited the radical aesthetic rupture that would mark the Western victors' new artistic patterns. In addition, the underlying message of the initiative, the solidarity with distant brothers-in-arms – well represented by the RAF, a symbol of British pride in those dramatic times of War – was extremely attractive and efficient. The combination of top-tier political backing, without which it would not have been possible to accomplish the feat of sending the artworks across the ocean, and the participation of non-governmental cultural figures, lending credibility to the initiative, made the Exhibition a successful case of outreach. Finally, the engagement of key Brazilian and British individuals and institutions was the result of a two-way Public Diplomacy action, which involved listening to the receiver and conveying a world-class, coherent and appropriate message, aligned with and serving diplomatic objectives.

Despite some initial reluctance, the subsequent acclamation of Brazilian Modernist painters and the reassuring reception of the Exhibition – inferred not only from the high attendance and government satisfaction with its

outcomes, but also from the unparalleled press repercussions – provided evidence that the previous pessimism was product of the British artistic establishment's prejudiced and ill-informed views of Modern Art and Brazil. In special, the influential words of Sacheverell Sitwell, the English critic who wrote the preface to the show's catalogue, jeopardised the reverberation of the message emitted by the Brazilian diplomacy. An unavoidable consequence of the desirable involvement of non-governmental institutions with Cultural Diplomacy initiatives, this unruly side effect did not dim the impressive impacts of the Exhibition. Besides its high attendance, the contribution to the formation of a collection of Brazilian art in the United Kingdom and the considerable sales and funds raised in aid of the War effort, the Exhibition accomplished other relevant and less tangible diplomatic goals. Having selected Leonard's framework of analysis as the main parameter for the difficult task of evaluating the endeavour's outcomes, the research identified notable successes and a critical shortcoming. The immediate coverage from the British media was extensive and rather positive; the establishment of long-lasting relations with influential figures from the host society was equally striking; and the conveyance of a politically appropriate narrative was indisputable. Nonetheless, the revision of the Brazilian foreign policy that followed the replacement of Aranha and Vargas impeded the sustaining of the Exhibition's reputational impacts for a longer period, which is a most coveted goal of Public Diplomacy.

Another remarkable long-term development of the Exhibition was its partial restaging in 2018. The show 'The Art of Diplomacy – Brazilian Modernism Painted for War', planned as a diplomatic initiative as much as the one that it celebrated, was guided by renewed goals and circumstances and took place within a historical, political and cultural context entirely different from the one in which the Exhibition came into existence. By 2018, Brazil was one of the ten largest economies on earth, had cemented its leadership in Latin America and amongst developing nations in general and amassed a totally different sort of cultural influence and reputation abroad. The level of awareness and prestige of Brazilian culture had long before been transformed and reached a very respectable position in the most prominent international circles. Brazil had become well-known and admired across the globe, in defiance of successive political and economic crises from 2015 on, including the impeachment of President Dilma Rousseff (b. 1947) in 2016. Even though the TAoD was idealised during Rousseff's term (2011–2016), most of its planning and realisation occurred in the period of Michel Temer's (b. 1940) presidency (2016–2018). Despite their ideological divergences, the main lines of Brazil's diplomacy remained the ones that had characterised it since its return to democracy in 1989. Brazilian foreign policy

CONCLUSIONS 159

sought, *tout court*, to contribute to a balanced and peaceful international order, in which multilateral rules should grant development, fairness and equality to the community of nations. Brazil positioned itself as a consensus builder, a bridge between developing and developed countries – a Latin American and Western emerging power. In this context, the need for cultural credentials that presented the nation as a creative force capable of contributing to the international progress persisted. In his speech at the United Nations General Assembly in 2018, President Temer emphasised Brazil's belief in multilateralism as an antidote to the growing intolerance and isolationism and defended international integration and openness as instruments of a desirable universalist foreign policy (Agência Brasil, 2018). The participation in global value chains and the pledge to free trade with all nations were seen as the pathway to accomplish prosperity and well-being, according to diplomatic discourse at that time. In bilateral terms, the United Kingdom, even though less central to Brazilian foreign relations than in the previous centuries, was still a relevant source of investments.[2] As a matter of fact, relations with the United Kingdom were being reassessed after 2016, when the British voted to leave the European Union. The new motto of a post-Brexit 'global Britain' was perceived as a chance for Brazil to strengthen bilateral ties and to negotiate a less restrictive trade agreement.[3]

In 2018, the Brazilian Embassy in London declaredly viewed the commemorative show as a diplomatic instrument of pursuing foreign policy objectives. The goals for the bilateral relations with the United Kingdom were clearly stated, and ranking Brazil as its long-standing close ally on the verge of a wholly new British geopolitical insertion was a priority. This intended projection was grounded on a shared history of solidarity during WW2, a topic that knowingly triggers affection amongst the British to this day. Revitalising the bilateral relations, in the wake of radical political changes in both countries, should include the use of cultural connections and lasting commonality, in order to present Brazil as a solid partner, capable of offering sophisticated and original contributions in artistic, economic and political realms. Besides, London was, more than ever, perceived as a nodal point of cultural irradiation, and it was evident for Brazilian diplomacy that the initiative's consequences would extrapolate the bilateral relations and convey a desirable image of the nation worldwide. The TAoD was not only a homage to and a legacy of the Exhibition but was also built up from

2 In 2017 the United Kingdom was the fourteenth trade partner of and the twelfth foreign investor in Brazil (dos Santos, 255/2018).

3 Brazil had a special interest in lifting barriers to agricultural exports, a sector traditionally protected by British partners in the European Union.

the original experience. As much as in the 1940s, Brazilian diplomacy sought to involve non-governmental players from both the United Kingdom and Brazil, attempted to read British society in order to deliver the right message, aligned with its foreign policy goals, and gave priority to amplifying its outreach by means of an intense media relations effort, this time in a digital environment of immense connectivity. The TAoD may inspire future cultural initiatives and attract scholarly attention, but it is still early to assert whether the 2018 initiative will render long-term benefits for Brazil's reputation and its relations with the United Kingdom. It is an unhappy coincidence that, just like what happened in the wake of the War, once again the Public Diplomacy initiative was followed by a rare disruption in Brazilian foreign policy, historically associated with gradual transitions and subtle shifts. Jair Bolsonaro's term (2019–2022) marked a radical distancing from deep-rooted Brazilian diplomatic consensuses. The pleading for universalism was replaced with a self-declared anti-globalist stance, while championing multilateralism made way for the pursuit of a favoured nation relationship with the United States, similar to the foreign policy adopted by Dutra after Vargas left office. Furthermore, temporal and personal distance will be necessary to gain a more complete understanding of the TAoD consequences. The remembrance of the little-known Brazilian part in WW2, an underexploited diplomatic asset, has positively impacted Brazil's reputation, and its rescue by means of a cultural endeavour was a clever and subtle way of associating the nation with democratic values and benign causes. The rediscovery of the diplomatically useful narrative conveyed by the long-forgotten Exhibition still offers an opportunity to reinforce affective ties between Brazilian and British societies and enhancing the inter-state relation.

In both cases, the employment of abundant resources to adjust its image amongst the British to its foreign policy objectives of boosting global status pursued what Celso Lafer considers to be the main diplomatic task, to translate domestic needs into external possibilities (2002, p. 21). Having proved that exceptionally complex endeavours – organising a show of Brazilian paintings at the RAA in wartime and restaging it seventy-four years later – were conceived of and successfully undertaken by the Ministry of Foreign Affairs as part of broader, coherent and purposeful diplomatic strategies, this BOOK expects, moreover, to emphasise Brazil's vocation for Public Diplomacy and TO remind one of the overlooked potency of this form of foreign practice. By uncovering and studying the Exhibition, IT will hopefully foster interest in the identification of a Brazilian strain of Public Diplomacy, with its own subjects and methods, thus contributing to further this field's theoretical development. The advantages for Brazil of valuing and perfecting its congenital aptitude for Public Diplomacy are many and evident.

CONCLUSIONS 161

As a regional power with limited economic and military assets, its place on the international stage benefits greatly from its capacity to persuade and captivate foreign societies. By doing so, Brazil has better conditions to deal with more powerful nations, to function as a bridge between diverse actors, to add value to its products, to receive investments, students and tourists, to participate in global forums, to shape and influence agendas and to ensure better treatment of its citizens abroad. Brazil's traditional social consensus around pacifism, embodied in its constitution, as well as its historic reliance on multilateralism, reinforce the convenience of the country's scholars and practitioners advancing Public Diplomacy theory and *praxis*. Increasing its symbolic assets and its capacity to launch sophisticated Public Diplomacy initiatives is imperative for Brazil today as much as in its origins, to enhance its international status and maximise potential opportunities for the sake of its citizens' well-being. This book, by filling the gap of knowledge about the Exhibition, aims to recover past accomplishments to inspire new endeavours and avoid reproducing mistakes. In addition to introduce an early case of a Brazil's input to the Public Diplomacy's field, it aspired to contribute to the histories of the nation's visual arts and diplomacy, by revealing an unknown yet pivotal episode of cultural internationalisation with a diplomatic purpose. It will hopefully foment, amongst scholars, interest in the history of Brazilian Public Diplomacy – which could be object of a historical compilation that identified distinctive features of it. Furthermore, academics and practitioners would benefit from the development of a framework to evaluate initiatives of this kind that take into consideration Brazil's specificities, a limitation that this book had to deal with. This knowledge would advance the definitive incorporation of the public dimension of diplomacy into the nation's foreign policy *repertoire*, in a rational and efficient way. A future examination of the 2018 restaging and its diplomatic consequences, at last, would inaugurate a relevant academic discussion about this field's utility for Brazilian foreign presence.

After all, the legacy of the Itamaraty as a knowledge-based institution remains untouched as long as it endures the ultimate goal of obtaining for Brazil a higher degree of influence in the continental and global decision-making process (Ricupero, 2017, p. 673). Despite that axiom and notwithstanding dispersed resounding successes such as the Exhibition, Public Diplomacy and its Cultural subset's capacity to add prestige to Brazil – and consequently increase its global power – has not been evident, in a consistent manner, for Brazilian policymakers, which has hampered its adequate funding and status within the national bureaucracy. A necessary process of revaluing Brazilian Cultural Diplomacy as a factor of development should enable the ultimate assimilation of the cultural element into the

universe of the nation's international action as a central tool of foreign policy. Telles Ribeiro rightly states that despite its tradition in the field and relative leadership among developing nations, Brazil is still in the dawning of its foreign cultural policy (1989, p. 94). Brazilian Cultural and Public Diplomacy should learn from past experiences, develop models to assess their performance and be conducted in a more planned, professional, coordinated and systematic fashion. If the Baron of Rio Branco brought a set of principles and values that made foreign policy the only domain of undisputed success in Brazil, ratified not only by tangible results in defining its borders but also by the respect of the outside world (Ricupero, 2017, p. 672), it is also true that, as seen across this book, methodology and a long-term Public Diplomacy approach would add to the principle-based prestige amassed since then.

REFERENCES

Abreu, E. (2018, 1 6). *Obras brasileiras modernistas serão expostas em Londres*. Retrieved from RedeTV: https://www.redetv.uol.com.br/videos/redetv-news/obras-brasileiras-moder02nistas-serao-expostas-em-londres.

ABS. (1943a, 8 23). Minute of ABS meeting. London: ABS.

ABS. (1943b, 6 3). Minute of ABS sixth meeting. London: ABS.

ABS. (1943c, 3 25). Minute of ABS third meeting. London: ABS.

ABS. (1944a, 2 28). Minute of ABS meeting. London: ABS.

ABS. (1944b, 10 10). Minute of ABS meeting. London: ABS.

ABS. (1944c, 11 14). Minute of ABS meeting. London: ABS.

ABS. (1945, 2 7). Minute of ABS meeting. London: ABS.

Ades, D. (2018). Modern Brazilian Painting. In M. Asbury, H. Gadelha, & M. Sono (Eds.), *The Art of Diplomacy – Brazilian Modernism Painted for War* (pp. 59–66). London: Embassy of Brazil.

Agência Brasil. (2018, 9 25). *Em discurso na ONU, Temer critica unilateralismo e intolerância*. Retrieved from Agência Brasil: https://agenciabrasil.ebc.com.br/internacional/noticia/2018-09/em-discurso-na-onu-temer-critica-unilateralismo-e-intolerancia.

Allen, R. H. (1944a, 12 15). Annotation in a letter from Somerville (BC) to McQuillen (8/12/44). *AS 6412/698/6*. *Exhibition of Brazilian paintings*. London: TNA/FO.

Allen, R. H. (1944b, 11 17). Letter to Captain Lord Sidney Herbert. *AS 5998/698/6*. London: TNA/FO.

Allen, R. H. (1944c, 3 25). Letter to F. A. Rawlings (Ministry of War Transport). *AS 1724/698/6*. London: TNA/FO.

Almeida, P. R. (2005). *Formação da Diplomacia Econômica do Brasil*. São Paulo: Senac.

Almeida, P. R. (2017). O chanceler no conflito global. In S. E. Lima, P. R. Almeida, & R. d. Farias (Eds.), *Oswaldo Aranha – um Estadista Brasileiro* (pp. 197–234). Brasília: FUNAG.

Amaral, A. (2002). Brasil: Commemorative exhibitions or notes on the presence of Brazilian modernists in international exhibitions: http://www.lehman.cuny.edu/ciberletras/v08/amaral.html.

Amirsadeghi, H., & Petitgas, C. (2012). *Contemporary Art Brazil*. London: Thames & Hudson.

Anderson, D. P. (1944, 11 17). Letter to Bertrand Rumble (RAF Benevolent Fund). *48*. London: TNA/FO. Dorland Advertising.

Andrade, M. d. (1989). *O banquete*. São Paulo: Duas Cidades.

Andrade, O. d. (1928, 5). Manifesto Antropofágico. *Revista da Antropofagia*, p. 7.

Andreoli, E., & Forty, A. (2007). *Brazil's Modern Architecture*. Phaidon.

Anholt, S. (2010). *Places: Identity, Image and Reputation*. New York: Palgrave Macmillan.

Anholt, S. (2015). Public diplomacy and competitive identity: Where's the link? In G. J. Golan, S.-U. Yang, & D. F. Kinsey (Eds.), *International Public Relations and Public Diplomacy*. New York: Peter Lang.

Archdaily. (2017, 2). *RIBA Awards 2017 Royal Gold Medal to Paulo Mendes da Rocha*. Retrieved from Archdaily: https://www.archdaily.com/796342/riba-awards-2017-gold-medal-to-paulo-mendes-da-rocha/57ed0367e58ece2045000159-riba-awards-2017-gold-medal-to-paulo-mendes-da-rocha-image.

Architectural Review. (1944). *Architectural Review, XCV* (January-June).

Armitstead, C. (2018, 4 22). Club tropicália: The mesmerising power of Brazilian art. *Guardian*, p. G2.

Aronczyk, M. (2013). *Branding the Nation: The Global Business of National Indentity*. Oxford: Oxford University.

artuk.org/discover/artworks. (n.d.). *artuk.org/discover/artworks*. Retrieved 5 17, 2016, from artuk: artuk.org/discover/artworks.

Asbury, M. (2018). British and Brazilian art in the 1940s: Two nations at the crossroads of modernism. In M. Asbury, H. Gadelha, & M. Sono (Eds.), *The Art of Diplomacy: Brazilian Modernism Painted for War* (pp. 35–42). London: Embassy of Brazil.

Ashwin, C. (2017, 1 10). *Studio International*. Retrieved 12 3, 2018, from https://www.studiointernational.com/index.php/the-founding-of-the-studio.

Aulicus. (1944). Arte não leva endereço. *Revista da semana*.

Barbosa, M. I. (2015, 11 24). Soft Power. *Arte! Brasileiros*, pp. 138–140.

Barbosa, R. (1942). *Obras completas*. Rio de Janeiro: MES.

Barone, J. (2013). *1942 – O Brasil e sua guerra quase desconhecida*. Rio de Janeiro: Nova Fronteira.

Barroso Neto, N. (2007). *Diplomacia Pública: Conceitos e Sugestões para a Promoção da Imagem do Brasil no Exterior*. Brasília: Instituto Rio Branco.

Bath & Wilts Chronicle & Herald. (1945, 4 26). Brazil artists'fine gesture. *Bath & Wilts Chronicle & Herald*.

Bath Weekly Chronicle and Herald. (1945, 4 28). Bicycile at crucifixion. *Bath Chronicle*, p. 12.

BBC Brasil. (2017, 11 17). *Londres vai rever exposição usada como 'arma' diplomática pelo Brasil em plena 2ª Guerra*. Retrieved from BBC Brasil: https://www.bbc.com/portuguese/geral-42010289.

Beddington, C. (1944, 10 9). Letter from the Wildenstein & Co to to Edward Mather Jackson (FO). *AS 3846/698/6*. London: TNA/FO.

Bettany, G. (1944, 11 22). Exposição representativa da arte moderna no Brasil. *Jornal do Brasil*, p. 7.

Birmingham Post. (1944). A gesture from Brazil. *The Birmingham Post*.

Boavista, P. T. (1943). Modern Architecture. *The Studio,* October, pp. 121–129.

Bonham-Carter, O. H. (1943, 12 10). Letter to K. T. Gurney. *W16161/33/49 AS 698/698/6*. London: TNA/FO. Ministry of Information.

brasiliapoetica.blog.br. (n.d.). Retrieved 5 24, 2016, from http://brasiliapoetica.blog.br/site/index.php?option=com_content&task=view&id=1463.

Brazilian art. (1944, 11 16). *The Nottingham Post*, p. 3.

Brazilian art. (1945a, 8 11). *Reading Mercury*.

Brazilian art. (1945b). *Scotsman*.

Brazilian Art for the RAF. (1944). *Manchester Evening News*.

Brazilian artists' gift. (1944, 11 23). *The Times*, p. 6.

REFERENCES

165

Brazilian tribute. (1944, 11 16). *The Yorkshire Post and Leeds Mercury.*

Bristol Art Museum and Art Gallery. (1949). Historical file 2750. *'Composition'*. Bristol: Bristol Art Museum and Art Gallery.

Bristol Evening Post. (1945, 5 31). First time in Europe. *Bristol Evening Post*, p. 2.

Bristol Museum and Art Gallery. (1945, 1 2). Longden – Wallis. Bristoll Museum and Art Gallery.

British Embassy in Rio de Janeiro. (1944, 2 8). Cable to the Foreign Office. *AS 700/698/6 AS 1290.* Rio de Janeiro: TNA/FO.

British Embassy in Rio de Janeiro. (1945a, 6 13). Cable to the Foreign Office. *AS 3339.* Rio de Janeiro: TNA/FO.

British Embassy in Rio de Janeiro. (1945b, 2 19). Cable to the Foreign Office. *AS 1448.* Rio de Janeiro: TNA/FO.

Broadmed, M. (1945, 4 26). Annotation in a letter from Somerville (BC) to McQuillen. *BRA 28/2 AS 1448/101/6.* London: TNA/FO. BC.

Broadmed, M. (1944a, 3 17). Cable to the Foreign Office. *151/1944 AS 1724 AS 861/698/6.* Rio de Janeiro: TNA/FO.

Broadmed, M. (1944b, 5 13). Cable to the Foreign Office. *245/1944 AS 2611 AS 2358/ 698/6.* Rio de Janeiro: TNA/FO.

Brown, R. (2016). Alternatives to soft power. In N. Chitty, L. Ji, G. D. Rawnsley, & C. Hayden (Eds.), *Rouledge Handbook of Soft Power* (p. 488). Routledge.

Bull, D., & Pisano, F. (2017). *The Art of Soft Power: A Study of Cultural Diplomacy at the UN Office in Geneva.* London: King's College London.

Callado, A. C. (1943, 10). Brazilian sculpture. *The Studio*, p. 133.

Caminha, P. V. (1500, 5 1). *A carta.* Retrieved 9 3, 2016, from Dominio Público: http://www.dominiopublico.gov.br/download/texto/bv000292.pdf.

Caminha, P. V. (n.d.). *A carta.* Retrieved 9 3, 2016, from Dominio Público: http://www.dominiopublico.gov.br/download/texto/bv000292.pdf.

Campbell-Johnston, R. (2018, 4 13). A diplomatic feat: But is it good art? *The Times*, p. 11.

Campos, V. (2018, 4 4). *Bailarino Thiago Soares abre mostra de modernismo brasileiro em Londres.* Retrieved from Globo: https://gq.globo.com/Cultura/noticia/2018/04/bailarino-thiago-soares-abre-mostra-de-modernismo-brasileiro-em-londres.html.

Cândido, A. (1984). A revolução de 1930 e a cultura. Novos Estudos CEBRAP, v2, 267–236.

Carline, R. (1946, 10 18). Letter to Mr. Maciel. Paris, France: UNESCO.

Carneiro, P. (1946, 9 25). Letter to Alfred Longden (BC). Paris, France: UNESCO.

Carrilho, M. (1998, 4 1). *Brazil Builds – 55 anos da Exposição.* Retrieved 8 13, 2016, from Piniweb: http://piniweb.pini.com.br/construcao/noticias/brazil-builds---55-anos-da-exposicao-84648-1.aspx.

Carvalho, V. M. (2018). Two fronts of the same war: The Exhibition of Brazilian Modern Paintings in London in 1944 and the FEB. In M. Asbury, H. Gadelha, & M. Sono (Eds.), *The Art of Diplomacy – Brazilian Modernism Painted for War* (pp. 53–58). London: Embassy of Brazil.

Carvalho, V. M. (2019). Dois "fronts" da mesma guerra. *Problemas Brasileiros*, 454 (Out-Nov/2019), 52–54.

Cavalcanti, L. (2005). O Brasil sai do exílio: da belle époque ao modernismo. In C. Lessa. (Ed.), Enciclopédia da Brasilidade (pp. 186–195). Rio de Janeiro: Casa das Palavras.

Charles, N. (1943a, 12 20). Cable to Anthony Eden. *244 AS/700/698/6.* Rio de Janeiro: TNA/FO.

Charles, N. (1943a, 11 20). Cable to the Foreign Office. *614/1943. AS 698*. Rio de Janeiro: TNA/FO.

Charles, N. (1943b, 12 20). Charles – Eden. TNA/FO.

Charles, N. (1943c, 10 12). Letter to Oswaldo Aranha. Doação pinturas brasileiras ao governo da Grã-Bretanha. *146/1943*. Rio de Janeiro: MRE/RJ.

Charles, N. (1944a, 1 26). Cable to Nigel Law. *AS 946 AS 700/698/6*. Rio de Janeiro: TNA/FO.

Charles, N. (1944b, 11 16). Charles – Law. London: TNA, & FO.

Charles, N. (1944c, 2 6). Charles – Nigel: TNA/FO.

Chiodetto, E., Fonseca, R. d., & Henriques, R. (2014). *Brazil: A Celebration of Contemporary Brazilian Culture*. Phaidon.

Chitty, N. (2017). Soft power, civic virtue and world politics. In N. Chitty, L. Ji, G. D. Rawnsley, & C. Hayden (Eds.), *The Routledge Handbook of Soft Power* (p. 488). Routledge.

Chitty, N., Ji, L., Rawnsley, G., & Hayden, C. (2017). *The Routledge Handbook of Soft Power*. New York: Routledge.

Corrêa do Lago, P. (2017). *Oswaldo Aranha: uma fotobiografia*. Rio de Janeiro: Capivara.

Costa, A. (1943). Manifestations of Art in Brazilian Archeology. *The Studio, October*, 119–120.

Court and personal. (1944, 11 29). *The Yorkshire Post and Leeds Mercury*, p. 2.

Cowan, G., & Arsenault, A. (2008). Moving from monologue to dialogue to collaboration: The three layers of public diplomacy. *The ANNALS of the American Academy of Political and Social Science, 616*(1), 10–30. https://doi.org/10.1177/0002716207311863.

Cowan, G., & Arsenault, A. (2008a). Moving from monologue to dialogue to collaboration: The three layers of public diplomacy. *The ANNALS of the American Academy of Political and Social Science, 616*(1), 10–30. https://doi.org/10.1177/0002716207311863.

Cowan, G., & Cull, N. J. (2008b). Public diplomacy in a changing world. *The ANNALS of the American Academy of Political and Social Science, 616*(1), 6–8. https://doi.org/10.1177/0002716207312143.

Cull, N. J. (2008). Public diplomacy: Taxonomies and histories. The ANNALS of the American Academy of Political and Social Science, 616(1), 31–54. https://doi.org/10.1177/0002716207311952.

culture.pl. (n.d.). Retrieved 5 22, 2016, from http://culture.pl/en/artist/august-zamoyski.

Cummings, M. (2009). Cultural diplomacy and the United States Government: A survey. *Cultural Diplomacy Research Series*.

da Manhã, C. (1943, 10 1). A exposição de arte moderna brasileira em Londres. *Correio da Manhã*, p. 9.

da Manhã, C. (1944, 11 16). Resenha do dia. *Correio da Manhã*.

da Manhã, C. (1945, 3 11). 1o Congresso Brasileiro de Artistas Plásticos. *Correio da Manhã*, p. 1.

da Silva, J., & Lee, D. (2018, 4 6). *Three to see: London*. Retrieved from The Art Newspaper: https://www.theartnewspaper.com/news/three-to-see-london-6-april-2018.

Daily Mail. (1943, 11 27). Brazilian art. *Daily Mail*, p. 4.

Daily Telegraph. (1944, 12 5). Brazilian art helps RAF. *Daily Telegraph*.

The Daily Telegraph. (1944, 11 22). Brazil's Picasso. *The Daily Telegraph*, p. 4.

Dantas, M. (2018, 4 24). *Embaixada brasileira exibe em Londres obras doadas durante Segunda Guerra*. Retrieved from Diário de Pernambuco: https://www.diariodepernambuco.com.br/noticia/viver/2018/04/embaixada-brasileira-exibe-em-londres-obras-doadas-durante-segunda-gue.html.

REFERENCES 167

de Aragão, M. (1943, 8 20). Moniz de Aragão – Aranha. Rio de Janeiro: MRE.

Devane, C. (2018). Foreword. In M. Asbury, H. Gadelha, & M. Sono (Eds.), *The Art of Diplomacy – Brazilian Modernism Painted for War* (pp. 21–22). London: Embassy of Brazil.

Diário Carioca. (1943a, 10 1). A exposição de arte moderna brasileira em Londres. *Diário Carioca*, p. 5.

Diário Carioca. (1943b, 11 12). Os artistas modernos brasileiros e o apoio ao esforço de guerra das Nações Unidas. *Diário Carioca*, p. 3.

Diário Carioca. (1944, 8 26). A arte brasileira a serviço da democracia contra o nazismo. *Diário Carioca*.

Diário da Noite. (1944, 11 22). Forte impressão em Londres. *Diário da Noite*, pp. 1–2.

Dinnie, K. (2008). *Nation Branding: Concepts, Issues, Practices*. Oxon: Routledge.

Doratioto, F., & Vidigal, C. E. (2014). *História das Relações Internacionais do Brasil*. São Paulo: Saraiva.

dos Santos, E. (2017a, 117). 1095/2017. *Embassy in London – Itamaraty*. London: Embassy in London.

dos Santos, E. (2017b, 11 13). 1257/2017. *Embassy in London – Itamaraty*. London: Embassy in London.

dos Santos, E. (2018a, 5 14). 255/2018. *Embassy in London – Itamaraty*. London, Embassy in London – Itamaraty: Itamaraty.

dos Santos, E. (2018b, 3 16). 266/2018. *Embassy in London – Itamaraty*. London: Embassy in London.

dos Santos, E. (2018c, 1 8). 27/2018. *Embassy in London – Itamaraty*. London: Itamaraty.

dos Santos, E. (2018d, 4 9). 341/2018. *Embassy in London – Itamaraty*. London: Embassy in London.

dos Santos, E. (2018e, 4 10). 344/2018. *Embassy in London – Itamaraty*. London: Itamaraty.

dos Santos, E. (2018f, 4 10). 349/2018. *Embassy in London – Itamaraty*. London: Embassy in London.

dos Santos, E. (2018g, 4 17). 373/2018. *Embassy in London – Itamaraty*. London: Embassy in London.

dos Santos, E. (2018h, 51). 426/2018. *Embassy in London – Itamaraty*. London: Embassy in London.

dos Santos, E. (2018i, 5 8). 449/2018. *Embassy in London – Itamaraty*. London: Embassy in London.

dos Santos, E. (2018j, 6 15). 623/2018. *Embassy in London – Itamaraty*. London: Embassy in London.

dos Santos, E. (2018k, 7 6). 698/2018. *Embassy in London– Itamaraty*. London: Embassy in London.

dos Santos, E. (2018l, 8 18). 893/2018. *Embassy in London – Itamaraty*. London: Embassy in London.

dos Santos, E. (2018m, 9 6). 920/2018. *Embassy in London – Itamaraty*. London: Embassy in London.

Dumont, J., & Fléchet, A. (2014). "Pelo que é nosso!": a diplomacia cultural brasileira no século XX. Revista Brasileira de História v34 n67, 203–221.

Dundee Evening Telegraph. (1943, 11 27). Brazil gift. *Dundee Evening Telegraph*, p. 4.

East London. (1945, 7 13). Brazilian art exhibited at Whitechapel. *East London*.

Eastern Daily Press. (1945a, 1 1). Gift collection at Castle Museum. *Eastern Daily Press*, p. 2.

Eastern Daily Press. (1945b, 1 1). Modern Brazilian Paintings. *Eastern Daily Press*, p. 2.

168 PUBLIC DIPLOMACY ON THE FRONT LINE

Eastern Evening News. (1945, 1 1). Brazilian art at the Castle Museum. *Eastern Evening News*, pp. 3–4.

Eden, A. (1944, 10 6). Letter to Alfred Munnings (RAA). London: TNA/FO.

Edinburgh National Gallery. (1945, 3 20). National Gallery – British Council. Edinburgh National Gallery.

Embassy of Brazil in London. (2018, 2 8). Press Release. *Hidden story of Brazilian artists' contribution to Britain's War effort revealed in major exhibition in London*. London: Embassy in London.

Enciclopédia Itaú Cultural. (n.d.). Retrieved 4 26, 2016, from http://enciclopedia. itaucultural.org.br/evento240385/exhibition-of-modern-brazilian-paintings-1945-manchester-reino-unido.

Estado de São Paulo. (1943, 9 16). Exposição de artistas modernos brasileiros em Londres. *Estado de São Paulo*, p. 3.

Estado de São Paulo. (1944a, 11 11). Exposição de pintores brasileiros em Londres. *Estado de São Paulo*, p. 1.

Estado de São Paulo. (1944b, 11 22). Exposição representativa da pintura brasileira em Londres. *Estado de São Paulo*.

Evening News. (1944, 11 29). *Evening News*.

Fabris, A. (2010). Modernidade e vanguarda: o caso brasileiro. In A. Fabris (Ed.), *Modernidade e modernismo no Brasil* (pp. 09–24). Porto Alegre: Zouk.

Fausto, B. (2012). *História do Brasil*. São Paulo: EDUSP.

Ferreira, R. L. (2013). Difusão cultural e projeção internacional: o Brasil na América Latina. In H. R. Suppo, & M. L. Lessa (Eds.), *A quarta dimensão das relações internacionais* (pp. 65–88). Rio de Janeiro: Contracapa.

Fisher, A. (2009). Four seasons in one day. In N. Snow, & P. M. Taylor (Eds.), *Routledge Book of Public Diplomacy*, (pp. 1–11). Oxon: Routledge.

Foreign Office. (1944a, 7 24). Annotation in a letter from Alfred Longden (BC) to Gurney (27/6/44). *AS 3856/698/6*. London: TNA/FO.

Foreign Office. (1944b, 1 31). Cable to the Embassy in Rio de Janeiro. *48 AS 700/698/6*. London: TNA/FO.

Foreign Office. (1944c, 1 31). Cable to the Embassy in Rio de Janeiro. *48/1944 AS 700/698/6*. London: TNA/FO.

Foreign Office. (1944d, 2 22). Document for Eden. TNA/FO. London: TNA/FO.

Foreign Office. (1945a, 12 5). Cable to the Embassy in Rio de Janeiro. *AS 6030/101/6*. London: TNA/FO.

Foreign Office. (1945b, 1 25). FO – Embassy in Rio. London: TNA/FO.

Foreign Office. (1945c, 2 17). Minute of FO. London: TNA/FO.

Gadelha, H. (2018a). A Modernist Palimpsest. In M. Asbury, H. Gadelha, & M. Sono (Eds.), *The Art of Diplomacy – Brazilian Modernism Painted for War* (pp. 27–32). London: Embassy of Brazil.

Gadelha, H. (2018b). The Art of Diplomacy. In M. Asbury, H. Gadelha, & M. Sono (Eds.), *The Art of Diplomacy – Brazilian Modernism Painted for War* (pp. 43–52). London: Embassy of Brazil.

Gadelha, H., & Storm, M. (Directors). (2018). *The Art of Diplomacy* [Motion Picture]. United Kingdom.

Gallery, B. M. (1945, 11 27). Wallis – Longden.

Gay, P. (2010). *Modernism: The Lure of Heresy*. New York: Norton.

Gazette. (n.d.). Retrieved 52 23, 2016, from https://www.thegazette.co.uk/London/issue/36552/supplement/2707.

REFERENCES

169

Gelber, D. (2018, 4 13). *The Brazilian paintings that made a splash in wartime Britain*. Retrieved from Apollo: https://www.apollo-magazine.com/the-brazilian-paintings-that-made-a-splash-in-wartime-britain/.

George VI, K. (1945, 5 8). Letter to Getúlio Vargas. *K107*. Rio de Janeiro, UK: MRE.

Gienow-Hecht, J. C. (2010). What are we searching for? In J. C. Gienow-Hecht, & M. C. Donfried (Eds.), *Searching for a Cultural Diplomacy* (p. 278). Berghahn Books.

Gienow-Hecht, J. C., & Donfried, M. C. (2010). The model of cultural diplomacy. In J. C. Gienow-Hecht, & M. C. Donfried (Eds.), *Searching for a Cultural Diplomacy* (p. 278). Berghahn Books.

Gienow-Hecht, J. D. (2010). *Searching for a Cultural Diplomacy*. New York: Berghahn.

Gilboa, E. (2008). Searching for a theory of public diplomacy. In G. &. Cowan (Ed.), (pp. 55–77). *The Annals of the American Academy of Political and Social Science – Public Diplomacy in a Changing World*. Annenger School for Communication, University of South Carolina.

Glasgow Evening News. (1945, 3 20). *Glasgow Evening News*.

Glasgow Herald. (1945). Modern Brazilian Art. *Glasgow Herald*.

Glasgow Museum and Art Galleries. (1945). Calendar of events. Glasgow Museum and Art Galleries.

Golan, G. J., & Yang, S.U. (2015). The integrated public diplomacy perspective. In G. J. Golan, S.U. Yang, & D. F. Kinsey (Eds.), (pp. 1–14). *International Public Relations and Public Diplomacy*. Nova York: Peter Lang.

Gomes, L. (2008). 1808. Planeta.

Goodwin, P. (1943). *Brazil Builds*. New York: Museum of Modern Art.

Gouthier, H. (1944, 11 24). Letter to Candido Portinari. *F-0653 CO-1995*. London: TNA/FO.

Grande Campina. (n.d.). Retrieved 5 23, 2016, from http://www.grandecampina.com.br/2012/01/bruno-gaudencio-traca-o-perfil-de-um.html.

Greenway, J. (1944, 9 25). Letter from the UK Embassy to Pedro Leão Velloso (MRE). *155/1911. Convite do governo britânico ao General Gaspar Dutra para visitar a Inglaterra*. Rio de Janeiro: MRE.

Gregory, B. (2008). Public Diplomacy: Sunrise of an academic field. (pp. 274–290). In *The Annals of the American Academy of Political and Social Science*. Philadelphia: Sage.

Gurney, K. (1943a, 12 8). Gurney – Bonham-Carter. TNA/FO. London: TNA/FO.

Gurney, K. (1943b, 12 8). Gurney – White. TNA/FO. London: TNA/FO.

Gurney, K. (1944a, 5 13). Gurney – Church. London: TNA/FO.

Gurney, K. (1944b, 4 12). Letter to Eric Church (BC). *AS 1695/698/6*. London: TNA/FO.

Gushiken, Y., Brito, Q. G., & Ueta, T. M. (2017). Popular culture, banal cosmopolitanism and hospitality: Notes for a Brazilian soft power. In *The Routledge Handbook of Soft Power*. (pp. 1–10). New York: Routledge.

Hayden, C. (2016). Technologies of influence. In N. Chitty, L. Ji, G. D. Rawnsley, & C. Hayden (Eds.), *The Routledge Book of Soft Power* (p. 488). New York: Routledge.

Herbert, S. (1944, 11 22). Letter to Alfred Longden (BC). *AS 5998/698/6. Exhibition of Brazilian paintings*. London: TNA/FO. St James' Palace.

Hilton, S. (1994). *Oswaldo Aranha: uma biografia*. Rio de Janeiro: Objetiva.

Hocking, B. (2005). Rethinking the 'New' public diplomacy. In J. Melissen.(Ed.), (pp. 3–11). *The New Public Diplomacy*. New York: Palmgrave.

Holledge, R. (2018, 5 10). When art went to War. *New European*.

Horizon. (1944, 12). *Horizon*, p. 394.

Hull Daily Mail. (1943, 11 27). Brazilian art. *Hull Daily Mail*.

Hunt, A. (2015). *Public Diplomacy: What it is and how to do it*. Geneva: Unitar.

Hutchison, S. C. (1968). *The History of the Royal Academy 1768–1986*. London: Robert Royce.

i. (2018, 4 6). Brazilian war effor revealed. *The i*, p. 15.

Irish Examiner. (2018, 4 6). Well Hung. *Irish Examiner*, p. 8.

Itamaraty. (23 11 1944a). Embassy in London – Itamaraty.

Itamaraty. (28 11 1944b). Embassy in London – Itamaraty.

Jackson, M. (1944a, 10 7). Letter to Colonel Beddington (Wildenstein & Co). *AS 3846/698/6*. London: TNA/FO.

Jackson, M. (1944b, 11 11). Letter to Mrs. Somerville (BC). *AS 5830/698/6*. London: TNA/FO.

Jackson, R. F. (1946, 1 27). Annotation in a letter from Alfred Longden (BC) (23/10/45). *AS 6564/948/6*. London: TNA/FO. BC.

Ji, L. (2016). Measuring soft power. In N. Chitty, L. Ji, G. D. Rawnsley, & C. Hayden (Eds.), *The Routledge Handbook of Soft Power* (p. 488). New York: Routledge.

Jornal do Brasil. Exposição representativa da arte moderna no Brasil. (1944). *Jornal do Brasil*.

Kelley, J. R. (2009). Between take-offs and crash landings. In N. Snow, & P. M. Taylor (Eds.), *Routledge Book of Diplomacy*. (pp. 1–14). Oxon: Routledge.

Kidder Smith, G. E. (1944). The architects and the modern scene. *Architectural Review*, XCV(January-June).

Kieling, F. (2018, 3 4). *Exposição em Londres reúne diversas obras brasileiras*. Retrieved from Band. com.br: https://entretenimento.band.uol.com.br/melhordatarde/videos/16405015/andre-mantovanni-tira-cartas-da-semana.html.

Kim, H. (2011, 12). *Cultural diplomacy as the means of Soft Poer in the information age*. Retrieved 7 25, 2017, from Cultural Diplomacy: http://www.culturaldiplomacy.org/pdf/case-studies/Hwajung_Kim_Cultural_Diplomacy_as_the_Means_of_Soft_Power_in_the_Information_Age.pdf.

Kim, H. (2017). Bridging the theoretical gap between public diplomacy and cultural diplomacy. *Korean Journal of International Studies*, 15(2), 293–326.

Lafer, C. (2002). O Itamaraty na cultura brasileira. In A. da Costa e Silva.(Ed.), *O Itamaraty na Cultura Brasileira* (pp. 15–25). Brasília: Instituto Rio Branco.

Lamb, W. (1944a, 11 2). Letter to Alfred Longden (BC). *4526*. London: TNA/FO. RAA.

Lamb, W. (1944b, 3 15). Letter to Victor Perowne (FO). *AS 946/698/6*. London: RAA.

Lamb, W. (1951). *The Royal Academy: A Short History of its Foundation and Development*. London: G. Bell & Sons.

Lancaster, O. (1944, 11 26). Brazilian. *Observer*, p. 2.

Lannes Smith, B. (2017, 4 18). *Propaganda*. Retrieved 7 9, 2018, from https://www.britannica.com/topic/propaganda.

Law, N. (1944, 12 16). *Law – Charles*. London: Archive/FO.

Lawford, V. (1944, 10 17). Letter to Alfred Munnings (RAA). *AS 5149/698/6*. London: TNA/FO.

Leal, M. d. (2009). Os jornais do Rio de Janeiro nas décadas de 40 e 50. *Apresentação de Trabalho/Comunicação*.

Leonard, M. (2002). *Public Diplomacy*. London: The Foreign Policy Centre.

Lessa, H. S. (2013). *A Quarta Dimensão das Relações Internacionais: a Dimensão Cultural*. Rio de Janeiro: Contra Capa.

REFERENCES

171

Lima, F. V. (2010). *O primeiro congresso brasileiro de escritores. Dissertação de mestrado em História/USP.* São Paulo: USP.

Limnander, A. (2011). *Brazilian Style.* Assouline.

Lincolnshire Echo. (1943, 11 27). Brazil gives pictures. *Lincolnshire Echo,* p. 4.

Lins, V. (2013). Crítica em tempos de guerra: Ruben Navarra e os anos 40. In V. Lins. (Ed.), *O poema em tempos de barbárie e outros ensaios* (pp. 159–169). Rio de Janeiro: Eduerj.

Lochery, N. (2014). *Brazil: The Fortunes of War.* New York: Basic Books.

Locke, A. (2018). Oranges and bananas or pears and apples? Exhibition of modern brazilian paintings at the RAA. In H. G. Michael Asbury (Ed.), *The Art of Diplomacy – Brazilian Modernism Painted for War* (pp. 67–74). London: Embassy of Brazil.

Londonist. (n.d.). *Retrieved* 6 5, 2016, from http://londonist.com/2009/01/london_v2_rocket_sitesmapped.

Longden, A. (1944a, 10 16). Annotation in a letter by Victor Perowne (FO). *4470.* London: TNA/FO. BC.

Longden, A. (1944b, 6 2). Letter to K. T. Gurney (BC). *BRA 8/1 AS 2761/698/6.* London: TNA/FO. BC.

Longden, A. (1944c, 5 23). Letter to K. T. Gurney (FO). *BRA 8/1.* London: TNA/FO. BC.

Longden, A. (1944d, 10 21). Letter to Victor Perowne (BC). *AS 5580.* London: TNA/FO. BC.

Longden, A. (1944e, 10 31). Letter to Victor Perowne (FO). *AS 5631/698/6.* London: TNA/FO. BC.

Longden, A. (1944f, 11 7). Letter to Victor Perowne (FO). *BRA 28/2 AS 5830.* London: TNA/FO. BC.

Longden, A. (1945a, 1 2). Letter to F. S. Wallis (Bristol Museum and Art Gallery). London: Bristol Museum and Art Gallery.

Longden, A. (1945b, 11 14). Letter to R. H. S. Allen (FO). *BRA/28/2 AS 6030.* London: TNA/FO. BC.

Longden, A. (1945c, 5 3). Letter to Victor Perowne. *BRA/28/2.* London: TNA/FO. BC.

Longden, A. (1945d, 6 11). Letter to Victor Perowne (FO). *BRA 28/2 AS 3113.* London: TNA/FO. BC.

Longden, A. (1946a, 10 23). Letter to South American Department (FO). *BRA 28/2.* London: TNA/FO.

Longden, A. (1946b, 2 11). Letter to Richard Allan (FO). *BRA 28/2. Brazilian exhibition.* London: TNA/FO. BC.

Longden, A. A. (1935). *British art exhibitions at home and abroad.*

Longden, A. (1943, 12 16). Longden – Gurney. TNA/FO. London: TNA/FO.

Magno, C. P. (1942, 9 18). Letter to Eric Church. London: MRE.

Magno, P. C. (1936, 10 29). Letter to Alfredo Polzin. *Cons. Londres 0.0. 310/1936.* London: MRE/RJ.

Magno, P. C. (1943). Brazilian painting. *The Studio,* 98–113.

Malan, C. (2018, 4 22). *Crônica do JH: obras brasileiras são expostas em Londres.* Retrieved from Globo: https://globoplay.globo.com/v/6680487/.

Malone, E. (1797). *The Works of Sir Joshua Reynolds.* London. T, Cadell, Jun. and W. Davies.

Manhã, A. (1944, 11 23). *Pinturas modernas do Brasil numa exposição em* Londres. A Manhã, p. 7.

Manchester Gallery Archive. (1945). Curator Annual Report. Manchester Gallery Archive.

172 PUBLIC DIPLOMACY ON THE FRONT LINE

Manchester Evening News. (1943, 11 27). Brazil's art gift to Britain. *Manchester Evening News*, pp. 4,8.

Manchester Evening News. (1944, 11 18). Brazilian art for the RAF. *Manchester Evening News*, p. 5.

Mantzavinos, C. (2016, 6 22). *Hermeneutics*. Retrieved May 1, 2020, from Stanford Encyclopedia of Philosophy: https://plato.stanford.edu/entries/hermeneutics/.

Mark, S. (2009). A greater role for cultural diplomacy. In I. d'Hooghe, & E. Huijgh (Eds.), *Discussion Papers in Diplomacy* (pp. 1–44). Clingendael: Netherlands Institute of International Relations 'Clingendael'.

Marlow, T. (2018). Foreword. In M. Asbury, H. Gadelha, & M. Sono (Eds.), *The Art of Diplomacy – Brazilian Modernism Painted for War* (pp. 17–18). London: Embassy of Brazil.

Martins, W. (1970). *The Modernist Idea*. New York: New York University.

Mayor of Bath. (n.d.). Retrieved 6 5, 2016, from http://mayorofbath.co.uk/files/myrlist-cityofbath_june1011.pdf.

McClory, J. (2017). *The Soft Power 30: A Global Ranking of Soft Power 2017*. London: Portland.

McClory, J. (2018). The Soft Power 30 2018. London: Portland.

McQuillen, J. (1944a, 9 19). McQuillen. *AS 5149 Foreign Office document*. London: TNA/FO.

McQuillen, J. (1944b, 6 6). Annotation by McQuillen in a letter from Longden to Gurney. *AS 2761/698/6 BRA 8/1*. London: TNA/FO.

McQuillen, J. (1945, 6 30). Annotation in a cable from the Embassy in Rio de Janeiro (13/6/45). *AS 3339/101/6*. London: TNA/FO.

McQuillen, J. M. (1944a, 11 16). Annotation in a Foreign Office minute (16/11/44). *As 5998/698/6*. London: TNA/FO.

McQuillen, J. M. (1944b, 12 18). Annotation in a letter from Mrs. Moss (BC) (15/12/44). *AS 6491/698/6*. London: TNA/FO.

McQuillen, J. M. (1944c, 11 30). Letter to E. P. A. Murray-Scott (Ministry of Information). *AS 6103/698/6*. London: TNA/FO.

McQuillen, J. M. (1946, 11 15). Annotation in a letter from Alfred Longden (BC) to South American Department (23/10/46). *AS 6564/948/6. Sale of Brazilian paintings*. London: TNA/FO.

Melissen, J. (2005a). The New Public Diplomacy: Between Theory and Practice. In J. Melissen, *The New Public Diplomacy*. New York: Palmgrave.

Melissen, J. (2005b). *The New Public Diplomacy: Soft Power in International Relations*. Nova York: Palgrave.

Mendonça Telles, G. (2012). *Vanguarda Europeia & Modernismo Brasileiro*. Rio de Janeiro: José Olympio.

Min War Transport. (1944, 4 1). Min War Transport – FO. London: TNA/FO.

Modern Art Oxford. (2018,3). *The Family in Disorder: Truth or Dare, Cinthia Marcelle*. Retrieved from Modern Art Oxford: https://www.modernartoxford.org.uk/event/cinthia-marcelle/.

Modern Brazilian art. (1945, 3 20). *The Glasgow Herald*.

MoMA. (2018, 2). *Inventing Modern Art in Brazil*. Retrieved from MoMA: https://www.moma.org/calendar/exhibitions/3871.

Moniz de Aragão, J. J. (1943, 3 2). Cable to Oswaldo Aranha. Exposição de arte brasileira em Londres. *131*. London: MRE.

Moniz de Aragão, J. J. (1944a, 3 30). Moniz de Aragão – Aranha. MRE.

Moniz de Aragão, J. J. (1944b, 10 18). Letter to Pedro Leão Velloso. *467/1944 541.33.60. Exposição brasileira de arquitetura*. London: MRE.

REFERENCES

Moniz de Aragão, J. J. (1945a, 5 30). Cable to MRE. *DC/193/540.31 (60)*. London: MRE.

Moniz de Aragão, J. J. (1945b, 4 30). Cable to Pedro Leão Velloso. *175/540.3d Exposição brasileira de pintura e de arquitetura*. London: MRE.

Monocle Minute. (2018, 4 7). Brazil's soft-power play during the Second World War is a work of art. *The Monocle Minute*. London: Monocle.

Moraes, J. B. (2005). *A FEB pelo seu comandante*. Rio de Janeiro: Biblioteca do Exército.

Morais, F. (1986). *Tempos de Guerra*. Rio de Janeiro.

Morais, F. (1994). *Cronologia das Artes Plásticas no Rio de Janeiro*. Rio de Janeiro: Topbooks.

Moss. (1944, 12 15). *Moss – McQuillen*. London: TNA/FO.

Moura, G. (1980). *Autonomia na dependência: a política externa brasileira de 1935 a 1942*. Rio de Janeiro: Nova Fronteira.

Moura, G. (1991). *Tio Sam chega ao Brasil*. São Paulo: Brasiliense.

Moura, G. (2013). *Brazilian Foreign Relations: 1939–1950*. Brasília: FUNAG.

MRE. (1943, 20). Itamaraty – Embassy in London. Doação de quadros brasileiros à Grã-Bretanha. *212 540.33 (60)*. Rio de Janeiro: MRE/RJ.

Munnings, A. (1944, 10 11). Letter to Anthony Eden. *AS 5149/698/6*. London: TNA/FO. RAA.

Murray, D. (2018). Foreword. In M. Asbury, H. Gadelha, & M. Sono (Eds.), *The Art of Diplomacy – Brazilian Modernism Painted for War* (pp. 19–20). London: Embassy of Brazil.

Nash, M. (1945, 8 31). Letter to H. D. Bryan (FO). *BRA/28/2d AS 4778. Brazilian painting exhibition*. London: TNA/FO. BC.

National Gallery of Scotland. (1945). *Catalogue of the Exhibition of Modern Brazilian Paintings*. Edinburgh, UK: National Gallery of Scotland.

National Portrait Gallery. (n.d.). Retrieved 5 26, 2016, from http://www.npg.org.uk/collections/search/person/mp12179/john-farleigh.

Navarra, R. (1945a). O catálogo da exposição brasileira. *Correio da Manhã*.

Navarra, R. (1945b). Sobre a exposição de pintura brasileira em Londres. (April).

Navarra, R. (1945c, 2 18). Vida artística – o catálogo da exposição de Londres. *Correio da Manhã*.

Neto, L. (2013). *Getúlio: 1930–1945*. São Paulo: Schwarcz.

Neto, U. (2018, 1 12). A arte da diplomacia. *Valor Econômico*.

Newton, E. (1944, 11 26). A gesture from Brazil. *Sunday Times*, p. 2.

Nottingham Evening Post. (1943, 11 27). Brazilian art collections gift to Britain. *Nottingham Evening Post*, p. 4.

Nye Jr., J. (1990). *Bound to Lead: The Changing Nature of American Power*. New York: Basic Books.

Nye Jr., J. (2004). *Soft Power: The Means to Success in World Politics*. New York: Public Affairs.

Nye Jr., J. (2008a). Public diplomacy and soft power. In G. Cowan, & N. J. Cull (Eds.), *The Annals of the American Academy of Political and Social Science* Los Angeles: (pp. 94–109). Annenberg School for Communication, University of Southern Carolina.

Nye Jr., J. (2008b, 3 1). *Public Diplomacy and Soft Power*. Retrieved 7 27, 2017, from Sage Journals: http://journals.sagepub.com/doi/abs/10.1177/0002716207311699.

Otago Daily Times. (2018, 4 6). Exhibition has spring in its steps. *Otago Daily Times*.

Pacheco, F. (2018, 4 6). *The Globalist*. Retrieved from Monocle: https://monocle.com/radio/shows/the-globalist/1680/.

Palin, M. (2013). *Brazil*. London: W & N.

Pamment, J. (2015). A contextualized interpretation of public diplomacy evaluation. In G. J. Golan, S.-U. Yang, & D. F. Kinsey (Eds.), (pp. 255–281). *International Public Relations and Public Diplomacy*. New York: Peter Lang.

174 PUBLIC DIPLOMACY ON THE FRONT LINE

Parkinson, M. (1945, 8 2). Letter to Alfred Longden. *BRA 28/2c*. London: TNA/FO. BC.

Perowne, V. (1943, 12 9). Annotation by Perowne. *4223*. London: TNA/FO.

Perowne, V. (1944a, 10 28). Annotation in a Foreign Office document. *Brazilian pictures*. London: TNA/FO.

Perowne, V. (1944b, 11 16). Annotation in a Foreign Office minute (16/11/44). *AS 5998/698/8. Exhibition of Brazilian pictures*. London: TNA/FO.

Perowne, V. (1944c, 10 2). Annotation in a letter from Somerville (BC) to Miss McQuillen (29/9/44). *AS 5149*. London: TNA/FO.

Perowne, V. (1944d, 11 29). Cable to Donald Gainer (UK Embassy in Rio de Janeiro). *AS 62227/698/6*. London: TNA/FO.

Perowne, V. (1944e, 2 18). Foreign Office document. *4280*. London: TNA/FO.

Perowne, V. (1944f, 10 3). Foreign Office document. *4471*. London: TNA/FO.

Perowne, V. (1944g, 10 28). Foreign Office document. *AS 5580/698/6*. London: TNA/FO.

Perowne, V. (1944h, 10 16). Letter to Alfred Logden (BC). *AS 5149/698/6*. London: TNA/FO.

Perowne, V. (1944i, 10 27). Letter to Alfred Longden (BC). *4501*. London: TNA/FO.

Perowne, V. (1944j, 10 24). Letter to Alfred Longden (BC). *4497*. London: TNA/FO.

Perowne, V. (1944k, 10 24). Letter to Osbert Sitwell. *4495*. London: TNA/FO.

Perowne, V. (1944l, 2 1). Letter to the secretary of the Ministry of War Transport. AS 700/698/6. London: TNA/FO.

Perowne, V. (1944m, 2 1). Letter to the secretary of the Board of Custom Excise. *AS 700/698/6*. London: TNA/FO.

Perowne, V. (1944n, 3 1). Letter to Walter Lamb (RAA). *AS 946/698/6*. London: TNA/FO.

Perowne, V. (1944o, 3 4). *4279*. Annotation in a letter from Allen (3/3/1944). London: TNA/FO.

Perowne, V. (1944p, 10 21). Perowne – Longden. London: TNA/FO.

Perowne, V. (1944q, 11 30). Perowne – Murray-Scott. London: TNA/FO.

Perowne, V. (1944r, 2 18). Perowne. London: TNA/FO.

Perowne, V. (1945a, 1 9). Annotation in a cable from the UK Embassy in Rio de Janeiro (30/11/44). *AS 101/101/6. Gift of Brazilian paintings*. London: TNA/FO.

Perowne, V. (1945b, 7 26). Annotation in a letter from Alfred Logden (BC) (13/7/45). *As 4032/101/6*. London: TNA/FO. BC.

Perowne, V. (1945c, 4 28). Annotation in a letter from Liliam Somerville (BC) to Mis McQuillen (19/4/45). *BRA 28/2 AS 1448/101/6*. London: TNA/FO. BC.

Perowne, V. (1945d, 9 18). Annotation in a letter from Miss Nash (BC) to Mr. Bryan (31/8/45). *AS 4778/101/6*. London: TNA/FO.

Perowne, V. (1945e, 1 29). Annotation in a letter from Somerville (BC) to McQuillen (23/1/45). *As 567/101/6*. London: TNA/FO.

Perowne, V. (1945f, 1 16). Letter to A. J. D. Winnifrith (Treasury). *AS 101/101/6*. London: TNA/FO.

Perowne, V. (1945g, 7 4). Letter to Alfred Longden. *AS 2433/101/6*. London: TNA/FO.

Perowne, V. (1945h, 5 14). Perowne – Longden. AS 2433/101/6. London: TNA/FO.

Perowne, V. (1945i, 1 16). Perowne – Winnifrith. London: TNA/FO.

Pes, J. (2018, 4 3). *The Brazilian Embassy in London Reboots a Show of Modern Art That Wowed the City in Wartime*. Retrieved from Artnet: https://news.artnet.com/exhibitions/brazilian-modern-art-impressed-wartime-london-returns-1258754.

Peterson, M., & Higgs, J. (2005, 6 Volume 10 Number 2). Using hermeneutics as a qualitative research approach in professional practice. *The Qualitative Report*, pp. 339–357.

REFERENCES 175

Pisarka, K. (2016). Americas and Europe. In N. Chitty, L. Ji, G. D. Rawnsley, & C. Hayden, New York: *The Rouledge Book of Soft Power*. Routledge.

Polzin, A. (1936, 10 29). Cable to José Carlos de Macedo Soares. Cooperação intelectual. *510/1935*. London: MRE/RJ.

Pontual, R. (1984). In J. Hoole, & R. Pontual (Eds.), *Portraits of a Country*. London: Barbican.

Portal FEB. (n.d.). Retrieved 6 5, 2016, from http://www.portalfeb.com.br/jose-renault-coelho-fraternidade-do-fole/.

Power, G., & Curran, T. (2018). *Optimizing Engagement: Research, Evaluation and Learning in Public Diplomacy*. Washington: Advisory Comission on Public Diplomacy.

RAA. (1944). *Catalogue of the Exhibition of Modern Brazilian Paintings*. London: Royal Academy of Arts/British Council.

RAA. (1945). *Annual Report 1944*. RAA.

RAF. (1948, 2 26). Aid from art. *Flight*, p. 244.

RAF Harrowbeer. (n.d.). Retrieved 6 5, 2016, from www.rafharrowbeer.co.uk/bellows_of_brazil.htm.

Rafferty, S. (2018, 4 3). *Rachel Kelly, Thiago Soares, Marcelo Bratke, Hayle Gadelha, Katherine Bryan*. Retrieved from BBCX: https://www.bbc.co.uk/programmes/b09xk9s5.

Rangarajan, V. (2018). Foreword. In M. Asbury, H. Gadelha, & M. Sono (Eds.), *The Art of Diplomacy – Brazilian Modernism Painted for War* (pp. 15–16). London: Embassy of Brazil.

Read, H. (1943). Exposição de pintura britânica contemporânea. *Catálogo da Exposição de pintura britânica contemporânea*. Rio de Janeiro: British Council.

Reading Mercury. (1945, 8 11). Brazilian art. *Reading Mercury*, p. 4.

Reading Standard. (1945a, 8 17). Brazil' gift to the RAF Fund. *Modern paintings with exotic backgrounds*, p. 8.

Reading Standard. (1945b, 8 17). Brazilian artists. *Reading Standard*, p. 8.

The Reading Standard. (1945, 8 10). Brazil's gift to the RAF fund. *The Reading Standard*, p. 5.

Rebaza-Soraluz, L. (2007). The study of Latin America art in the UK: a preliminary note. *Bulletin of Spanish Studies*, vol LXXXIV, 4–5.

Revolvy. (n.d.). *Revolvy*. Retrieved 12 3, 2018, from https://www.revolvy.com/page/The-Studio-%28magazine%29.

Richard Saltoun. (2018, 4). *Paulo Bruscky: the gallery will be fumigated of art*. Retrieved from Richard Saltoun: https://www.richardsaltoun.com/exhibitions/60/.

Riche, C. A. (2005). A formação dos símbolos nacionais. In C. Lessa (Ed.), *Enciclopédia da Brasilidade* (pp. 52–64). Rio de Janeiro: Casa da Palavra.

Ricupero, R. (2017). *A diplomacia na construção do Brasil: 1750–2016 (1a ed.)*. Rio de Janeiro: Versal.

Robertson, M. (1941, 10). *Exposição de desenhos de escolares da Grã-Bretanha*. Rio de Janeiro: British Council.

Rodd, P. (1944, 11 13). Press release. *GB/16/1. Brazilian gift to Britain*. London: TNA/FO. BC.

Sanderson, D. (2018, 219). War paint. Brazilian art helped fight Hitler. *Times*.

Santos, E. d. (2018). Foreword. In M. Asbury, H. Gadelha, & M. Sono (Eds.), *The Art of Diplomacy – Brazilian Modernism Painted for War* (pp. 11–14). London: Embassy of Brazil.

Scotsman. (1945, 2 9). Brazilian art. *Scotsman*.

Scottish architects. (n.d.). Retrieved 5 24, 2016, from http://www.scottisharchitects.org.uk/architect_full.php?id=206874.

Silva, J. L. (2009). *L'Anthropophagisme dans l'Identité Culturelle Brésilienne*. Paris: Harmattan.

Singh, J. P., & Stuart, M. (2017a). *Soft Power Today: Measuring the Influences and Effects*. Edinburgh: University of Edinburgh.

Singh, J. P., & Stuart, M. (2017b). *Soft Power Today: Measuring the Influences and Effects*. Edinburgh: University of Edinburgh.

Sitwell, S. (1924). *The Thirteenth Caesar, and Other Poems*. London: Grant Richards.

Sitwell, S. (1944, 10 27). Letter to Victor Perowne. *4502*. Towcester, UK: TNA/FO.

Sitwell, S. (1944, 1 6). The Brazilian style. *Architectural Review*.

Snow, N. (2009). Rethinking public diplomacy. In N. Snow, & P. M. Taylor (Eds.), *Routledge Book of Public Diplomacy*, (pp. 1–10). Oxon: Routledge.

Snow, N., & Taylor, P. (2009). *Routledge Handbook of Public Diplomacy*. New York: Routledge.

Somerville, L. (1944, 12 8). Letter to McQuillen (FO). *AS 6412*. London: TNA/FO. BC.

Somerville, L. (1945a, 1 8). Letter to F. S. Wallis (Bristol Museum and Art Gallery). *BRA/28/2*. London: Bristol Museum and Art Gallery.

Somerville, L. (1945b, 4 19). Letter to McQuillen, J. M. *BRA 28/2 AS 1448/101/6*. London: TNA/FO. BC.

Somerville, L. (1945c, 2 1). Letter to Miss McQuillen (FO). *BRA/28/2d AS 803*. London: TNA/FO. BC.

Somerville, L. (1945d, 1 23). Letter to Miss McQuillen (FO). *BRA/28/2d AS 567*. London: TNA/FO. BC.

Sousa-Leão, J. (1943). Brazilian Colonial Architecture. *The Studio, October*, 113–118.

Sousa-Leão. (1944a, 6 13). Sousa-Leão – Gallop. TNA/FO.

Sousa-Leão, J. d. (1944b). Brazil: the Background. *Architectural Review, XCV* (January-June).

Sousa-Leão, J. d. (1944c, 11 30). Letter to Pedro Leão Velloso (MRE). *523/1944 140.31/60. Exposição de pintura brasileira em Londres*. London: MRE.

Sousa-Leão, J. d. (1945a, 2 12). Cable to Pedro Leão Velloso. *43/540/3d(60a). Exposição brasileira em Edimburgo*. London: MRE.

Sousa-Leão, J. d. (1945b, 3 19). Cable to Pedro Leão Velloso. *96/540/3d (60a)*. London: MRE.

South American Journal. (1944, 1 15). The Brazilian year. *The South American Journal*, pp. 25–26.

South London Gallery. (2018, June). *Luiz Zerbini: Intuitive Ratio*. Retrieved from South London Gallery: https://www.southlondongallery.org/exhibitions/luiz-zerbini/.

Squeff, L. (2015). *Originalidade e Modernidade na Arte Latino-Americana: a Exposição de Arte Latino Americana de Paris (1924)*. Retrieved 7 31, 2017, from MAc: http://www.mac.usp.br/mac/conteudo/academico/publicacoes/anais/labex_br_fr/pdfs/9_Labex_leticiasqueff.pdf.

St James Club. (n.d.). Retrieved 5 23, 2016, from http://www.stjameshotelandclub.com/news-and-press?nid=13.

Sunderland Daily Echo & Shipping Gazette. (1943, 11 27). Art collection for Britain. *Sunderland Daily Echo & Shipping Gazette*, p. 2.

Tainted Glory. (2018, 4 8). *The Art of Diplomacy – Brazilian Modernism Painted for War*. Retrieved from Tainted Glory: https://www.taintedglory.co.uk/single-post/2018/04/08/The-Art-of-Diplomacy-Brazilian-Modernism-Painted-for-War---Brazilian-Embassy-London.

Takac, B. (2018, 3 28). *How the UK and Brazil Collaborated through Art at the Outbreak of WW II*. Retrieved from Wide Walls: https://www.widewalls.ch/magazine/how-the-uk-and-brazil-collaborated-through-art-at-the-outbreak-of-ww-ii.

REFERENCES

Tate. (n.d.). Retrieved 5 26, 2016, from http://www.tate.org.uk/art/artists/john-piper-1774.

Tate. (2018,4). *Opavivará: Utupya*. Retrieved from Tate: https://www.tate.org.uk/whats-on/tate-liverpool/exhibition/opavivara.

Taylor, B. (1999). *Art for the Nation*. Oxford: Alden Press.

Teixeira, O. (1940). *Getúlio Vargas e a Arte no Brasil*. Rio de Janeiro: DIP.

Telles Ribeiro, E. (1989). *Diplomacia cultural: seu papel na política externa brasileira*. Brasília: FUNAG.

The Duke of York. (2018, 6 6). *@TheDukeOfYork*. Retrieved from Twitter: https://twitter.com/thedukeofyork.

They work for you. (n.d.). Retrieved 5 24, 2015, from http://www.theyworkforyou.com/mp/21562/thomas_cook/norfolk_northern.

Time & Tide. (1944, 12). Arts. *Time & Tide*.

Times. (1944a, 11 23). Brazilian artists' gift. *The Times*, p. 6.

Times. (1944b, 2 19). The national theme. *The Times Literary Supplement*, p. 92.

Times. (1944c, 2 8). *Times*.

Times. (1945, 2 3). Cardoso picture for the Tate Gallery. *Times*.

Times. (2018, 4 6). *The Times*, p. 4.

Toye, F. (1944, 3 14). Toye – Longden. London: TNA/FO.

Toye, F. (1943, 11 9). Cable to Eric Church. *C/2/569*. Rio de Janeiro: TNA/FO. FO.

Toye, F. (1943, 12). Cable to Frederick Ogilvie. *C/2/605*. Rio de Janeiro: TNA/FO. BC.

Udo-Udo, J. (2016). Cultural approaches to soft power. In N. Chitty, L. Ji, G. D. Rawnsley, & C. Hayden (Eds.), *The Routledge Book of Soft Power* New York: (p. 488). Routledge.

UNESCO. (1946, 11). Catalogue of the 'Exposition Internationale d'Art Moderne'. Paris: UNESCO.

Vargas, G. (1943, 12 29). *Discurso de posse na Academia Brasileira de Letras*. Retrieved 5 30, 2016, from Academia Brasileira de Letras: academia.org.br/abl/cgi/cgilua.exe/sys/start.htm?infoid=585&sid=335.

Victoria Art Gallery. (1945). List of attendance, Brazilan Modern Art Exhibition. *Victoria Art Gallery*.

Vieira, K. A., & de Queiroz, G. M. (2017, 9 Volume 2 Issue 8). Hermeneutic Content Analysis: a method of textual analysis. International Journal of Business Marketing and Management, 8–15.

Villaverde, J. (2015, 5 10). Resgate histórico: Londres pode rever mostra de arte do Brasil realizada em 1944. *Estado de São Paulo*, p. c10.

Wallis, F. S. (1944, 11 27). Letter to Alfred Longden (BC). Bristol, UK: Bristol Museum and Art GAllery.

Wallis, J. S. (1945a, 2 3). Letter to Colonel Vining. Bristol, UK: Bristol Museum and Art Gallery.

Wallis, J. S. (1945b, 1 12). Letter to Miss Somerville (BC). Bristol, UK: Bristol Museum and Art Gallery.

Ward. (1944, 11 1). Letter to Miss McQuillen (FO). *AS 5710*. London: TNA/FO. BC.

Western Daily. (1945, 5 30). Brazilian Exhibition in Bristol. *Western Daily*, p. 1.

Whitburn, J. (2004). *The Billboard Book Of Top 40 Country Hits: 1944–2006*. Record Research.

White Cube. (2018, 4). *Beatriz Milhazes Rio Azul*. Retrieved from White Cube: https://whitecube.com/exhibitions/exhibition/beatriz_milhazes_bermondsey_2018.

Whitney Museum of American Art. (2017, 7). *Hélio Oiticica: To Organize Delirium*. Retrieved from Whitney: https://whitney.org/exhibitions/heliooiticica.

Who was who. (n.d.). Retrieved 4 9, 2016, from http://www.ukwhoswho.com/view/article/oupww/whowaswho/U50691, accessed 9 April 2016.

Wilcox, C. H. (1944, 5 3). Letter to the undersecretary of State (F). *AS 1685/698/6 S.51784*. London: TNA/FO.

Williams, D. (2001). *Culture of Wars in Brazil*. Durham: Duke University.

Wullschlager, J. (2018, 3 31). Critics' Choices. *Financial Times*, p. 16. Retrieved from Financial Times.

Yonezawa, J. (2018, 3 12). *Como artistas brasileiros apoiaram Londres contra o nazismo*. Retrieved from Deutsche Welle: https://www.dw.com/pt-br/como-artistas-brasileiros-apoiaram-londres-contra-o-nazismo/a-42913043.

Yorkshire Post and Leeds Intelligencer. (1944, 11 23). Brazil's part. *Yorkshire Post and Leeds Intelligencer*, p. 2.

Yorkshire Post and Leeds Mercury. (1944). Court and personal. *Yorkshire Post and Leeds Mercury*.

Zaharna, R. S. (2009). Mapping out a spectrum of public diplomacy initiatives. In N. Snow, & P. M. Taylor (Eds.), *Routledge Book of Public Diplomacy*, (pp. 86–100). Oxon: Routledge.

Zanini, W. (1991). *A arte no Brasil nas décadas de 1930–40*. São Paulo: Edusp.

Zanini, W. (1991). Exposições coletivas brasileiras e no exterior (decênios de 1930 e 1940). In Editora da UFRGS, *Anais do IV Congresso Brasileiro de História da Arte*, (pp. 175–180). Porto Alegre: UFRGS.

Zilio, C. (2010). A questão política no modernismo. In A. Fabris.(Ed.), *Modernismo e modernidade no Brasil* (pp. 101–108). Porto Alegre: Zouk.

Zweig, S. (1941). *Brazil: A Land of the Future*. Riverside: Ariadne.

APPENDIX

List of Artworks

The following lists present the 1944–1945 Exhibition of 168 artworks and the 2018 TAoD display of 24 paintings, in the order that they appear in their respective catalogues.

Exhibition of Modern Brazilian Paintings

1. Virginia Artigas Composition oil
2. Aldo Bonadei Landscape with sun oil
3. Aldo Bonadei Music [*Menino na paisagem*] oil
4. Aldo Bonadei Landscape oil
5. Roberto Burle Marx[1] Portrait[2] oil
6. Roberto Burle Marx Landscape oil
7. Roberto Burle Marx Fish oil
8. Hilda Campofiorito Flowers [*Flores*] oil
9. Quirino Campofiorito Landscape [*Composição*] oil
10. Cardoso Júnior [3] They amuse themselves [*Elas se divertem*] oil
11. Cardoso Júnior Jacuicanga River [*Paisagem*] oil
12. Ignês Correia da Costa[4] Composition oil
13. Milton Dacosta[5] Head of a girl [*Cabeça de mulher*] oil
14. Milton Dacosta Cyclists oil
15. Quirino da Silva Landscape oil
16. Flávio de Carvalho Portrait oil
17. Oswald de Andrade Filho[6] Composition oil

1 In the catalogue, the artist's last name is misspelled as Burle-Marx.
2 Also referred to as 'Portrait of a Young Man'.
3 In the catalogue, the artist appears as José Cardoso Junior.
4 In the catalogue, the artist's name is spelled as Inez Correia da Costa.
5 In the catalogue, the artist's last name is misspelled as Da Costa.
6 In the catalogue, the artist appears as Filho de Andrade.

18. Oswald de Andrade Filho The dead girl oil
19. Oswald de Andrade Filho Composition oil
20. Jorge de Lima Angel [*O anjo*] oil
21. Urbano de Macedo The artist's family oil
22. Urbano de Macedo Batrachians, huns and bersaglieri oil
23. Cícero Dias Painting oil
24. Cícero Dias Painting oil
25. Emiliano Di Cavalcanti Women from Bahia [*Baianas*] oil
26. Djanira Church, Congonhas oil
27. Djanira Children in the garden [*O parque*] oil
28. Tarsila do Amaral Seascape oil
29. Tarsila do Amaral Landscape oil
30. Heitor dos Prazeres Washerwoman oil
31. João Maria dos Santos Brazilian dance oil
32. João Maria dos Santos Brazilian carnival oil
33. Lucy Citti Ferreira Little girl and cat oil
34. Lucy Citti Ferreira Still life with lamp [*Natureza morta*] oil
35. Martim Gonçalves[7] Boy in the library oil
36. Francisco Rebolo[8] From my studio oil
37. Francisco Rebolo Landscape [*Paisagem*] oil
38. Francisco Rebolo Painting oil
39. Francisco Rebolo Painting oil
40. Clóvis Graciano Figure oil
41. Clóvis Graciano Dancer [*Bailarina*][9] oil
42. Duja Gross Tenement houses oil
43. Alberto da Veiga Guignard Landscape, Ouro Preto oil
44. Alberto da Veiga Guignard Landscape, Ouro Preto oil
45. Alberto da Veiga Guignard Head of a girl oil
46. Alberto da Veiga Guignard Head of a girl oil
47. Thea Haberfeld Fish oil
48. Thea Haberfeld Composition[10] oil
49. Thea Haberfeld Landscape oil
50. Bellá Paes Leme Group oil
51. Bellá Paes Leme Family Group oil
52. Bellá Paes Leme Landscape oil
53. Emeric Marcier Crucifixion oil

7 In the catalogue, the artist appears as Elos Goncalves.
8 In the catalogue, the artist appears as Francisco Rebolo Goncalves.
9 Also referred to as '*Ballerina*'.
10 Also referred to as 'Composition: Brazilian Landscape'.

APPENDIX 181

54. Manoel Martins Suburb oil
55. Oscar Meira Sailor oil
56. Alcides Rocha Miranda Head oil
57. José Moraes Portrait [*Retrato*] oil
58. José Moraes Head of a girl oil
59. Nelson Nóbrega Landscape oil
60. Nelson Nóbrega Landscape oil
61. Paulo Rossi Osir Fish oil
62. José Pancetti Campos de Jordão oil
63. José Pancetti Flowers oil
64. José Pancetti Tenement house oil
65. José Pancetti Portrait of the artist [*Auto-retrato*] oil
66. Candido Portinari Group [*Mulher e crianças*] oil
67. Candido Portinari The half-wit [*A boba*] oil
68. Carlos Prado Figure oil
69. Carlos Prado Figure oil
70. Carlos Prado Portrait of the artist oil
71. Tomás Santa Rosa[11] Man with fish [*Homem*] oil
72. Lasar Segall[12] Lucy with flower oil
73. Luís Soares Pastoral [*Pastoril*] oil
74. Árpád Szenes[13] Studio [*Intérieur / Escrevendo*] oil
75. Orlando Teruz Soldier on horseback oil
76. Toledo Piza Landscape oil
77. Alfredo Volpi Women [*Figuras*] oil
78. Gastão Worms Still life oil
79. Mario Zanini Landscape oil
80. Mario Zanini Landscape oil
81. Livio Abramo[14] Bombs wood engraving
82. Livio Abramo Figure in boat wood engraving
83. Livio Abramo Town [*Vila operária*] wood engraving
84. Edith Behring Child's head drawing
85. Edith Behring[15] Child's head drawing
86. Athos Bulcão Composition gouache
87. Roberto Burle Marx Pen and ink drawing [*Lapa*] drawing
88. Iberê Camargo Group etching

11 In the catalogue, the artist's name is spelled as Thomaz Santa Rosa.
12 In the catalogue, the artist's name is spelled as Lazar Segall.
13 In the catalogue, the artist's name is spelled as Harpad Szenes.
14 In the catalogue, the artist's name is misspelled as Livio Abrano.
15 In the catalogue, the artist's name is misspelled as Edith Bhering.

182 PUBLIC DIPLOMACY ON THE FRONT LINE

89. Iberê Camargo Girl and old man drawing
90. Rubem Cassa Figure lithograph
91. Rubcm Cassa Fishermen gouache
92. Raimundo Cela Circus etching
93. Vieira da Silva[16] Cyclists [*Ciclistas*] watercolour
94. Vieira da Silva Fish Wives gouache
95. Vieira da Silva Composition [*Lisbonne / Lisboa*] gouache
96. Percy Deane Bather drypoint
97. Percy Deane Lovers drawing
98. Flávio de Carvalho Nude drawing
99. Odette de Freitas Landscape watercolour
100. Odette de Freitas Landscape watercolour
101. Axl von Leskoschek[17] Lovers wood-cut in colour
102. Axl von Leskoschek The banana tree wood-cut in colour
103. Axl von Leskoschek Illustration wood engraving
104. Axl von Leskoschek Nausicaa wood engraving
105. Jorge de Lima Brazilian family tempera
106. Cícero Dias Painting [*Aquarela*] watercolour
107. Cícero Dias Painting watercolour
108. Djanira Itaipava brush drawing
109. Djanira Figure drawing
110. Mariusa Fernandez Composition[18] tempera
111. Mariusa Fernandez Composition tempera
112. Lucy Citti Ferreira Refugee wood engraving
113. Lucy Citti Ferreira Man and Woman wood engraving
114. Lucy Citti Ferreira Homeless drawing
115. Oswaldo Goeldi Fisherman wood engraving
116. Oswaldo Goeldi Red fish wood engraving
117. Oswaldo Goeldi Old age wood engraving
118. Martim Gonçalves Landscape drawing
119. Martim Gonçalves Landscape drawing
120. Martim Gonçalves Figure drawing
121. Clóvis Graciano Landscape gouache
122. Clóvis Graciano Figure drawing
123. Percy Lau Girl by the river etching
124. Percy Lau Sugar mill etching
125. Percy Lau Reeds drawing

16 Maria Helena Vieira da Silva
17 In the catalogue, the artist appears as Axel de Leskoschek.
18 Also referred to as 'Composition with religious figure'.

APPENDIX 183

126. Percy Lau Figure etching
127. Carlos Leão Composition drawing
128. Carlos Leão Prodigal son drawing
129. Carlos Leão Women drawing
130. Carlos Leão Girls drawing
131. Ahmés de Paula Machado Figures lithograph
132. Ahmés de Paula Machado Figures lithograph
133. Walter Machado Figures drawing
134. Emeric Marcier Prophet drawing
135. Emeric Marcier Prophet drawing
136. Emeric Marcier figure drawing
137. Manoel Martins War wood engraving
138. Manoel Martins Town wood engraving
139. Manoel Martins Women wood engraving
140. Manoel Martins Portait of the artist wood engraving
141. Manoel Martins Slave ship wood engraving
142. Oscar Meira Figure drawing
143. Alcides Rocha Miranda Composition drawing
144. Alcides Rocha Miranda Composition drawing
145. Noemia Mourão Head watercolour
146. Nelson Nóbrega Girls drypoint
147. Nelson Nóbrega Boys drypoint
148. Carlos Oswald Girl at piano etching
149. Poty Lazzarotto[19] Sowers etching
150. Poty Lazzarotto Cobblers [*Os sapateiros*] etching
151. Poty Lazzarotto Drunkards [*Embriagados*] etching
152. Augusto Rodrigues Figures gouache
153. Augusto Rodrigues Women at the window gouache
154. Jacob Ruchti[20] Composition gouache
155. Tomás Santa Rosa Figure lithograph
156. Tomás Santa Rosa Figure lithograph
157. Tomás Santa Rosa Composition drawing
158. Carlos Scliar Composition tempera
159. Carlos Scliar Composition tempera
160. Carlos Scliar Composition tempera
161. Carlos Scliar Composition tempera
162. Luís Soares Circus watercolour

19 In the catalogue, this artist appears as Napoleão Pottyguara, a pseudonym from his younger days.
20 In the catalogue, the artist appears as Jacob Mauricio Ruchti.

184 PUBLIC DIPLOMACY ON THE FRONT LINE

163. Luís Soares Brazilian dance watercolour
164. Árpád Szenes Woman at the piano tempera
165. Árpád Szenes War [*Guerre*] tempera
166. Aldari Toledo Woman in a mirror drawing
167. Aldari Toledo Women drawing
168. Paulo Werneck Little black herder drawing

The Art of Diplomacy – Brazilian Modernism Painted for War

1. Oswald de Andrade Filho Composition oil
2. Roberto Burle Marx Landscape oil
3. Roberto Burle Marx Portrait of a young man oil
4. Cardoso Júnior They amuse themselves oil
5. Emiliano Di Cavalcanti Women from Bahia oil
6. Milton Dacosta Head of a girl oil
7. Lucy Citti Ferreira Little girl and cat oil
8. Lucy Citti Ferreira Still life with lamp oil
9. Martim Gonçalves The boy in the library oil
10. Clóvis Graciano *Ballerina* oil
11. Thea Haberfeld Composition: Brazilian landscape oil
12. Thea Haberfeld Fish oil
13. Thea Haberfeld Landscape oil
14. Urbano de Macedo Batrachians, huns & bersaglieri oil
15. Manoel Martins Suburb oil
16. Oscar Meira Sailor oil
17. Alcides Rocha Miranda Head oil
18. José Moraes Portrait of a boy oil
19. José Moraes Head of a girl oil
20. Bellá Paes Leme Family Group oil
21. Candido Portinari The scarecrow oil
22. Lasar Segall Lucy with flower oil
23. Luís Soares Pastoral oil
24. Gastão Worms Still life oil

INDEX

Adrian Locke 6n2, 96, 120, 132, 151
Ahmés de Paula Machado 183
Air Lord Sherwood 38, 149
Alberto da Veiga Guignard 21, 180
Alcides Rocha Miranda 181, 183, 184
Aldari Toledo 87n100, 184
Aldo Bonadei 108n186, 142, 179
Aleijadinho 42, 44, 46
Alfred Munnings 65, 66, 89
Alfredo Volpi 58, 143, 181
Allies 5, 16, 22, 28, 31, 32, 34, 36, 37,
 39, 53, 55n10, 61n30, 62n32, 106,
 109n187, 124, 126–128, 135, 136,
 141, 147, 150, 153, 156
Amsterdam 86n99
Anaïs Fléchet 3
Anglo-Brazilian Society 38, 51, 52, 60,
 71, 79, 84, 86, 99
Angyone Costa 42
Aníbal Machado 56n13, 59, 90
Anita Malfatti 12, 20, 97n123, 98,
 103n157
Anthony Eden 35, 54, 65, 66, 89
Antonio Callado 42, 135
Aracy Amaral 7
Archibald Sinclair 73, 111
Architectural Review 42, 45, 47, 91, 147
Arthur Vere Harvey 82
Athos Bulcão 181
Augusto Rodrigues 55, 87, 106, 110, 116,
 127, 143, 183
Axis 17, 28, 29, 33, 35, 36, 38, 61n28,
 150, 156

Bath & Wilts Chronicle & Herald 37
Bellá Paes Leme 59, 118, 180, 184
Big Stick Policy 31

Brasília 57n18, 77
Brazil Builds' 22–24, 32, 42, 44, 45n31,
 49, 52, 71n48, 77, 80, 82, 84, 86,
 111, 119, 120, 147
Brazilian Congress of Writers 17
Brazilian Expeditionary Force 4, 61n29, 72
Brazilian Ministry of Foreign Affairs 2, 5,
 77n68, 125, 156
Brazilian Modern Art 2, 70, 101, 104,
 105, 114, 128
Brazilian Modernism 3, 6n3, 12, 13, 19,
 21, 49, 115, 126n4, 133, 134n31,
 136, 143, 158, 184
Brazilian Squadron 38
Bristol Museum and Art Gallery 1, 83n92,
 85n95
British Broadcasting Corporation
 (BBC) 42
British Council 6n2, 19, 24n10, 49, 51, 52,
 60, 62, 64, 66, 70, 71, 73n54, 74, 76,
 79, 80, 83, 84, 86–89, 91, 92n112,
 96, 99, 100, 103n152, 110, 112, 117,
 119, 129, 131, 132, 142, 145

Candido Portinari 1, 15, 115, 117, 118,
 143, 181, 184
Cardoso Júnior 57, 86n100, 105, 108, 117,
 143, 179, 184
Carlos Leão 87n100, 100, 107, 143, 183
Carlos Oswald 21, 43, 183
Carlos Prado 99, 108n186, 115, 118, 120,
 124, 181
Carlos Scliar 108n186, 183
Carmen Miranda 46, 50, 147
Casablanca Conference 33
Castle Museum 1, 79, 117, 119
Chagall 63n35, 93, 98, 102, 105

186 PUBLIC DIPLOMACY ON THE FRONT LINE

Cícero Dias 14, 15, 21, 86n100, 94, 98n128, 99, 104, 105, 112n193, 115, 117, 118, 121, 123, 143, 180, 182
Clóvis Graciano 55, 87n100, 107, 108n186, 180, 182, 184
Competitive Identity 5
Composition 84, 86n100, 143, 179, 180n10, 181, 182n18, 183, 184
Congress of Brazilian Visual Artists 17
Coordinator of Inter-American Affairs (OCIAA) 23
Cultural Diplomacy 3, 5, 17, 24n10, 25, 73, 126, 130n9, 132, 135, 136, 138, 150, 152, 153, 157, 158, 161
Cyclists 99, 114, 121, 179, 182

Daryle Williams 3, 11, 12, 14, 15, 19, 21, 39, 58, 136
Dawn Ades 6n2, 20, 36, 48, 95, 124, 151
Diego Rivera 94, 119
Djanira 86n100, 105, 135, 180, 182
Donald Gainer 72, 75n64
Duchess of Kent 76, 77n69, 78, 88, 146
Duja Gross 108n186, 180

Edgar Clements 81
Edith Behring 181
Edmund Gullion 5n1, 25n11
Eleanor Hennessy 82
Eliseu Visconti 43
Emeric Marcier 116, 122n207, 143, 180, 183
Emiliano Di Cavalcanti 1, 14, 15, 21, 180, 184
Estado Novo 15n5, 16–20, 22, 30, 38, 39, 41, 45, 147
Eton College 90
Eurico Dutra 31
Europe 12, 18, 23, 24, 28, 29n16, 34, 36, 37, 39, 41, 43, 46, 48, 55, 58, 61, 85, 89, 94, 96, 97n123, 98, 102–104, 110, 111, 119–121, 122n206, 123, 133, 134, 148, 151
Exhibition d'Art Américain-Latin 20
Exhibition Internationale d'Art Moderne 86
Exhibition of Modern Brazilian Paintings 1, 20, 36, 50, 55, 77, 82, 85n96, 92, 103, 152, 155, 179

FEB 4, 17, 33–37, 70, 81n80, 82, 127, 132, 134, 136, 138, 149, 156
Fellowship of the Bellows 38, 74, 116, 137, 142
Fernando Azevedo 11
Flávio de Carvalho 21, 23n9, 107, 108n186, 179, 182
Fourth Corps 35
Francis Toye 49, 52, 54, 55
Francisco Adolfo de Varnhagen 11
Francisco Rebolo 86, 108n186, 114, 180n8
Franklin Delano Roosevelt 4, 31
Frederico de Morais 7
French Artistic Mission 11, 15, 19, 42, 43

Gastão Worms 21, 87n100, 181, 184
Germany 25, 27n13, 28–31, 33, 53, 102, 133, 151
Getúlio Vargas 3, 13, 15n5, 30, 47, 55, 83
Gilberto Freyre 26, 104
Goeldi 107, 143, 182
Good Neighbour Policy 23, 24, 31
Graça Aranha 12, 17
Guignard 21, 94, 98, 99, 102, 104, 107, 112n193, 115, 122, 124, 135n14
Gustavo Capanema 15, 47

Heitor dos Prazeres 57, 94, 98, 105, 108, 112n193, 116, 117, 121, 180
Heitor Villa-Lobos 40
Herbert Read 20, 96
Hilda Campofiorito 179
Hugo Gouthier 27, 81, 142

Iberê Camargo 86n100, 181, 182
Ignês Correia da Costa 179
Italy 24, 33, 35, 58, 61n29, 64n37, 70, 72, 74, 75n65, 81, 83, 110, 150, 156
Itamaraty 17, 24, 26, 34, 39, 52, 54, 60n26, 61, 77n69, 106, 127, 131, 133, 136, 139, 141, 145, 150, 151n45, 152, 161

Jacob Ruchti 108n186, 183
Joachim Lebreton 11
João Maria dos Santos 87n100, 180
Joaquim de Sousa-Leão Filho 27, 42
Johann Moritz Rugendas 46
Jorge de Lima 180, 182
José Moraes 181, 184

INDEX

Joseph Lea Gleave 80
Joseph Nye 5, 139, 145
Joseph Plowman 82
Joshua Reynolds 63, 72
Josias Leão 27
Juliette Dumont 3

Kandinsky 93
Kelvingrove Gallery 1, 81
Kidder Smith 22, 45, 47
King George VI 82, 83, 148
King John VI 11

Lasar Segall 1, 12, 68, 81, 93, 116, 117,
 120, 151n45, 181, 184
Latin America 28, 31–33, 37, 46, 75, 148,
 151, 158
Lawford 66, 71n49
Le Corbusier 47, 48, 95
Leão Velloso 72, 80, 110
Livio Abramo 108n186, 143, 181
London 1, 2, 4, 6n2–3, 8, 18, 20–23, 26,
 31, 35–38, 40, 42, 43, 45n31, 49, 51,
 52n2, 53n7, 54n9, 55, 59–63, 71n49,
 72, 79, 81, 83, 85, 86, 87n102,
 89, 91, 95, 99, 100, 102, 103, 107,
 108n178, 110, 112, 116, 122, 124,
 128, 130, 131, 135, 136, 137, 143n31,
 144, 150, 151, 155, 159
Lord Keynes 73
Lord Methuen 82
Lord Riverdale 88
Lucio Costa 14, 21, 23, 47, 58, 59, 82
Lucy Citti Ferreira 85, 87n100, 108n186,
 180, 182, 184
Lucy with flower' 68, 81, 94, 99, 105, 107,
 115, 118, 120, 121, 142
Luís Soares 87n100, 118, 181, 183, 184
Luiz Martins Souza Dantas 18, 21

Machado de Assis 46
Malcom Robertson 19, 74
Manoel Martins 87n100, 110, 128,
 181, 183, 184
Manuel Ataíde 46
Marie Laurencin 95n118, 102
Mário de Andrade 8, 12n2, 49, 58, 59
Mario Zanini 108n186, 181
Mark Gertler 93, 102
Mark Leonard 5, 126n4

Martim Gonçalves 87n100, 118, 120, 180,
 182, 184
Mayor W. M. Newham 85
Mestre Valentim 42, 44, 46
Milton Dacosta 114, 121, 179, 184
Ministry of Health and Education
 22, 23, 25, 47
MNBA 14, 18, 19, 57n16, 144
Moniz de Aragão 27n13, 38, 51, 71n48,
 83, 84, 86, 122, 130
Monte Castello 72, 75, 81n80
Museum of Modern Art of New York
 (MoMA) 22

Natal 29n16, 33–35, 136
Nation Branding 5
National Defence League 17
National Gallery of Edinburgh 1
National Historical and Artistic Heritage
 Service 23
Nazi 23, 27n13, 28, 36, 61
Neil Lochery 3
Nelson Nóbrega 181, 183
Nelson Rockefeller's 23
New York 21, 22, 43, 56, 99, 103,
 111, 117, 147
New York World Fair 21
Noel Charles 32, 34, 35, 54, 60,
 106, 109n187
Noemia Mourão 108n186, 183

Orlando Teruz 181
Osbert Sitwell 70, 90
Oscar Meira 143, 181, 183, 184
Oscar Niemeyer 21, 47, 77, 82
Oswald de Andrade 12, 115n198,
 179, 180, 184
Oswaldo Aranha 2, 3, 16, 27, 28, 36, 51,
 53, 106, 109, 110n191, 124, 125, 127,
 134, 147, 155, 156
Oswaldo Teixeira 14, 16, 43, 51

Pancetti 98n126, 99, 105, 107,
 108n186, 115, 117, 121, 122,
 124, 143, 181
Paris 8, 21, 23, 36, 43, 57, 86, 89, 93,
 96n121, 99, 102, 103n156, 114, 116,
 119, 121, 143, 151n45
Paschoal Carlos Magno 4, 27, 39, 42, 51,
 147n39

Pauline in the yellow dress' 68
Paulo Boavista 42, 49
Paulo Carneiro 86
Paulo Rossi Osir 21, 181
Paulo Werneck 87n100, 143, 184
Pearl Harbour 28, 33
Pedro Leão Velloso 80
Pen and ink drawing' 74
Percy Lau 75n62, 87n100, 107, 182, 183
Peter Gay 12
Philip Goodwin 22, 44
Picasso 18, 40, 65n38, 95, 112
Poty Lazzarotto 57, 87n100, 108, 143, 183
Pragmatic equilibrium' 3, 29, 156
Princess Margaret 77, 146
Public Diplomacy 2, 5n1, 9, 24n10, 25n11,
 26, 54, 75, 83, 126n4, 129, 130n9,
 131, 134, 136, 139, 144–147, 152,
 153, 157, 158, 160, 161

Queen Elizabeth 77
Queen Mother 144, 146
Quirino Campofiorito 19, 75n62, 121,
 124, 179
Quirino da Silva 21, 77n80, 99, 108n186,
 114, 115, 124, 179

Reading Museum and Art Gallery
 1, 85
Rio de Janeiro 1, 7, 8, 11, 12, 17–19, 22,
 30, 32–34, 42, 44, 46, 52, 53n4,
 54n9, 55, 57n18, 59, 60n25, 61,
 64n37, 71, 75n64, 80n76, 82,
 87n101, 93n113, 94, 97, 98n128,
 100, 104, 112, 129, 138, 143, 144
Roberto Burle Marx 47, 94, 179, 181, 184
Royal Academy 1, 2, 6n2, 8, 20, 23,
 45n31, 50, 62, 63n34n35, 64, 66,
 69n44, 70–72, 75–77, 79, 89, 92n111,
 96, 100, 131, 132, 142n26, 144
Royal Air Force 1, 6n2, 37, 54, 73n54, 74,
 76, 80, 84, 87, 90, 111, 116, 132, 137,
 141, 142, 149, 157
Royal Air Force Benevolent Fund 1, 6n2,
 76, 80, 84, 85, 88, 92, 111, 132, 142
Royal Air Force Benevolent Fund
 magazine 85
Rubem Cassa 182
Ruben Navarra 8, 56, 89, 91, 92, 99, 100,
 103, 116, 120, 135
Rubens Ricupero 9, 125, 148

Sacheverell Sitwell 8, 38, 46, 73n56, 89,
 90n106, 91, 92, 95, 99, 111, 116,
 120, 158
Santa Rosa 43
São Paulo 12, 15, 17–19, 21, 24, 55, 57, 58,
 72n50, 80n76, 93n113, 95, 97n123,
 98n128, 99, 104, 106, 111, 142
Sidney Herbert 76
Sidney Hutchison 8
Simon Anholt 5, 133, 138
Sir Charles Reilly 73, 85
Soft and Smart Power 5
Somerville 77, 79, 84
Sousa-Leão 27, 37, 42, 44, 45, 46, 52, 61,
 70–72, 73n58, 74–76, 77n68, 80, 82,
 111, 112, 136
South America 29, 32, 33, 35, 38, 40, 62,
 148, 150, 156
South American Journal 37, 38
Stefan Zweig 41
Sumner Welles 33
Szenes 59, 99, 103, 108, 116, 181n13, 184

Tarsila do Amaral 1, 14, 15, 21, 39, 43,
 48, 86n100, 87n100, 98, 99, 105,
 107, 108n186, 116, 142, 180
The Art of Diplomacy – Brazilian
 Modernism Painted for
 War 6, 133, 158
The Studio 40, 41
Thea Haberfeld 84, 180, 184
Theodore Roosevelt 31
Thomas Cook 79
Tim Marlow 6n2, 96
Toledo Piza 21, 108, 181
Tomás Santa Rosa 181, 183

UNESCO 86
United Kingdom of Portugal, Brazil and
 the Algarves 11
United States 3, 21, 24n10, 25n11, 27–35,
 42, 44, 46, 49, 53n5, 56n12, 82,
 122n206, 126, 133, 134n12, 141,
 150, 151, 156, 160
Urbano de Macedo 86n100, 122, 180, 184
US Department of State 34

Victor Brecheret 20
Victor Perowne 49, 54, 59, 75, 76n67,
 105, 129
Victoria Gallery 1, 81, 83, 148

INDEX

Vieira da Silva 59, 86n100, 103, 108, 143, 182n16
Villa-Lobos 47, 94, 147
Virginia Artigas 179
Volta Redonda 38
V2 rockets 72

Walter Lamb 8, 63, 71
Walter Machado 183

Walter Zanini 7, 51
Wassily Kandinsky 102
Whitechapel Gallery 1, 85
Winston Churchill 34, 35, 83
WW2 1–3, 6, 8, 9, 23, 26, 27, 31, 37, 41, 51, 61n28, 63, 90n107, 128, 133, 134, 137, 139, 141, 147, 155, 159

Printed in the USA
CPSIA information can be obtained
at www.ICGtesting.com
JSHW020900281023
50928JS00001B/1